Old Masters, Impressionists, and Moderns

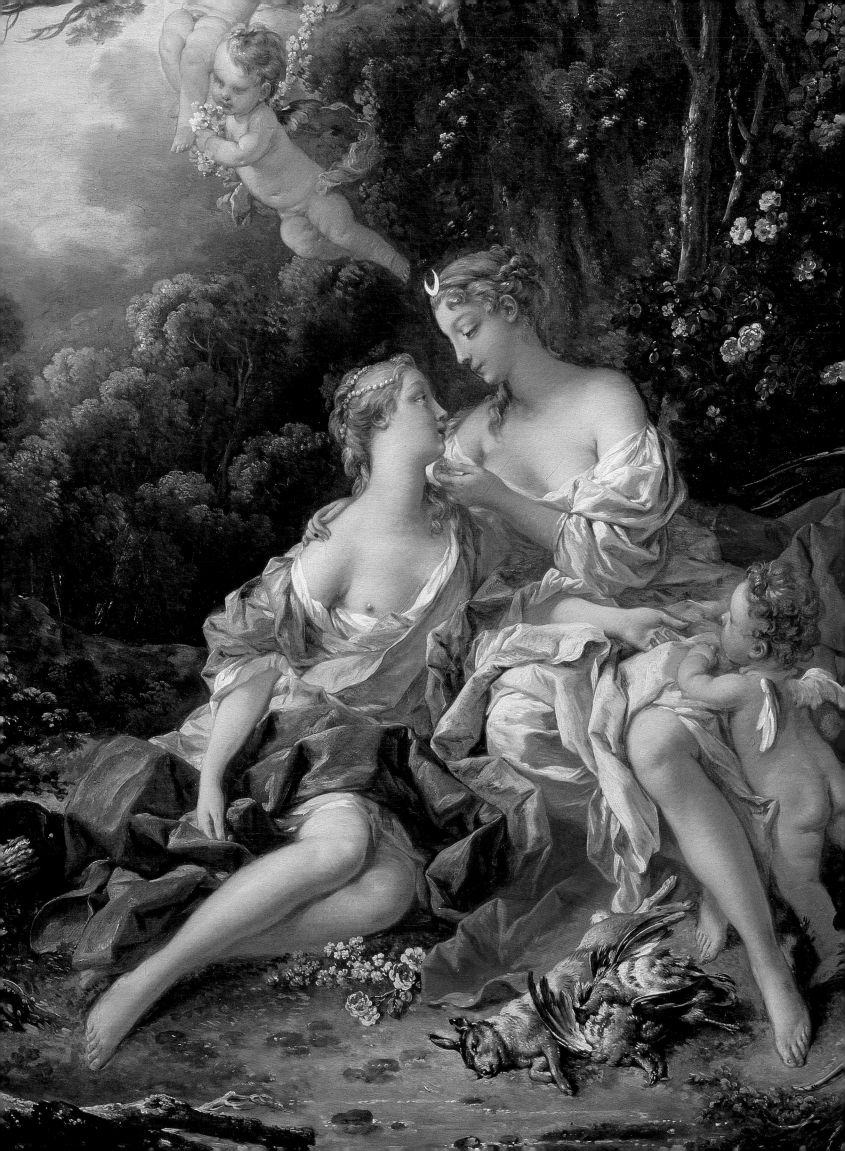

Irina Antonova

with

Charlotte Eyerman

Eugenya Georgievskaya

Elena Sharnova

Old Masters, Impressionists, and Moderns

FRENCH MASTERWORKS FROM THE STATE PUSHKIN MUSEUM, MOSCOW

YALE UNIVERSITY PRESS, NEW HAVEN AND LONDON

IN ASSOCIATION WITH THE MUSEUM OF FINE ARTS, HOUSTON

Front cover: Pablo Picasso, *Harlequin and His Companion* (*The Saltimbanques*) (detail), cat. 69. © 2002 Estate of Pablo Picasso/ Artists Rights Society (ARS), New York.

Back cover: Auguste Renoir, *In the Garden*, cat. 33.

Page ii: François Boucher, *Jupiter and Callisto* (detail), cat. 5.

Page 10: Henri Rousseau, *Jaguar Attacking a Horse* (detail), cat. 67.

EXHIBITION ITINERARY

The Museum of Fine Arts, Houston
 December 15, 2002–March 9, 2003

High Museum of Art, Atlanta
 April 5–June 29, 2003

Los Angeles County Museum of Art
 July 27–October 13, 2003

Photography: Sergei Fhil and Anatoly Sapronenkov, the State Pushkin Museum of Fine Arts, Moscow

Works by Pierre Bonnard, Georges Braque, Maurice Denis, André Derain, Henri-Charles Manguin, Albert Marquet, and Édouard Vuillard © 2002 Artists Rights Society (ARS), New York/ADAGP, Paris.

Works by Henri Matisse
© 2002 Succession H. Matisse, Paris/Artists Rights Society (ARS), New York

Works by Pablo Picasso
© 2002 Estate of Pablo Picasso/Artists Rights Society (ARS), New York.

Printed in Singapore by C S Graphics

Library of Congress Cataloging-in-Publication Data

Antonova, Irina Aleksandrovna.
 Old masters, impressionists, and moderns : French masterworks from the State Pushkin Museum, Moscow / Irina Antonova with Charlotte Eyerman, Eugenya Georgievskaya, Elena Sharnova.
 p. cm.
 "Exhibition itinerary, The Museum of Fine Arts, Houston December 15, 2002–March 9, 2003, High Museum of Art, Atlanta, April 5–June 29, 2003, Los Angeles County Museum of Art, July 27–October 13, 2003."
 Includes bibliographical references and index.
 ISBN 0-300-09736-0 (hardcover : alk. paper)
 ISBN 0-89090-111-2 (pbk. : alk. paper)
 1. Painting, French—Exhibitions.
 2. Painting—Russia
 (Federation)—Moscow—Exhibitions.
 3. Gosudarstvennyi muzei
 izobrazitelnykh iskusstv imeni A. S.
 Pushkina—Exhibitions. I. Museum of Fine
 Arts, Houston.
 II. High Museum of Art. III. Los Angeles County
 Museum of Art. IV. Title.
 ND544 .A58 2002
 759.4'074'44731—dc21 2002007461

 10 9 8 7 6 5 4 3 2

CONTENTS

Foreword

E VER SINCE the time of Czar Peter I (the Great) (r. 1682–1725), Russia has had a love affair with French art. Peter the Great and his successors filled their palaces with fine and decorative arts from throughout Europe, shaping the taste of Russian court society with French paintings, fashions, and luxury goods. During the reign of Peter's daughter Elizabeth (r. 1741–61), French became the preferred language at court, and, under Catherine the Great (r. 1762–96), the formation of the Hermitage art collection secured the primacy in Russia of French art. Throughout the nineteenth century, noble families, prosperous businessmen, scholars, and clergy followed Catherine's lead; by the beginning of the twentieth century, Russia was in the enviable position of possessing the greatest collections of French painting anywhere outside of France.

The cataclysmic events in Russia in the early twentieth century forever changed the shape of these collections. After the Revolution of 1917, private collections were nationalized and museum collections redistributed. Whereas once the Hermitage had been the sole significant repository of European art in Russia, now there was a second great collection: the State Pushkin Museum of Fine Arts in Moscow. The Pushkin opened to the public in 1912; in less than forty years it had become one of the finest collections of French painting anywhere in the world.

The purpose of this exhibition is to introduce the Pushkin Museum's superb collection to American audiences. Until now, American presentations of French art from Russia have relied primarily on the holdings of the Hermitage Museum, along with smaller numbers of paintings from the Pushkin included in thematic or monographic exhibitions. This exhibition consists of seventy-six works that range chronologically from the classicist Nicolas Poussin to the modernists Pablo Picasso and Henri Matisse. Fifty-three of these paintings have never before been seen in the United States, including important works by François Boucher, Jean-Auguste-Dominique Ingres, Camille Corot, Gustave Courbet, Claude Monet, Camille Pissarro, and Paul Cézanne. Of the remaining twenty paintings—among which are Matisse's *Nasturtiums and The Dance* and Vincent van Gogh's *The Prison Courtyard*—few have been on view in Houston, Atlanta, or Los Angeles.

The exhibition—*Old Masters, Impressionists, and Moderns: French Masterworks from the State Pushkin Museum, Moscow*—was organized by the Museum of Fine Arts, Houston, and the State Pushkin Museum of Fine Arts, Moscow, in cooperation with the Foundation for International Arts and Education, an organization based in Bethesda, Maryland, and dedicated to preserving the cultural heritage of the countries of the former Soviet Union. It is a milestone in a partnership among these three institutions that will include additional exhibitions, long-term exchanges of individual paintings, and an ambitious publications program.

After opening in Houston in December 2002, the exhibition will travel to the High Museum of Art in Atlanta and the Los Angeles County Museum of Art. The partnership, exhibition, and national tour have been sustained from their inception by the generous support of Philip Morris Companies, whose faith in the value of these projects ensures that our

vision for this international exchange is realized.

Our gratitude goes to Janet Landay, curator of exhibitions at the Museum of Fine Arts, Houston, for her energy, insight, and hard work as project director of the partnership and as an organizing curator of this exhibition. Edgar Peters Bowron, the Audrey Jones Beck Curator of European Art at the MFAH, selected the works on view, and Mary G. Morton, MFAH associate curator of European art, contributed her expertise to the project. We are indebted to the staff at the Pushkin Museum, particularly Vitaly Mishin, deputy director of research; Maria Kostaki, head of the foreign office; Zinaida Bonami, deputy director of exhibitions and foreign affairs; Tatyana Potapova, chief curator; and Elena Sharnova, curator of French painting, for their able assistance in all aspects of organizing this exhibition. Building on the material provided by the Pushkin, Charlotte Eyerman, catalogue author; Theresa Papanikolas, MFAH associate editor; and Christine Waller Manca, MFAH assistant publications director, produced the excellent catalogue manuscript. We thank Yale University Press for publishing this catalogue and for its commitment to reaching a wide audience of readers. For navigating the legal complexities we thank Natalia Morosova and her colleagues at Vinson and Elkins, L.L.P., as well as Dennis Whelan and Xenia Menshova of the Russia Law Center. A complete list of the many people who devoted their talents and energy to making this exhibition possible appears on page x.

All of us involved in organizing this international loan exhibition believe in the power of cultural exchanges to bring people closer together. To share these artistic treasures between nations affirms our commitment to celebrating the great achievements of human creation. As current events make such an undertaking increasingly difficult, they also make the pleasures it brings all the more precious.

Irina Antonova
Director
State Pushkin Museum of Fine Arts

Peter C. Marzio
Director
The Museum of Fine Arts, Houston

Gregory Guroff
President
Foundation for International Arts and Education

Michael E. Shapiro
Director
High Museum of Art

Andrea L. Rich
Director
Los Angeles County Museum of Art

SPONSOR'S STATEMENT

THE ARTS are a foundation for bridging communities around the world—they foster freedom of expression, transform lives, provoke thought, uplift, and inspire. That is why we at Philip Morris are proud to sponsor this unprecedented exhibition of French masterpieces from the State Pushkin Museum of Fine Arts, Moscow, many of which have never been exhibited outside of Russia. American audiences will see some of the greatest French paintings and will experience the depth of the Pushkin Museum's extraordinary collection.

We are equally pleased to support the unique partnership between two of the most distinguished cultural institutions in the world, the Museum of Fine Arts, Houston, and the State Pushkin Museum in Moscow. It is through the leadership and vision of these remarkable museums that an exhibition of the caliber of *Old Masters, Impressionists, and Moderns: French Masterworks from the State Pushkin Museum, Moscow* could become a reality.

During the past forty-five years, the Philip Morris family of companies has supported thousands of charitable organizations and helped to make a difference in people's lives. As a major international company, we are an active member of the 180 communities around the world where we do business, and we have a commitment to address the needs of these communities to help them grow and thrive. We would like to thank the Museum of Fine Arts, Houston, and the State Pushkin Museum of Fine Arts, Moscow, for their commitment and shared belief that the arts are for everyone. Through this exhibition and catalogue, they will educate and inspire audiences all over the world.

Louis C. Camilleri
President and Chief Executive Officer
Philip Morris Companies Inc.

PREFACE

T HE EXHIBITION of French paintings from the State Pushkin Museum of Fine Arts, which opens at the Museum of Fine Arts, Houston, and then travels to the High Museum in Atlanta and the Los Angeles County Museum of Art, is one of the most important events in the history of exhibition exchanges between Russia and the United States. Russian viewers still remember such outstanding exhibitions as *100 Paintings from the Metropolitan Museum* (1975) and *American Painting of the Nineteenth and Twentieth Centuries* (1980). These exhibitions have been followed by many others, including, most recently, the wonderful presentation of gold objects from Africa lent to the Pushkin by the Museum of Fine Arts, Houston (2001–02). Thanks to this tradition of exchanges, treasures from the finest American museums have become familiar to tens of thousands of people in Russia.

At the same time, there have been a substantial number of exhibitions in the United States featuring Russian and foreign art from Russian museums, and in these the State Pushkin Museum has been an active participant. In particular, the works of nineteenth- and twentieth-century masters from the Pushkin Museum's collection have been shown many times in the United States. However, the current exhibition is distinguished not only by its considerable size (seventy-six paintings), its rigorous selection, and its high artistic quality, but also by the fact that it represents a significant part of the Pushkin's paintings collection—a collection of French painting that spans from the seventeenth century to the first decades of the twentieth.

French language and culture have occupied an important place in educated Russian society since the eighteenth century,

the epoch of Peter the Great and Catherine the Great. Empress Catherine assiduously collected French art, as did art lovers from aristocratic families. The most outstanding collection was brought together by Prince N. B. Yusupov, who persistently acquired the works of Hubert Robert. During the second half of the nineteenth century, a new group of Russian collectors, this time from the enlightened circles of the merchant class, became attracted to French painting. Among them was Sergei Tretyakov, a connoisseur of the Barbizon landscape painters and brother of the founder of the Tretyakov Gallery. In the early twentieth century, Sergei Shchukin and Ivan Morozov, with remarkable courage and discriminating taste, acquired innovative works by contemporary French masters.

Thanks to the achievements of these collectors, the State Pushkin Museum can include in this exhibition masterpieces by Nicolas Poussin, Claude Lorrain, Jacques-Louis David, Hubert Robert, Claude Monet, Paul Gauguin, and Henri Matisse, as well as treasures created in France by the Dutch artist Vincent van Gogh and the Spaniard Pablo Picasso. By showing the exhibition in several American cities, we in Russia hope to inspire in visitors a proper and deserved appreciation of these beautiful works of art, and of the accomplishments of the Russian collectors. This exhibition aims to promote understanding of Russian history and culture, an understanding essential to fostering good relations among peoples.

Mikhail Shvydkoi
Minister of Culture
The Russian Federation

ACKNOWLEDGMENTS

*O*LD *MASTERS, Impressionists, and Moderns: French Masterworks from the State Pushkin Museum, Moscow* was organized by the Museum of Fine Arts, Houston, and the State Pushkin Museum of Fine Arts, in cooperation with the Foundation for International Arts and Education.

The organization of the exhibition and its national tour were sponsored by Philip Morris Companies Inc. Additional funding was provided by Vinson & Elkins, L.L.P.; the Hamill Foundation; and Caroline Wiess Law. Funding for travel of museum professionals was provided by the Trust for Mutual Understanding.

PROJECT DIRECTOR

Janet Landay, *Curator of Exhibitions, MFAH*

CURATORS

Edgar Peters Bowron, *The Audrey Jones Beck Curator of European Art, MFAH*
Janet Landay
Mary Morton, *Associate Curator of European Art, MFAH*

CATALOGUE AUTHORS

Irina Antonova, *Director, Pushkin*
Charlotte Eyerman, *independent art historian*
Eugenya Georgievskaya, *Curator of French Painting, Pushkin*
Elena Sharnova, *Curator of French Painting, Pushkin*

CATALOGUE EDITORS

Christine Waller Manca, *Assistant Publications Director, MFAH*
Theresa Papanikolas, *Associate Editor, MFAH*

Grateful acknowledgment is made to the many people listed below who helped to make this exhibition possible.

STATE PUSHKIN MUSEUM OF FINE ARTS

Zinaida Bonami, *Deputy Director, Exhibitions and Foreign Affairs*
Galina Erkhova, *Painting Restorer*
Maria Kostaki, *Head of Foreign Office*
Vitaly Mishin, *Deputy Director, Research*
Inna Orn, *Foreign Office Coordinator*
Tatyana Potapova, *Chief Curator*
Vadim Sadkov, *Head of the Department of European and American Art*

MUSEUM OF FINE ARTS, HOUSTON

Julia Bakke, *Chief Registrar*
Kathleen Crain, *Registrar for Exhibition*
Jack Eby, *Exhibition Design Director*
Gwendolyn H. Goffe, *Associate Director, Finance and Administration*
Diane Lovejoy, *Publications Director*
Margaret Mims, *Public Programs Manager*
Emily Rendon, *Assistant to the Curator of Exhibitions*

Leslie Scattone, *Curatorial Assistant, European Art*
Beth Schneider, *Education Director*
Margaret C. Skidmore, *Associate Director, Development*
Patricia M. Smith, *Retail Operations Director*
Frances Carter Stephens, *Public Relations Director*
Katherine Story, *Senior Graphic Designer*
Karen Vetter, *Curatorial Administrator*

FOUNDATION FOR INTERNATIONAL ARTS AND EDUCATION

Alec Guroff, *Senior Program Officer*
Katharine Guroff, *Director of Programs*
Elena Romanova, *Program Officer*

HIGH MUSEUM OF ART

David Brenneman, *Chief Curator and Frances B. Bunzl Family Curator of European Art*
Jody Cohen, *Manager of Exhibitions*
Frances R. Francis, *Registrar*
Linnea Harwell, *Exhibitions Coordinator*
Rhonda Matheison, *Director of Finance and Operations*
Maureen Morrisette, *Associate Registrar*
Philip Verre, *Deputy Director*

LOS ANGELES COUNTY MUSEUM OF ART

Cim Castellon, *Assistant Vice President, Merchandising*
Christine Lazzaretto, *Exhibition Coordinator*
J. Patrice Marandel, *Chief Curator, Center for European Art*
Irene Martin, *Assistant Director, Exhibition Programs*
Portland McCormick, *Associate Registrar, Exhibitions*
Beverley Sabo, *Financial Analyst, Exhibitions*

Nancy Thomas, *Deputy Director, Curatorial Affairs*
Aya Yoshida, *Curatorial Assistant, European Paintings and Sculpture*

YALE UNIVERSITY PRESS

Heidi Downey, *Senior Manuscript Editor*
Patricia Fidler, *Executive Editor, Art and Architecture*
Leslie Fitch, *Book Designer*
Mary Mayer, *Production Manager, Fine Arts Books*

Gallery of seventeenth- and eighteenth-century French art. State Pushkin Museum of Fine Arts, Moscow.

THE STATE PUSHKIN MUSEUM OF FINE ARTS

Irina Antonova

THE State Pushkin Museum in Moscow is one of the most celebrated collections of artistic works in Russia. Its holdings are varied and broad, with works from ancient through modern times by artists from all over the world. The museum is particularly well known for its collection of French painting. Now the American public can experience these French masterpieces, through the exhibition *Old Masters, Impressionists, and Moderns: French Masterworks from the State Pushkin Museum, Moscow.*

Although famous for its collection of French paintings, the museum is also renowned for its general painting collection. It includes among its holdings Byzantine icons and celebrated works by Sandro Botticelli, Lucas Cranach the Elder, Rembrandt van Rijn, Nicolas Poussin, Antoine Watteau, Giovanni Battista Tiepolo, Peter Paul Rubens, Bartolomé Estebán Murillo, Claude Monet, Auguste Renoir, Paul Cézanne, Edgar Degas, Vincent van Gogh, Paul Gauguin, Henri Matisse, and Pablo Picasso. The collection of Egyptian treasures includes original Fayum portraits. The department of drawings and engravings contains more than 350,000 graphic works and drawings by western European, American, and Asian artists; this department also houses the largest collection of old Russian graphic works. Among the museum's exceptional examples of western European sculpture are works by Jacopo Sansovino, Théodore-Jean-Antoine Gudin, Gianlorenzo Bernini, Auguste Rodin, and Aristide Maillol.

The museum has a fine collection of original Greek and Roman artifacts, with particular depth in Greek vases. Limoges enamels, Italian majolica, and Venetian and Spanish furniture are the pride of the decorative arts department. The museum also houses a collection of coins and medals that is one of the most significant in Russia.

The State Pushkin Museum of Fine Arts, Moscow.

The idea of creating in Moscow an art museum focused on examples of world culture arose in the mid-eighteenth century, and the concept gathered support from the Moscow intelligentsia throughout the next century and a half. It found expression both in Princess Zinaida Volkonskaya's well-known project for an Aesthetic Museum (1831) and in the activities of several generations of professors who established academic collections at Moscow University. The sustaining concept behind these endeavors was that art enlightens and educates.

The founder of what ultimately became the State Pushkin Museum of Fine Arts was Professor Ivan Tsvetaev (1846–1913) of Moscow University. He was able to do what his predecessors could not—namely, to procure a plot of land

I

Ivan Tsvetaev, founding director of the State
Pushkin Museum of Fine Arts, Moscow. c. 1913.

in the center of the city not far from the Kremlin, attract early supporters, and raise private funds for construction. Well-known Moscow architect Roman Klein designed the building.

The museum was established in 1898 and opened to the public in 1912. Initially named the Alexander III Museum of Fine Arts, it was built with nongovernmental funds as a teaching institution under the auspices of Moscow University. The museum began as an extensive collection of plaster-cast replicas of sculptural and architectural monuments, many of them commissioned for the museum. Tsvetaev dreamed of expanding the museum beyond its original concept in order to, in his words, "raise the significance of the collection by the acquisition of as many original works as possible."

By the early 1920s Tsvetaev's vision began to be realized. The museum developed along several paths: from the nationalization of private collections after the 1917 revolution and the voluntary closing or transfer of collections from existing museums (including the State Hermitage Museum), to the regular expansion of the collection through state purchases, private donations, and deposits of archeological artifacts. This teaching collection rapidly grew into one of the most important art museums in the world. A gallery of paintings was established, as well as a department of drawings and engravings and a collection of coins. The scholars associated with the museum vigorously gathered important works of art. In 1937 the museum was renamed to honor the Russian poet Alexander Pushkin (1799–1837).

The museum underwent its most significant changes in 1948, when the collections of the then-closed Museum of Modern Western Art were transferred to the State Pushkin Museum. The Museum of Modern Western Art was founded in the late 1920s to house the collections of two outstanding Russian patrons, Sergei Shchukin and Ivan Morozov. This famed museum of French Impressionists and Post-Impressionists had been closed and reorganized under a directive from Joseph Stalin, who considered this type of art to be corrupt. Stalin further ordered that the collection be divided between the Hermitage and Pushkin museums with the implicit understanding that neither museum would hang the paintings in their galleries. It was not until the 1960s that these French masterworks were displayed for museum visitors.

Since the Pushkin opened, its collection has increased more than fiftyfold. Today it has 575,000 objects, 650 staff members, and approximately 1 million visitors each year. But the museum is defined not just by its collection. Over the years it has initiated a number of programs and projects. In 1945,

Czar Nicholas II at the opening of the State Museum of Fine Arts, Moscow
(renamed the State Pushkin Museum of Fine Arts in 1937). May 31, 1912.

for example, the museum received a collection of masterpieces salvaged by the Soviet Army from the Dresden Gallery. The paintings were in desperate need of restoration, and the museum staff worked hard on them. Ten years later the works were shown to Russian audiences and subsequently returned to Dresden.

The Pushkin Museum has developed many educational initiatives, including frequent lectures, clubs for young art historians, children's theater, and family activities. During the past thirty years the museum has hosted the Vipper Lectures, a series of scholarly conferences related to major exhibitions at the museum. The museum has published catalogues of paintings, including comprehensive studies of the museum's Dutch, Flemish, Italian, and French collections. In addition to this exhibition catalogue, an English edition of the two-volume French painting catalogue raisonné is being published by Yale University Press in association with the State Pushkin Museum of Fine Arts and the Museum of Fine Arts, Houston.

In the mid-1950s the Pushkin Museum became a major stop in Russia for traveling international exhibitions. Over the course of several decades the museum has hosted exhibitions from the Musée du Louvre in Paris, the Museo del Prado in Madrid, Vienna's Kunsthistorisches Museum, the Metropolitan Museum of Art and the Museum of Modern Art in New York, the National Gallery of Art in Washington, D.C., the Centre Georges Pompidou in Paris, and national museums in Prague, Warsaw, Venice, Tokyo, and London. Those who attended these exhibitions saw masterpieces: Leonardo da Vinci's *Mona Lisa* and *The Lady with an Ermine (Cecilia Gallerani)*, Eugène Delacroix's *Liberty Leading the People,* Jan Vermeer's *Artist's Studio,* Titian's *Venus of Urbino,* El Greco's *View of Toledo,* the Gold Mask of Tutankhamen, and many others. In 1980 the Moscow public had the opportunity to see American masterpieces in an exhibition organized by the Fine Arts Museums of San Francisco and the Metropolitan Museum. A major event in 1984 was the exhibition of the Leonardo da Vinci codex from the Armand Hammer collection. In 2000 the State Pushkin Museum embarked on a long-term collaboration with the Museum of Fine Arts, Houston, including a series of six-month exchanges of individual paintings and this presentation of French masterpieces. Another result of this collaboration was the exhibition *African Gold: Selections from the Alfred C. Glassell Collection,* presented at the Pushkin in 2001–2002 to enthusiastic acclaim.

Exhibitions at the State Pushkin Museum of Fine Arts

have reached well beyond presenting the collections of the world's greatest museums. The museum organized the exceptional *Moscow-Paris,* an exhibition on the developmental paths of art in the first thirty years of the twentieth century. It was held in 1981–82 at the Centre Georges Pompidou in Paris, as well as at the Pushkin. The exhibition marked the first time, after many years of silence, that the works of the Russian avant-garde were displayed—it was a rare feat in light of the ideological restrictions in place at the time. Similarly, the Pushkin organized exhibitions in the 1950s and 1960s of works by Pablo Picasso and Fernand Léger, and it was the first museum in Russia to exhibit the works of Marc Chagall and Salvador Dalí. The museum was also the first in Russia to put the works of Vassily Kandinsky on permanent display. Following in the footsteps of *Moscow-Paris* was the monumental exhibition *Moscow-Berlin* (1995–96), the first exhibition of works from the totalitarian period of Germany and the Soviet Union.

Notable among the museum's groundbreaking exhibition initiatives is its systematic display of the so-called "transferred treasures," art that was brought back by the Soviet Army during World War II. The Pushkin began exhibiting these works in 1955, with the masterpieces from Dresden, but then avoided the issue for several decades. Beginning in the 1990s the museum revisited the question of the transferred treasures. For example, it has prepared and exhibited drawings from the former Koenigs collection, a renowned collection of western European art purchased from the original collector by the Nazis and liberated by Russia during World War II. Paintings from German and Hungarian collections have also been displayed, as has one of the most famous collections of antiquities, *The Treasure of Troy: Heinrich Schliemann's Excavations.*

In 1981 the Pushkin entered into a partnership with the great pianist Svyatoslav Richter (1915–1997) to organize and host the annual international December Evenings music festival and accompanying exhibitions. Held each winter since its inception, the festival brings together art from the greatest museums of the world and an outstanding schedule of musicians and performers.

In 1994 the Museum of Private Collections, a new division based on gifts from collectors, was opened under the auspices of the State Pushkin Museum. This unusual museum would not have been possible without the support of renowned scholar Ilya Zilbershtein (1905–1988), who not only gave the Pushkin an enormous collection of paintings and drawings by Russian and foreign masters, but also conceived the idea of such a museum. Since its opening the Museum of Private Collections has been enriched by donations from a number of impressive collections.

In 1997 a branch of the Pushkin was established at the State Russian Humanities University, where plaster casts from the Pushkin are now on display. Through this link the Pushkin has come full circle, returning to its origins as a university museum based on replicas of works of art; it is hoped that the project will serve as a model for other Russian universities.

In the coming years the Pushkin Museum plans to develop further exhibitions from its collections for American audiences. The goals are not only to share the museum's wonderful works of art, but also to convey a spirit of friendship and cooperation. We are pleased that *Old Masters, Impressionists, and Moderns: French Masterworks from the State Pushkin Museum, Moscow* takes an important step toward achieving those goals.

The French Painting Collection at the State Pushkin Museum

Eugenya Georgievskaya and Elena Sharnova

COMPRISING more than seven hundred works dating from the end of the sixteenth century to the middle of the twentieth, the French painting collection is the pride of the State Pushkin Museum of Fine Arts, Moscow. Its development began in 1923, when the museum, under the auspices of the government, announced plans to form a collection of Western European paintings to complement its large collection of plaster casts of classical and Renaissance sculpture.[1] Benefiting from concurrent government efforts to nationalize and redistribute private collections, the Pushkin Museum acquired major works previously belonging to Catherine the Great and other Russian tsars, as well as those belonging to many important aristocratic families. Today, the old master section of the Pushkin's French collection contains more than 450 paintings, with particularly strong holdings from the seventeenth and eighteenth centuries.

For the most part, Russian collectors began acquiring French paintings during the latter part of the eighteenth century and the beginning of the nineteenth. Chief among the collectors was Empress Catherine the Great, who relied on the advice of such notable connoisseurs as the art critic, philosopher, and encyclopedist Denis Diderot to form the Hermitage collection in St. Petersburg. During her reign, the Hermitage became one of the greatest museums in Europe, and it was particularly strong in French art. So extravagant was Catherine in her purchasing that she managed to acquire major European collections, including those of the Count Heinrich von Brühl, prime minister to the Saxon Prince and Elector Frederic Augustus II, and the Crozat and Walpole collections from France and England, respectively. Masterworks from these collections eventually entered the Pushkin Museum, to which portions of the State Hermitage Museum in St. Petersburg (then Leningrad) were transferred in the 1920s and 1930s.

The history of the Pushkin Museum is thus intertwined with the history of the Hermitage. But perhaps even more significant to its development were the Russian private collections built at about the same time the Hermitage was formed. Following Catherine's example, members of the Russian aristocracy, including the Yusupovs, the Golitsyns, the Shuvalovs, the Baryatinskys, and the Stroganovs, competed with each other to amass ever more impressive collections of art. Although these collections generally followed eighteenth-century European tastes, they also reflected the unique interests of their owners. Alexander Stroganov, for example, specialized in Italian paintings, whereas Prince Nikolai B. Yusupov preferred the works of French old and contemporary masters. Both interests are reflected in the Pushkin Museum, whose Italian section was supplemented by selections from the Stroganov collection, and whose French holdings were greatly enriched with works from the Yusupov collection.

Prince Nikolai Borisovich Yusupov housed his collection at his Moscow residence, as well as at Archangelskoe, his country estate, whose architecture befitted the French masterpieces he loved. A connoisseur of European art, Yusupov collected continuously for almost forty years, assembling a collection of exquisite quality and variety. This exhibition includes several paintings from Yusupov's collection, including Claude Lorrain's *Abduction of Europa* (cat. 2), Boucher's *Jupiter and Callisto* (cat. 5), and Louis-Léopold Boilly's *Studio of a Woman Artist* (cat. 17, proof of the duke's foresight—he was the first Russian to collect Boilly's works).

Also represented in the exhibition is the collection of

Ivan Abramovich Morozov (1871–1921).

Sergei Ivanovich Shchukin (1854–1936).

Prince Dmitri Mikhailovich Golitsyn, founder of the first Russian public museum in Moscow. Golitsyn commissioned a portrait of himself by François-Hubert Drouais (cat. 12). The exhibition also contains works from the Baryatinsky collections, which were housed in the family's luxurious palace at Ivanovskoe, their estate in the Kursk province.

The second half of the nineteenth century brought significant changes in Russian collecting. As new generations of nobility sold their ancestors' holdings, merchants and intellectuals took the initiative in purchasing art. Favoring Realism and genre scenes, these members of the bourgeoisie avidly acquired paintings by Gustave Courbet and Jean-François Millet, as well as Barbizon landscapes. Included in this group of upstart connoisseurs were merchants such as P. I. Kharitonenko, intellectuals such as I. S. Ostroukhov, and industrialists such as Pavel and Sergei Tretyakov, who owned a tapestry factory in Kostroma.

The Tretyakov brothers assembled collections that formed the basis for the Tretyakov Gallery in Moscow. Pavel, the elder brother, collected works by the Russian Peredvizhniki (the Wanderers) and presented them to the city of Moscow.[2] His zeal in collecting was rivaled by that of Sergei, longtime mayor of Moscow, who avidly collected nineteenth-century French paintings and bequeathed them to the city

upon learning of his brother's gift. His collection, like Pavel's, was housed in the Tretyakov gallery for thirty years and transferred to the Pushkin Museum in the 1920s and 1930s. Sergei Tretyakov was particularly fond of Camille Corot: seven of the twelve Corots in the Pushkin Museum came from his collection, including *Castle of Pierrefonds* (cat. 22) and *Gust of Wind* (cat. 23), both featured in this exhibition. He also owned Jules Bastien-Lepage's *Village Lovers* (cat. 45), which inspired a generation of young Russian artists.

⁓⊚⌁

In addition to its outstanding collection of late-eighteenth- and early-nineteenth-century French paintings, the Pushkin Museum also contains more than 250 exceptional French paintings from the late nineteenth and early twentieth centuries. Represented in this group are such French artists as Édouard Manet, Claude Monet, Auguste Renoir, Edgar Degas, Camille Pissarro, Paul Gauguin, Paul Cézanne, Henri Rousseau, Pierre Bonnard, and Henri Matisse, as well as two expatriates working in France: Vincent van Gogh and Pablo Picasso. The collection consists largely of paintings amassed by the Moscow merchants Sergei Shchukin and Ivan Morozov, two of the most visionary collectors and connoisseurs of the early twentieth century.

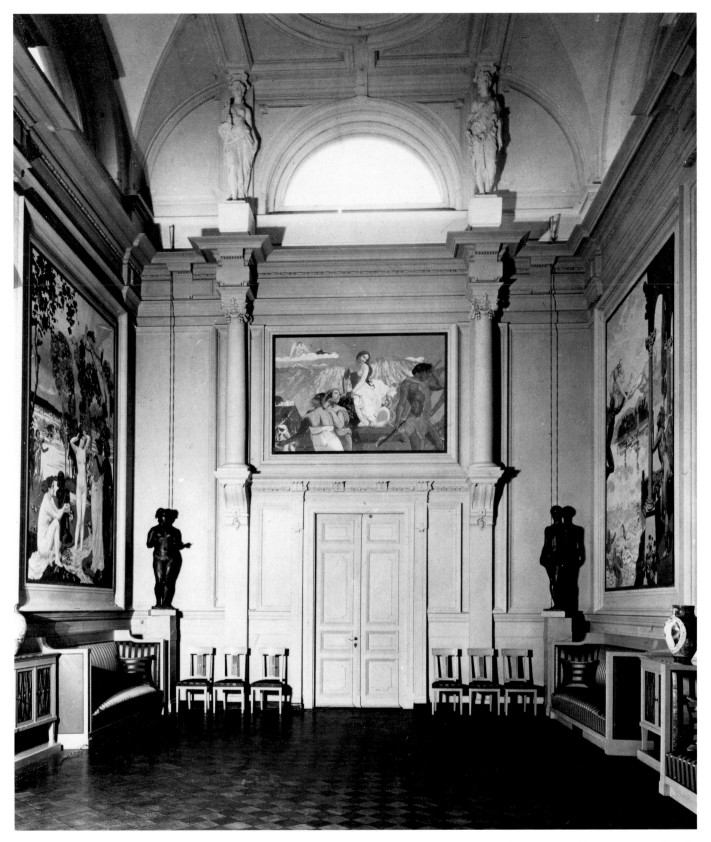

Great Hall in the home of Ivan Morozov, featuring *Amour and Psyche* by Maurice Denis and sculptures by Aristide Maillol. Undated.

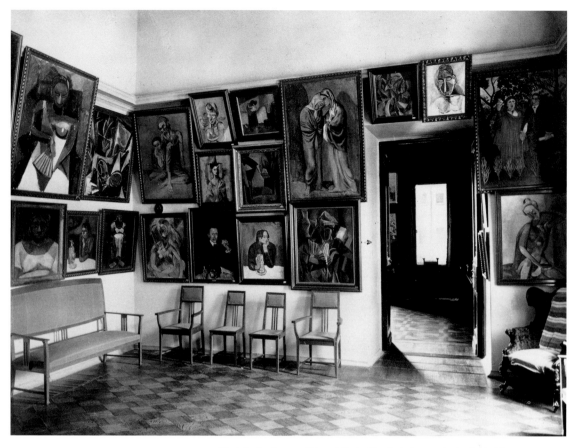

Study in the home of Sergei Shchukin, featuring works by Pablo Picasso. c. 1910.

Shchukin's tastes were diverse: he was just as passionate about collecting paintings by Monet as he was about purchasing—and, at times, commissioning—works by Picasso and Matisse. Among the twenty-six paintings from the Shchukin collection included in this exhibition are Degas's *Dancer Posing for a Photographer* (cat. 42), Cézanne's *Pierrot and Harlequin* (cat. 55), and Matisse's *Goldfish* (cat. 73). Morozov preferred to focus largely on Impressionism and Post-Impressionism, and he enthusiastically acquired paintings by Monet, Renoir, Alfred Sisley, and Cézanne. Morozov's collection is represented in the exhibition by sixteen paintings, including Renoir's *Bathing on the Seine* (cat. 32), Monet's *Boulevard des Capucines* (cat. 34), van Gogh's *Prison Courtyard* (cat. 51), and Gauguin's *Flowers of France* (cat. 52).

In the early twentieth century, the Shchukin and Morozov collections were widely known in Russia and abroad. In 1918, however, the Russian state seized both collections (as well as the residences that housed them). Shchukin, having lost official ownership of the paintings in his charge, began an effort to convert his former home into the First Museum of New Western Painting. Morozov followed suit in 1919, establishing the Second Museum of New Western Painting at his own former residence, at 21 Prechistenka.

In 1923, the holdings of the First Museum were transferred to the Second Museum to form the State Museum of New Western Art. From 1928 until 1948 this museum occupied two wings of the Morozov house: Section I contained Shchukin's collection, and Section II contained Morozov's. In the 1930s and 1940s the State Museum of New Western Art boasted one of the most significant collections of Modernism in Russia and, perhaps, abroad. According to Boris Ternovets (1884–1941), longtime director of the Museum of New Western Art, "The value of this museum stems not only from the completeness of its collections, but also from their unusually high quality. Most of the leading artists of the 19th and 20th century—Monet, Renoir, Van Gogh, Cézanne,

Museum of New Western Art. 1935.

Gauguin, Matisse, Picasso—are represented here by . . . first class [and, at times] principal [examples of their] works. . . . The brightness and the intensity of the impressions engulf the visitor to the museum and keep him or her in a constant aesthetic tension."[3]

In 1948, the State Museum of New Western Art was closed by a special government order, and its collections were divided between the Pushkin Museum and the Hermitage Museum. Russian art historians lament this act because it ran counter to the desires of Shchukin and Morozov, who intended their collections to be gifts to the city of Moscow. Even so, the portions of the collections that remain at the Pushkin have become the centerpieces of its painting galleries. Although select works from the Pushkin Museum have been exhibited in the United States and abroad before, this is the first comprehensive exhibition to introduce this remarkable collection to American audiences.

NOTES

1 In 1923, the Pushkin Museum (renamed in 1937 to honor the great Russian poet) achieved independent status when it was placed under the jurisdiction of the museums department of Glavnauka, the Central Board of Scientific, Art, Museums, Theatrical and Literary Establishments, and Organizations under the Commissariat of Education.

2 Officially named the Association of Traveling Exhibits, the Wanderers was an affiliation of Russian artists dedicated to organizing traveling exhibitions of contemporary art in St. Petersburg, Moscow, and provincial towns. Between 1871 and 1923 the group held forty-eight exhibitions. Two of the most prominent members were Ilya Repin and Vasily Surikov, whose historical canvases exemplified the Wanderers' interest in documenting Russia's cultural past.

3 B. N. Ternovets, *Diaries. Articles.*, ed. L. S. Alyoshina and N. V. Yavorskaya (Moscow, 1977), 127–28.

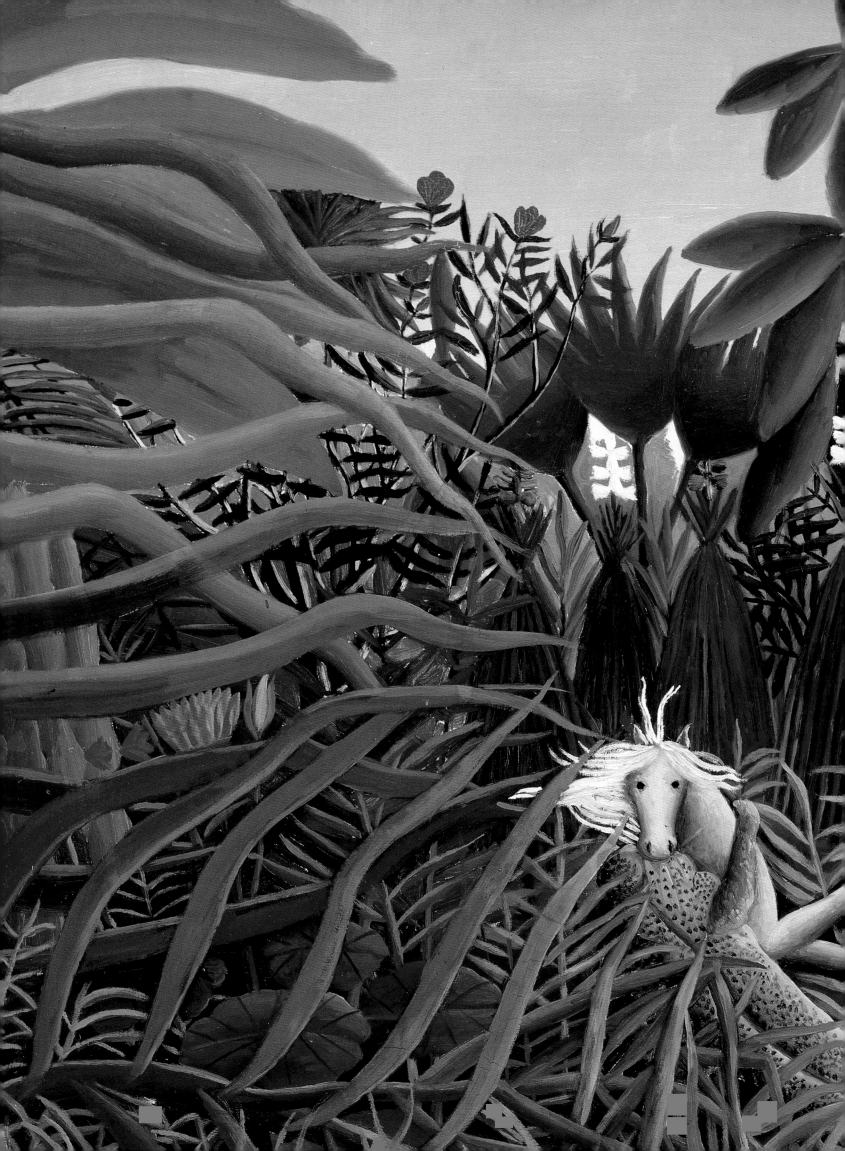

CATALOGUE OF THE EXHIBITION

NICOLAS POUSSIN
French, 1594–1665

I *Rinaldo and Armida*

Oil on canvas,
c. 1630
37³/₈ × 52³/₈ in.
(95 × 133 cm)
Inv. no. 2762

NICOLAS POUSSIN enjoyed tremendous recognition and international renown during his career.[1] Poussin, born into a peasant family in Normandy, became interested in art after an encounter with a minor itinerant painter working near his hometown.[2] He went to Paris to study art at the age of eighteen and, in 1624, moved to Rome, where he found success.

Poussin assiduously studied examples from Rome's ancient and recent past, ranging from classical statuary to paintings by Raphael. Like his countryman Claude Lorrain (cat. 2), Poussin studied Roman ruins and the landscape surrounding the city. Whereas Claude was attentive to light effects and nature, Poussin was foremost a history painter, creating compositions that incorporated mythological, historical, and literary subjects, often depicted in landscape settings. Consequently, his paintings emphasize the actions of figures. Indeed, the depiction of the human body, with its eloquence of gestures and expressions, was the building block of history painting. According to the French Academy, history painting was the most important genre of painting. Poussin played a significant role in the formation of the French Academy (founded in Paris in 1648), which had an institutional home in Rome as well.

During the 1630s, Poussin gained the attention of powerful patrons in Paris and Rome, including King Louis XIII, Cardinal Richelieu, and the Barberini family. After a two-year trip to France at the behest of the king in 1640, Poussin returned to Rome. He remained there, primarily painting for private collectors; those works are similar to this earlier painting of *Rinaldo and Armida* rather than ambitious public commissions.

Rinaldo and Armida is based on *Gerusalemme liberata (Jerusalem Delivered)*, an epic tale of the capture of Jerusalem during the first crusade, written in 1580 by the Italian poet Torquato Tasso.[3] The painting demonstrates Poussin's interest in literary subjects, as well as his delight in painting a variety of figural types in order to tell the story. It depicts the moment when the sorceress Armida falls in love with Rinaldo, a Christian knight.[4] Armida, niece of the prince of Damascus, has been charged with the task of seducing and capturing the crusaders. She succeeds, yet their compatriot Rinaldo sets them free. Armida seeks revenge, hoping to entrap and kill Rinaldo. However, when he lands on her enchanted island, she instead falls in love with him.

Poussin's interpretation of the story emphasizes Armida's tender embrace of the disarmed and vulnerable sleeping Rinaldo:[5]

But when she looked on his face awhile,
And saw how sweet he breath'd how still he lay,
How his fair eyes though closed seem to smile,
At first she stay'd, astound with great dismay;
Then sat her down (so love can art beguile),
And as she sat and looked, fled fast away
Her wrath. Thus on his forehead gaz'd the maid

. .

Thus (who would think it?) his hot-eyed glance can
Of that cold frost dissolve the hardness great
Which late congeal'd the heart of that fair dame,
Who, late a foe, a lover now became.[6]

Poussin's depiction of the reclining Rinaldo and his attentive lover essentially adheres to Tasso's

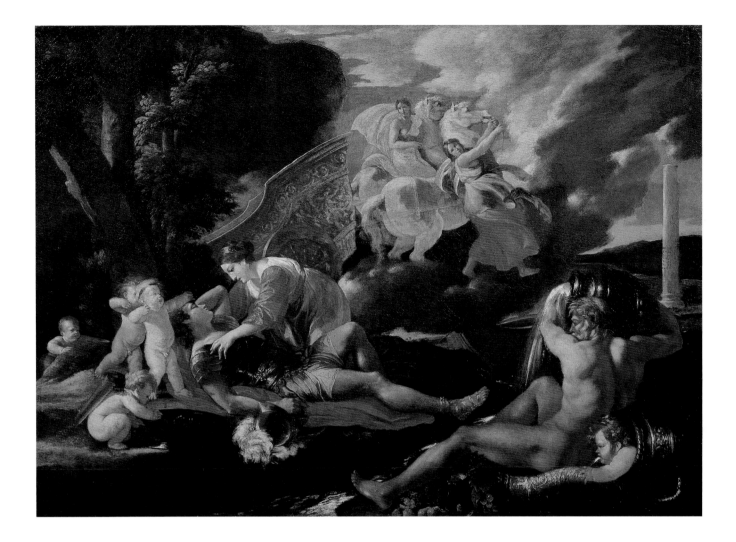

poem, yet his pictorial imagination embroiders beyond the rudiments of the narrative. Putti cavort around the couple, symbols of Armida's amorous intentions. A muscular, nude river god plays the role of the old man who will tell Rinaldo's rescuers how to liberate him. In the distance, Armida's minions prepare her golden chariot in order to whisk Rinaldo away.

Literary tales such as this one, rife with love and conflict, met the aesthetic standards Poussin articulated in his "Observations on Painting": "The first requirement, fundamental to all others, is that the subject and the narrative be grandiose, such as battles, heroic actions, and religious themes. . . . Thus the painter not only must possess the art of selecting his subject, but judgement in comprehending it."[7]

Poussin eschewed extraneous and anecdotal details in favor of austere, lucid compositions. Indeed, the clear, linear style of his classical works inspired generations of French artists, including Jacques-Louis David, Jean-Auguste-Dominique Ingres, and Edgar Degas.

NOTES

1 See Katie Scott, ed., *Commemorating Poussin: Reception and Interpretation of the Artist* (Cambridge: Cambridge University Press, 1999). On his milieu, see also Elizabeth Cropper, *Nicolas Poussin: Friendship and the Love of Painting* (Princeton, N.J.: Princeton University Press, 1996).

2 Erika Langmuir, ed., *The National Gallery Companion Guide* (London: National Gallery Publications, 1994), 223.

3 This work is one of several Tasso-inspired paintings that Poussin produced in the 1630s. See Anthony Blunt, *The Paintings of Nicolas Poussin: A Critical Catalogue* (London: Phaidon, 1966), 140–42. On Poussin's pictorial borrowings from a series of etchings by Antonio Tempesta illustrating Tasso's *Gerusalemme liberata*, see Jonathan Unglaub, "Poussin's Purloined Letter," *Burlington Magazine* 142, no. 1162 (2000): 35–39.

4 Torquato Tasso, *Jerusalem Delivered*, 14.57–67, trans. Edward Fairfax, with an introduction by John Charles Nelson (New York: Capricorn, 1963), 296–99.

5 On the significance of sleeping figures in Poussin's work, see Louis Marin, *Sublime Poussin*, trans. Catherine Porter (Stanford, Calif.: Stanford University Press, 1999), 152–70.

6 Tasso, *Jerusalem Delivered,* 14.66–67, 298–99.

7 Nicolas Poussin, "Observations on Painting," notes for a treatise published in Giovanni Pietro Bellori, *Vite de' pittori, scultori et architetti moderni* (Rome, 1672), reprinted in Elizabeth Holt, ed., *A Documentary History of Art*, vol. 2 (Princeton, N.J.: Princeton University Press, 1982), 144.

CLAUDE LORRAIN

(Claude Gelée, called Le Lorrain)
French, 1600–1682

2 *The Abduction of Europa*

Oil on canvas,
1655
39³/₈ × 53⁷/₈ in.
(100 × 137 cm)
Signed and dated:
*Claudio G. IV
Romae 1655*
Inv. no. 916

CLAUDE LORRAIN was born in the Lorraine region of France but spent his career in Italy, as did his countryman Nicolas Poussin (cat. 1). Claude intently studied the *campagna romana* (the Roman countryside). His gift was for rendering that landscape with incredible mastery of light effects.[1] Claude, along with Poussin, developed the formula for historical landscapes, in which small-scale figures are set into landscapes and are involved in mythological or biblical narratives.

In the foreground of *The Abduction of Europa* is a scene from ancient mythology, recounted in the *Metamorphoses* of Ovid. Jupiter has become enamored of Europa, the daughter of the Phoenician king.[2] To seduce the young mortal woman, he takes the form of a white bull and absconds with Europa to the island of Crete. The king of the gods frequently assumed guises to deceive his wife, Juno, while he pursued his extramarital erotic interests.

The composition is typical of classical French landscape painting and is one of Claude's best-known works. He favored pictorial arrangements that create a sense of balance in spite of an asymmetrical placement of natural elements. Such a balance is achieved in this work through the placement of trees in two distinct zones. A large tree demarcates the left edge of the canvas, and a unified clump of several trees in the middle ground, just right of center, anchors the composition. The tightly packed group of trees draws the eye back in space across the ships moored in the harbor, the hill town further back at right, and the towering mountains in the far distance. The trees create a diagonal axis from the left fore-ground into the right middle ground. Just beyond them, a smaller cove mediates between the middle ground and the mountains.

In addition to topographical details, Claude also uses subtly modulated light to suggest spatial relationships as well as to unify the composition. The enormous mountain and the smaller island in the far background are rendered in pale blue, a tonal variation on the color of the sky. A dusting of snow on the mountaintop echoes thin white clouds in the sky and the small whitecaps that lap at the shore. The mountains closer to the foreground are depicted in progressively richer tones that resonate with the leafy green trees.

Claude renders the man-made with the same keen attention he pays to nature. The architectural forms on the hill town are tiny, but structural details are legible, as are those of the round tower in the harbor. Numerous boats, from elaborate sailboats to a simple skiff, dot the waters near the shore. Some are under way while others are moored, a thematic link to the main narrative, in which Europa is carried off by Jupiter the bull.

Though his primary interest is in the landscape and the light, Claude includes many narrative details. Figures in the distance go about their routines: a woman carrying a jug walks along a path with a companion; a shepherd rests while his sheep graze. In the foreground, cattle are scattered about, perhaps providing cover for Jupiter and aiding in his deception. Maidens lead the animal toward a group of women making garlands while the unsuspecting and soon to be abducted Europa rides on his back.

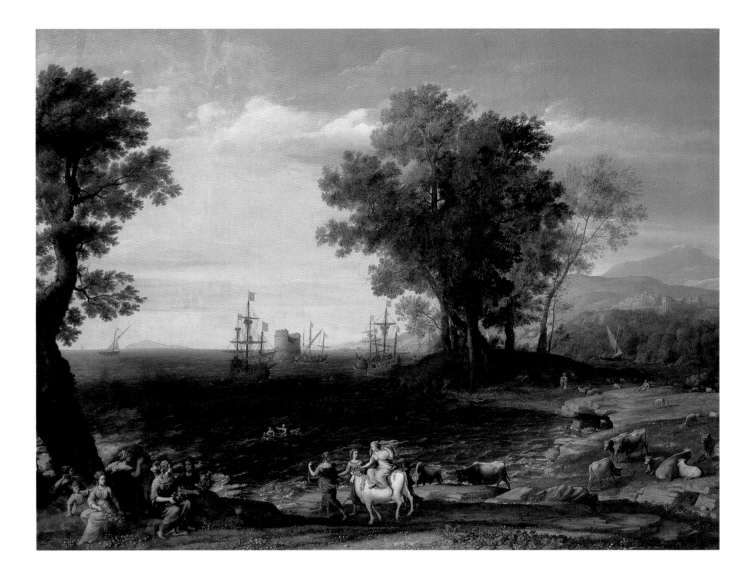

Claude's example inspired landscape painters from the seventeenth to the nineteenth centuries. His pictorial legacy resides in his achievements in compositional strategies and use of light, and his Arcadian landscapes established a standard that future generations would admire, emulate, and transform.

NOTES

1 See Sergei Daniel and Natalia Serebriannaya, *Claude Lorrain: Painter of Light* (St. Petersburg, Russia: Aurora, 1995).

2 In his *Liber veritatis*, a book in which Claude kept an account of all his paintings, *The Abduction of Europa* is recorded as number 136. On the corresponding drawing in the *Liber veritatis* (British Museum, London, inv. no. 142) there is an inscription, "*Facto al pio Cardinal [...] creato pero giusto pap [...]*" ("made for cardinal [...] elected Pope [...]"). Thus, the painting seems to have been created upon commission from Cardinal Fabio Chigi, who, by the date of its completion on 7 April 1655, was elected Pope Alexander VII (1655–1667). The word *"cardinal"* is so close to the edge of the page that it is probable that the name "Chigi" was cut off. Pope Alexander VII was one of Claude's principal patrons in Rome.

JEAN-FRANÇOIS DE TROY

French, 1679–1752

3 *Susanna and the Elders*

Oil on canvas,
1715
29$\frac{1}{8}$ × 35$\frac{7}{8}$ in.
(74 × 91 cm)
Signed and dated:
de Troy fils 1715
Inv. no. 2771

JEAN-FRANÇOIS DE TROY enjoyed a highly success-ful career in both France and Italy. He began his training with his father, the famous portrait painter François de Troy, and spent several formative years in Italy. He returned to Paris and was admitted to the Academy in 1706. He became famous for his highly finished, detailed genre scenes, which were much in demand by art patrons and collectors. De Troy was also an accomplished history painter, and he pro-duced tapestry cartoons (large-scale paintings used as models for tapestry designs) for the Gobelins tapestry manufactory. In 1738 he was named director of the French Academy in Rome, where he was an influential force until his return to Paris upon his retirement.[1]

De Troy's *Susanna and the Elders* depicts an Old Testament story from the Book of Daniel. According to the text, Susanna, the virtuous wife of Joachim, was bathing in the garden while two men spied on her. The men, elders from the community, tried to seduce the young woman. When she rebuffed their advances, screaming for help, a crowd arrived. The elders promptly accused her of adultery, claiming that they had found her with a lover. Susanna was sen-tenced to death but was ultimately saved by the prophet Daniel, who proved that the elders had lied.

This painting is one of the earliest of several por-trayals by de Troy of the theme of Susanna and the Elders. Indeed, many sixteenth- and seventeenth-century artists had treated the Susanna and the Elders theme; the most celebrated example is by Peter Paul Rubens (1614, Nationalmuseum, Stockholm). The Pushkin painting focuses on the moment when the elders approach Susanna. Recently emerged

from the bath and in the process of getting dressed, Susanna is partially nude and therefore vulnerable. The men physically encroach upon her, touching her skin and garments. De Troy emphasizes Susanna's beauty and sensuality. Her pale skin and white drap-ery contrast markedly with the tanned skin and color-ful robes of the elders.

As the man on the right caresses her arm and reaches for her thigh, Susanna gently pushes him away, while the other man attempts to lift the fabric off her shoulder. Susanna was the victim of unwanted sexual advances, yet de Troy's painting conveys an underlying erotic charge. Rather than underscoring her virtue, evidenced by the vigorous rejection de-scribed in the biblical text, de Troy depicts a moment that lingers on the visual and tactile pleasure the elders take from Susanna. For de Troy's eighteenth-century viewers, her vulnerability heightened the eroticism of the moment.

Although de Troy was an esteemed member of the French Academy, where a linear classicism was encouraged, he was more indebted to the Venetian painter Titian and the Flemish artist Rubens, both of whom he admired for their use of color and emphasis on sensuality. Their work represented an alternative to the paradigmatic academic style embodied in the approach of de Troy's most illustrious French prede-cessor, Nicolas Poussin (cat. 1). According to seven-teenth- and eighteenth-century art theory, the styles of Poussin and Rubens were regarded as diametrically opposed; the theorist Roger de Piles characterized Poussin's work as embodying linearity (*dessin*), while that of Rubens was equated with color (*coloris*).[2]

In keeping with the traditions forged by the

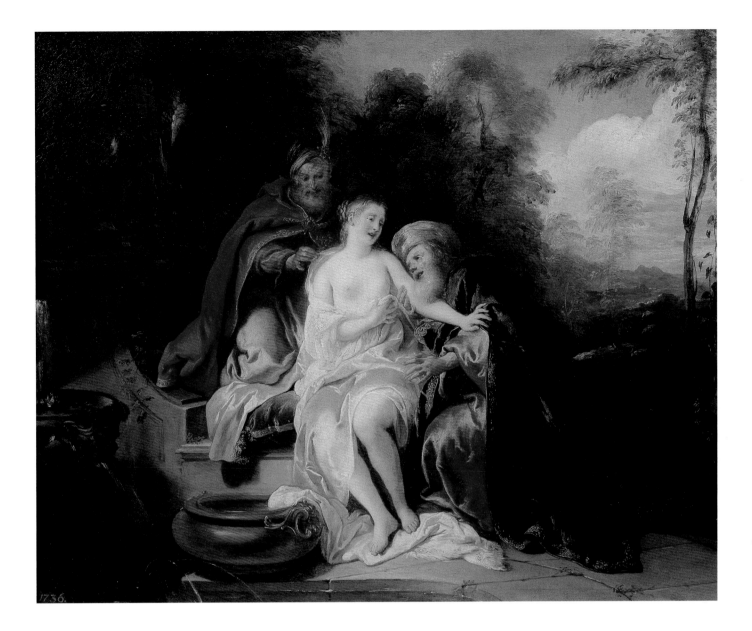

colorists Titian and Rubens, de Troy celebrates the
sensuality of flesh and fabric, delighting in the repre-
sentation of different textures. The lush landscape
setting in *Susanna and the Elders* reinforces the
emphasis on sensory experience. De Troy draws our
attention to the pleasures of nature and the bath in
the context of Susanna's humiliation at the hands of
the elders. The painter concentrates on the moment
when Susanna's solitary pleasure gives way to painful
confrontation. Soon, however, her virtue will triumph
and she will be vindicated.

NOTES

1 Biographical information is from J. Patrice Marandel, entry
on Jean-François de Troy in *Art in Rome in the Eighteenth
Century,* ed. Edgar Peters Bowron and Joseph Rishel
(London: Merrell, in association with the Philadelphia
Museum of Art, 2000), 447–48.

2 For an analysis of de Piles's theory of painting and its role in
shaping discourses on seventeenth- and eighteenth- century
art, see Tomas Puttfarken, *Roger de Piles' Theory of Art* (New
Haven: Yale University Press, 1985).

CHARLES-JOSEPH NATOIRE

French, 1700–1777

4 *Venus and Vulcan*

Oil on canvas,
1734
25^1/$_8$ × 20^7/$_8$ in.
(64 3 53 cm)
Signed: *C. Natoire*
Inv. no. 1036

A CONTEMPORARY of the great Rococo master François Boucher (cats. 5–7), Charles-Joseph Natoire specialized in mythological subjects. Like Boucher, Natoire painted for royal and aristocratic patrons. Though the two artists did not have a formal relationship, they were rivals. Natoire was certainly aware of Boucher's example and his extremely successful painting style. Indeed, Boucher had painted a similar version of *Venus and Vulcan* (1732, Musée du Louvre, Paris), with which Natoire was undoubtedly familiar.[1]

The theme of Natoire's *Venus and Vulcan* is based on Roman mythology, the literary source for Virgil's *Aeneid*.[2] The complex composition depicts an interaction between Venus, the goddess of love, and her estranged husband, Vulcan, the god of fire and craftsmanship. Venus occupies the upper register of the canvas, floating on a cloud and surrounded by various attendants: putti, nymphs, and a swan, which may refer to one of Jupiter's many guises. Vulcan occupies the lower register, displaying a shield that had been crafted in his forge, the fiery workshop housed in a cave.

Natoire conflates two distinct moments in Virgil's text. Venus gestures to Vulcan, asking the god to forge arms for her son Aeneas, the Trojan prince whose father was the mortal Anchises. Aeneas was a hero of the Trojan War whose destiny was to found Rome.[3] Vulcan presents the arms to Venus, a clear indication that Venus has charmed him and that he has fulfilled her request. Accordingly, Vulcan facilitated Aeneas's predestined trajectory: "At last he succeeded in founding his city, and installing the gods of his race in the Latin land: and that was the origin of the Latin nation, the Lords of Alba, and the proud battlements of Rome."[4] He fulfilled this destiny with his mother's divine protection.

Natoire emphasizes Venus's beauty and sensuality. His depictions of female nudes, especially Venus, were popular with Natoire's patrons. Eighteenth-century representations of Venus most often depict her in relation to the primary men in her life—Vulcan, her son Cupid, or her lover Mars, the god of war—or in the act of beautifying herself (such as in Jean-Baptiste Regnault's *The Toilet of Venus*, cat. 15). Vulcan, in contrast, here is rendered with tremendous attention to his powerful, muscular form, which represents sweaty toil. As he gazes up at Venus, listening to her instructions, he displays his handiwork as a master blacksmith. The shield and a helmet rest on an anvil, and other arms for Aeneas lie at his feet. Natoire's compositional choices also reinforce thematic oppositions. Placing Venus above and Vulcan below stresses the differences between women and men, between the aims of love and the aims of battle.

Venus and Vulcan marks a significant professional step in Natoire's career. The work is a highly finished oil sketch for the final version (Musée Fabre, Montpellier). Natoire submitted that painting as his *morceau de réception* (presentation piece) for admission to the Academy. Natoire earned lucrative and prestigious commissions for mythological, historical, and religious works in Paris and Versailles.[5] He also made designs for wallpaper and tapestries, activities integral to the career of a successful decorative painter during the reign of Louis XV.

In 1751, Natoire was appointed director of the

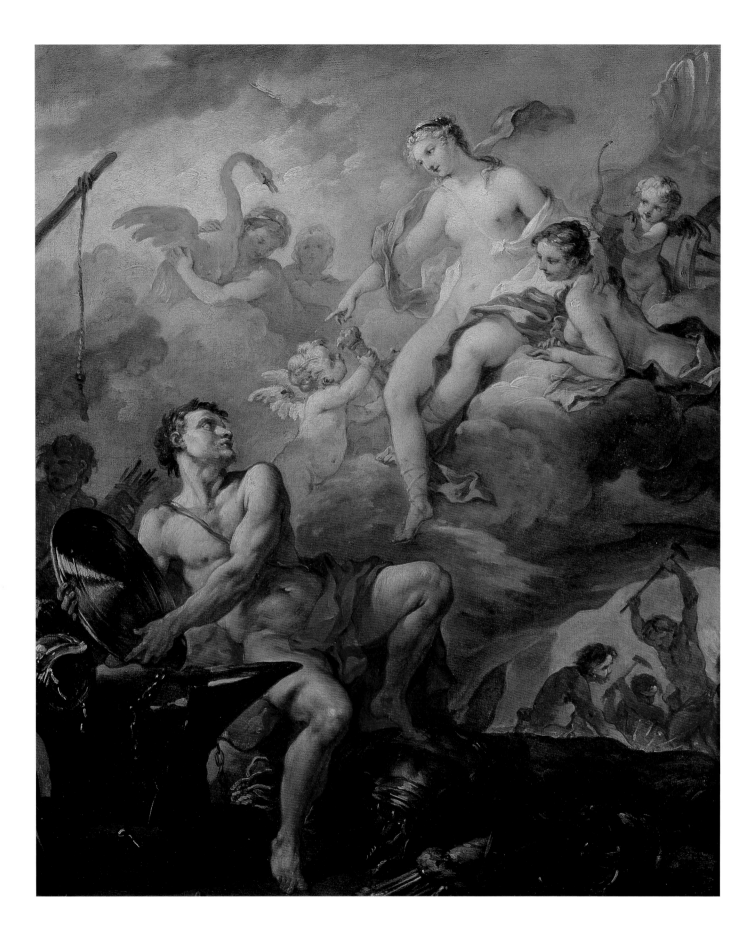

French Academy in Rome, where he trained young artists such as Jean-Honoré Fragonard and Hubert Robert (cat. 13). Like his students, Natoire was adept at drawing the landscape surrounding Rome. He also continued to accept public commissions, such as the ceiling fresco for San Luigi dei Francesi, the French national church in Rome.[6] Though his art-historical reputation has not endured as Boucher's has, Natoire was a respected and prestigious painter in his day. *Venus and Vulcan,* with its compelling narrative and masterful handling of paint, attests to his considerable facility.

NOTES

1 In fact, Natoire includes a sword with an eagle head handle (held by the blue-winged putto who approaches Venus) that is an exact replica of the sword Vulcan holds in Boucher's 1732 painting. See Colin Bailey, ed., *The Loves of the Gods: Mythological Painting from David to Watteau,* exh. cat. (New York: Rizzoli, in association with the Kimbell Art Museum, Fort Worth, 1992), 342–45, 382.

2 Virgil, *Aeneid,* 8.370–458.

3 James Hall, *A History of Ideas and Images in Italian Art* (New York: Harper & Row, 1983), 37.

4 Virgil, *Aeneid,* in Hall, *History of Ideas and Images,* 37.

5 Edgar Peters Bowron and Mary G. Morton, *Masterworks of European Painting in the Museum of Fine Arts, Houston* (Princeton, N.J.: Princeton University Press, in association with the Museum of Fine Arts, Houston, 2000), 105.

6 Bowron and Morton, *Masterworks of European Painting,* 105.

FRANÇOIS BOUCHER
French, 1703–1770

5 *Jupiter and Callisto*

Oil on canvas,
1744
$38^{5}/_{8} \times 28^{3}/_{8}$ in.
(98 × 72 cm)
Signed and dated:
F. Boucher 1744
Inv. no. 733

FEW ARTISTS were as celebrated in eighteenth-century France as the Rococo painter François Boucher. Tremendously successful as a member of the Academy and, later, as court painter to Louis XV, Boucher catered primarily to the tastes of aristocratic and royal patrons, who enjoyed the pursuit of pleasure, both aesthetic and erotic.[1] This audience favored pictures of amorous themes, often set in lush landscapes or in richly appointed interiors. Boucher, a master of sensuous color and texture,[2] specialized in painting sumptuous fabrics and voluptuous female bodies, skills he shared with the predecessors he most admired: Titian, Peter Paul Rubens, and Antoine Watteau.[3]

Boucher's audience was quite familiar with the literature of classical mythology. Thus, in addition to painting pastorals (*Farm*, cat. 6), genre scenes, portraits, allegories, and religious works (*Nativity*, cat. 7), Boucher was steadily employed producing paintings that celebrated the tempestuous lives and loves of the gods.[4]

Jupiter and Callisto is drawn from Ovid's ancient tales of deception and seduction, *Metamorphoses*.[5] Among the central characters in these stories is Jupiter, the king of the gods, who routinely changes his form in order to seduce beautiful young women. By transforming himself into a swan, a bull, and a cloud (to name only a few of his disguises), Jupiter could prey upon his subjects and at the same time cheat on Juno, his long-suffering wife.

Here, Jupiter poses as Diana, goddess of the hunt, and approaches the nymph Callisto, who, as Diana's favorite, was obligated to remain chaste. By assuming Diana's identity, Jupiter capitalized on the trusting, warm relationship between the goddess and her minion to ensure a sexual conquest. Boucher emphasizes Jupiter's seductive slyness, depicting "Diana" gazing tenderly into the rapt Callisto's eyes. The nymph, completely taken in, coyly reveals one breast and rests her left arm in Diana's lap. Diana holds Callisto close as she gently lifts and caresses her chin. The moment is filled with erotically charged anticipation as Boucher suggests that Diana will soon lean in for a kiss.

The homoerotic subtext of this painting, suggested in the frisson of two women about to embrace, appealed to Boucher's viewers, who were quite accepting of—and indeed delighted in—homoeroticism, extramarital affairs, and cross-dressing.[6] These audiences considered such activities integral to the elaborate dance of desire, and Boucher catered to their cultural mores and aesthetic standards by making the female nude a staple of his artistic practice. Only rarely did he paint male figures, such as Hercules, Vulcan, Mars, and Adonis.[7]

In Boucher's painting, Jupiter adopts Diana's emblem (the crescent-moon tiara) and her attributes (bow and arrows, dead game). Contemporary audiences, familiar with Ovid's tale, would have been in on the deception and immediately aware of Jupiter's true identity, reinforced as it was by the presence of his attribute, an eagle in military armor intently watching the dissembling god. Another clue that Diana is in fact Jupiter is her enormous size: if she were to stand, she would tower over Callisto, in contrast to Boucher's *Diana at the Bath* (1742, Musée du

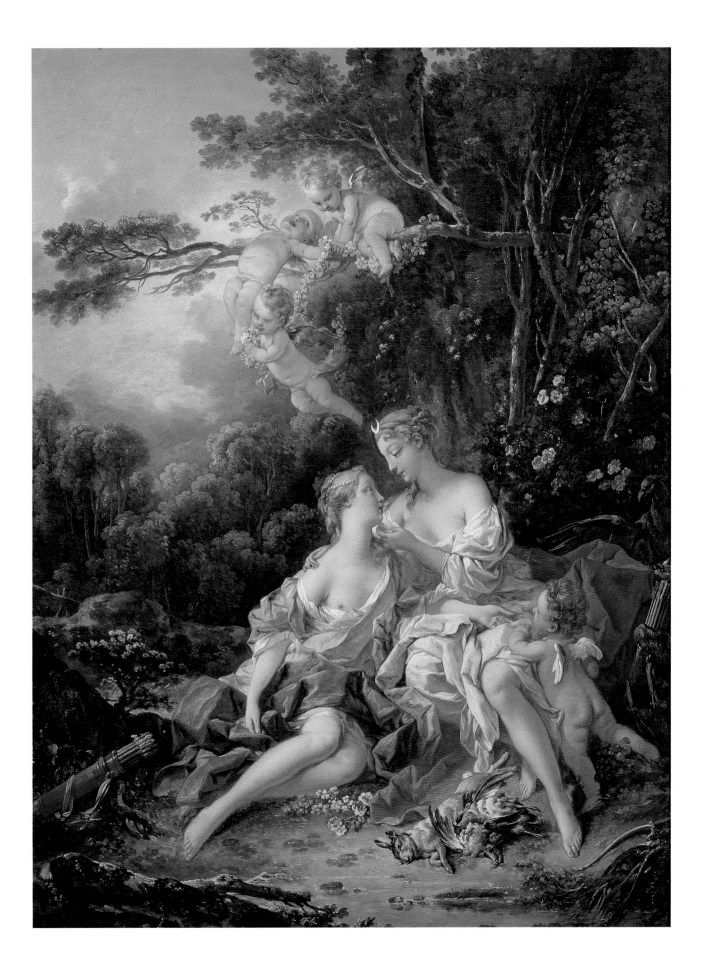

Louvre, Paris), in which the "true" goddess of the hunt shares the same physical proportions as her nymph companion.[8]

Jupiter's union with Callisto resulted in the birth of a son, a theme of fertility that is reinforced in Boucher's painting by the lush landscape setting. The abundant flora additionally enhances the painting's overarching mood of pleasure, as do the playful putti attending the couple, emissaries of Cupid and emblems of love. Three of them cavort in the branches above, forming a fleshy garland that draws our eye to "Diana." Another of the winged creatures attends closely to the courtship ritual, leaning on the disguised Jupiter's left leg.

Of all the mythological subjects, Jupiter and Callisto was one of the most frequently depicted by Boucher.[9] Typically, he focused on the titillating moment of seduction. Traditionally, however, artists chose to depict the grim consequences for Callisto at the end of the story. Months after her encounter with Jupiter, Callisto's lost chastity and pregnancy were discovered, and Diana cast her out. This left her at the mercy of Juno, who, enraged and jealous, turned Callisto into a bear.

Jupiter and Callisto had an essentially decorative function. Its purpose: to complement the gilded picture frames and furniture, as well as the tapestries, rugs, and decorative arts that typically graced the properly decorated, aristocratic eighteenth-century home. For Boucher, the designation of this work as "decorative" would have been high praise indeed, for he was intimately involved in the production of decorative arts, designing porcelain objects produced at Sèvres, as well as stage sets and tapestries.[10]

NOTES

1 On Boucher's relationship with his most important patron in Louis XV's court, the Marquise de Pompadour, see Melissa Hyde, "The 'Makeup' of the Marquise: Boucher's Portrait of Pompadour at Her Toilette," *Art Bulletin* 82, no. 3 (2000): 453–75.

2 Eighteenth-century art theory distinguished between color and line as organizing principles, and as literal formal/stylistic devices. On this debate see Hyde, "The 'Makeup' of the Marquise," as well as Thomas Puttfarken, *Roger de Piles' Theory of Art* (New Haven: Yale University Press, 1985).

3 Alastair Laing, "François Boucher: His Circle and Influence," *Apollo* 27, no. 311 (1988): 50–51.

4 See Colin B. Bailey, *The Loves of the Gods: Mythological Painting from Watteau to David,* exh. cat. (New York: Rizzoli, in association with the Kimbell Art Museum, Fort Worth, 1992).

5 The tale of Jupiter and Callisto is from Book II, 410–40 of Ovid's *Metamorphoses.*

6 See Thomas M. Kavanagh, "The Libertine Moment," in "Libertinage and Modernity," *Yale French Studies* 32, no. 94 (1998): 79–100.

7 *François Boucher,* exh. cat. (New York: Metropolitan Museum of Art, 1986), 283–285; and G. Brunel, *Boucher et les Femmes* (Paris: Flammarion, 1986).

8 Old inventories refer to the work as *Diana and Callisto,* but Jupiter's identity is firmly secured by Boucher's visual and iconographic choices.

9 *François Boucher,* 283. Another version of this subject, from 1759, is housed at the Nelson-Atkins Museum, Kansas City. On the genesis of that work and for similarities to the Pushkin version in composition and iconography, see R. Ward, "A Drawing for Boucher's *Jupiter and Callisto* at Kansas City," *Burlington Magazine* 125, no. 969 (1983): 752–53.

10 Alicia M. Priore, "François Boucher's Designs for Vases and Mounts," *Studies in the Decorative Arts* 3 (Spring–Summer 1996): 2–51.

FRANÇOIS BOUCHER

French, 1703–1770

6 *Farm (Peasant Watering His Horse)*

Oil on canvas,
1752
22⅝ × 28 in.
(57.5 × 71 cm)
Signed and dated:
F. Boucher 1752
Inv. no. 735

IN ADDITION to painting mythological and religious works (cats. 5 and 7), Boucher produced landscapes that mixed believable representations of nature with decorative fantasy. Landscape operated as a lushly overgrown backdrop for the central action in *Jupiter and Callisto*. In *Farm (Peasant Watering His Horse)*, moreover, Boucher elevates landscape to center stage: majestic trees and large, rustic buildings dominate the setting, towering over the diminutive figures going about their daily business. At the left, a farmer leads his horse to drink at the river's edge. He approaches a small footbridge, which divides the canvas and leads the eye back to the structures in the middle ground. Perched high above the farmer, a woman on a balcony empties a bucket over the railing. To the right of the footbridge, ducks swim while pigeons fly overhead. A third figure, partially hidden in the cool shadows, approaches the water's edge and looks up, dreamily. In Boucher's pastoral vision, human beings coexist harmoniously with nature.

The peasant world presented in *Farm* is idyllic indeed. Nature's abundance registers in the copious foliage, which, far from being manicured by garden-ers, flourishes unfettered, a reminder that the rural inhabitants of this land chose not to control nature, but to live by its rhythms. Boucher's interpretation of nature does not adhere to the precepts of classical French landscapes, as practiced by, for example, his seventeenth-century predecessors Nicolas Poussin and Claude Lorrain (cats. 1 and 2). Whereas those artists painted in Rome and its environs, Boucher portrayed ruins alongside the vernacular architecture of rural France.

Only in his fascination with the rich qualities of light does Boucher acknowledge the innovations of his forebears. An expansive, luminous sky dominates the left side of the canvas; balancing its brilliance are the sturdy buildings and thick tangle of leaves at right. The immediate foreground is bathed in a rich, golden glow, while a comparatively dim and diffuse haze suggests the distant horizon.

Enhancing Boucher's subtle treatment of atmo-sphere is his sophisticated use of color. By punctuat-ing the sky in *Farm* with only a few traces of faded blue, he gives a clear sense that the day is coming to an end. Floating clouds, thin on the left and thick on the right, variegate his palette, which is in turn har-monized by the warm hues of the golden light and red garments on the right and the cooler greens and blues of the water, foliage, and sky on the left.

Boucher's mastery of the landscape genre was a result of his early artistic training. Though art that focused on human subjects was more highly regarded in the artistic hierarchy, landscape scenes were in high demand in the realm of the decorative arts, the milieu in which Boucher began his career. He worked on tapestry illustrations (cartoons) for the Gobelins tapestry works; in addition, he made designs for porcelain objects and created theatrical sets, decora-tive campaigns that relied on landscape backgrounds and natural motifs.

Giving further impetus to Boucher's interest in landscape was his early contact with the work of Antoine Watteau, who was noted for having invented the *fête galante* (literally, "noble party"), a type of landscape painting that features happy aristocrats

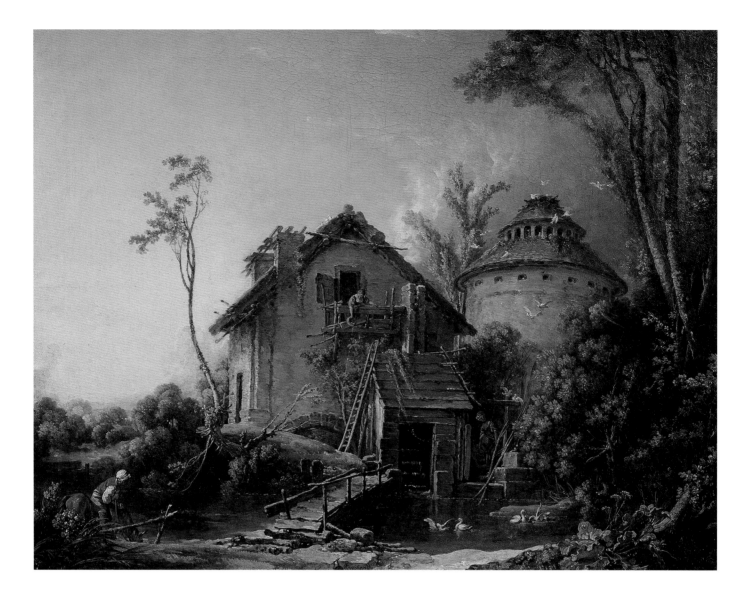

flirting, conversing, dancing, listening to music, and cavorting in nature. After Watteau's untimely death, a publisher engaged Boucher to make drawings after his works, which were published as a suite of engravings. In his own work, Boucher followed Watteau's lead, often transforming landscape into a kind of erotic playground. But his interest in the genre also encompassed rural scenes like *Farm*, as well as pastorals, allegorical representations of the seasons, illustrations of popular literature such as the fables of La Fontaine, and backgrounds for his ambitious mythological works.[1]

NOTE

1 Alastair Lang, "Boucher: The Search for an Idiom," in *François Boucher*, exh. cat. (New York: Metropolitan Museum of Art, 1986), 56–72.

FRANÇOIS BOUCHER

French, 1703–1770

7 *Nativity (Virgin and Child with Young Saint John the Baptist)*

Oil on canvas,
1758
46 1/2 × 35 3/8 in.
(118 × 90 cm)
Signed and dated:
F. Boucher 1758
Inv. no. 730

NATIVITY WAS commissioned by Boucher's most prominent patron, the Marquise de Pompadour.[1] In taking up this religious theme, Boucher makes stylistic choices similar to those that inform *Jupiter and Callisto* (cat. 5): he uses rich colors to suggest sumptuous fabrics and delights in the depiction of the fleshy children. The holy theme is infused with warmth and sentimentality.

Mary, young and beautiful, sits on a heavily canopied bed and cradles the sleeping infant Jesus in her lap. Silently, she greets her toddler nephew, John the Baptist. Her delicate gesture and warm smile set the painting's inviting tone, reminding us that this is a family scene as much as it is a biblical event.

John was born to Mary's elder, barren sister, Elizabeth, about six months before the birth of Jesus. In many ways, his life was intertwined with—and often anticipated—the life of his cousin. His miraculous birth was considered the precursor to the Immaculate Conception, and, as an adult, John baptized Jesus and recognized him as the Lamb of God. John preceded his cousin in martyrdom.

The presence of John the Baptist in the composition signals these and other important events to come. Reclining, seemingly relaxed, on the bed, he leans toward Jesus and the Virgin Mary, bearing grapes and wheat. These iconographic details refer to the wine and bread of the Holy Eucharist, attributes that will continue to be associated with Jesus as he grows up and fulfills his prophesied destiny.

Similarly, Boucher includes in the painting the cross-like staff that John the Baptist carried. This scepter bears a scroll with the Latin inscription "Agnus Dei" (Lamb of God), a phrase that refers to Jesus's ultimate sacrifice, his crucifixion. Boucher fur-

ther pursues this theme by including in the foreground a lamb, lying placidly near Jesus's cradle. This lamb is a metaphor not only for Christ's death, but also for his role in life as the shepherd of his flock of believers.

The lamb also possesses the composure of a house pet, similar to the little dogs that populated eighteenth-century aristocratic households and frequently appear in French genre paintings from the period. Reinforcing this sense of domestic authenticity is the red ball of yarn that spills out of the knitting basket at Mary's feet, suggesting that Mary, like any ordinary mother, engages in mundane activities such as knitting.

Even so, we are reminded of Mary's extraordinary qualities by the lilies in the foreground, symbols of her purity. And the ball of yarn itself has an important iconographic function, for red items typically signify the blood of Christ. Juxtaposed with the lamb's body, this seemingly insignificant detail—together with the red blanket upon which Jesus sleeps—is a visual device that foreshadows Christ's Passion and his death.

The *Nativity* was unveiled at the Salon of 1759 to a generally favorable critical reception. Many, however, complained that the Virgin looked "more like one of the graces or even a theatrical dancer" than the Holy Mother of Jesus.[2] The critic Denis Diderot remarked: "I consider that its colors are false . . . that there is nothing more ridiculous in such a context than the grand bed with its canopy, but . . . I wouldn't mind owning the painting."[3] That pleasure, however, went to Madame de Pompadour, who owned many of Boucher's works.

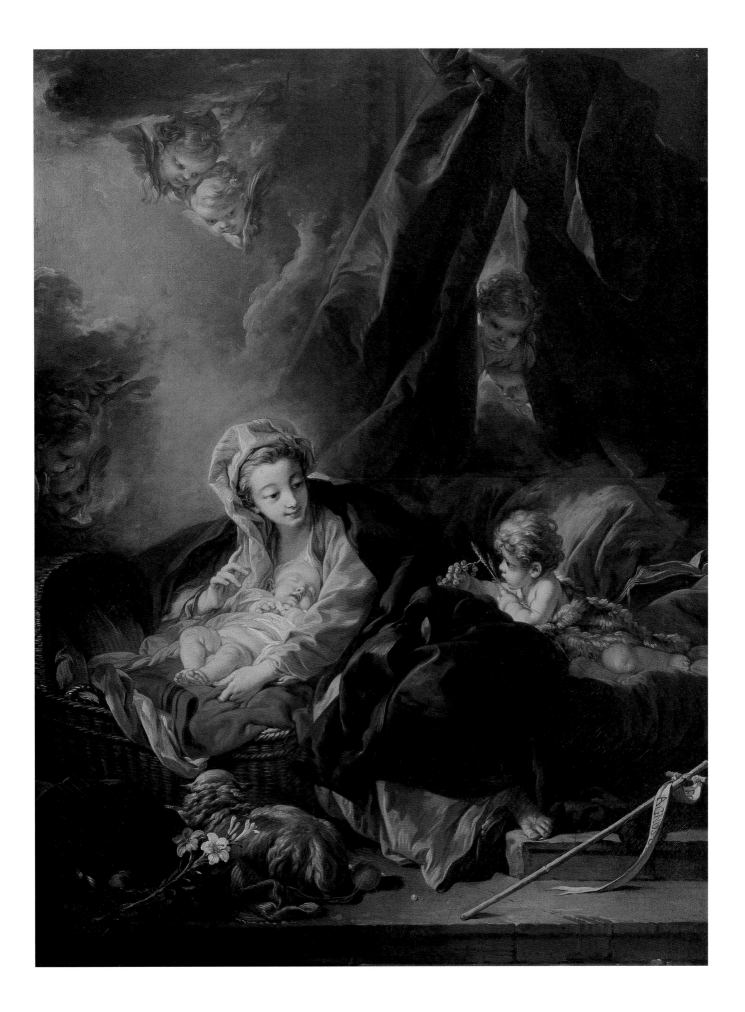

NOTES

1 On Boucher's relationship with his patron, see Melissa
 Hyde, "The 'Makeup' of the Marquise: Boucher's Portrait
 of Pompadour at Her Toilette," *Art Bulletin* 82, no. 3
 (2000): 453–75.

2 *French Painting from the USSR: Watteau to Matisse*, exh.
 cat. (London: National Gallery, 1988), 44.

3 Reprinted in *French Painting from the USSR*, 44.

PIERRE SUBLEYRAS
French, 1699–1749

8 *Two Figures (Study for "Saint Camillo de Lellis Saving a Sick Man")*

Oil on canvas,
1746
26 × 19¼ in.
(66 × 49 cm)
Inv. no. 1102

THE ACADEMIC PAINTER Pierre Subleyras was a successful artist who specialized in historical, mythological, and literary compositions and portraits. He learned to paint in his hometown of Toulouse, studying with Antoine Rivalz. Subleyras went to Rome in 1728 and in 1739 married an Italian woman who was also a painter. He spent the majority of his career in Rome.[1]

Whereas his peers—like François Boucher (cats. 5–7), Charles-Joseph Natoire (cat. 4), and Jean-Marc Nattier (cat. 11)—practiced a Rococo style of painting, Subleyras's approach anticipates the Neoclassicism pursued later in the century by Jacques-Louis David. In an approach similar to that taken by David in *Andromache Mourning Hector* (cat. 14), Subleyras concentrates on the eloquence of the human body to tell a dramatic story in *Two Figures (Study for "Saint Camillo de Lellis Saving a Sick Man")*. However, the subject here concerns a recent tragedy rather than events from ancient literature or history. Camillo de Lellis rescues a patient from the flooded Santo Spirito Hospital in Rome. The disaster occurred when the Tiber River surpassed its banks on the night of December 23–24, 1598.[2] Camillo de Lellis (1550–1614) founded the Camillian monastic order, dedicated to caring for the sick, in 1591. Upon Camillo's canonization by Pope Benedict XIV in 1746, he was recognized as the patron saint of hospitals and the sick. That same year, the Camillian order in Rome commissioned Subleyras to paint a scene that commemorates the heroic rescue of the patients from the flood.[3] That work, *Saint Camillo Saving a Sick Man*, was offered to the pope as a gift.

The painting here is an oil sketch for the final composition. The study focuses on the two central figures, Camillo and the sick man he rescues. The monk's dark robe has been hoisted up and secured with a white swath of fabric to keep it from getting wet, revealing his powerful calves as he gingerly lifts the patient and carries him to safety. The limp, helpless sick man clings to Camillo. His bandaged head droops, and his legs dangle in the air, in contrast with Camillo's firm, powerful body.

Subleyras's treatment of these two figures recalls portrayals of the ancient literary theme of Aeneas rescuing his father, Anchises. Aeneas, the Trojan hero who founded Rome, carried his elderly father out of Troy.[4] Subleyras's compositional strategy in depicting these two figures changes little between the initial conception of the sketch and the final work (in the finished version the patient wears a red turban and Camillo's left foot is submerged in water). However, the finished work presents a complex figural composition, with Camillo and the man he saves flanked by groups of men helping the sick. In the right foreground of the finished painting, a muscular servant lifts a basket laden with food, dishes, and kitchen implements. Fabric hangs over the edge of the basket and trails in the rising water. On one hand, the still life, a seemingly incidental detail, reveals a pictorial debt to the seventeenth-century Italian painter Caravaggio (with whom Subleyras was undoubtedly familiar). On the other, it reinforces the pressing, time-sensitive nature of the situation. While the action occurs in the foreground, Subleyras depicts the cavernous, empty space of the hospital's architecture in the distance. The painter imagines the terrifying moments in the besieged hospital to celebrate Saint Camillo's selfless act of compassion and bravery.

33

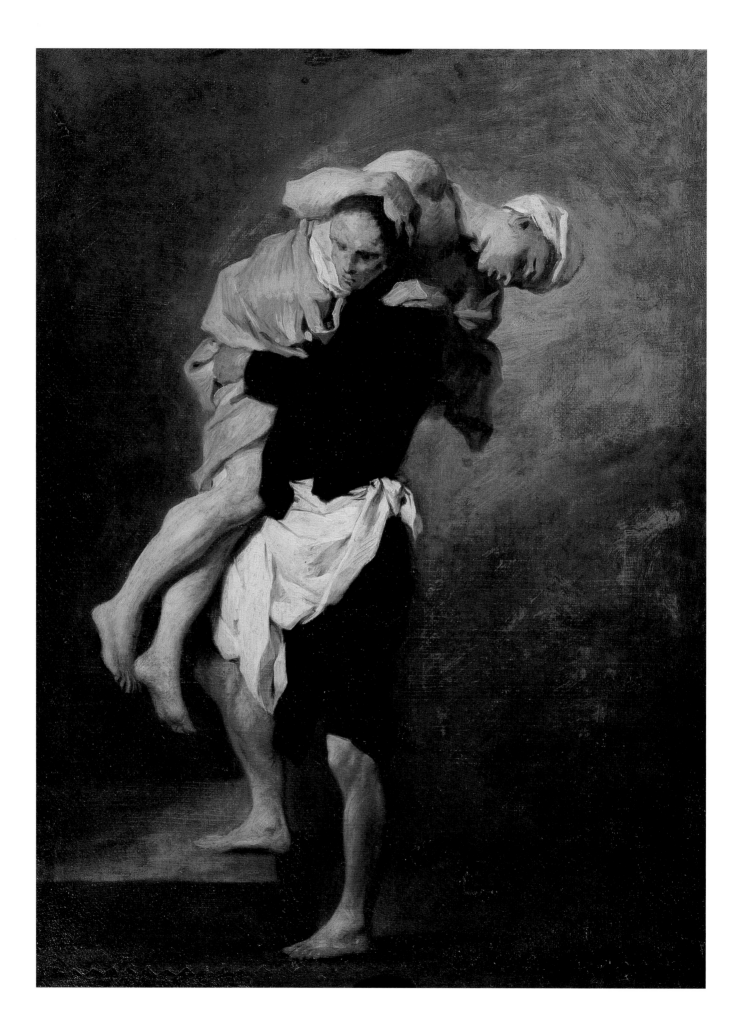

NOTES

1 Olivier Michel and Pierre Rosenberg, eds., *Subleyras,
 1699–1749*, exh. cat. (Paris: Musée du Luxembourg, in
 association with Ministère de la Culture et de la
 Communication, Éditions de la Réunion des Musées
 Nationaux, 1987), 12–13.

2 On this sketch, the finished version, and other prepara-
 tory works, see Michel and Rosenberg, *Subleyras*,
 307–13.

3 Michel and Rosenberg, *Subleyras*, 308. The painting
 heroizes Camillo to the extent that it overlooks the fact
 that he gravely injured his foot during the rescue; see
 309.

4 A possible source for the work was Barocci's painting
 Aeneas & Anchises (Galleria Borghese; see Michel and
 Rosenberg, *Subleyras*, 311. Another likely source is
 Bernini's sculpture *Aeneas, Anchises, and Ascanius Fleeing
 Troy* (c. 1619, Galleria Borghese).

CLAUDE-JOSEPH VERNET

French, 1714–1789

9 *Romantic Landscape*
 (Landscape in the Manner of Salvator Rosa)

Oil on canvas,
1746
$29^1/8 \times 38^1/8$ in.
(74 × 97 cm)
Signed: *J. Vernet f.*
Romae. 1746
Inv. no. 770

AN HEIR TO the classical landscape tradition forged by Nicolas Poussin and Claude Lorrain (cats. 1 and 2), Claude-Joseph Vernet was among the foremost practitioners of the genre in the eighteenth century. Like his illustrious seventeenth-century forebears and his contemporary Hubert Robert (cat. 13), Vernet perfected his skills in Italy, traveling to Rome in 1734 and remaining there until 1752.[1] Prior to his Roman sojourn Vernet studied with the painter Jacques Viali in Aix-en-Provence, not far from his native Avignon in the south of France.[2]

Vernet specialized in landscapes and was best known for his marine paintings, a sub-genre of landscape that gained popularity during the eighteenth century.[3] His seascapes and watery scenes were prized by an international clientele, notably aristocratic, royal, and imperial patrons in England, France, Italy, and Russia. For instance, Vernet became well known in Russia in the 1760s when Empress Catherine II (the Great) purchased two paintings for the St. Petersburg Art Academy. Art collector N. B. Yusupov knew Vernet personally and was his first Russian patron. The two exchanged letters, and Yusupov's collection included seven Vernet paintings. Vernet's European fame was propelled by the positive responses that greeted his contributions to the Paris Salon. Vernet exhibited regularly at the official exhibitions from 1746 until his death. He earned critical acclaim from Denis Diderot, who sang Vernet's praises in imaginative, richly descriptive commentary in his essay "Salon of 1767."[4]

In his *Romantic Landscape (Landscape in the Manner of Salavator Rosa)*, Vernet articulates the tenuous balance between nature and civilization. Nature's power seems to dominate humankind and the man-made world. Strong, clear light illuminates the right side of the canvas. Just beyond the figures, craggy rocks project into the picture space. These chiseled rocks, the twisting tree dangling from their upper edge, and the rushing waterfall draw the eye down to the water. Together these elements create a level of dramatic tension that overshadows the human actors.

In the background, high on a ridge, Vernet depicts an enormous complex of buildings that suggests the glories of the distant past. A cross perched on a precipice, a signifier of Christianity and perhaps meant as a beacon to believers, is tiny in comparison to the trees growing throughout the landscape. At the far-left edge of the canvas, another building with classical architecture is nestled into the rocky hillside. Cypress trees, typical features of the landscape around Rome, seem to grow out of the structure, perhaps suggesting nature's dominion, its relentless proliferation regardless of man's incursion into the landscape.

Vernet's conception of the landscape certainly owes a debt to the example of Claude Lorrain, though the artist cites a connection to the works of Salvator Rosa, an Italian landscapist and contemporary of Claude. Although Vernet's use of light and emphasis on classical elements recall Claude's approach, the wild drama and sublime character of his scenes directly invoke Rosa's example. Rosa was immensely popular as a painter of *banditti* scenes, in which the natural setting and the narrative combine to give the viewer a sensation of the untamed and dangerous; an emblematic work is Rosa's *Bandits on a Rocky Coast* (c. 1656, Metropolitan Museum of Art, New York).[5]

Salvator Rosa.
Bandits on a Rocky Coast. c. 1656.
Oil on canvas,
29 1/2 × 39 1/2 in.
(75 × 100.3 cm).
The Metropolitan
Museum of Art,
New York. The
Charles B. Curtis
Fund, 1934.

Romantic Landscape was one of eight paintings commissioned by the Marquise de la Villette in 1746. This work resonates strongly with another Vernet painting from the same year, *Landscape with a Waterfall* (Collection of Duke Buccleuch, Queensbury, England), suggesting that Vernet worked from a highly successful template. Vernet's landscapes met the requirements of his educated, Enlightenment patrons. His pictures hung on the walls of prestigious houses, furnishing the well-educated and well-heeled with imaginative journeys into the untamed natural world.

NOTES

1 See Philip Conisbee, "Vernet in Italy," in *Pittura toscana e pittura nel secolo dei lumi,* ed. Roberto Paolo Ciardi, Antonio Pinelli, and Cinzia Maria Sicca (Florence: S.P.E.S., 1993), 129–40.

2 *French Painting 1774–1830: The Age of Revolution,* exh. cat. (Detroit: Wayne State University Press, in association with the Detroit Institute of Arts, 1975), 654–55.

3 For a theoretical and psychoanalytic analysis of the significance of the genre, see Steven Z. Levine, "Seascapes of the Sublime: Vernet, Monet, and the Oceanic Feeling," *New Literary History* 16, no. 2 (1985): 377–400.

4 Denis Diderot, "Salon of 1767," in *Art in Theory, 1648–1815, An Anthology of Changing Ideas,* ed. Charles Harrison, Paul Wood, and Jason Gaiger (Oxford: Blackwell, 2000), 620–24.

5 Michael Fried discusses these issues, as well as Vernet's distinctive originality, in *Absorption and Theatricality: Painting and Beholder in the Age of Diderot* (Chicago: University of Chicago Press, 1980), 132–36.

CARLE VAN LOO

French, 1705–1765

10 *Allegory of Comedy*

Oil on canvas,
1752
48 × 61¾ in.
(122 × 157 cm)
Signed: *Carle
Vanloo*
Inv. no. 742

ADHERENTS of the Rococo style were kept very busy by royal and aristocratic patrons during the reign of Louis XV. Wealthy, influential art lovers sought allegorical, mythological, and historical paintings primarily to decorate their lavish homes. Within this milieu, the Marquise de Pompadour was one of the most important patrons of the arts.[1] As an arbiter of taste, she played a vital role at court dictating choices about art, music, and theater.

The marquise commissioned Carle Van Loo to paint *Allegory of Comedy,* as well as a pendant, *Allegory of Tragedy* (1752, State Pushkin Museum of Fine Arts, Moscow), for her château at Bellevue.[2] Though François Boucher was her best-known protégé, Van Loo enjoyed her favor and a highly successful career. The incomparable eighteenth-century French critic and man of letters Denis Diderot praised Van Loo as a "grand talent."[3]

Van Loo was the son and the grandson of painters, natives of the Netherlands.[4] A contemporary of such masters as Boucher (cats. 5–7), François-Hubert Drouais (cat. 12), and Charles-Joseph Natoire (cat. 4), Van Loo was an esteemed member of the Academy. As was customary among painters of his stature and ambition, Van Loo won the Prix de Rome in 1724. He worked at the French Academy in Rome while Boucher was also in residence there.

In terms of subject matter and technique, *Allegory of Comedy* exemplifies the Rococo style favored by the Marquise de Pompadour. Allegorical works represent abstract concepts, such as the arts, academic disciplines, and morals, through personification. Some critics and theorists, including Diderot,

dismissed allegories for their "abstruse use of symbolism," preferring the "unity and clarity" offered by history painting.[5] Nonetheless, allegories were popular among eighteenth-century painters and their patrons.

Here, Van Loo imagines Comedy as a playful, attractive, and beguiling young woman, bejeweled and sumptuously dressed. Crowned with laurel leaves, an emblem of victory, she occupies the stage with bold confidence. An inscribed scroll at her feet acts as a program announcement, identifying two fourth-century B.C. Greek playwrights who personify the genre of comedy, Aristophanes and Menander.

The figure of Comedy holds two essential attributes of the theater: a curtain and a mask. She gazes coyly at the audience, as if at any moment she might pull the thick, richly colored curtain across her body and deny us access to her diverting charms, or perhaps lift the black mask to her face, transforming her identity in an instant.

The fundamental aim of comedy—whether an ancient Greek play or an eighteenth-century French farce—is to reveal rather than conceal. Indeed, the comedic genre reveals truth by exploiting our human foibles and our capacity to laugh at ourselves. In Van Loo's representation, playful cherubs underscore the light tone of the work, cavorting and playing "dress up" as one of the children blows a horn, perhaps to announce that the play shall soon begin.

The stage on which this scene unfolds is an outdoor portico, a space that mediates between the interior and the landscape. The column demonstrates

Carle Van Loo.
Allegory of Tragedy.
c. 1741. Oil on canvas,
48 × 61 ⅞ in.
(122 × 157 cm).
State Pushkin
Museum of Fine Arts,
Moscow.

Van Loo's mastery of classical architecture, which he most likely acquired during his studies in Rome. The lush fabric of Comedy's garments and of the curtain, as well as the soft-focus imaginary landscape, counterbalance the cold, rigid lines of the architectural setting.

Other elements add to the sense of anticipation: several masks lie in a jumble in the lower left corner, while another musical instrument hovers above them. These accoutrements will be put to use when the performers take the stage. Comedy, meanwhile, holds our attention with the promise of the unique pleasures the art form provides.

NOTES

1 On the Marquise de Pompadour, see Melissa Hyde, "The 'Makeup' of the Marquise: Boucher's Portrait of Pompadour at Her Toilette," *Art Bulletin* 82, no. 3 (2000): 453–75; see also Cynthia Lawrence, ed., *Women and Art in Early Modern Europe: Patrons, Collectors, and Connoisseurs* (University Park: Pennsylvania State University Press, 1997).

2 The paintings were moved to the Marquise de Pompadour's Paris residence in 1757.

3 Denis Diderot, quoted in Pierre Rosenberg and Marie-Catherine Sahut, *Carle Vanloo, Premier Peintre du Roi (Nice, 1705–Paris, 1765)*, exh. cat. (Nice: Musée des Beaux-Arts, 1977), 11.

4 Rosenberg and Sahut, *Carle Vanloo*, 19. The Van Loo family included many painters; Carle's nephew, Louis-Michel, painted him in the act of producing a portrait of his daughter: *Portrait de Carle Van Loo et sa famille* (c. 1757, Versailles); on this work and Diderot's response to it, see Michael Fried, *Absorption and Theatricality: Painting and Beholder in the Age of Diderot* (Chicago: University of Chicago Press, 1980), 110–13.

5 Fried, *Absorption and Theatricality*, 90.

JEAN-MARC NATTIER
French, 1685–1766

II *Portrait of Princess Ekaterina Golitsyna*

Oil on canvas,
1757
21¼× 17¾ in.
(54 × 45 cm)
Signed: *Nattier px.*
1757
Inv. no. 1034

PRINCESS Ekaterina Golitsyna was the wife of the Russian diplomat Prince Dmitri Golitsyn (see cat. 12). The Golitsyns lived in Paris from 1757 to 1761 while Prince Dmitri served in the Russian embassy. Princess Golitsyna sat for the painter Jean-Marc Nattier shortly after her arrival in Paris.[1] In 1761 the Golitsyns moved to Vienna, where Prince Dmitri held the post of ambassador until 1790. They collected art and were fond of eighteenth-century Dutch, French, and Italian painting.

In Nattier's portrait, Ekaterina Golitsyna gazes to her left, her attention captured by something or someone we cannot see. A slight, sly smile animates her peaceful expression. Her demeanor, garments, and jewels establish her identity as a distinguished, worldly woman. Soft light illuminates her flushed face and the creamy skin revealed by her low-cut yet decorous garment.

Nattier's skill as a portraitist registers in his representation of the princess's face and body, as well as in his rendering of her jewels and garments. A thin strand of pearls caresses her left shoulder. The pearls shimmer softly in the light, for Nattier aptly depicts their lustrous surfaces. A translucent jewel secures the delicate veil on her head, which is further decorated with a delicate spray of flowers tucked into her hair. Using a reduced palette of muted greens, grays, and whites, the artist captures the princess's serene elegance.

Nattier first studied art with his father and mother, a portrait painter and a miniaturist, respectively. An early talent for drawing led him to formal study in the Academy, where he won a prize for drawing. In 1718 he was accepted as a professional member of the Academy. Unlike most French academic painters, Nattier never traveled to Rome. Except for a stint in Amsterdam, where he painted Peter the Great and his wife, Catherine I (1717, State Hermitage Museum, St. Petersburg), he lived and worked exclusively in Paris and Versailles. Nattier was a favorite court painter of the queen of France, Marie Leczinska, whose patronage enabled Nattier to develop a thriving career as a portraitist who catered primarily to wealthy women. He was extremely popular among aristocratic Russians living in Paris.

Adapting his pictorial skills to the tastes of the day, Nattier specialized in portraying his sitters as gods and goddesses.[2] They would pose with attributes of Diana or Venus, playing a role for the portrait. The taste for these "theatrical" portraits declined after 1740. Accordingly, Nattier adjusted his approach, opting to produce more conventional—yet no less elegant—portraits, such as *Portrait of Princess Ekaterina Golitsyna*. In this work, the sitter confidently and calmly plays the role she knew best: beautiful wife of a distinguished ambassador.

NOTES

1 Recently discovered, unpublished archival documents in the State Hermitage Museum, St. Petersburg, have led Pushkin curator Elena Sharnova to identify the sitter as Princess Golitsyna. The sitter's identity was previously unknown. The Pushkin also owns another portrait of Princess Golitsyna by the French painter L. M. Van Loo, painted in 1759. Similarities between the Van Loo and the Nattier portraits, in addition to documentary evidence, led Sharnova to make this confident identification.

2 See Dominique Jarrasseé, *Eighteenth-Century French Painting*, trans. Murray Wyllie (Paris: Terrail, 1999).

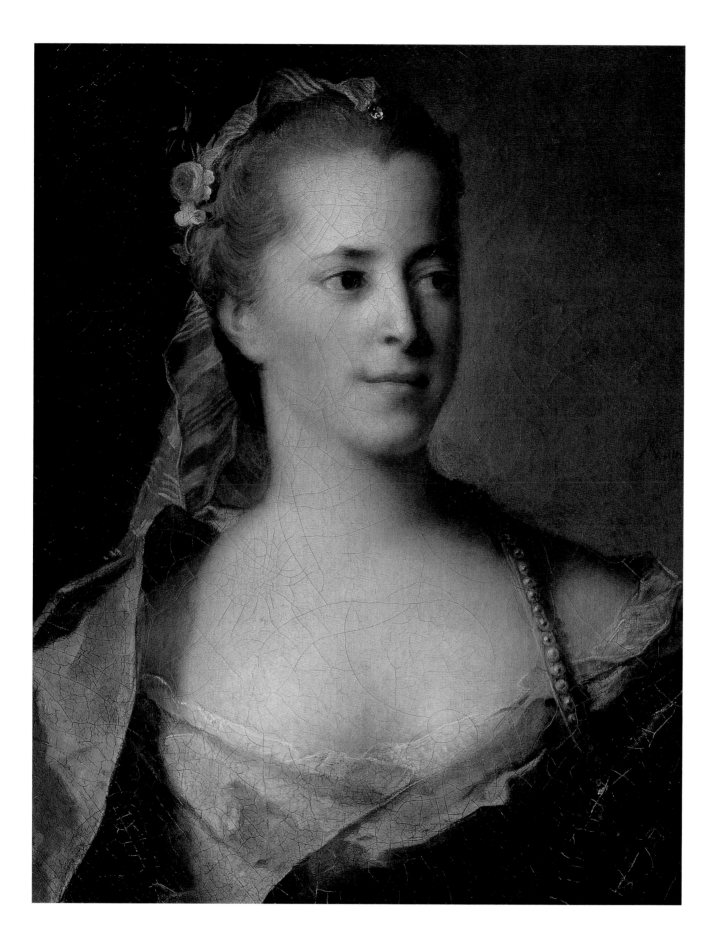

FRANÇOIS-HUBERT DROUAIS
French, 1727–1775

12 *Portrait of Prince Dmitri Golitsyn*

Oil on canvas,
1762
38 1/8 × 30 3/4 in.
(97 × 78 cm)
Signed and dated
(on globe): *Peint
par Drouais le fils,
1762*[1]
Inv. no. 894

A PORTRAIT aims to capture a sitter's identity. The painter's task is not merely to reproduce a convincing likeness but to capture the essence of a personality. The most important elements are the sitter's pose, gaze, gestures, and garments, and the accoutrements that surround him. Together these elements provide clues that the viewer can interpret, even when the sitter's identity is unknown.

This painting presents an image of a learned, wealthy, well-traveled man. We are able to discern this from his fancy garments, as well as from the attributes that surround him. He sits in an elegant chair at a gilded table, where we imagine that a great deal of important correspondence and study take place. He holds a letter in his right hand. On the table just behind it is a globe, a luxury item in the eighteenth century, suggesting the man's awareness of and fascination with the larger world. His social status is reinforced by the clothes he wears: his blue velvet coat is trimmed with fur, he wears an elaborate gold sash around his waist, and a jewel-encrusted cross, the Russian order of Saint Anne, hangs from his neck. His garb, posture, and gaze reinforce a sense of formality, elegance, and dignity.

Drouais's subject here is Prince Dmitri Mikhailovich Golitsyn (1721–1793), a diplomat, man of letters, and patron of the arts. He began his career as a Russian diplomat assigned to France, moving to Paris in 1757 and, three years later, becoming director of the Russian embassy there. It is likely that the prince sat for Drouais while still in Paris in 1761, although

Drouais did not complete and sign the painting until 1762. Also during the Golitsyn's residence in Paris, L. M. Van Loo painted a small portrait of the prince's wife, Princess Ekaterina Golitsyna.[2] Drouais, who was both the son and the father of a painter, enjoyed very high status as "First Painter to the King" in the court of Louis XV. He painted the portraits of notable aristocrats, magistrates, scholars, and ambassadors.

In 1761, Golitsyn was appointed ambassador to Vienna, where he spent the next thirty years of his life. His position proved an asset to his artistic patronage, for he became a fixture in high European society, associating with the enormously wealthy, with important scientists, and with notable artists. These contacts enabled him to amass an outstanding collection of paintings, prints, and drawings.

Upon his death, Prince Golitsyn bequeathed both his fortune and his art collection to the city of Moscow, stipulating that the city build a hospital in his honor. A hospital complex in a garden setting was constructed on the banks of the Moscow River. It included a wing to accommodate Golitsyn's art collection. It was the first free picture gallery in Moscow and was opened to the public in 1810. Two years later the gallery fell victim to Napoleon's invasion of Moscow and was forced to close. The prince's heirs were left financially unstable and had to liquidate the collection. Although the prince's collection has been dispersed, Drouais's elegant portrait is an enduring reminder of his legacy.

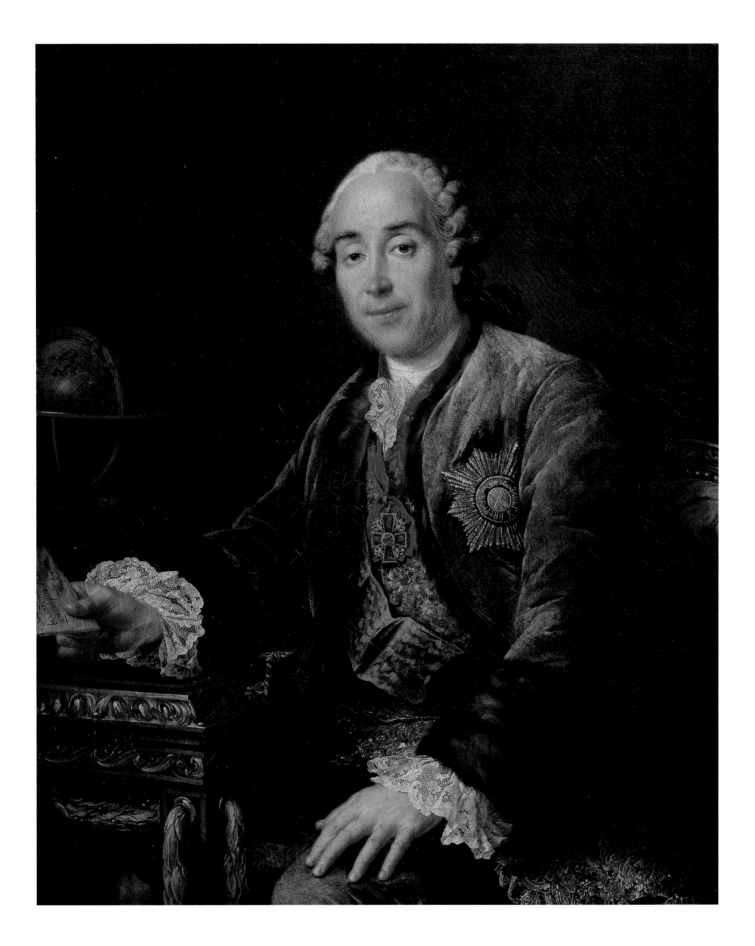

NOTES

1 The painting bears the following inscription on the reverse
 (translated from the Russian): *Active chamberlain, cavalier
 and Minister Plenipotentiary / to the French court, active
 secret counselor of the Orders of St. Apostle Andrew the First
 Called / St. Alexander Nevsky, St. Prince Vladimir of the
 First Class / and St. Anna cavalier and serving at the Roman
 Impe / rial court as an Ambassador Extraordinary and
 Plenipotentiary / Prince Dimitri Mikhailovich Golitsyn.
 No. 303.*

2 See cat. 11 for an earlier portrait of the princess, by Jean-
 Marc Nattier.

HUBERT ROBERT

French, 1733–1808

13 *Landscape with a Sarcophagus*
Ruins with an Obelisk in the Distance

PAGE 48

Oil on canvas,

1775

63³/₈ × 41 in.

(161 × 104 cm)

Inv. no. 2799

PAGE 49

Oil on canvas,

1775

63 × 41 in.

(160 × 104 cm)

Signed: *Robert 1775*

Inv. no. 2910

CAPITALIZING on the eighteenth-century fascination with the ancient world, Hubert Robert specialized in architectural views, a sub-genre of landscape painting. Italian artists pioneered the genre of view paintings (*vedute*), which rose to prominence during the eighteenth century. Hubert Robert followed in the footsteps of the genre's greatest practitioners, emulating Giovanni Paolo Panini, who specialized in views of Rome, and Canaletto, who is celebrated for his scenes of Venice.[1]

Vedute were often commissioned by or marketed to foreigners. Panini's patrons, for example, were primarily French or English visitors to Rome. Likewise, Canaletto catered to wealthy English tourists enjoying Venice while on the Grand Tour, an integral part of an elite Enlightenment education. French and Russian aristocrats were especially fond of Robert's view paintings. He received commissions from Peter the Great, as well as from wealthy members of the Yusopov, Stroganov, and Shuvalov families.[2] Like many French artists before him, Robert made a career-shaping trip to Rome.[3] He arrived there in 1754 and studied the works of Panini, quickly mastering the technique of minutely recording interior and exterior views of Rome's imposing ancient monuments.[4]

Robert's large paintings *Landscape with a Sarcophagus* and *Ruins with an Obelisk in the Distance* were conceived as a pair. Each canvas depicts soaring, vertiginous spaces capped by enormous arches. The vertical orientation of the paintings (each is more than five feet in height) reinforces the dizzying quality of the spaces. Though Robert studied ancient

Roman monuments in situ during his eleven-year stay in Italy, these paintings depict not specific historical buildings but rather imagined ones. Robert synthesizes his direct study of ancient architectural and sculptural forms with the influence of Panini. Robert's compositions suggest that he was also acquainted with Giovanni Battista Piranesi's engravings of Roman views and invented architectural fantasies.[5]

Both *Landscape with a Sarcophagus* and *Ruins with an Obelisk in the Distance* combine the architectural grandeur of the ancient past with anecdotal scenes of contemporary Romans cavorting among the ruins. In *Landscape with a Sarcophagus*, three men use levers and rolling logs to move an ancient burial tomb.[6] Ancient sculptures, friezes, and architectural elements, both intact and in fragments, litter the space. A few people observe the proceedings from above, perched on the railings. In the distance, men, women, and children go about their business as clouds gather in the sky. A few figures gaze into the hazy landscape. All the figures are overwhelmed by the enormous vaulted space. Although the building's majestic scale is impressive, clearly its grandeur has faded over time.

In the same way that still-life paintings address the theme of *vanitas* (the ephemeral nature of human existence, or the folly of vanity), Robert's ruins attest to the inevitability of decay. The crumbling stairs, stones, and supports in *Ruins with an Obelisk in the Distance*, as in *Landscape with a Sarcophagus*, depict the decomposition of architecture over time. *Ruins with an Obelisk*, too, presents an oblique view of

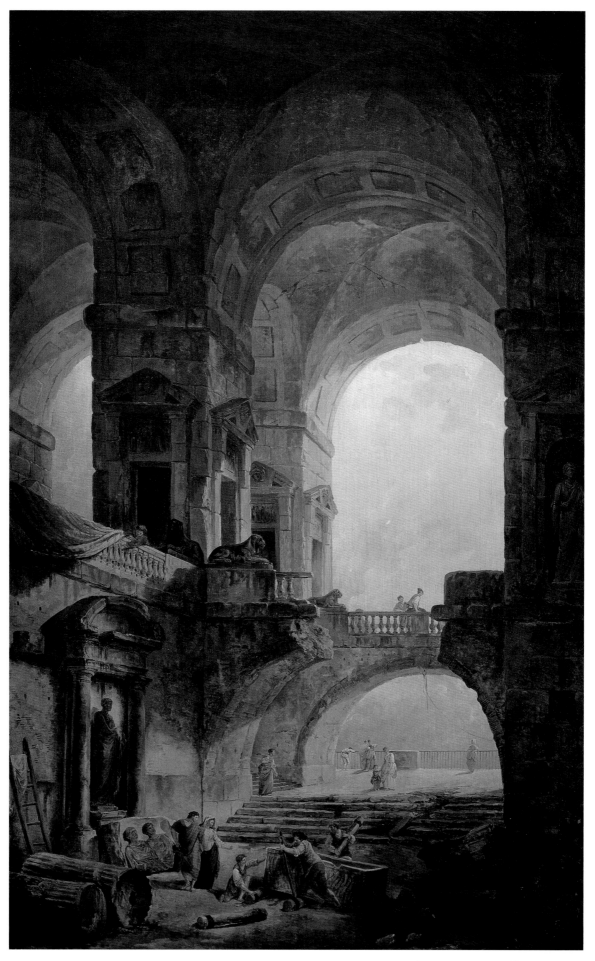

LANDSCAPE WITH A SARCOPHAGUS

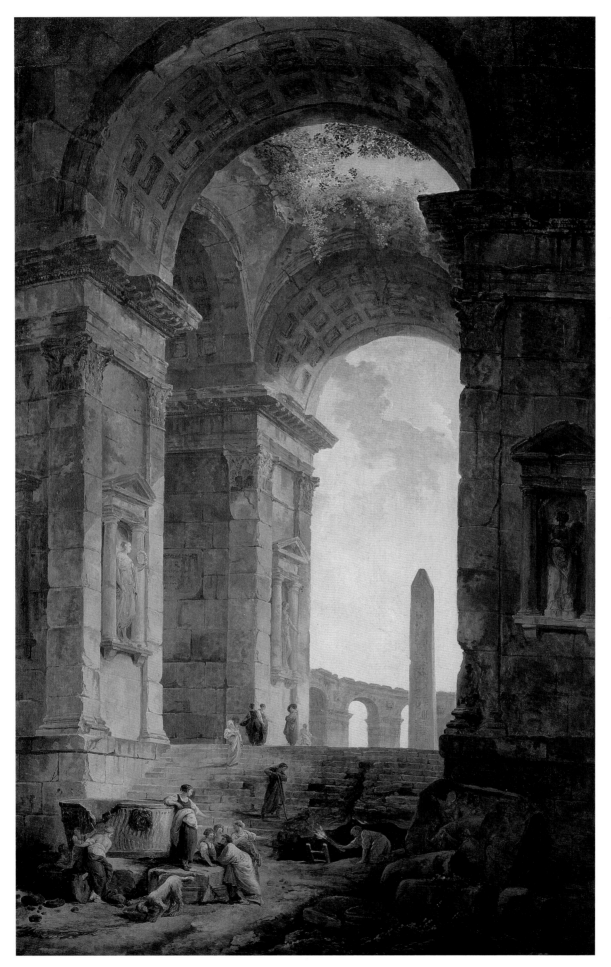

Ruins with an Obelisk in the Distance

arches towering over a group of figures that has discovered artifacts from the ancient world. An excavation seems to be going on beneath the stairs, where a crouching figure holds a torch for unseen explorers who may soon climb up the ladder bearing centuries-old treasures. Though a fringe of vegetation peeks through the open space between the arches, Robert celebrates the wonders of man-made architecture and sculpture rather than those of nature.

The obelisk in the distance recalls the extensive reach of the ancient Roman Empire. The monument, which originally served a commemorative function in Egypt, symbolizes Roman military might and cultural dominion. In Robert's painting, however, the obelisk is a monument to the faded splendors of the past: ancient Egypt and ancient Rome equalized by time.[7] These works transport the viewer, transcending numerous historical eras.

Landscape with a Sarcophagus and *Ruins with an Obelisk in the Distance* were painted in France, long after Robert's return from Italy. His Roman works were quite popular at the Salon and with his patrons. Responding to Robert's view paintings at the Salon of 1767, the critic and man of letters Denis Diderot extolled the poetry of ruins.[8] Diderot, an Enlightenment *philosophe*, was the most important art critic in eighteenth-century France. He was enthusiastic about Robert's Roman views for their ability to transport the viewer to another time, place, and state of mind: "The ideas which the ruins awake in me are grand. Everything vanishes, everything dies, everything passes, only time endures. . . . I see the marble of tombstones fall into dust and I do not wish to die!

. . . In that vast deserted sanctuary, unbelievably solitary and vast, I have broken with all the obstacles of life; no one pushes me, no one hears me; I can talk out loud to myself, grieve, shed tears without constraint."[9] Robert's depictions of ancient ruins appealed to the Enlightenment thinker's interest in the sublime.[10] The effects that Diderot describes might equally apply to Robert's *Landscape with a Sarcophagus* and *Ruins with an Obelisk in the Distance*.

In his study of eighteenth-century French art and criticism, *Absorption and Theatricality,* Michael Fried explains the critic's response to Robert's paintings of ruins:

> In short, Diderot held that the poetics or imaginative essence of depictions of ruins required that the beholder be compelled to enter the painting, to mediate not only on but among the remains of ancient civilizations. . . . Accordingly, Diderot seems to have held that an essential object of paintings belonging to those genres was to induce in the beholder a particular psychological condition, equivalent in kind and intensity to a profound experience of nature, which for the sake of brevity might be characterized as one of existential reverie or *repos délicieux* (delicious rest).[11]

Robert's masterful views delighted his patrons, who desired this kind of repos délicieux. A painting by Hubert Robert (or better yet, two) on the wall offers the viewer a poetic escape from the concerns of the present and an opportunity to muse on the passage of time.

NOTES

1 Canaletto (Giovanni Antonio Canale) and Panini were both trained as theatrical set painters.

2 On Russian patronage of Hubert Robert, see Marianne Roland Michel, "Hubert Robert," *Burlington Magazine* 141, no. 1160 (1999): 703–5, a review of *Hubert Robert, 1733–1808, et Saint-Pétersbourg: les Commandes de la Famille Impériale et des Princes Russes entre 1733 et 1802*, exh. cat. (Valence, France: Musée des Beaux-Arts et d'Histoire Naturelle, 1999).

3 See Marianne Roland Michel, "Light and Ruins: Fragonard and Hubert Robert in Rome," *Master Drawings* 29, no. 4 (Winter 1991): 430–35, review of Catherine Boulot, Jean-Pierre Cuzin, and Pierre Rosenberg, ed., *J. H. Fragonard e H. Robert a Roma* (Rome: French Academy, Villa Medici, 1991).

4 *French Painting 1774–1830: The Age of Revolution,* exh. cat. (Detroit: Wayne State University Press, in association with the Detroit Institute of Arts, 1975), 589; see also Paula Rea Radisich, *Hubert Robert: Painted Spaces of the Enlightenment* (Cambridge: Cambridge University Press, 1998), 108–11.

5 Giovanni Battista Piranesi, "Carcere oscura," *Prima parte di architettura* (Rome, 1743).

6 On Robert's attitude toward death and his links to the philosophies of Diderot and Voltaire, see Jean de Cayeux, "Images of Death in the Works of Hubert Robert," *Register of the Spencer Museum of Art* 6, no. 7 (1990): 7–21.

7 On other Robert paintings that depict the obelisk, see John D. Bandiera, "Form and Meaning in Hubert Robert's Ruin Caprices: Four Paintings of Fictive Ruins for the Château de Méréville," *Museum Studies (Art Institute of Chicago)* 15, no. 1 (1989): 20–37, 82–85.

8 Denis Diderot, "Salon de 1767," quoted in Ian J. Lochhead, *The Spectator and the Landscape in the Art Criticism of Diderot and His Contemporaries* (Ann Arbor: UMI Research Press, 1982).

9 Diderot, "Salon de 1767," *Salons* 3, edited by Jean Seznec and Jean Adhémar (Oxford: Oxford University Press, 1963), quoted in *French Painting 1774–1830,* 590.

10 Radisich, *Hubert Robert,* 133–35.

11 Michael Fried, *Absorption and Theatricality: Painting and Beholder in the Age of Diderot* (Chicago: University of Chicago Press,) 130.

JACQUES-LOUIS DAVID
French, 1748–1825

14 *Andromache Mourning Hector*

Oil on canvas,
1783
22 7/8 × 16 7/8 in.
(58 × 43 cm)
Signed and dated:
L. David / 1783
Inv. no. 843

THIS SKETCH is a highly refined study for Jacques-Louis David's history painting *Andromache Mourning Hector* (1783, Musée du Louvre, Paris), which was submitted as his *morceau de réception* (presentation piece) for admission to the French Academy.[1] David was admitted to the Academy and went on to become the most important history painter of his generation.

The creation of a large-scale, ambitious history painting, regarded as the highest in the hierarchy of genres, involved many steps.[2] First, the artist made numerous drawings to devise the composition and perfect the figures' poses. These drawings became increasingly finished as the artist refined his pictorial strategy.[3] Then the artist would make a large-scale oil sketch, like this one, which is most likely the penultimate step in David's conception of the final version of *Andromache Mourning Hector.* This work was acquired by Nicholas Demidoff, the Russian ambassador to Florence, on a visit to Paris in 1805.[4]

Here, David retells Homer's tale in *The Iliad* (24.724–45) of Hector's death at the hands of Achilles. The dead hero has been crowned with a laurel wreath and laid out on a bed. Art historian Dorothy Johnson succinctly describes the narrative import of the work: "A grief stricken wife laments the untimely death of her young husband and like the Virgin of Sorrows (whose iconography inspired David), she foresees the grim fate that awaits her innocent son Astyanax who seeks to comfort her and seems unaware of the cadaver of his father on the bed. David, who was always pondering the meaning of classical texts, meditated on Homer's characterization of Hector as the archetypal family man."[5]

Hector was indeed a hero, but David reminds us that he was a beloved husband and father as well.

When the work was shown in 1783 it was well received, but critics found the depiction of Hector's dead body disconcertingly realistic: "The painting ... has a most imposing impact. It is appalling because of the character of death, which is perfectly expressed The greatest severity of drawing and vigor of color characterize [Monsieur] David. He is the painter who best renders the extremities."[6] David's treatment of the feet, inert and drained of color, draws the eye to the right edge of the canvas. Directly below them, on the bed frame, he has included a bas-relief that depicts the moment when Achilles delivers the fatal blow to Hector. At left, Hector's helmet and sword rest, useless.

For David and his contemporaries, this ancient subject was not distant and inaccessible but absolutely relevant to a world in need of moral education. "Antiquity," the artist wrote in 1799, "has not ceased to be the great school of modern painters, the source from which they draw the beauties of their art. We seek to imitate the ancient artists, in the genius of their conceptions, the purity of their design, the expressiveness of their features, and the grace of their forms."[7] As a student, David won the Prix de Rome in 1774 and spent five years studying ancient Greek and Roman architecture, sculpture, and literature. He inherited the mantle of French Classicism established by Nicolas Poussin (cat. 1) in the seventeenth century. He remained true to Poussin's vision, privileging classical subjects above all. Unlike his predecessor, however, David rarely depicted figures in the landscape. Rather, the stories he tells unfold in austere

interiors. David focuses on the eloquence of the body, for he was guided by the aesthetic principles of the ancients: "It was a recognized custom among the painters, sculptors, and poets of antiquity to portray gods [and] heroes . . . in the nude." Furthermore, David's desire "was to represent the customs of antiquity with such exactitude that the Greeks and the Romans, had they seen my work, would not have found me a stranger to their culture."[8]

David was an avid student of the classics, drawing inspiration from ancient literature and history. He visited the excavations at Herculaneum and Pompeii and steeped himself in classical culture. Because he emulated ancient forms and represented ancient stories, David's style of painting is termed Neoclassicism. His manner was seen as antithetical to the Rococo style that prevailed earlier in the century. Whereas Rococo painting emphasized frivolity and pleasure, David's Neoclassical mode emphasized serious, moralizing subjects.

The ancient stories of heroism, loyalty, and sacrifice represented in David's paintings resonated with viewers in late-eighteenth-century France, particularly during the political turmoil of the Revolutionary era.[9] In the critically acclaimed *Oath of the Horatii* (1784, Salon of 1785, Musée du Louvre, Paris) and *Brutus* (1789, Musée du Louvre, Paris), as in *Andromache Mourning Hector,* David represents heroic men whose loyalty to the ideals of the state outweighed devotion to family. His works anticipated and coincided with the political tensions that became painfully real as the French Revolution unfolded.

NOTES

1 Dorothy Johnson, *David: Art in Metamorphosis* (Princeton: Princeton University Press, 1993), 28.

2 On academic practices, see Albert Boime, *The Academy and French Painting in the Nineteenth-Century* (London: Phaidon, 1971).

3 Antoine Schnapper, *Jacques-Louis David*, exh. cat. (Paris: Musée du Louvre, 1989), 150–53.

4 Schnapper, *David*, 148.

5 Johnson, *David*, 28.

6 Quoted in Johnson, *David*, 28.

7 Jacques-Louis David, "The Sabines," in Elizabeth Gilmore Holt, ed., *From the Classicists to the Impressionists*, vol. 3 of *A Documentary History of Art* (New Haven: Yale University Press, 1986 [1966]), 4.

8 Jacques-Louis David, "Note: On the Nudity of My Heroes," in Holt, *Classicists to the Impressionists*, 11–12.

9 See Thomas E. Crow, *Painters and Public Life in Eighteenth-Century Paris* (New Haven: Yale University Press, 1985).

JEAN-BAPTISTE REGNAULT

French, 1754–1829

15 *The Toilet of Venus*

Oil on canvas,
c. 1789
39³/₈ × 32¹/₄ in.
(100 × 82 cm)
Inv. no. 737

A CONTEMPORARY and a competitor of Jacques-Louis David (cat. 14), Jean-Baptiste Regnault concentrated on historical, allegorical, and mythological subjects. Whereas David's Neoclassical style emphasized an austere, hard-edged clarity, Regnault's work harks back to the Rococo masters François Boucher (cats. 5–7) and Charles-Joseph Natoire (cat. 4).

Regnault's *Toilet of Venus*, created during the French Revolution, gives evidence that the taste for mythological subjects did not decline as precipitously as the monarchy had. Set in a lush landscape, *The Toilet of Venus* delights in the pleasures of feminine beauty. Venus, the goddess of love, prepares for an amorous meeting with one of her many suitors. Venus's lovers include her husband, Vulcan, the god of fire; Mars, the god of war; and the mortals Adonis, renowned for his beauty, and Anchises, who fathered her son Aeneas. Her golden chariot will carry her off to this romantic rendezvous when her preparations have been completed.

Venus is in the midst of her bathing ritual. The ornate pitcher and basin, draped with a sheet, suggest that she has completed her ablutions. Now she prepares to beautify herself with jewels and other adornments. Even nature has been cosmetically enhanced, for Venus's entourage has decorated her milieu with rich, sumptuous fabrics: blue on the ground, pink on the gilded chair, and pale blue draped on a tree limb behind Venus.

The goddess gazes at herself in a mirror proffered by two putti, while a minion puts the finishing touches on her ornate hairstyle. Various accoutrements rest on the elegant marble table: pearl earrings, a garland, and bottles of perfume and other

unguents. The carved relief on the table represents two doves (attributes of the goddess) and a laurel wreath, signifying the triumph of love. The dove motif is reiterated at left, with each nymph holding a lovebird. The two birds might be read as symbols of Venus and the lover she anticipates.

The Toilet of Venus plays with levels of representation. The oval mirror acts as a painting within the painting, for the reflection presents a partial portrait of Venus and a putto. Although we glimpse only Venus's left eye and cheek, this image serves to double her presence within the work (Pierre Bonnard used a similar device in his update of the theme in *Mirror Above a Washstand,* 1908, cat. 61). Furthermore, Regnault's awareness of "reality" versus "representation" registers in the doubling of the doves, sculpted and real.

Beyond these thematic concerns, Regnault demonstrates his mastery of depicting a variety of materials and textures. The imagined landscape—lush, fertile, and abundant—and the soft, elegant fabrics might be read as an extension of Venus's sensuality. Regnault attends to these supporting elements with the same sensitivity he brings to depicting Venus's smooth skin. While representations of the female nude had fallen somewhat out of fashion during the era dominated by David and his students, Regnault's works continued to find an audience.

Regnault had been admitted to the French Academy in 1782. The following year he gained attention with his *Education of Achilles* (1783, Musée du Louvre, Paris) and even greater renown from the tremendously popular engraving after the work.[1] During the Revolutionary era he was commissioned

to paint many portraits, and he continued to depict ancient and mythological subjects (including a *Mars and Venus,* c. 1799, State Pushkin Museum, Moscow). Regnault was particularly fond of representing stories from Ovid's *Metamorphoses.*

Throughout his long career Regnault was able to adapt to the changing political and social conditions in France. Though he came of age during the reign of Louis XVI, Regnault navigated the challenges posed by the Revolutionary era (1789–99), Napoleon's rule during the Consulate and the Empire (1799–1815), and the Restoration (1816–30). His style may have been antithetical to Davidian Neoclassicism, but Regnault never failed to attract powerful patrons.

NOTE

1 *French Painting 1774–1830: The Age of Revolution,* exh. cat. (Detroit: Wayne State University Press, in association with the Detroit Institute of Arts, 1975), 577.

16 *The Swoon*

Oil on canvas,
c. 1791
24³/₈ × 19⁵/₈ in.
(62 × 50 cm)
Signed: *L. Boilly*
Inv. no. 721

LOUIS-LÉOPOLD BOILLY was a keen observer of contemporary mores and social practices. He was especially drawn to subjects involving romantic intrigue in spaces both public and private. The son of a wood carver, Boilly studied painting with a master in the provinces and devoted himself to genre scenes, glimpses of everyday life. At the age of twenty-four he set off to establish himself in Paris. Happily, he discovered that art lovers in the capital had a taste for the genre subjects in which he specialized.[1]

The Swoon depicts a moment of domestic drama. A woman has fainted, apparently while reading a letter. The document must contain powerful words—undoubtedly concerning love or a loved one. Boilly stages this melodrama to emphasize the woman's overwrought emotional state: she slumps in her chair, her bodice loosened to expose her heaving bosom. Her bonnet, still fastened around her neck with a big pink bow, has fallen indecorously off her head. The strong arm of a man supports the swooning woman; his relationship to her, however, is unclear. Is he her husband, her father, her brother? As he holds her he pulls a cord to summon a servant, while a little boy worriedly looks on.

This moment is not based on a particular text or story, but it is a moment laden with narrative tension—the sort of moment that occurs in novels, a new art form at the time. Thus, Boilly is the author of an elaborate fiction, and he masterfully leaves us to speculate on the source of the letter and, by extension, the swoon. Such a strong reaction certainly suggests that the woman's lover sent the letter. Perhaps she has been unfaithful, and, if so, does the swoon reveal a secret? In raising such questions Boilly draws on the example of Fragonard, the Rococo master of romantic and erotic intrigue.[2]

Boilly's technique also owes a debt to the illusionism of seventeenth-century Dutch genre painting, which enjoyed a vogue in late-eighteenth-century France.[3] Dutch painters of domestic scenes emphasized the visual and narrative effects of everyday objects. Boilly, who collected Dutch art, follows suit in his depictions of the rich, shiny fabric of the woman's dress and the anecdotal details of her domestic surroundings: mantel clock, mirror frame stuffed with calling cards, papers strewn on the table, an open portfolio underneath it. The inclusion of these details lends authenticity to the scene, yet, typically, they also raise questions, fueling our already intense curiosity about what has taken place that afternoon. Does the portfolio contain architectural drawings or perhaps artist's sketches? Is the man, then, an artist, perhaps the woman's teacher? Has the boy been present all along or has he just surprised the man and the woman by delivering the swoon-inducing letter?

Whatever has caused the woman to faint and her bodice to loosen, Boilly understands that his audience delighted in the questions such a painting poses. Rather than make clear what has happened and what will unfold, Boilly allows us to invent our own scenarios. He carefully describes the physical realities of the figures, their fashions, and their surroundings, but he revels in the mysteries of what has transpired in the midst of such trappings. The letter provides the narrative catalyst, as well as the visual evidence, but we will never know its contents. That, Boilly knowingly leaves to our fertile imaginations.

NOTES

1 Jane Turner, ed., *The Grove Dictionary of Art. From David to Ingres: Early Nineteenth-Century French Artists* (New York: St. Martin's, 2000), 25.

2 John Stephen Hallam, "The Two Manners of Louis-Léopold Boilly and French Genre Painting in Transition," *Art Bulletin* 63, no. 4 (1981): 618–33.

3 Turner, *Grove Dictionary of Art. From David to Ingres*, 25.

LOUIS-LÉOPOLD BOILLY

French, 1761–1845

17 *Studio of a Woman Artist*

Oil on canvas,
1800
25⅝ × 21¼ in.
(65 × 54 cm)
Signed and dated:
L. Boilly 1800
Inv. no. 1260

BOILLY WAS fond of representing studio spaces both uninhabited and populated by artists at work. In his numerous pictures of painters and sculptors—men and women alike—he acknowledged his fascination with the processes of making art.[1]

Studio of a Woman Artist records in minute detail the tools and accoutrements that littered a typical studio in early-nineteenth-century France. The seated artist holds a palette in her left hand and a piece of white chalk in her right; an easel supports the canvas on which she works. The picture, or the early stages of one, is turned away from the viewer. We can only guess at the subject.

By hiding the picture, Boilly plays a kind of visual game, for he places us, as spectators, in the position of sitter. The little girl who stands behind the artist gazes directly outward, a nonchalant glance that extends the studio into our space and engages us in the fictional world of the painting.

Perhaps the painting on the easel is a portrait, a genre in which many women painters specialized. In Boilly's age, women acquired skills through training in the visual and musical arts. The ability to paint or draw, to play the harp or the piano, was considered vital to the social prospects of young women, who were discouraged from professional ambitions. Although women artists were permitted to participate in the official Salon exhibitions beginning in 1791, they were largely excluded from the most important French art institution: the Academy. Against these societal restrictions, however, some women were able to pursue successful careers as painters of still lifes, genre scenes, and portraits.[2]

Further emphasizing the unique professional circumstances of the early-nineteenth-century woman artist are the numerous still-life elements that buttress the painting's central genre scene. Plaster casts are arranged on the shelf, table, and even the floor, referring to the academic requirement of Boilly's day that all serious art students study plaster casts of ancient sculptures before being allowed to draw, paint, or sculpt directly from the live nude model. Women artists, however, could work from plaster casts only, since it was considered inappropriate for women to study the nude.[3] This artist has a number of portrait busts in her collection of plasters, suggesting that she focused on mastering physiognomy and facial expressions—vital technical skills for the portraitist.

Boilly demonstrates a still-life painter's love of describing different textures. He particularly delights in painting the vessels filled variously with water, linseed oil, and other substances employed by painters. These glass and ceramic objects allow Boilly to show off his skill in capturing the play of light and reflections. His exacting attention to these qualities—as well as his virtuosity in rendering flowing, silky fabrics—brings to mind seventeenth-century Dutch painting.

Another connection to the Dutch tradition is the inclusion of a camera obscura, an important tool in artists' studios for two centuries. The camera obscura aided artists in the convincing depiction of space by enabling them to capture accurately the image to be reproduced. This device, together with the array of glass vessels, plasters, canvases, and drawings, gives

the impression that the artist's studio is akin to a scientist's laboratory. There, creativity takes on an alchemical quality, for the artist routinely creates images and objects from a blank canvas, mixing together pigments and arranging them just so to create a lasting thing of beauty.

Of all the tools included in the artist's working space, the most important are the painter's eyes, hands, and pictorial imagination. In communicating this, Boilly stresses artistic process rather than product. He signed the work on a piece of board resting on an empty frame in the left foreground, reminding us that he is the master of the painting we see.

NOTES

1 Susan Siegfried, *The Art of Louis-Léopold Boilly: Modern Life in Napoleonic France*, exh. cat. (New Haven: Yale University Press in association with the Kimbell Art Museum, Fort Worth, and the National Gallery of Art, Washington, D.C., 1995).

2 On the training and status of women artists, see Charlotte Yeldham, *Women Artists in Nineteenth-Century France and England* (New York: Garland, 1984).

3 Yeldham, *Women Artists in Nineteenth-Century France and England,* 40–41.

LOUISE-ÉLISABETH VIGÉE-LEBRUN
French, 1755–1842

18 *Portrait of Prince Ivan Baryatinsky*

Oil on canvas,
1802–05
34¼ × 26⅜ in.
(87 × 67 cm)
Inv. no. 839

THIS ELEGANT portrait of a Russian prince was created by Louise-Élisabeth Vigée-Lebrun, whose remarkable career provides insight into the state of artistic patronage in the eighteenth century. Ambitious French painters of the period aspired to acceptance in the prestigious Royal Academy. Gender, however, played a crucial role in professional formation, and being female was a considerable impediment. Only a few women were admitted to this exclusive institution, a feat that attests to their determination and talent, as well as to formidable support networks.

Vigée-Lebrun was one among a tiny cohort of women artists admitted to the Academy in the late eighteenth century, which also included Thérèse Reboul-Vien, the wife of David's teacher; the still-life painter Anne Vallayer-Coster, and the portraitist Adélaïde Labille-Guiard.[1]

Vigée-Lebrun joined the Academy's elite ranks in 1783. In spite of vigorous opposition mounted by some Academy members, she was admitted by order of the king, rather than by the customary process of submitting a *morceau de réception* (presentation piece, an exemplary painting judged by a jury) that was subject to a vote.[2] Indeed, Vigée-Lebrun's association with King Louis XVI and Queen Marie-Antoinette would prove decisive in her career trajectory.

Because the Academy did not admit women students, Vigée-Lebrun's father, a portraitist who specialized in pastel, supervised her early training. Following his death when she was twelve, the young Élisabeth taught herself to paint by copying Flemish, Italian, and French masterpieces in Parisian collections.[3] She particularly admired Peter Paul Rubens,

whose works she studied at the Palais du Luxembourg in Paris. Inspired in part by his example, Vigée-Lebrun developed a love of color and a painterly technique that emphasized glazing, the process of applying layer upon layer of translucent oil paint. By the age of fifteen she had become an accomplished portraitist and had launched a promising career.

Vigée-Lebrun's breakthrough came when she was commissioned to paint the queen's portrait in 1779. Marie-Antoinette was Vigée-Lebrun's most prominent patron, and the artist painted numerous portraits of her, both as a single figure and with her children.[4] Because of her association with Marie-Antoinette, Vigée-Lebrun's professional fortunes were closely tied to the court, and the queen's patronage served her exceedingly well until the outbreak of the French Revolution in 1789. In the volatile political and cultural environment of revolutionary France, it became clear that, as a royalist sympathizer, Vigée-Lebrun's only option was to go into exile.

Vigée-Lebrun departed for Italy in 1789, with her young daughter in tow, leaving behind her husband, the art dealer Jean-Baptiste-Pierre Lebrun, a notorious gambler who squandered most of his wife's substantial earnings.[5] She remained in Italy for four years, enjoying steady work and professional acceptance by academicians in Rome, Parma, and Bologna. Career opportunities took her to Vienna in 1793, and two years later she traveled to St. Petersburg on the invitation of the Russian ambassador to Vienna, Count A. K. Razumovsky. Vigée-Lebrun found great success in Russia. In St. Petersburg and Moscow she painted portraits of Russian aristocrats and members of Catherine II's Imperial court, and she was received

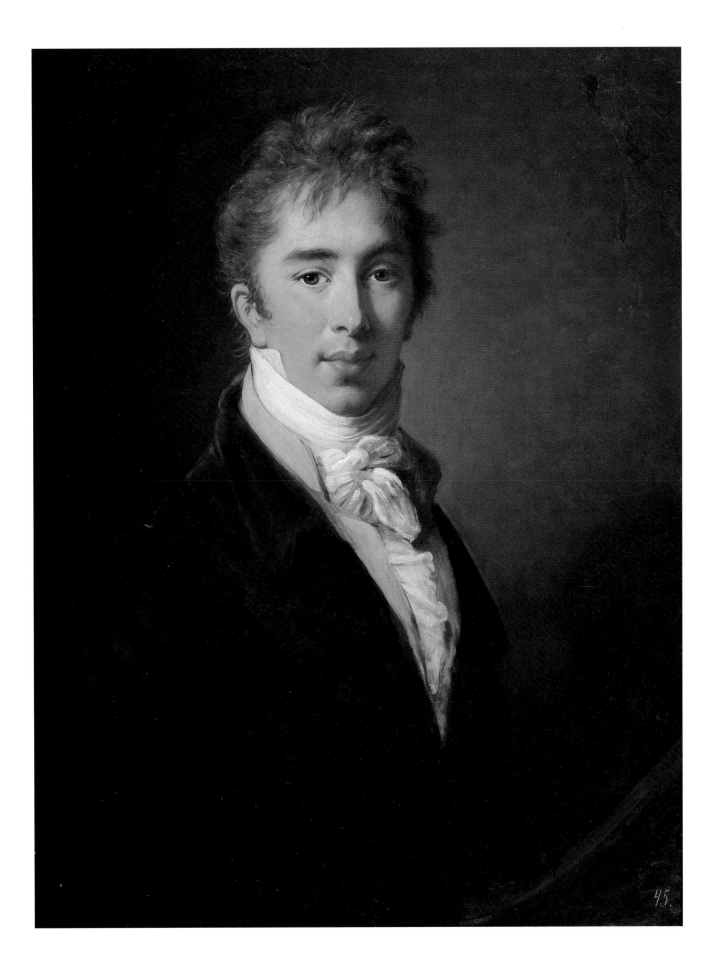

45.

as a member of the St. Petersburg Academy in 1800. She remained in Russia until 1801, returning briefly to France and then traveling to England and Switzerland.[6]

In 1800, during her Russian sojourn, Vigée-Lebrun painted Prince Ivan Baryatinsky (State Tretyakov Gallery, Moscow). She later painted this second portrait of Prince Baryatinsky, most likely when both the painter and the prince, a Russian diplomat, resided in London. The austere portrait captures Baryatinsky's stately elegance, befitting a member of the Russian diplomatic corps. Baryatinsky was stationed at the Russian embassy in London in the early nineteenth century and was posted to Munich in 1808. Shortly thereafter he was recalled to Russia and settled at his estate Ivanovskoe in the Kursk region, where he pursued the life of a country gentleman. His rural palace boasted an extensive art collection, including murals by European masters, as well as a family portrait gallery. After the Russian Revolution the portrait collection was distributed among Moscow museums.

Vigée-Lebrun portrays the prince in a subdued range of warm browns. The hint of his yellow vest and the high white collar with its elaborate, sumptuously painted knot animate the largely monochromatic work. Prince Baryatinsky's full features convey confidence and warmth as he gazes directly at the viewer. Portraiture, according to Vigée-Lebrun, was like a conversation.[7] This work expresses the sense of ease and comfortable intimacy that the artist aimed to establish with her sitters.

NOTES

1 G. Bidermann, "Les Femmes peintres de l'Académie Royale de peinture," *L'Estampille,* no. 204 (1987): 46–54. See also the essays by Gill Perry and Emma Barker, "Women Artists, 'Masculine' Art and the Royal Academy of Art," and "Women Artists and the French Academy: Vigée-Lebrun in the 1780s," in *Gender and Art*, Gill Perry, ed. (New Haven: Yale University Press, in association with the Open University, 1999).

2 Mary D. Sheriff, *The Exceptional Woman: Élisabeth Vigée-Lebrun and the Cultural Politics of Art* (Chicago: University of Chicago Press, 1996), 74.

3 *French Painting 1774–1830: The Age of Revolution*, exh. cat. (Detroit: Wayne State University Press, in association with the Detroit Institute of Arts, 1975), 664.

4 On the range of representations and the significance of this relationship, see "The Portrait of the Queen," in Sheriff, *Exceptional Woman*, 143–79; see also Louise-Élisabeth Vigée-Lebrun, *Memoirs of Madame Vigée-Lebrun*, trans. Lionel Strachey (New York: George Brazillier, 1989), 25–31.

5 Vigée-Lebrun, *Memoirs*, xvii, 41–42.

6 *French Painting 1774–1830*, 665; for her account of her experiences in Russia, see Vigée-Lebrun, *Memoirs*, 83–118.

7 Vigée-Lebrun, *Memoirs*, xvi.

FRANÇOIS-MARIUS GRANET
French, 1775–1849

19 *The Painter Jacques Stella in Prison*

Oil on canvas,
1810
76 3/8 × 56 3/4 in.
(194 × 144 cm)
Signed and dated:
Granet Roma 1810
Inv. no. 816

THE SON of a mason, François-Marius Granet studied art in his hometown of Aix-en-Provence. His early sketchbooks include many drawings of cloisters and ruins, reflecting a fascination with picturesque architectural structures that remained an enduring feature of his work. In 1793, Granet moved to Paris and studied briefly with the history painter Jacques-Louis David (cat. 14). He worked on a project for a Parisian monastery alongside Jean-Auguste-Dominique Ingres (cat. 20) and Anne-Louis Girodet, fellow pupils of David. Granet submitted his first work, *Interior of a Cloister* (present location unknown), to the Salon in 1799. He traveled to Rome in 1802, where he lived and worked until his definitive return to France in 1819.[1]

While in Rome, Granet visited ancient prisons and made studies of their voluminous spaces and distinctive green-hued stone, called *peperino*. In his memoirs he records his impressions of the space that he would depict in *The Painter Jacques Stella in Prison*. Granet wrote that he sought "a subject for this remarkable site." Apparently he had recently read the story of the seventeenth-century painter Jacques Stella, a French artist working in Rome who, in 1633, was falsely accused of illicit love affairs.[2] The French academician André Félibien wrote about the case in *Entretiens*, the source for Granet's painting: "To divert himself during the short time he was in prison, he made a drawing in charcoal of the Virgin holding her Son, which was declared so beautiful that Cardinal Francesco Barberini went there expressly to see it. Not long ago, it was still in the same place,

with a lighted lamp before it; the prisoners go there to say their prayers."[3]

The painter Jacques Stella stands on a table that acts as a makeshift stage. Stella has completed the figures of the Virgin and Child, but he continues to draw. He is in the midst of completing a halo above the figures' heads. Fellow prisoners gather to look, admire, and pray before Stella's image. Granet wrote in his memoirs that the prisoners "are gathered around the painter admiring with awe Madonna's angelic features. Their feelings are sincere; contemplation of the esteemed image, which is capable of healing the suffering, makes them drop to their knees. From that moment, the unfortunate prisoners began sharing their meager piece of bread to pay the expense of a lamp illuminating the beautiful image day and night."[4]

Golden light from the windows shines on the painter and his impromptu creation and suggests a holy presence. In *The Painter Jacques Stella in Prison*, light directs our attention to Stella and his representation. Off in the gloomy distance a figure, perhaps a jailer, stands behind the bars and looks into the space the prisoners occupy. The deep shadows underscore the cavernous space and ominous atmosphere of the prison.

The Painter Jacques Stella in Prison is a large work, more than six feet high and four feet wide. But despite its scale, this work is not a history painting, according to the precepts that Granet learned under David's tutelage. Because it represents an event from the recent, rather than the ancient, past, the work is

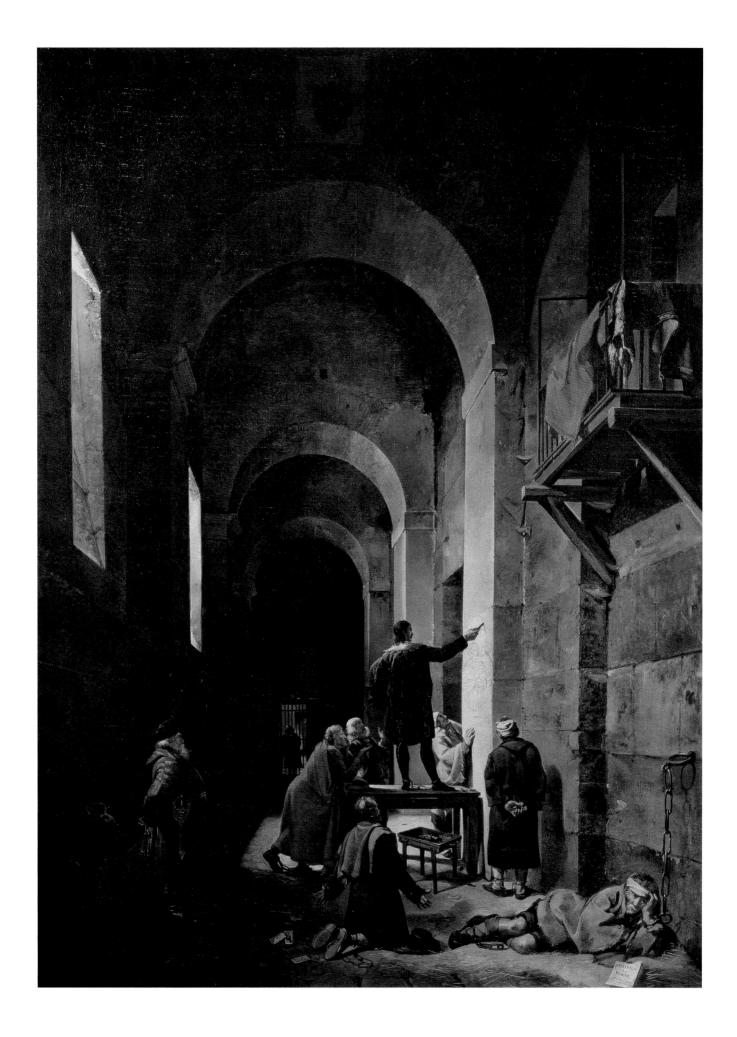

more an anecdotal genre scene than a grand *peinture d'histoire*. Indeed, Granet's artistic education was shaped by diverse influences. In addition to his work in David's atelier, Granet studied sixteenth- and seventeenth-century Flemish and Dutch genre painting.[5] The taste for romantic representations of the recent past was especially keen in early-nineteenth-century France, and images of artists in dramatic situations were also quite popular.

The work was well received in Rome and later at the Salon of 1810 in Paris. The critic François Guizot commented, "Never was a scene more felicitously conceived, better disposed and executed . . . the brushwork is broad and firm, yet it is well finished."[6] The painting was exhibited again at the Salon of 1814. *The Painter Jacques Stella in Prison* was purchased by the Empress Josephine and hung in the music room of the Imperial Palace Malmaison.

NOTES

1 Biographical information on Granet is from *French Painting 1774–1830: The Age of Revolution*, exh. cat. (Detroit: Wayne State University Press, in association with the Detroit Institute of Arts, 1975), 458–59.

2 *French Painting 1774–1830*, 460.

3 André Félibien, *Entretiens*, 1688, quoted in *French Painting 1774–1830*, 460.

4 François-Marius Granet, *Memoirs*, quoted in J. Neto Daguerre and D. Coutagne, *Granet: Peintre de Rome* (Aix-en-Provence, 1992), 192.

5 *French Painting 1774–1830*, 459.

6 François Guizot, quoted in *French Painting 1774–1830*, 460.

JEAN-AUGUSTE-DOMINIQUE INGRES

French, 1780–1867

20 *Virgin with Chalice*

Oil on canvas,
1841
45 5/8 × 33 in.
(116 × 84 cm)
Signed and dated:
*A.D. Ingres pinx. /
Rome 1841*
Inv. 2761

UNTIL HIS death in 1867, Ingres was the standard-bearer for the academic tradition in nineteenth-century France. As a young man in the studio of David (cat. 14), Ingres was exposed to the purest strains of Neoclassical training, and he learned the importance of espousing the past both in theory and in practice. In the "great modern periods," he wrote, "men of genius did over what had been done before them. Homer and Phidias, Raphael and Poussin, Gluck and Mozart, have, in reality, said the same things. It is error then . . . to believe that health for art resides in absolute independence; to believe that runs the risk of being stifled by the discipline of the ancients; that the classic doctrines impede or arrest the flight of the intelligence."[1]

Among the artists most inspirational to Ingres were Raphael and other sixteenth-century Italian masters, whose works he studied while living in Italy from 1806 until 1824 and from 1835 until 1841.[2] Their influence is evident in the extreme symmetry, geometric harmonies, and subtle use of color in this version of the *Virgin with Chalice,* another version of 1854 in the Musée du Louvre, Paris, and other paintings of the Virgin Mary, including *Virgin with a Blue Veil* (1822–27, São Paulo Museum, Brazil).[3]

Not only does Ingres pay stylistic homage to the Italian Renaissance in *Virgin with Chalice,* but he also upholds the Renaissance tradition of referencing donors in religious monuments. The painting was commissioned by the future Czar Alexander II of Russia during a visit to Ingres in Italy in 1840 and purchased by Alexander for the considerable sum of 10,000 francs. Ingres has honored his patron by posi-

tioning the Russian saints Alexander and Nicolai—the patron saints of Alexander and of his father, Czar Nicholas I—on each side of the Virgin.

The many years Ingres spent in Italy were a consequence of his shifting artistic and political fortunes. Although his early career brought prestigious honors, such as the 1801 Prix de Rome and numerous commissions—including two for Napoleon Bonaparte—Ingres's career path was fraught with difficulty. His *Napoleon on the Imperial Throne* (1806, Musée de l'Armée, Paris) was met with overwhelmingly negative criticism when it appeared at the 1806 Paris Salon, prompting Ingres to flee to Rome and stay there for eighteen years.[4]

He finally returned to Paris in 1824, accompanying a major commission, *The Vow of Louis XIII* (1821–24, Montauban Cathedral, France), to the Salon. By then the political climate in France had changed, and Ingres discovered that his conservative style resonated with the current royalist policies. Indeed, he was surprised that his large-scale religious/history painting was warmly received.[5] Following the Revolution of 1830, however, Ingres again fell out of favor. The new "July Monarchy" government (1830–48) ushered in anticonservative and antiroyalist sentiments, bringing Ingres professional difficulties, even though he was an Academy member and professor at the École des Beaux-Arts. He returned to Rome in 1835 to serve as director of the French Academy and stayed there for six years.[6]

Ingres's years in Italy were fruitful for his ongoing education, his artistic production, as well as his career.[7] After completing *Virgin with Chalice* for

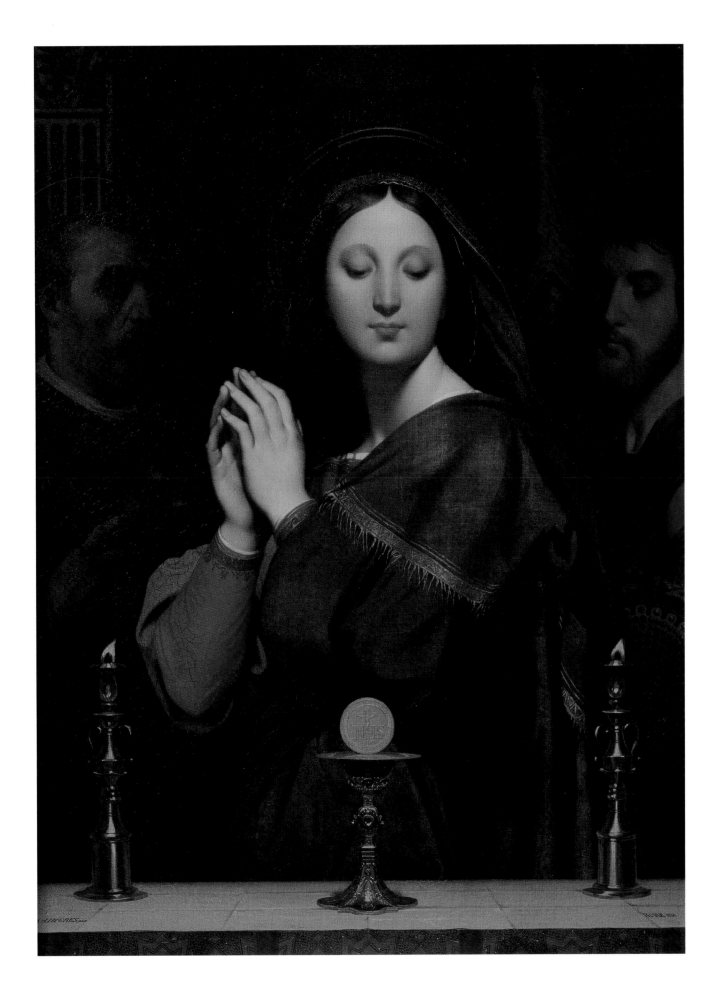

the future czar, he sent it to Moscow. The court minister, Count Olsufiev, confirmed receipt of the painting in a letter to Ingres dated May 17, 1842. He thanked Ingres on behalf of Alexander and his father. Soon afterward, *Virgin with Chalice* was exhibited at the Academy of Fine Arts in St. Petersburg and later installed in the Academy Museum.

Before sending the painting to St. Petersburg, however, Ingres ended his moratorium on the Parisian art world by exhibiting the *Virgin with Chalice* at his Paris studio.[8] Critical response, of course, depended on the political affiliation of the viewer. Religious subjects were anathema to French liberal thinkers, for whom Catholicism was inextricably linked to ultra-conservative, royalist leanings.[9] Yet for sympathetic viewers, the *Virgin with Chalice* was paradigmatic. They extolled the painting's devotional and educational importance for the Russian audiences for whom it was intended.[10] Furthermore, one Catholic leader proclaimed, "We believe that all the genius of painting in representations of the Virgin is captured in the work of Monsieur Ingres."[11]

NOTES

1 Jean-Auguste-Dominique Ingres, "Notebooks," reprinted in *Art in Theory, 1815–1900*, ed. Charles Harrison, Paul Wood, and Jason Gaiger (Oxford: Blackwell, 1998), 184–85.

2 On some connections between Ingres and Raphael, see Jacques Thuillier, *Raphael et l'art français* (Paris: Éditions de la Réunion des Musées Nationaux, 1983); and Eldon N. Van Liere, "Ingres' Raphael and the Forarina: Reverence and Testimony," *Arts Magazine* 56 (December 1981): 108–15.

3 Michael Paul Driskel, *Representing Belief: Religion, Art, and Society in Nineteenth-Century France* (University Park: Pennsylvania State University Press, 1992), 102. On Ingres's habit of returning to the same subjects, see Patricia Condon, *Ingres, In Pursuit of Perfection: The Art of J. A. D. Ingres*, exh. cat. (Bloomington: Indiana University Press, in association with the J. B. Speed Art Museum, Louisville, Ky., 1983).

4 The critics derisively called the work "Gothic" owing to its severe precision and rigid frontality. Lorenz Eitner, *An Outline of Nineteenth-Century European Painting: From David Through Cézanne* (1987; reprint, New York: HarperCollins, 1992), 160.

5 Eitner, *Nineteenth-Century European Painting*, 164.

6 Ingres wrote about his move to Rome in a letter to fellow painters in 1835. See Daniel Ternois, "An Unpublished Letter to the Painters of Notre-Dame de Lorette," *Revue de l'art* 80 (1988), 88–91.

7 Hans Naef, *Ingres in Rome*, exh. cat. (Meriden, Conn.: Meriden Gravure Co. for the International Exhibitions Foundation, 1971).

8 Driskel, *Representing Belief*, 101.

9 See Laura Hickman Neis, "Ultra-Royalism and Romanticism: The Duc de Blacas's Patronage of Ingres, Delacroix, and Horace Vernet" (Ph.D. diss, University of Wisconsin, Madison, 1987).

10 Driskel, *Representing Belief*, 113.

11 Driskel, *Representing Belief*, 101–102.

CAMILLE COROT
French, 1796–1875

21 *Morning in Venice*

Oil on canvas,
c. 1834
10 7/8 × 15 3/4 in.
(27.5 × 40 cm)
Inscribed: *Vente
Corot*
Inv. no. 3148

CAMILLE COROT came of age as an artist at a fortuitous moment for landscape painters. At the dawn of the nineteenth century, landscape painting was considered a minor genre or merely an appropriate background for weightier subjects like those found in history paintings. By the time Corot began studying with landscape masters in the 1820s, the art market was expanding beyond the state as a primary patron, and the category of landscape painting was increasingly recognized as valid on its own terms. As the nineteenth century progressed, there was a growing demand for small-scale genre and landscape works destined for private homes.[1]

Corot's father was a successful clothier who initially wished his son to become a salesman, but Corot's artistic inclination and talent outshone his aptitude for sales, which was decidedly lacking. Though his parents were not thrilled by his choice of profession, they nonetheless granted him generous financial support.[2]

In Corot's time, artistic training typically involved an extended trip to Rome. Artists from all over the world traveled there to steep themselves in the city's great artistic, architectural, and historical traditions. Whereas history painters like Jacques-Louis David (cat. 14) and Jean-Auguste-Dominique Ingres (cat. 20) went to Rome on government fellowships, Corot was subsidized by his father. He embarked on his first Italian sojourn in 1825.

In Rome, Corot embraced the tradition of painting and sketching the Roman countryside established by his forebears Nicolas Poussin and Claude Lorrain (cats. 1 and 2) two centuries earlier. But Corot also reveled in the great city's ancient and Renaissance architecture.[3] His works in Rome are characterized by strong, clear light and solid, classical forms.

In 1828, Corot returned home to Paris by way of Venice. Though captivated by the city, he stayed only a few days. Corot returned to Venice in 1834 during a six-month study tour of northern Italy. On that trip he painted the small, enchanting *Morning in Venice*. Following the tradition of the eighteenth-century Venetian painter Canaletto, who specialized in *vedute* (views) of his hometown, Corot turned his attention to the city's rich, varied architecture and its breathtaking vistas. He concentrated on the portrayal of the distinct, magical light conditions of Venice, as did the English painter J. M. W. Turner and many other artists who fell under the city's spell.

Morning in Venice is one of four paintings by Corot that depict this view, and it is probably the first in the series and painted on site, given its small size.[4] Corot's painting practice combined working en plein air (out of doors) with studio work. The painting transports us to the Riva degli Schiavone, an embankment bordered by the San Marco Canal, looking toward the Piazzetta San Marco, a narrow space between the library and the Doge's palace that leads to the Piazza San Marco. *Morning in Venice* illuminates the architectural monuments and the canal with a clear raking light. The buildings stand out against the pale blue sky, which counterbalances the stony surface of the Piazzetta. Directly ahead, at the far end of the Piazzetta, looms the Sansovino library. Two columns, brought from Constantinople by Venetian sailors, punctuate the space and lead our eye back to the library's rhythmic facade. These columns form a metaphorical gate into the Piazzetta: each bears a

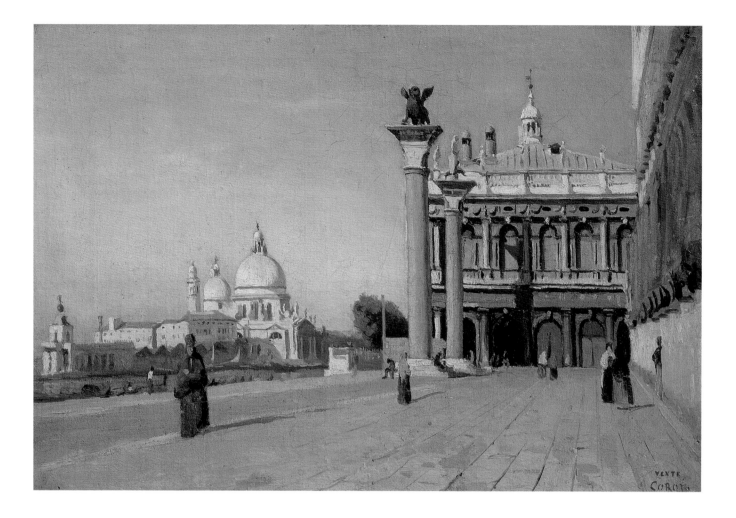

statue—one of the lion of Saint Mark, the city's patron saint, and the other of Saint Theodore.[5] Strong morning light from the east casts a shadow on the library.

A deep, perspectival view of the Doge's palace, with its repeating Moorish arches, defines the right edge of the picture. Diminutive figures dispersed in the space lend a sense of scale. The public square will grow busier as the day wears on, but at the moment, an early-morning calm pervades the space. In the distance, just across a narrow band of water, looms the majestic church of Santa Maria della Salute. Situated at the mouth of the Grand Canal, this church was built in the seventeenth century to commemorate the plague that struck in 1630. Corot depicts nearly the same scene, though at closer proximity to the Sansovino library and at a slightly larger scale in *View of Venice: The Piazzetta Seen from the Riva degli Schiavone* (1834, Norton Simon Museum, Pasadena, California). He also painted the Santa Maria della Salute from an opposing vantage point along the Grand Canal.

Of all the places Corot visited in northern Italy, "Venice delighted him above all. After visits to churches and palaces, where he paid homage to Titian, his favorite master, his days were filled with work. He was particularly struck by the transparency of the salt air, by the brilliance of the light, by the joyful coloration of the buildings that the waters of the Grand Canal reflect with still more delectable intonations."[6] Indeed, as Corot's biographer and collector Étienne Moreau-Nelaton remarked, "On six or eight small canvases, Corot brought Venice home with him."[7]

NOTES

1 Fronia Wissman, "The Generation Gap," in Kermit S. Champa, *The Rise of Landscape Painting in France: Corot to Monet*, exh. cat. (Manchester, N.H.: Currier Gallery of Art, 1991), 64–65.

2 Lorenz Eitner, *An Outline of Nineteenth-Century European Painting: From David Through Cézanne* (New York: HarperCollins, 1992), 199–201.

3 Peter Galassi, *Corot in Italy: Open-Air Painting and the Classical Landscape Tradition* (New Haven: Yale University Press, 1991); and Philip Conisbee, *In the Light of Italy: Corot and Early Open-Air Painting*, exh. cat. (New Haven: Yale University Press, in association with the National Gallery of Art, Washington, D.C., 1996).

4 Gary Tinterow, *Corot*, exh. cat. (New York: Metropolitan Museum of Art, 1996), 130.

5 Tinterow, *Corot*, 131.

6 Émile Michel, 1905, quoted in Tinterow, *Corot*, 130.

7 Étienne Moreau-Nelaton, quoted in Tinterow, *Corot*, 130.

CAMILLE COROT
French, 1796–1875

22 The Castle of Pierrefonds

Oil on paper,
mounted on board,
c. 1860
18 1/2 × 15 in.
(47 × 38 cm)
Signed: *Corot*
Inv. no. 958

"NO MAN should become an artist who is not passionate about nature," Corot recorded in his notebook.[1] Indeed, whereas *Morning in Venice* focused primarily on architecture, *The Castle of Pierrefonds* relegates architecture to the background, moving nature to center stage. Here, Corot uses a range of greens to depict grass, brush, bushes, and trees. The castle, near Compiègne, was built for Louis d'Orléans in the fourteenth century, suffered a fire, and was in ruins by the end of the seventeenth century.[2]

Two small figures, dressed in costumes suggesting a distant historical era, occupy the foreground of the painting. The figure with his back to us wears a metal helmet and a cape and wields a long spear. The medieval castle in the background evokes literary or historical associations; however, there is no clear source for this work other than Corot's encounters with the site and his own narrative and pictorial imagination. Corot aims not to portray a specific historical moment but rather to represent a timeless world. There was a vogue for medieval subjects in early-nineteenth-century French painting, and the artist's inclusion of these figures is "an interesting if late adoption of the neo-medieval fashion that Corot had ignored in his youth."[3]

Corot visited the Pierrefonds castle many times and painted numerous versions of the subject over the course of his career (other versions from the 1830s and 1840s are in Quimper, France, and in Cincinnati). The castle, like many medieval monuments in France, was restored in the nineteenth century. It had been purchased by Napoleon Bonaparte in 1813 but was not restored until 1857, when Emperor Louis-Napoleon (Bonaparte's nephew, who ruled 1851–70)

hired the architect Eugène Emmanuel Viollet-le-Duc to alter the castle for use as an imperial residence.[4]

In *The Castle of Pierrefonds*, the enormous structure looms in the background, setting a medieval tone. Though the building occupies the far distance of the picture space, Corot establishes its formidable size. Architectural details are not evident, only the general form of the massive towers that echo the verticality of trees in the center. Like the trees' spiky leaves and branches, the castle's turrets punctuate the light sky.

The artist's mastery of color and his ability to modulate tones create convincing spatial relationships. In contrast to the conventional mathematical perspective in *Morning in Venice*, here he employs atmospheric perspective, using color and light to suggest distance. For instance, the castle is depicted with monochromatic mauve-gray, and the same color describes the middle ground, just past the first veil of trees.

Corot's composition unfolds progressively as a series of zones, with the smallest objects in the foreground and the largest in the background. A small clump of brush and wildflowers occupies the space closest to the viewer. The figures dwarf this flora and in turn are dwarfed by the trees. The castle clearly dominates the landscape in the distance, yet the vast expanse of sky, luminous and dotted with clouds, overwhelms the man-made structure. In the framework of a balanced palette and a balanced composition, Corot explores the relationship between the natural and the built environment. The presence of the guards and the exquisite medieval castle clearly establish mankind's incursion into nature.

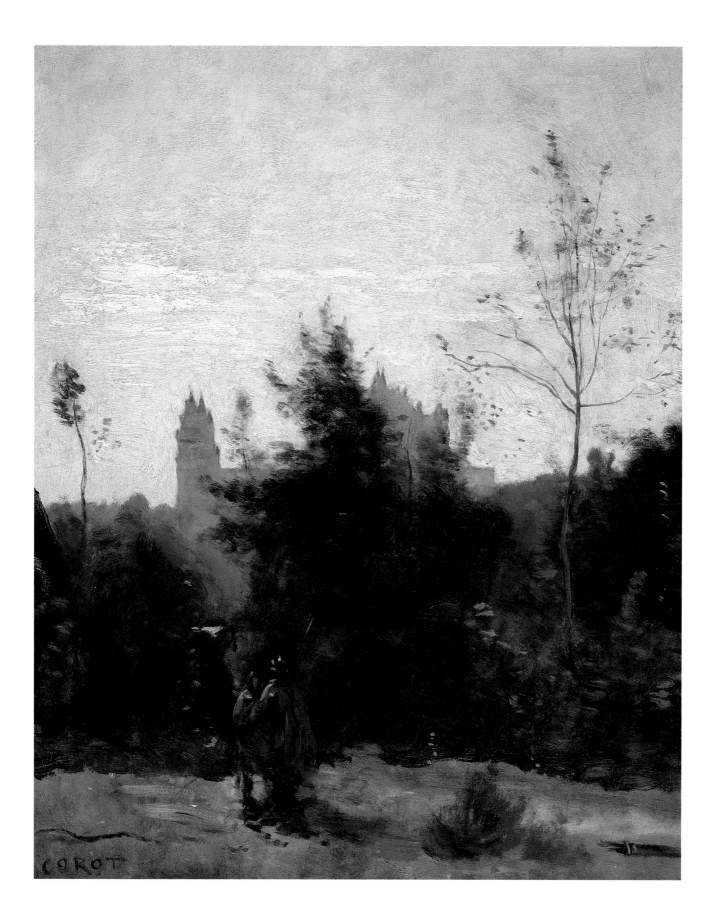

Corot's interest resides in formal and tonal harmonies, and, of course, light. In his notebooks he wrote, "The most important things to study are shape and tonal values. These two things for me are the only serious starting points for any study of art. If you want to do a study or a picture, first try out the shape in your head. When you have tried it out in all sorts of ways, then move on to the values. Look for them in blocks. Be conscientious. A good method to follow, if your canvas is white, is to start with the darkest tone. Proceed from there to the lightest. It is most illogical to start with the sky."[5] *Castle of Pierrefonds* makes it clear that Corot followed this pictorial logic with great success.

NOTES

1 Camille Corot, cited in Gary Tinterow, *Corot*, exh. cat. (New York: Metropolitan Museum of Art, 1996), 5.

2 Tinterow, *Corot*, 166.

3 Tinterow, *Corot*, 166.

4 Ann Dumas, "The Public Face of Landscape," in John House, *Landscapes of France: Impressionism and Its Rivals*, exh. cat. (London: Hayward Gallery, 1995), 98–99, 104–5.

5 Camille Corot, "Reflections on Painting," in *Art in Theory, 1815–1900*, ed. Charles Harrison, Paul Wood, and Jason Gaiger (Oxford: Blackwell, 1998), 231.

CAMILLE COROT

French, 1796–1875

23 *A Gust of Wind*

Oil on canvas,
1864–73
18 7/8 × 26 in.
(48 × 66 cm)
Signed: *Corot*
Inv. no. 956

WHEREAS works like *Morning in Venice* and *Castle of Pierrefonds* (cats. 21 and 22) evoke tranquility and luminosity, *A Gust of Wind* reveals Corot's fascination with the power of nature. The setting is a rural, windswept place. A country woman walks along a rutted path, carrying a bundle on her back, striding forward despite the strong wind ahead.

Corot conveys motion and energy through the dramatic sky and the bending trees as the gale sweeps across the landscape. Evening light emanates in the distance as the sun sinks into the horizon. The effect is that of a halo around the swaying central tree. The woman must hurry home before the last light of day fades.

The artist exhibited a similar work of the same title at the Salon of 1864 (private collection).[1] Upon viewing that version, the critic Jules Castagnary wrote, "We are on the edge of a wood. The wind blows; shivers sweep across the meadows and plains. The branches twisting, the trees shake off their leaves. A peasant woman returning home with a bundle of wood has trouble keeping her balance and stumbles, caught in the whirlwind. This work has an extraordinary power of unity and impact."[2] This description aptly applies to the Pushkin version, as well. Yet by including a clear horizon in this painting, Corot appears to have addressed a specific criticism of Castagnary's: "It is a shame that the land ends somewhat abruptly; by prolonging it toward the horizon the artist would have given more breadth to his canvas and more intensity to his squall."[3]

The low horizon line and enormous, cloud-filled sky of this turbulent scene attest to Corot's interest in the tradition of seventeenth-century Dutch landscape painting. Corot was familiar with Dutch art in the Louvre and was inspired by Jacob van Ruisdael's paintings, including *Thicket* (1647, Musée du Louvre, Paris). Furthermore, Corot had traveled to Holland with a painter friend in 1854, and the two of them made sketches of the dunes.[4]

A Gust of Wind demonstrates Corot's facility with a mode of landscape painting that departs from the classical French landscape tradition, as practiced by Claude Lorrain and Nicolas Poussin. Works like *A Gust of Wind*, curator Gary Tinterow notes, "are, quite simply, the corollary of the pacific *souvenirs* that we have wrongly come to regard as the artist's sole mode of expression."[5]

This late work marks a transition in Corot's painting technique.[6] Thin layers of paint make up large areas of the canvas, such as the sky. Flecks of golden-yellow and beige, applied with quick brushstrokes, represent the grasses and leaves. Corot's later style is often referred to as "lyrical," given the musical evocations of his works from the 1860s and 1870s.[7] Although *A Gust of Wind* is not meditative or dreamy, like his *Souvenir of Mortefontaine* (1864, Salon of 1864, Musée du Louvre, Paris), it shows this artist's wholehearted embrace of nature in all its variety.

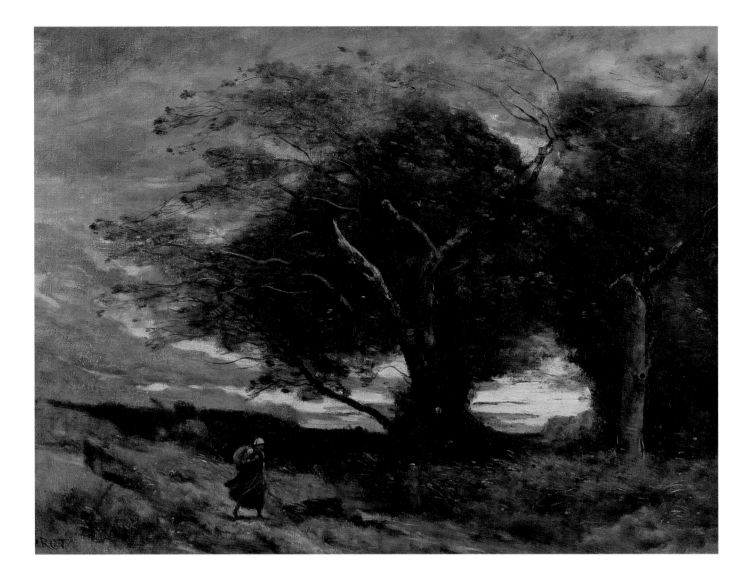

Jacob van Ruisdael.
The Thicket. 1647.
Oil on canvas,
26 ¾ × 32 ¼ in.
(68 × 82 cm).
Musée du Louvre,
Paris.
© Réunion des
Musées
Nationaux/Art
Resource, N.Y.

NOTES

1 Reproduced in Gary Tinterow, *Corot,* exh. cat. (New York: Metropolitan Museum of Art, 1996), 340.

2 Jules Castagnary, "Salon de 1864," quoted in Tinterow, *Corot,* 340.

3 Castagnary, "Salon de 1864," quoted in Tinterow, *Corot,* 340.

4 According to the diary of Constant Dutilleux; Tinterow, *Corot,* 340.

5 Tinterow, *Corot,* 340.

6 Richard Shiff, "Corot and the Painter's Mark: Natural, Personal, Pictorial," *Apollo* 147, no. 435 (1998): 3–8.

7 On Corot and music, as well as painting in a musical mode, see Kermit S. Champa, *The Rise of Landscape Painting in France: Corot to Monet,* exh. cat. (Manchester, N.H.: Currier Gallery of Art, 1991), 23–51; see also Edgar Peters Bowron and Mary G. Morton, *Masterworks of European Painting in the Museum of Fine Arts, Houston* (Princeton: Princeton University Press, in association with the Museum of Fine Arts, Houston, 2000), 142.

THOMAS COUTURE
French, 1815–1879

24 *Supper After the Fancy Dress Ball*

Oil on canvas,
c. 1855
12⅝ × 16⅛ in.
(32 × 41 cm)
Signed: *T.C.*
Inv. no. 968

THOMAS COUTURE's career intersected with major changes in the nineteenth-century art world. He studied in the ateliers of Antoine-Jean Gros (1771–1835, a student of Jacques-Louis David) and then of Paul Delaroche (1797–1856, a student of Gros). In 1850, the young Édouard Manet entered Couture's studio and studied with him for six years. Couture's best-known work is the enormous history painting *The Romans of the Decadence* (1847, Musée d'Orsay, Paris), a work that attempts to negotiate the delicate balance between subjects set in the ancient world and an increasingly modern taste for genre pictures.[1]

Rather than depicting heroic and inspirational acts, *The Romans of the Decadence* represents languid, partially nude men and women in the aftermath of what appears to have been an extremely raucous dinner party. In contrast to David's history paintings of the 1780s, which moralize about great acts by great men, *The Romans of the Decadence* tells the story of a drunken orgy. Such was the state of history painting by the mid-nineteenth century. Couture tried six times to win the coveted Prix de Rome, a necessary achievement for a history painter. His inability to garner that vital stamp of approval resulted in a change of strategy: Couture became a genre painter.

Although it is a small-scale scene from modern life, *Supper After the Fancy Dress Ball* echoes the thematic concerns, as well as some figures' poses, in *The Romans of the Decadence*.[2] The scene takes place in a well-known Parisian restaurant, La Maison d'Or (the Golden House), which was frequented by men of arts and letters, such as the Goncourt brothers,

Alexandre Dumas, the critic Théophile Gautier, and Couture himself. Gautier recognized the similarities between this work and *The Romans of the Decadence*, noting that "the private room of the Maison-d'Or has replaced the great hall with the Corinthian columns, with the pale statues of the ancestors, and the cabaret table the ancient triclinium: day will break soon and the candles are burning very close to the candleholders; a young man dressed as Pierrot is seated on the edge of the table, pale, elegant, worn out. . . . Harlequin lets his black muzzle fall on the back of the chair he has straddled."[3]

Exhausted and evidently sated figures, clad in costumes based on the commedia dell'arte, lounge about: two men are slumped on and propped up by the table, while a provocatively dressed sleeping woman reclines on a footstool. Only one figure is sentient, the central figure dressed in the costume of Pierrot, a key character from the commedia dell'arte. The Pierrot figure resembles Couture and may be an "autobiographical projection of the painter himself."[4] The model for the figure of the reclining woman was the famous Parisian courtesan Alice Ozy. Undoubtedly, the group has attended a *bal masqué*. These costume balls were quite popular in Paris, particularly during the winter season, culminating with Mardi Gras. Masked balls "were an integral part of Parisian social life and they cut across the classes in their fashionable yet ribald features."[5] Whereas Paul Cézanne's *Pierrot and Harlequin* (cat. 55) presents a staged moment in the studio, Couture's work presents *Supper After the Fancy Dress Ball* with the authenticity of an observed moment as it unfolds.

Thomas Couture
*Romans of the
Decadence.* 1847.
Oil on canvas,
15 ft. 6½ in. × 25 ft.
10 in. (4.75 × 7.87 m).
Musée d'Orsay,
Paris.
© Réunion des
Musées Nationaux/
Art Resource, N.Y.
[photograph] RMN

Couture came of age when the foundations of the art world were shifting away from the classical subjects and modes of painting that were the basis of his training. Even after he abandoned his quest to be a history painter, Couture urged young artists to venerate traditions and to trust their instincts: "Do not listen to those who say to you, these rules are useless, and even hurtful to those who have originality. There are not two ways of painting; there is but one, which has always been employed by those who understand the art. Knowing how to paint and to use one's colors rightly has not any connection with originality. This originality consists in properly expressing your own impressions."[6]

NOTES

1 Robert Rosenblum, *Paintings in the Musée d'Orsay* (New York: Stewart, Tabori and Chang, 1989), 22–23.

2 Albert Boime, *Thomas Couture and the Eclectic Vision* (London: Phaidon, 1971), 183. Couture made several versions of this subject, including a highly finished drawing, an *ébauche*, and a large-scale picture that probably served as the cartoon for the panoramic wallpaper design he executed for a Parisian firm.

3 Théophile Gautier, quoted in Boime, *Thomas Couture*, 302, 304.

4 Boime, *Thomas Couture*, 184.

5 Boime, *Thomas Couture*, 305.

6 Thomas Couture, quoted in "Conversations on *Art Methods*" in *Art in Theory, 1815–1900*, ed. Charles Harrison, Paul Wood, and Jason Gaiger (Oxford: Blackwell, 1998), 618.

CONSTANT TROYON
French, 1810–1865

25 *Approach of a Thunderstorm (At the Watering Place)*

Oil on wood,
1851
20⁷/8 × 15 in.
(53 × 38.2 cm)
Signed and dated:
C. Troyon 1851
Inv. no. 1115

A MEMBER of the Barbizon School, Constant Troyon was committed to the careful and direct observation of nature. The Barbizon School was a loose-knit group of artists who worked in the village of Barbizon, which bordered the Fontainebleau forest and was a short train ride from Paris.[1] Troyon and his fellow Barbizon landscapists Camille Corot (cats. 21–23), Charles-François Daubigny (cat. 28), Narcisse-Virgile Diaz de la Peña (cats. 29 and 30), and Jean-François Millet (cat. 26) were attracted to the rustic simplicity of the forest of Fontainebleau and its environs. These painters did not require the grandeur of ancient Roman history, literature, or architecture. Instead, they found an endless array of pictorial subjects in the countryside near Paris. Works by the Barbizon artists emphasize the inherent cyclical dramas of seasonal and climatic change, as witnessed in Troyon's *Approach of a Thunderstorm (At the Watering Place).*

Barbizon painters focused on the natural phenomena they observed in the French landscape, a concentration on native sites that marked a significant shift from traditional modes of the genre. Whereas Classical masters such as Nicolas Poussin and Claude Lorrain (cats. 1 and 2) spent the majority of their careers in Rome and depicted idealized, Arcadian landscapes studded with ancient ruins, Barbizon painters turned their attention to the local countryside in its contemporary state. "The heart of Barbizon art was direct study from nature, be it landscape or the human figure. Barbizon artists were the first to narrow the gap that had traditionally existed between the direct sketch and the finished studio picture."[2]

Like Diaz de la Peña, Troyon was trained as a porcelain painter and, following in his father's footsteps, he worked for the Sèvres factory. His early landscape paintings depict views of the area around the town of Sèvres. He submitted his first painting to the Salon in 1833 (the year he met Diaz) and began to frequent the Fontainebleau forest in 1843. Troyon was honored with a first-class medal at the Salon of 1846 and the following year took a formative trip to Holland.[3] By 1851, when he painted this work, Troyon was well established in the French art world. He was admitted to the French Legion of Honor in 1849, and his work consistently won honors in France, Belgium, and Holland.[4]

Dutch landscape painting of the seventeenth century was an inspiration for Troyon. Known for his animal paintings, Troyon owes a particular debt to the seventeenth-century Dutch painters Albert Cuyp and Paulus Potter, landscapists who specialized in scenes with animals.[5] The Dutch vernacular landscape, rather than the Arcadian scenes favored by Poussin and Lorrain, became a model for Troyon and other Barbizon painters.

Approach of a Thunderstorm faithfully records the intensifying atmospheric conditions as threatening weather moves in, even as it presents a straightforward portrayal of the quotidian rural world. There is no grand, complex historical or literary narrative to

decode; instead, we witness the incidental activities of life on a farm, where humans and animals are unperturbed by the coming storm.

Troyon's composition is divided equally between the dark gray, steely sky and the verdant landscape. The landscape, however, consists of several distinct zones. In the right foreground, a shallow pond reflects the tall trees at the edge of the grassy field and the muted light from the sky. Man and nature coexist peacefully in Troyon's view. A horse drinks from the pond while the man riding him turns to address his attentive black dog. Ducks swim a bit farther beyond them, undisturbed by their presence. The scene is so placid that no ripples appear on the glassy surface of the water. This tranquility extends to the center of the composition, where two small figures look past the trees into the distant pastures. The white bark of the trees stands out against the dark sky, delineating the foreground from the background. In the far distance, thick, gray storm clouds already engulf the red-roofed houses that sit atop the hill.

NOTES

1 Jean Bouret, *The Barbizon School and Nineteenth-Century French Landscape Painting* (London: Thames and Hudson, 1973), 9.

2 Robert L. Herbert, *Barbizon Revisited,* exh. cat. (Boston: Museum of Fine Arts, Boston, 1962), 15.

3 Herbert, *Barbizon Revisited,* 191; see also Steven Adams, *The Barbizon School and the Origins of Impressionism* (London: Phaidon, 1994), 129–37.

4 Kermit S. Champa, *The Rise of Landscape Painting in France: Corot to Monet,* exh. cat. (Manchester, N.H.: Currier Gallery of Art, 1991), 222.

5 Champa, *Rise of Landscape Painting,* 222.

JEAN-FRANÇOIS MILLET
French, 1814–1875

26 *Women Gathering Kindling*

Oil on canvas,
c. 1860
14 $\frac{1}{2}$ × 17 $\frac{3}{4}$ in.
(37 × 45 cm)
Signed: *J.F. Millet*
Inv. no. 1019

JEAN-FRANÇOIS MILLET specialized in landscapes that emphasize peasants and workers. In Millet's images, figures are bound to the land, dependent on it for their meager livelihoods. Millet demonstrated tremendous empathy for the poor rural folk he depicted; his figures have dignity even as they struggle to make a living. A paradigmatic example of this is his famous *The Gleaners* (1857, Musée d'Orsay, Paris), in which the peasant women seem to be an organic part of the landscape as their bent bodies echo the haystacks in the distance. *Women Gathering Kindling* displays a similar thematic and visual harmony.[1]

The forest setting lacks the kind of dazzling effects of weather and light in Camille Corot's *A Gust of Wind* (cat. 23) or Narcisse Virgile Diaz de la Peña's *Approach of a Thunderstorm* (cat. 29). In those works, the figure is secondary to the landscape and to the dramas of nature. For Millet, however, human struggles were more compelling. This small work emphasizes the physicality of the women as they work to drag a large piece of wood. The strain of lifting the branch registers in the women's bodies, particularly in the figure with her back to us. Millet focuses on the utility of trees rather than on their natural beauty.

Although Millet's paintings do not romanticize the landscape and its inhabitants or emphasize the viewer's subjective experience, they explore the textures and colors of the setting. Here the artist describes the knotty kindling in the foreground with thick, built-up layers of paint. The palette ranges from the dark brown screen of trees in the background to the rich, reddish earth on which the women stand.

The composition is based on strong diagonals, counterbalanced by the vertical trees that have not yet been felled. The women have made their way up a sloping incline to pull the branch out of the woods. The branch creates a forceful diagonal that is reiterated by the land's edge in the distance. On the crest of that slope, a shadowy figure walks along, searching for kindling.

Millet's representation of the figures emphasizes their status as members of a class rather than as individuals. We see the face only of the woman wearing the red kerchief on her head, but her features are indistinct. Millet's emphasis on the socially marginalized members of the working class links him with his great Realist contemporary Gustave Courbet (cat. 27). In the 1840s and 1850s, Courbet depicted the backbreaking labor of anonymous peasants in works like *The Stone Breakers* (1849, formerly Dresden, destroyed in World War II). Like Courbet, Millet is considered a Realist painter in terms of both subject matter and style.

A native of Normandy, where he studied with a local painter, Millet journeyed to Paris in 1837. He enrolled in the École des Beaux-Arts, studying with the history painter Paul Delaroche. He also attended drawing classes at the less formal Académie Suisse and spent time studying works in the Louvre. Millet's aptitude was not for history painting, an art based on mastery of drawing the male nude form, but rather for landscape and genre paintings.

In the late 1840s, Millet befriended the painters Diaz and Constant Troyon (cat. 25) and settled in the village of Barbizon, near the Fontainebleau forest, in 1849. Unlike his cohorts, who also lived and worked there, Millet tends not to depict the Fontainebleau forest specifically.[2] In the same way that his figures seem to represent a timeless humankind, so too is nature rendered as a universal phenomenon rather than as a specific place. The landscape, the people who inhabit it, and the struggles they endure are timeless.

NOTES

1 Millet painted a similar work nearly ten years earlier: *The Kindling Gatherers* (c. 1851–52, Norton Museum, West Palm Beach, Fla.). A drawing from the 1840s includes a kindling gatherer as well: *Old Coalminer* (c. 1845–47, Cabinet des Dessins, Musée du Louvre, Paris).

2 Kermit S. Champa, *The Rise of Landscape Painting in France: Corot to Monet*, exh. cat. (Manchester, N.H.: Currier Gallery of Art, 1991), 182.

GUSTAVE COURBET

French, 1819–1877

27 *The Sea*

Oil on canvas,
1867
40½ × 49⅝ in.
(103 × 126 cm)
Signed and dated:
G. Courbet 1867
Inv. no. 969

GUSTAVE COURBET painted the thick surface of *The Sea* with a palette knife, one of the artist's early, pioneering techniques and one associated with his Realist aesthetic. This landscape represents but one artistic strain in Courbet's varied output.

Courbet made a grand entry into the Parisian art world at the Salon of 1850 when he exhibited the enormous painting *Burial at Ornans* (1849–50, Musée d'Orsay, Paris). The painting confounded the public's expectations, for it appropriated the scale of history painting but represented a genre subject (a funeral in a small town) in a landscape setting. The painting subverted the hierarchy of genres, causing traditionalists to regard Courbet as a scoundrel and younger generations to regard him as a hero. He benefited from the liberal republican government in power from 1848 to 1851, for under its rule a new arts administration loosened the restrictive policies of the Salon.

Even after the conservative Imperial government was installed by coup d'état in 1851 and juries made it difficult for Courbet to exhibit at the Salon, he continued to paint radical, sometimes shocking works. His *Studio: A Real Allegory Summing Up Seven Years of My Artistic Life* (1855, Musée d'Orsay, Paris) elaborated on the hybridizing approach of the *Burial*. The painting combines self-portraiture, landscape, the nude, and genre painting in a monumental canvas. Courbet displayed a great deal of confidence and bravado when, upon rejection from the official Salon in conjunction with the Exposition Universelle (World's Fair) of 1855, he held a private exhibition. Courbet set up a gallery in a tent bearing the sign "Pavilion of Realism," charging admission and writing a manifesto proclaiming that artists must paint only what is real, what they can themselves see.

Courbet rejected both the ancient subjects and the smooth surfaces of academic paintings. He embraced what was contemporary and readily observed, and he created painterly surfaces that emphasize the materiality of the medium.[1] He insisted that painting "is an essentially *concrete* art and can only consist of the representation of *real and existing* things. It is a completely physical language, the words of which consist of all visible objects; an object which is *abstract*, not visible, non-existent, is not within the realm of painting.... The beauty provided by nature is superior to all the conventions of the artist."[2]

Courbet demonstrated remarkable breadth as a painter. Although he pursued controversy and provoked critical wrath, he also understood that there were two mutually beneficial sides to his career. On one hand, he was the provincial renegade who came to the capital to upset artistic hierarchies and seek attention for his radical works and ideas. On the other, he was intelligent and savvy, well aware that large-scale, controversial works do not sell. Seeking a more commercially viable mode, he produced highly marketable landscapes during the 1860s.[3] Small-scale landscape paintings like *The Sea* were the sorts of pictures that middle-class buyers in France and abroad sought for their homes. Courbet's landscapes found critical approval as well as commercial success.

The Sea most likely portrays the shore near Montpellier, a city in the south of France where the painter visited his friend and patron Alfred de Bruyas in 1854 and 1857.[4] Shortly after these visits he painted *Sea* (1858, Van Gogh Museum, Amsterdam), a work that likely served as a template for the Pushkin painting and related works like *Seascape* (c. 1865,

Gustave Courbet.
Burial at Ornans.
1849–50.
Oil on canvas,
9 ft. 16 in. × 21 ft.
9 in. (3.15 × 6.63 m).
Musée d'Orsay, Paris.
© Réunion des
Musées Nationaux/
Art Resource, N.Y.
D. Arnaudet/G. B.

Museum of Fine Arts, Houston), which Courbet painted from memory years later.

The thickly applied paint vividly renders the craggy rocks and lumpy sand in this composition. Courbet adds an anecdotal touch with the small sailboat out in the deep blue water past the whitecaps near the shore, although the painting does not contain any specific literary or narrative content. The sea gives way to a light-filled sky, dappled with clouds that refract the light from the setting sun. Courbet shows a master landscapist's attention to the particularities of the moment, using dry, quick brushstrokes in the upper register of the sky to suggest the light flickering on the surface of the clouds.

Courbet increasingly turned his attention to landscape painting in the late 1850s and 1860s. He painted the rivers and rocks of his native region, as well as a series of seascapes along the coast of the English Channel (Etretat, Trouville, and Deauville, towns favored by the young Claude Monet), and along the Mediterranean.[5] Courbet's method of painting differed greatly from the emerging Impressionist style, but there is no doubt that the up-and-coming generation, led by Édouard Manet and Monet, regarded Courbet as an avant-garde role model.

NOTES

1 Sarah Faunce, "Courbet's Concept of Realism: The Battle for Earth," in *Barbizon: Malerei der Natur, Natur der Malerei,* ed. Andreas Burmester, Christoph H. Heilmann, and Michael F. Zimmerman (Munich: Klinkhardt & Biermann, 1999), 370–81, 258–59; see also Michael Fried, *Courbet's Realism* (Chicago: University of Chicago Press, 1990).

2 Gustave Courbet, quoted in Linda Nochlin, ed., *Realism and Tradition in Art, 1848–1900* (Englewood Cliffs, N.J.: Prentice-Hall, 1966), 35.

3 See Anne Middleton Wagner, "Courbet's Landscapes and Their Market," *Art History* 4, no. 4 (1981): 410–31.

4 Edgar Peters Bowron and Mary G. Morton, *Masterworks of European Painting in the Museum of Fine Arts, Houston* (Princeton: Princeton University Press, in association with the Museum of Fine Arts, Houston, 2000), 146; and Kermit S. Champa, *The Rise of Landscape Painting in France: Corot to Monet,* exh. cat. (Manchester, N.H.: Currier Gallery of Art, 1991), 136–39.

5 Sarah Faunce and Linda Nochlin, eds., *Courbet Reconsidered,* exh. cat. (Brooklyn: Brooklyn Museum, 1988), 14.

CHARLES-FRANÇOIS DAUBIGNY

French, 1817–1878

28 *The Village of Portejoie on the Seine*

Oil on panel,
1868
14 1/2 × 26 in.
(37 × 66 cm)
Signed: *Daubigny
1868*
Inv. no. 881

CHARLES-FRANÇOIS DAUBIGNY forged his craft among the landscape painters of the Barbizon School, the group of artists who worked in the village of Barbizon, near the Fontainebleau forest. During the 1840s and 1850s, Barbizon attracted not only Daubigny, but also his colleagues Camille Corot (cats. 21–23), Jean-François Millet (cat. 26), Narcisse Virgile Diaz de la Peña (cats. 29 and 30), and Constant Troyon (cat. 25). These artists practiced landscape painting at a time when changes in the artistic, economic, and cultural environment were fueling the desire for the genre.[1]

The Village of Portejoie on the Seine demonstrates Daubigny's love of the elements. Shades of silver, gray, and white dominate a canvas that is primarily concerned with the mirrorlike surface of the river and the cloud-filled sky. The river spans the width of the canvas and extends back almost to the horizon. The viewer hovers just above the water, suggesting a vantage point from a boat.

The artist's observation of the river scene emphasizes the quaint reality of the rustic village. In the foreground, a family of ducks swims across the river, drawing our eye to the shimmering expanse of water that extends to the right edge of the canvas and all the way back to the horizon. Daubigny uses white paint sparingly and to great effect to depict the small wake created by the ducks. They swim through a blurred reflection of the low farmhouse and outbuildings that occupy the tree-studded bank in the middle ground at left. On the edge of the bank, a figure kneels to collect water in an earthen jar.

The composition is divided nearly evenly between the left and right sides of the panel. At left is

the world of hard-working men and women who make their livelihood close to the land. The right edge of the canvas is nearly unoccupied—not even the ducks have yet arrived to disturb the calm, silvery surface of the Seine. The tall poplar tree punctuates the skyline and signals a spatial transition. The landscape to the right of the tree is markedly farther back, a dense, low horizon thick with trees and the dark shadows they cast on the river as it meanders into the background.

Daubigny's close observation of nature and river life was facilitated by plein-air painting and his use of a studio boat, which he first launched in 1857.[2] His facility with accurate transcription of physical details might be traced to his early days as an illustrator. Initially, his income came from his graphic work; he made prints for travel books, magazines, and sheet music.[3] His greatest commercial success as a painter came later in his career. His work was praised by the critic Frédéric Henriet, writing in *L'Artiste*. Daubigny, he wrote, "copies nature with his soul. The model is before his eyes, but it is in his heart that he finds the exquisite feeling with which he impregnates his work."[4]

NOTES

1 See Nicholas Green, *The Spectacle of Nature: Landscape and Bourgeois Culture in Nineteenth-Century France* (Manchester: Manchester University Press, 1990).

2 Robert L. Herbert, *Barbizon Revisited*, exh. cat. (Boston: Museum of Fine Arts, Boston, 1962), 47.

3 Herbert, *Barbizon Revisited*, 27–35.

4 Herbert, *Barbizon Revisited*, 47.

NARCISSE VIRGILE DIAZ DE LA PEÑA

French, 1808–1876

29 *Approach of a Thunderstorm*

Oil on wood panel,
1871
8 ¼ × 11 ¾ in.
(21 × 30 cm)
Signed and dated:
Diaz 71
Inv. no. 873

NARCISSE VIRGILE Diaz de la Peña, the son of political refugees from Spain, was born in Bordeaux. He became an orphan at the age of ten and was raised by a clergyman. Diaz got his artistic start as an apprentice to a porcelain painter. In the 1820s he studied briefly at the art school in Lille and then moved to Paris, where he made copies after Old Master paintings. Diaz began to paint near the Fontainebleau forest in the 1830s and forged relationships with other painters of the Barbizon School. His closest associate was Théodore Rousseau, though he later met Camille Corot (cats. 21–23), Charles-François Daubigny (cat. 28), Jean-François Millet (cat. 26), and Constant Troyon (cat. 25). He enjoyed early successes both in the Salon and in the private art market.[1]

Approach of a Thunderstorm expresses Diaz's fascination with dramatic weather and light effects. The canvas is divided between golden earth and pewter-colored sky. A band of trees in the middle ground stretches across the canvas, reiterating the horizontality of the landscape, yet an opening in the trees suggests a pathway into the thick forest. A tiny, sketchily rendered figure stands in the unsheltered space between the trees. Diaz focuses intently on capturing the fleeting effects of the approaching storm. Rays of light illuminate the trees and the earth. The tallest tree bears fiery leaves, rendered with thick, loose brushstrokes.

The painting's small scale and quickly applied brushstrokes suggest that it is a sketch. The Barbizon artists practiced plein-air painting, which involved painting their subjects directly from nature as the basis for larger works that would be completed in the studio.[2] Such studies allowed artists to develop a repertoire of views, natural phenomena, and light effects. For example, the turbulent, cloud-filled sky appears in many of Diaz's Fontainebleau paintings.

Like that of Corot's *Gust of Wind* (cat. 23), the composition of this work resonates with seventeenth-century Dutch landscape paintings. A particularly Dutch feature of *Approach of a Thunderstorm* is the openness of the foreground, which invites the viewer to enter and explore the space. Diaz's interest in the stormy sky also echoes the conventions of seventeenth-century Dutch landscape. The work's drama is generated by ephemeral and powerful weather patterns—the building mass of clouds and the brilliantly lit autumn trees.

The artist acknowledges the human presence but does not focus on it. As we gaze into the woods, Diaz transports us to a fleeting moment of calm before the storm, unsettled by increasing meteorological tension. We are left with the memory of the brilliant golden light, the eerie, undeniable beauty of the silver sky, and the promise of clearer skies another day.

NOTES

1 All biographical information from Kermit S. Champa, *The Rise of Landscape Painting in France: Corot to Monet*, exh. cat. (Manchester, N.H.: Currier Gallery of Art, 1991), 156.

2 On the Barbizon School and its practices, see Andreas Burmester and Christoph Heilmann, eds., *Barbizon: Malerei der Natur, Natur der Malerei* (Munich: Klinkhardt & Biermann, 1999).

NARCISSE VIRGILE DIAZ DE LA PEÑA
French, 1808–1876

30 *Autumn in Fontainebleau*

Oil on wood panel,
1872
17 3/4 × 22 in.
(45 × 56 cm)
Signed and dated:
Diaz 72
Inv. no. 875

DIAZ's *Autumn in Fontainebleau* is nearly twice the size of his *Approaching Thunderstorm* (cat. 29). The artist's interests are reflected consistently in these two paintings, particularly concerning compositional choices. As in the sketch from the previous year, Diaz emphasizes the openness of the foreground. A diminutive figure, most likely a peasant woman, walks along a narrow path toward the distant horizon.

The path recalls a typical motif in seventeenth-century Dutch landscape, particularly in the works of Jacob van Ruisdael and Meindert Hobbema, whose paintings Diaz would have known from his visits to the Louvre. Dutch landscape, with its emphasis on the craggy realities of the countryside, appealed to the Barbizon painters' visual sensibilities. Furthermore, Dutch painting offered nineteenth-century French landscapists an alternative model to the classical French tradition epitomized by Nicolas Poussin and Claude Lorrain, who worked in Italy and specialized in idealized views (cats. 1 and 2). The Fontainebleau landscape, as Diaz depicted it, "is interesting and inviting. Correspondingly, it is painted as it is seen—gently, often with a luscious softness of touch, and with an ingratiating movement of tone from lights to darks . . . The spectator can approach a Diaz without fear and with the knowledge that there will be much that is conventionally pleasant to be seen and to be felt."[1]

Unlike the preceding work, *Autumn in Fontaine-bleau* depicts a tranquil day. Clouds fill the sky, but they are not turbulent. The composition is divided between the upper and lower registers (sky and land), as well as left and right. Whereas the trees in

Approaching Thunderstorm create a thick, imperme-able screen, the trees in this work occupy the left and right sides of the canvas. Diaz varies the size of the trees: taller on the left, less tall and more numerous on the right. The trees act as gateposts on each side of the path, which, together with the surrounding grassy areas, carves a wide swath of open space leading into the distance. A lone small tree occupies this center zone, set in the background, a bit to the left.

In the lower register of the canvas Diaz applies the paint thickly yet evenly to suggest different textures and physical qualities of leaves, rocks, and grass. He uses short, overlapping strokes to suggest scrubby grass, dry path, chiseled rock, and marshy ground. While the palette here is not as rich and saturated as that in *Approaching Thunderstorm*, Diaz employs colors that evoke the subtle changes of early autumn. Only the tallest tree at the left edge of the canvas bears reddening leaves. The clump of trees on the opposite side shows traces of gold among the primarily green leaves. The range of colors is not dramatic but hints at the splendors that the change of seasons will bring.

The artist's close friend, the painter Théodore Rousseau, wrote eloquently about his encounter with nature in the Fontainebleau forest. These sentiments aptly apply to Diaz's *Autumn in Fontainebleau*: "I also heard the voice of the trees . . . this whole world of flora lives as deaf-mutes whose signs I divined and whose passions I uncovered; I wanted to talk with them and to be able to tell myself, by this other language—painting—that I had put my finger on the secret of their majesty."[2]

NOTES

1 Kermit S. Champa, *The Rise of Landscape Painting in France: Corot to Monet,* exh. cat. (Manchester, N.H.: Currier Gallery of Art, 1991), 156.

2 Théodore Rousseau, quoted in Robert L. Herbert, *Barbizon Revisited,* exh. cat. (Boston: Museum of Fine Arts, Boston, 1962), 14.

EUGÈNE FROMENTIN

French, 1820–1876

31 *Waiting for the Ferryboat across the Nile*

Oil on canvas,
1872
31 1/8 × 43 3/4 in.
(79 × 111 cm)
Signed and dated:
*Eug. Fromentin /
1872*
Inv. no. 1134

REPRESENTATIONS of North Africa and the Middle East were tremendously popular in nineteenth-century France. The desire for pictures with orientalizing themes, as they were then termed, grew with French military and colonial interests in North Africa.[1] The imperial domination of the region began with Napoleon Bonaparte's 1798 invasion of Egypt and was further secured by the colonization of Algeria in 1830.[2] Furthermore, in the 1820s, the Restoration government established the Musée d'Egypte at the Louvre, and in 1836, an obelisk from Luxor was installed in the center of Paris at the Place de la Concorde.[3] Objects from North Africa, as well as prints and paintings depicting North African subjects, were readily available to Parisian audiences.

Images of "the Orient" offered French viewers an exotic world of pleasure and danger, confirming European fantasies (and misconceptions) about these faraway places.[4] In the early nineteenth century, orientalizing works frequently depicted nude women at Turkish baths, wild animals, and dramatic desert landscapes. Additionally, the rising market for such images was concomitant with increasing demand for landscapes and genre scenes.

Fromentin, like Delacroix before him, traveled in North Africa.[5] He made many trips to Algeria and Egypt and wrote two novels based on his travels, *Un été dans le Sahara* (*A Summer in the Sahara*, 1857) and *Une année dans le Sahel* (*A Year in the Sahel*, 1859).[6] Fromentin's literary orientation and his habits of close observation informed his work as a painter.

In 1869, Fromentin traveled to Egypt as an official guest upon the opening of the Suez Canal. Among his colleagues on the two-month trip were the art critics Théophile Gautier and Charles Blanc, as well as the academic painter Jean-Léon Gérôme. Fromentin kept a journal in which he noted his impressions in both words and images. The studies he made on the trip, together with photographs he purchased in Egypt, provided the basis for the paintings he completed in France.[7]

Waiting for the Ferryboat across the Nile was painted from memory, but it reflects the artist's keen observations of Egypt's landscape and people. Several figures wait on the bank as the ferry slowly makes its way across the wide expanse of the river. An enormous sky fills three-quarters of the canvas. The brilliant orange sun hovers just above the horizon. Fromentin changed his mind about the placement of the sun, for its original placement shows as a *pentimento* through the layers of paint. This alteration reveals a decision to depict a moment closer to the arrival of darkness.

The men are weary from a long day. The man in white nearest the riverbank sits with his knees pulled close to his chest. Behind him, the blue-clad figure stands, leaning back on a walking stick. The man on the camel surveys the scene from his perch. Farther back and to the left, two other figures, perhaps women, dressed in blue from head to toe, wait passively.

Though he was trained by a landscape painter and worked at the same time as the Impressionists,

Fromentin did not embrace the new style. Rather, he painted according to the tenets of traditional, academic art. This style privileged smooth surfaces and highly illusionistic images over the sketchy aesthetic and the thick, spontaneous brushstrokes evident in works like Claude Monet's *Boulevard des Capucines* (cat. 34), painted the following year. Fromentin belonged to an older generation. He exhibited in the official Salons, was a jury member, and wrote an art-historical treatise extolling the virtues of past masters.[8] Indeed, academic art was challenged by the avant-garde movements of Realism and Impressionism, but it remained a major force in the official French art world until the end of the nineteenth century.

Waiting for the Ferryboat across the Nile transports us to a world far from our own. The work's meditative tone lulls the viewer into a state of patient anticipation. The life of the river fascinated Fromentin, who spent much of his journey in Egypt traveling by boat. In a letter to his wife, the artist wrote: "We stop to see, and see well, all the monuments, the historical detritus. But the landscape, the customs, the people, these delicious marine scenes at every turn of the river, things of interest to everyone were not included in our program of exploration. Cruelly, they made us, the painters, speed by our very subjects of study."[9] For Fromentin, the Nile was the heart of his Egyptian experience and a significant source of artistic nourishment.

NOTES

1 See Todd Porterfield, *The Allure of Empire: Art in the Service of French Imperialism, 1798–1836* (Princeton: Princeton University Press, 1998).

2 French rule in Algeria endured until the end of Algerian War of Independence, 1954–62.

3 See Porterfield, *Allure of Empire*.

4 See Roger Benjamin, *Orientalism: Delacroix to Klee* (Sydney: Art Gallery of New South Wales, 1997); Linda Nochlin, "The Imaginary Orient," in *The Politics of Vision: Essays on Nineteenth-Century Art and Society* (New York: Harper & Row, 1989), 33–59; and Edward Said, *Orientalism* (New York: Random House, 1978).

5 On links between Delacroix and Fromentin and artists' travel generally, see Barbara Stafford, *Voyage into Substance: Art, Science, Nature, and the Illustrated Travel Account, 1760–1840* (Cambridge, Mass.: M.I.T. Press, 1984).

6 James Peery Williams Thompson, "Eugène Fromentin: Painter and Writer" (Ph.D. diss., University of North Carolina, Chapel Hill, 1985).

7 Barbara Wright, *Eugène Fromentin: A Life in Art and Letters* (Bern: Peter Lang, 2000), 414–18.

8 In 1876, Fromentin published *Les Maîtres d'autrefois*, which was recently translated and published in English; see H. Gerson, ed., *The Masters of Past Time: Dutch and Flemish Painting from Van Eyck to Rembrandt* (Oxford: Phaidon, 1981).

9 Eugène Fromentin, quoted in Wright, *Eugène Fromentin*, 419. Translated by Charlotte Eyerman.

AUGUSTE RENOIR
French, 1841–1919

32 *Bathing on the Seine*

Oil on canvas,
1869
23 ¼ × 31 ½ in.
(59 × 80 cm)
Signed: *Renoir*
Inv. no. 3407

AUGUSTE RENOIR was one of the pioneers of Impressionism. With his friends Claude Monet (cats. 34–37), Edgar Degas (cats. 42 and 43), Camille Pissarro (cats. 40 and 41), and Berthe Morisot, he participated in the group's first independent exhibition, held in 1874. Renoir had begun to gravitate toward Impressionism as early as the 1860s, when he departed from his academic training to experiment with the plein-air technique.[1]

Bathing on the Seine is among the earliest of Renoir's numerous depictions of the theme of suburban leisure. During the Second Empire (1851–1870) it became fashionable for Parisians to seek the outdoor pleasures that lay only a short train ride away. Even the Emperor Napoleon III and the Empress Eugénie visited La Grenouillère on Croissy Island in the summer of 1869.[2] Artists, too, participated in this phenomenon—the same year that the emperor and empress were relaxing near Paris, Renoir and Monet joined hordes of fellow city-dwellers on the train to Bougival near Croissy, described in the 1850s as a thriving vacation spot with cosmopolitan appeal:

> The country near Chatou, Croissy, and Bougival is inhabited by a swarm of writers, men and women belonging to the artistic life of Paris. They have the habit of finding one another along the banks at certain hours of the day, sometimes for fishing, sometimes for the pleasures of bathing in open water, which usually takes place towards four o'clock. If, on a warm afternoon of a fine summer day, your spare-time activities direct you toward Croissy Island . . . you will find yourself in joyful sporting community with this attractive society.[3]

Renoir's *Bathing on the Seine* captures this spirit: its subject is the popular La Grenouillère.[4] Chic, bourgeois Parisians socialize on the shore, the men sporting top hats and the women carrying parasols that complement fancy dresses and bonnets. City dogs enjoy the lazy pace at the sun-dappled beach, while city people enjoy the river's relaxed setting. A small group of bathers splashes about in the water, while several of their fellow day-trippers enjoy an excursion on a sailboat.

Whereas earlier French landscape painters like Claude Lorrain and Camille Corot (cats. 2 and 21–23) emphasized contrasts of light and shade, Renoir mixes tonalities and emphasizes the play of light. He records the way late-afternoon sunshine filters through the trees, and in doing so eschews uniformity in favor of a richly varied surface. The brightly illuminated tree trunk in the foreground, the women in white at left, and the bank across the river are juxtaposed with the cool shade that registers on the shore in the foreground and in the leafy trees.

Like Monet, Renoir employs loose, quick brushwork. In fact, the two artists worked side by side in 1869, producing numerous versions of La Grenouillère, including two that depict the same view: Monet's *La Grenouillère* (1869, Metropolitan Museum of Art, New York) and Renoir's *La Grenouillère* (1869, Nationalmuseum, Stockholm). Although these paintings are compositionally similar and likewise feature the thick application of paint to canvas, differences abound in their palettes: Renoir relies on lighter tones, dominated by cool blues and greens, while Monet uses darker, more opaque hues.[5] Whereas Renoir's canvas stresses chromatic uniformity and harmony, Monet's work emphasizes con-

Auguste Renoir.
La Grenouillère.
1869. Oil on canvas,
$26\frac{1}{2} \times 32\frac{1}{2}$ in.
$(67.3 \times 82.5$ cm).
Nationalmuseum,
Stockholm.
© Foto
Nationalmuseum

Claude Monet.
La Grenouillère.
1869. Oil on canvas,
$29\frac{3}{8} \times 39\frac{1}{4}$
$(74.6 \times 99.7$ cm).
The Metropolitan
Museum of Art,
New York. Bequest
of Mrs. H. O.
Havemeyer. The
H. O. Havemeyer
Collection, 1929.
© All rights
reserved, The
Metropolitan
Museum of Art.

trasts. Furthermore, Renoir has a keen interest in the figures, taking pains to describe their attire, while Monet takes a more abbreviated approach to the human form.[6]

The association between Renoir and Monet dates to 1862, when both were students at the École des Beaux-Arts and met in the studio of the academic artist Charles Gleyre. Prior to his academic training, Renoir had worked as a decorative painter, producing "porcelain plates, tea pots, and vases with figural and floral designs in the pseudo-Rococo style then in fashion" for the Lévy Brothers china works during the 1850s.[7] Renoir's artistic ambitions eventually exceeded commercial decoration, so he pursued free drawing classes and made copies of works in the Louvre. Among the artists he most admired were Baroque, Rococo, and Romantic masters, especially the seventeenth-century Flemish painter Peter Paul Rubens, as well as the French artists François Boucher (cats. 5–7) and Eugène Delacroix.[8] Renoir refined his technical skills and expanded his social and artistic circle in the conventional atmosphere of Gleyre's studio. Over the course of the 1860s, however, he met the avant-garde artists Gustave Courbet and Édouard Manet (cats. 27 and 46), whose works inspired the young Renoir to pursue an untraditional path.

NOTES

1 On the reception of modernist painting in the years that preceded the Impressionist exhibitions, see Jane Mayo Roos, *Early Impressionism and the French State, 1866–1874* (Cambridge: Cambridge University Press, 1996).

2 See Robert L. Herbert, "Suburban Leisure," in *Impressionism: Art, Leisure, and Parisian Society* (New Haven: Yale University Press, 1988), 195–263. Herbert compares this leave-taking from Paris to a kind of modern-day pilgrimage to the island of Cythera and the paintings to updated versions of the *fête galante* genre pioneered by Watteau in the early eighteenth century; see 219.

3 Eugène Chapu, *Le Sport à Paris* (1854), 208, quoted in Herbert, *Impressionism*, 211.

4 On the history of La Grenouillère, see Jacques Lay, "Rediscovering La Grenouillère: Ars Longa, Vita Brevis," *Apollo* 137, no. 375 (1993): 281–86.

5 On Renoir's debt to Monet's painting style in the late 1860s, see Kermit S. Champa, *The Rise of Landscape Painting in France: Corot to Monet*, exh. cat. (Manchester, N.H.: Currier Gallery of Art, 1991), 207.

6 Similar distinctions are evident in Monet's *Bathing at Grenouillère* (1869, National Gallery, London) and Renoir's *La Grenouillère* (1869, Oskar Reinhart Collection, Winterthur), which likewise depict nearly the same view and employ similar compositional devices. Renoir pursued the theme of riverside leisure in later works as well. See *Impressionists on the Seine: A Celebration of Renoir's Luncheon of the Boating Party*, exh. cat. (Washington, D.C.: Phillips Collection, 1996).

7 Lorenz Eitner, *An Outline of Nineteenth-Century European Painting* (New York: HarperCollins, 1992), 368.

8 Eitner, *Nineteenth-Century European Painting*, 369.

AUGUSTE RENOIR

French, 1841–1919

33 *In the Garden*

Oil on canvas,
1876
31 $^7/_8$ × 25 $^5/_8$ in.
(81 × 65 cm)
Signed: *Renoir*
Inv. no. 3406

BY THE mid-1870s the Impressionist movement was in full swing, and Renoir was at its center. He exhibited several paintings at the third Impressionist exhibition of 1877, among them his famous *Ball at the Moulin de la Galette* (1876, Musée d'Orsay, Paris), a painting that is closely related to *In the Garden*.[1] Both works feature men and women eating, drinking, playing, dancing, and generally enjoying the pleasures of socializing outdoors. Likewise, these works demonstrate Renoir's mastery of portraying sunlight and its effects: in his hands, stippled, effervescent light dances on the surfaces of the world.

In the Garden and *Ball at the Moulin de la Galette* share many visual themes. The composition of the verdant garden scene in the former echoes that of the outdoor dance hall in the latter, notably in the lower right foreground of *Ball*. In 1877, a critic writing as "Jacques" enthused that *Ball at the Moulin de la Galette* was the "most important work" in the Impressionist show, using words that could just as easily apply to *In the Garden*: "These are humble female workers, good people of the suburbs enjoying themselves decently. Nothing unwholesome here. They are treating themselves to a day off and accept pleasure without a second thought. This, in an environment of lively, perfumed, clear tones—nothing excessive, no heaviness. This is the face of a corner of Paris in the nineteenth-century that will endure."[2]

Although both paintings express lighthearted enjoyment, *In the Garden* focuses tightly on a small group of two women and three men. It is well known that Renoir used his friends as models for *Ball at the*

Moulin de la Galette. The seated men in the right foreground have been identified as the painters Pierre Franc-Lamy and Norbert Goeneutte, as well as the writer Georges Rivière.[3] The working-class women with whom these middle-class bohemians socialize were likewise not professional artists' models (a rather stigmatized occupation), but the seamstresses, florists, and milliners who frequented the Sunday dances at the Moulin de la Galette.[4] Two of them have been identified as the sisters Estelle (who is seated and dressed in a pink and blue striped dress) and Jeanne (leaning over Estelle, dressed in dark blue).

Renoir similarly used his friends as models for *In the Garden*. Though they have not been precisely identified, an inscription on the back of the painting indicates that the male figures are Claude Monet (cats. 34–37), Frédéric Cordey, and Pierre Franc, and that one of the female figures is identified as "Nini."[5] The woman standing at left wears the same pink and blue dress that Estelle wears in *Ball*, and the seated young woman sharing food, drink, and conversation with the men wears a blue dress similar to Jeanne's.

In the Garden emphasizes the innocent pleasures of a lazy afternoon. The garden itself provides an escape from the workaday world of the city. The woman in the luminous striped dress enters the secluded glade from the narrow path to join the others. This vegetation forms a thick screen behind them, literally providing shelter from the outside world. In Renoir's pictorial imagination, nature is a respite from the stresses of city life.

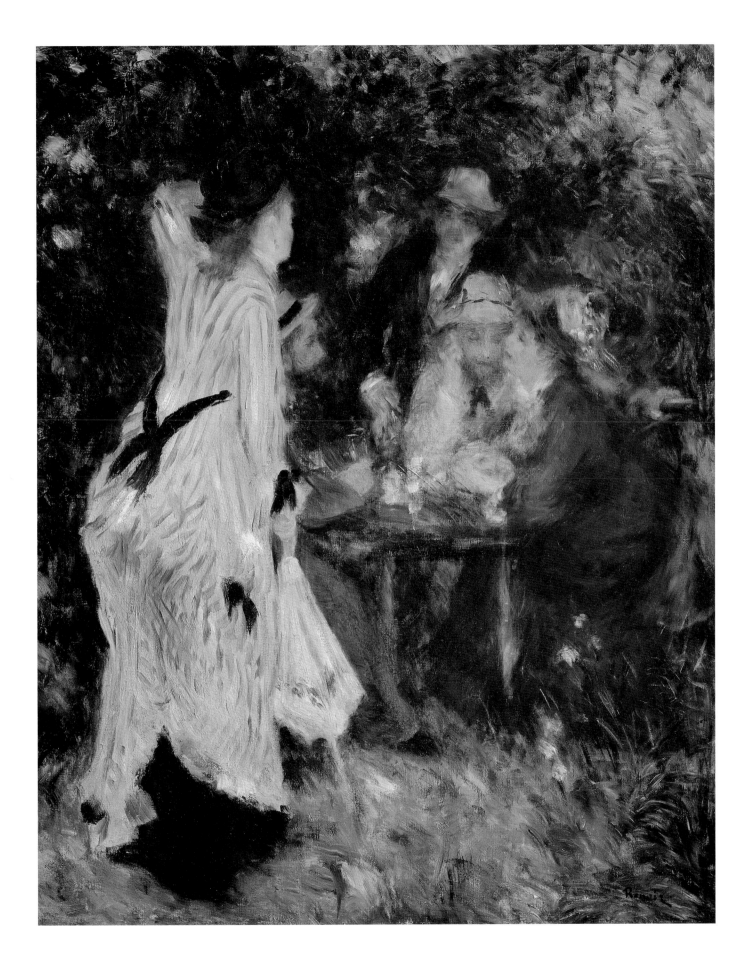

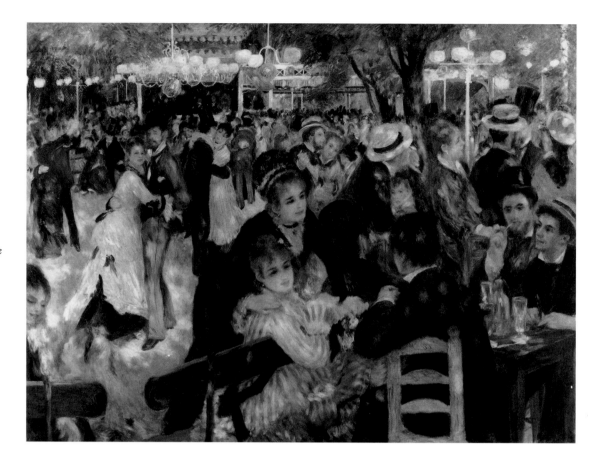

Auguste Renoir.
Ball at the Moulin de la Galette. 1876.
Oil on canvas,
51½ × 69 in.
(130.8 × 175.3 cm).
Musée d'Orsay,
Paris.
© Réunion des
Musées
Nationaux/Art
Resource, N.Y.

Ultimately, *In the Garden* focuses on the fleeting, ordinary pleasures of everyday life. Thus, Renoir reinvents the pastoral landscape tradition by replacing gods and goddesses with contemporary Parisians and dispensing with imagined Arcadian landscapes in favor of lush retreats in Paris and its environs.[6]

NOTES

1 In addition to the Musée d'Orsay *Ball at the Moulin de la Galette*, another, smaller version, also painted in 1876, is in the collection of Mrs. John Hay Whitney, New York. In 1990, this painting was part of an exchange between the Pushkin, the State Hermitage Museum, Moscow, and the Art Institute of Chicago. At the time, based on a label on the stretcher, it was titled *Under the Trees: Moulin de la Galette* and dated 1875.

2 Jacques [pseud.], untitled review of the 1877 Impressionist exhibition, *L'Homme libre,* 12 April 1877, quoted in Charles S. Moffett, ed., *The New Painting: Impressionism, 1874–1886,* exh. cat. (San Francisco: Fine Arts Museums of San Francisco, 1986), 235.

3 Georges Rivière provided a lengthy account of Renoir's production of *Ball at the Moulin de la Galette* and identified the figures: dancing in the background are the painters Henri Gervex and Frédéric Cordey and the journalist Lhote. See Robert L. Herbert, *Impressionism: Art, Leisure, and Parisian Society* (New Haven: Yale University Press, 1988), 136.

4 Herbert, *Impressionism,* 136–37.

5 The identity of the sitters in *In the Garden* was generously provided by the Pushkin curators. François Daulte identifies Claude Monet, seen in profile and seated at left; Alfred Sisley, standing toward the back, and Norbert Goeneutte, seated beside the young woman at the table under the arbor. François Daulte, *Auguste Renoir: Catalogue raisonné de l'oeuvre peint,* vol. 1: *Figures, 1860–1890* (Lausanne: Éditions Durand-Ruel, 1971), no. 197.

6 Robert Herbert reiterates the Rococo origins of Renoir's approach, relating the artist's work in particular to his eighteenth-century forebears Antoine Watteau and François Boucher. See Herbert, *Impressionism,* 138.

CLAUDE MONET
French, 1840–1926

34 *Boulevard des Capucines*

Oil on canvas,
1873
24 × 31½ in.
(61 × 80 cm)
Signed and dated:
Claude Monet 73
Inv. no. 3397

CLAUDE MONET'S *Boulevard des Capucines* was shown at the first Impressionist exhibition, held in April 1874, at the studio of the photographer Nadar.[1] Nadar's studio was located on an upper floor at 35, boulevard des Capucines and commanded a view of the street undoubtedly quite similar to the one Monet depicts.

Two men wearing black top hats reinforce this bird's-eye view. They lean on a balcony at the far right edge of the canvas, observing the spectacle of people mingling on the boulevard below, a multitude of tiny figures rendered allusively with quick, black strokes. Our view is similarly privileged, as if we occupy a neighboring balcony. Trees line the center of the wide boulevard, their descending scale creating depth, their branches weaving an intricate pattern against the facades of the monumental apartment buildings across the street. Monet's urban landscape dispenses with the conventional delineation of fore-, middle-, and background to embrace the light and movement of a single moment.

The first Impressionist exhibition was widely attended and generated much criticism, both positive and negative. *Boulevard des Capucines* in particular caught the attention of the sympathetic critic Ernest Chesneau, who described the painting in the newspaper *Paris-Journal:*

> The extraordinary animation of the public street, the crowd swarming on the sidewalks, the carriages on the pavement, and the boulevard's trees waving in the dust and light—never has movement's elusive, fugitive, instantaneous quality been captured

and fixed in all its tremendous fluidity as it has in this extraordinary, marvelous sketch that Monet has listed as *Boulevard des Capucines*. At a distance, one hails a masterpiece in this stream of life. . . . But come closer, and it all vanishes. There remains only an indecipherable chaos of palette scrapings. Obviously, this is not the last word in art. . . . It is necessary to go on and to transform the sketch into a finished work.[2]

Chesneau's conclusion that the painting's sketchiness indicated that it was unfinished expresses just how radically the Impressionists departed from academic convention. They eschewed the ancient and mythological subjects the Academy preferred in favor of slices of contemporary life, and they replaced the highly finished surfaces the Academy perpetuated with an aesthetic based on loose, thick brushstrokes—indeed, one associated with the sketch.

According to academic doctrine, sketches were an integral yet strictly preliminary part of painting. Academic painters like Jacques-Louis David (cat. 14) often made numerous studies before embarking on the final version of a painting. Monet was well acquainted with this practice, having trained with the history painter Charles Gleyre. Eventually, however, he rejected sketch-making and joined his fellow Impressionists in employing the plein-air technique to produce finished paintings outdoors directly from the motif. The resulting "sketchy" quality of his canvases suggests the ever-shifting spontaneity of light.[3]

The conservative factions of the Parisian artistic establishment did not reward the Impressionists'

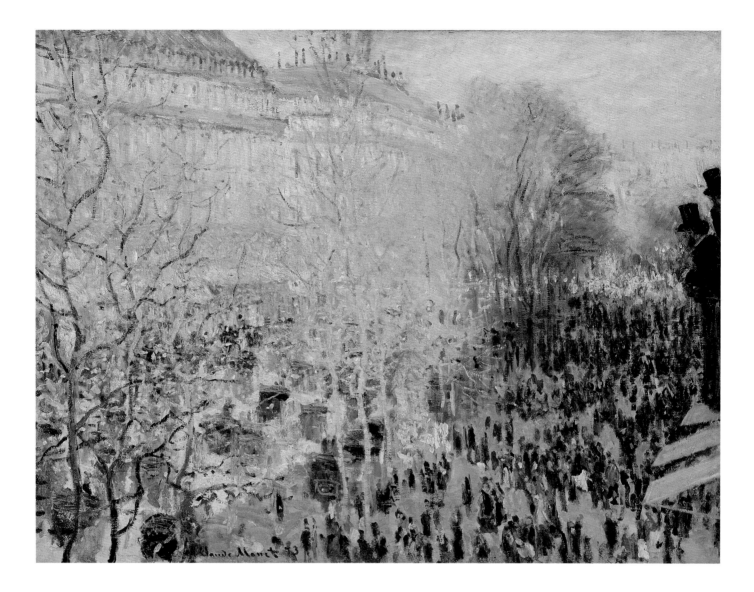

independent spirit. Instead, juries for the official Salon exhibitions often rejected the paintings submitted by Monet and his cohorts, who in response devised an alternative series of exhibitions, eight of which were held between 1874 and 1886. Monet helped organize the first of these groundbreaking shows; among the artists who participated were Paul Cézanne (cats. 55–58), Edgar Degas (cats. 42 and 43), Camille Pissarro (cats. 40 and 41), Auguste Renoir (cats. 32 and 33), and Alfred Sisley (cats. 38 and 39).

The Impressionist exhibitions provoked an intensely negative reaction, not only on the part of the Academy, but on the part of critics and the public as well. In a satirical dialogue for the journal *Charivari*, for example, the critic Louis Leroy made puns on the title of Monet's *Impression: Sunrise* (1872, Musée Marmottan, Paris), and, in the process, unwittingly coined the term Impressionism. Leroy's review recounts a conversation with an uncomprehending fictional friend, Mr. Vincent:

Unfortunately, I was imprudent enough to leave him too long in front of *Le Boulevard des Capucines* . . . "Ah-ha!" he sneered. . . . Is that brilliant enough, now! There's impression, or I don't know what it means. Only, be so good as to tell me what those innumerable black tongue-lickings in the lower part of the picture represent?" "Why, those are people walking along," I replied. "Then do I look like that when I'm walking along the boulevard des Capucines? Blood and thunder! So you're making fun of me at last?"[4]

It may be difficult to imagine how controversial Impressionist painting was when it was unveiled, because today it is considered familiar, even comforting. To their early Parisian audiences, however, Impressionist paintings seemed unfinished and hastily executed, a challenge to the very definition of French painting but one that ended up altering its course.

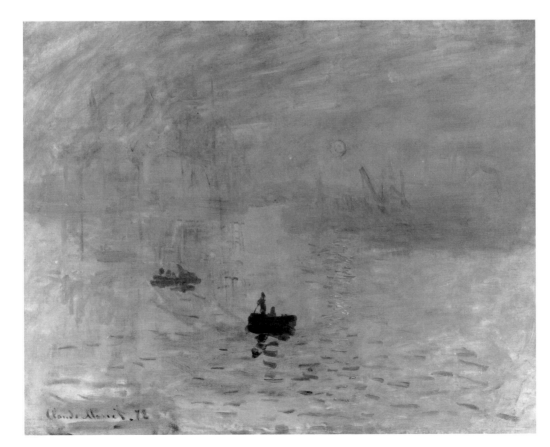

Claude Monet.
Impression: Sunrise.
1872. Oil on canvas,
17 3/4 × 21 3/4 in.
(45 × 55.25 cm).
Musée Marmottan-
Claude Monet,
Paris.
© Réunion des
Musées Nationaux /
Art Resource, N.Y.

NOTES

1 Monet painted another version of *Boulevard des Capucines*
 (1873, Nelson-Atkins Museum, Kansas City, Missouri).
 The two works seem to have been painted at different times
 of year (the Pushkin work in spring; the Nelson-Atkins
 version in winter). The Pushkin curators assert that their
 version was most likely the work shown at the first
 Impressionist exhibition.

2 Ernest Chesneau, *Paris-Journal*, 7 May 1874, quoted in
 Charles S. Moffett, ed., *The New Painting: Impressionism,
 1874–1886*, exh. cat. (San Francisco: Fine Arts Museums of
 San Francisco, 1986), 130.

3 For the relationship of the sketch to the Impressionist aes-
 thetic, see Albert Boime, *The Academy and French Painting*
 (London: Phaidon, 1971). For a more recent account, see
 Richard R. Brettell, *Impressionism: Painting Quickly in
 France, 1860–1890*, exh. cat. (New Haven: Yale University
 Press, in association with the Sterling and Francine Clark
 Art Institute, Williamstown, Mass., 2000).

4 Louis Leroy, *Charivari*, 25 April 1874, quoted in Moffett,
 New Painting: Impressionism, 130.

CLAUDE MONET

French, 1840–1926

35 *The Rocks of Belle-Île*

Oil on canvas,
1886
25⅝ × 31⅞ in.
(65 × 81 cm)
Signed and dated:
Claude Monet 86
Inv. no. 3310

MONET DID not participate in the eighth and final Impressionist exhibition, which took place in 1886. Instead, he spent time on Belle-Île off the coast of Brittany in western France, where he painted many versions of *The Rocks of Belle-Île*.[1] Monet had dedicated himself to painting the cliffs and beaches of the Normandy coast since the early 1880s, when he returned to his native region to reprise his first seascapes. After that Monet widened his travels, moving beyond Normandy to explore Brittany and other parts of France. In the ensuing decades he ventured even farther afield, traveling to Norway, as well as to the urban landscapes of London and Venice.

In *The Rocks of Belle-Île,* however, Monet focuses on the untamed rocky coastline with which he was familiar, conjuring its roiling sea and jagged rocks through painterly, expressive brushstrokes, and conveying the fierce energy of nature through a range of chromatic and tonal values. Monet depicts the Atlantic Ocean in shades of purple and blue, throughout which he sprinkles thick passages of white, representing the churning waves near the rocks. Smaller whitecaps are evident in the distance, but they fade at the horizon, where the ocean meets the pale pink and blue sky. This glowing, translucent realm contrasts with a grouping of coastal rocks, whose cragginess Monet re-creates with dense brushstrokes and a palette consisting primarily of dark purple, black, and blue, with traces of red, yellow, and pink.

Coastal views were a staple of Monet's repertoire throughout his career. In the late 1860s and early 1870s he began painting the seaside resort town of Trouville in Normandy. In this Monet was inspired by Gustave Courbet (cat. 27) and Eugène Boudin, established artists who befriended him. Boudin, a plein-air painter, recorded both the social pageantry and the natural beauty of Trouville in the 1860s. Monet met Boudin in 1858, when the young artist was producing mainly caricatures; when Monet embarked on landscape painting he discovered in the older painter a particularly strong mentor. Monet recounted his first meeting with Boudin:

> [He] came to me, complimented me in his gentle voice and said, "I always look at your sketches with much pleasure; they are amusing, clever, bright. You are gifted; one can see that at a glance. But I hope you are not going to stop there. It is very well for a beginning, but soon you will have enough of caricaturing. Study, learn to see and to paint, draw, make landscapes. The sea and the sky are so beautiful— the animals, the people and the trees, just as nature has made them, with their characters, their real way of being, in the light, in the air, just as they are."[2]

Monet ultimately followed Boudin's advice in his views of Trouville. A popular tourist destination, Trouville promoted itself as "Paris-by-the-sea" and, according to an 1868 pamphlet, boasted that its boardwalk was "the boulevard des Italiens of Norman beaches."[3] Many of Monet's Trouville paintings (and those by Boudin) capture the visual pageantry and cosmopolitan sophistication of this haven for international travelers, particularly the boardwalk and the

elegant hotels that lined the beach.[4] Eventually, however, Monet turned away from the parade of wealthy tourists to focus on what he considered the landscape painter's true subjects, nature and light.

In *The Rocks of Belle-Île* Monet dispenses with boats, fishermen, and tourists to center on the endless and powerful rhythms of the sea, including humanity only in the implicit presence of the artist and the viewer. In the end, this painting issues an invitation to marvel at the juxtaposition between the static, imposing rocks and the swirling seas, and to witness this natural drama from the safety of an elevated point of view.

NOTES

1 A nearly identical version is housed at the Ny Carlsberg Glyptothek, Copenhagen. The Musée d'Orsay, Paris, has two versions that depict slightly different views than in the Pushkin work. These Belle-Île paintings are reproduced, respectively, in Robert L. Herbert, *Impressionism: Art, Leisure, and Parisian Society* (New Haven: Yale University Press, 1988), 299–302, and Robert Rosenblum, *Paintings in the Musée d'Orsay* (New York: Stewart, Tabori, and Chang, 1989), 414–15.

2 Linda Nochlin, ed., *Impressionism and Post-Impressionism, 1874–1904* (Englewood Cliffs, N.J.: Prentice-Hall, 1966), 37–38.

3 Herbert, *Impressionism*, 294.

4 Such as Monet's *The Boardwalk of Trouville* (1870, Wadsworth Atheneum, Hartford, Conn.) and *Hôtel des Roches Noires* (1870, Musée d'Orsay, Paris).

CLAUDE MONET
French, 1840–1926

36 *White Water Lilies*

Oil on canvas,
1899
35 × 36 5/8 in.
(89 × 93 cm)
Signed and dated:
Claude Monet 99
Inv. no. 3309

IN 1883, after nearly twenty years of living a peripatetic life in Paris and in small coastal and river towns, Monet moved permanently to Giverny, a village northwest of the capital at the confluence of the Seine and Epte rivers. "Once settled," Monet wrote to his dealer Paul Durand-Ruel, "I hope to produce masterpieces, because I like the countryside very much."[1] These were prophetic words indeed, for Monet produced many masterpieces during his years in Giverny, his home until his death in 1926.

Upon his arrival, Monet rented a house that comfortably accommodated his large family and, appealingly, featured a garden, which he transformed over time to suit his personal vision. In 1890, after experiencing good fortune in the art market, Monet purchased the house. Three years later he acquired additional land, into which he expanded his garden and diverted a tributary of the Epte, forming a large lily pond. Spanning this pond was a Japanese footbridge, constructed to Monet's specifications.

White Water Lilies reflects Monet's dual passions for painting and for his garden. A *paysage d'eau*—waterscape—this work invites the viewer into the intimate confines of the artist's private oasis: a rich, verdant place thick with trees and shimmering with water and light, all rendered in a rich array of greens. Subtle reflections merge with the copious purple, yellow, and white flowers that carpet the surface of the water, and the footbridge arches gracefully in their midst, reminiscent of the bridges in Japanese prints, which Monet admired for their compositional and chromatic strategies.

This bridge serves as an organizing element in the composition, for it separates foreground from background, upper register from lower. Leading our eye back in space is the pond flowing beneath it, which penetrates the composition in a deep V shape. A terraced step divides this body of water, creating a two-tiered view of the pond that allows Monet to maximize the surface area perceivable by the viewer.

Additional structural elements and chromatic variations add further complexity to the composition. The grid-like pattern created by the bridge is reiterated in the lilies in the foreground, which, loosely striated, echo the horizontal dynamic asserted by the lower edge of the canvas, the terraced step, and the bridge. Wispy heather-colored vegetation at left counterbalances purple lily pads in the right foreground. These plants lead the eye upward, echoing the towering trees and defining the vertical edges of the canvas.

Monet painted eighteen versions of this view, twelve of which he exhibited at the Durand-Ruel Gallery in 1900.[2] He showed an additional series of water-lily paintings at the same gallery in 1909 and generated an extremely positive response. The critic Jean-Louis Vaudoyer deemed Monet's paysages d'eau "fabulous" and continued to enthuse, "Here, more than ever before, painting approaches music and poetry. There is in these paintings an inner beauty, refined and pervasive; the beauty of a play and of a concert, a beauty that is both plastic and ideal."[3] Monet's intricate harmonies of color and form had captured the public's attention.

In an interview after the 1909 exhibition, Monet explained to the critic Roger Marx that his paintings' "inner beauty" originated in his direct response to nature: "The richness I achieve comes from nature, the source of my inspiration. Perhaps my originality boils down to my capacity as a hypersensitive receptor, and to the expediency of a shorthand by means of which I project onto a canvas, as if onto a screen, impressions registered on my retina."[4] In *White Water Lilies*, Monet transforms his passion for nature into a celebration of his private retreat.

NOTES

1 Claude Monet in *Monet's Years at Giverny: Beyond Impressionism*, exh. cat. (New York: Metropolitan Museum of Art, 1978), 16.

2 Additional paintings in this series, all titled *The Water Lily Pond (Japanese Bridge)*, painted between 1899 and 1900, are in the collections of the Metropolitan Museum of Art, New York; National Gallery, London; Museum of Fine Arts, Boston; Musée d'Orsay, Paris; and Art Institute of Chicago. See Paul Hayes Tucker, *Monet in the 90s: The Series Paintings*, exh. cat. (New Haven and London: Yale University Press, in association with the Museum of Fine Arts, Boston, 1989), 255–84.

3 Jean-Louis Vaudoyer in *Monet's Years at Giverny: Beyond Impressionism*, exh. cat. (New York: Metropolitan Museum of Art, 1978), 31.

4 Roger Marx, "Les Nymphéas de M. Claude Monet," *Gazette des Beaux-Arts,* ser. 4. 1 (June 1909): 527–28, quoted in Edgar Peters Bowron and Mary G. Morton, *Masterworks of European Painting in the Museum of Fine Arts, Houston* (Princeton, N.J.: Princeton University Press, in association with the Museum of Fine Arts, Houston, 2000), 200.

CLAUDE MONET

French, 1840–1926

37 *Vétheuil*

Oil on canvas,
1901
35 3/8 × 36 1/4 in.
(90 × 92 cm)
Signed and dated:
Claude Monet 1901
Inv. no. 3314

OVER THE course of his long career Monet developed a serial practice of painting. He focused on places that were dear to him and painted them repeatedly: his garden at Giverny with its Japanese bridge and lily pond; haystacks; the façade of Rouen Cathedral; coastal scenes in Normandy and Brittany; and views around the town of Vétheuil, a village on the Seine forty miles from Paris. Monet painted *Vétheuil* in 1901, many years after his initial sojourn to the small town and long after the final Impressionist exhibition, held in 1886. Despite its late date, however, the painting reveals the consistency of Monet's pictorial interests: his sustained habit of returning to the same subjects and his abiding fascination with color and light.

In this painting, the village of Vétheuil sprawls up a hill on the far bank of the Seine River, whose opposite side is indicated by a thick fringe of grasses at the lower right edge of the canvas. Approaching it is a small boat, its rust-colored tonality echoed in the terracotta roofs of the town.

Monet delights in the chromatic relationships between the hilltop town with its solid architectural forms, the narrow strip of sky, and the broad swath of the river. This body of water dominates the composition, filling more than half the picture space; on its stippled surface are reflections of buildings cast by the first rays of the morning sun. Uniting buildings, water, and reflections is a palette consisting primarily of warm colors—purple, mauve, pink, gold, and russet—which are, in turn, counterbalanced by the cool greens of the vegetation in the immediate foreground and the trees that line the far bank. In Monet's world the natural coexists peacefully with the civilized.

Monet first painted *Vétheuil* when, plagued with poverty and in search of an affordable alternative to Paris, he rented a house there from 1878 to 1881. Monet, his wife, Camille, and their two sons shared this residence with the family of Mr. Hoschedé, a textile magnate and one of Monet's major patrons until he, too, experienced financial problems, in 1877. Hoschedé's wife, Alice, apparently became Monet's mistress in the mid-1870s and his live-in companion (along with her six children) after Camille's death in 1879.[1] In 1883, Monet settled in Giverny (cat. 36) with Alice and their large combined family, ultimately marrying her in 1892.

On his rented property at Vétheuil, Monet cultivated a garden, which he included in many of his paintings of the late 1870s and early 1880s. But he also enjoyed exploring the views beyond his backyard, particularly the broad expanse of the Seine and the provincial skyline along the low, rolling hills on its eastern bank (such as *Vétheuil in Summertime*, 1879, Art Gallery of Ontario, Toronto).

This essential composition figured in numerous versions of Vétheuil that Monet painted when he returned to the village in 1901 (other works in this series are currently in the Musée d'Orsay and at the Art Institute of Chicago).[2] These paintings vary only in time of day; indeed, Monet explores shifting color and light through the lens of an oft-studied motif. Monet explained the evolution of this process over the course of his career:

> Ever since I entered my sixties I had had the idea of setting about a kind of "synthesis" in each of the successive categories of themes that held my attention—of summing up on one canvas, sometimes in

two, my earlier impressions and sensations. I had given up the notion. It would have meant traveling a great deal and for a long time, revisiting, one by one, all the places through which my life as a painter had taken me, and verifying my former emotions. I said to myself, as I made my sketches, that a series of general impressions, captured at the times of day when I had the best chance of seeing correctly, would not be without interest. I waited for the idea to consolidate, for the grouping and composition of the themes to settle themselves in my brain little by little, of their own accord; and the day when I felt I held enough cards to be able to try my luck with a real hope of success, I determined to pass to action, and did so.[3]

For Monet, familiarity bred ongoing inspiration, and Vétheuil thus reminds us of the freshness he brought to the subjects he knew intimately.

NOTES

1 On the affair with Alice Hoschédé, see Robert L. Herbert, *Impressionism: Art, Leisure, and Parisian Society* (New Haven: Yale University Press, 1988), 262–63; see also Lorenz Eitner, *An Outline of Nineteenth-Century European Painting* (New York: HarperCollins, 1992), 357–58.

2 Monet also traveled to London in 1899, 1900, and 1901 to paint the Thames and the city's monuments. On Monet's series paintings, see Paul Hayes Tucker, *Monet in the '90s: The Series Paintings,* exh. cat. (Boston: Museum of Fine Arts, in association with Yale University Press, 1989).

3 Claude Monet, quoted in Linda Nochlin, ed., *Impressionism and Post-Impressionism, 1874–1900* (Englewood Cliffs, N.J.: Prentice-Hall, 1966), 44–45.

ALFRED SISLEY
English, 1839–1899

38 *Frosty Morning in Louveciennes*

Oil on canvas,
1873
$18^{1}/_{8} \times 24$ in.
(46 × 61 cm)
Signed: *Sisley 73*
Inv. no. 3420

THOUGH HIS name is not as immediately recognizable as that of Claude Monet (cats. 34–37), Alfred Sisley was an original member of the Impressionist group.[1] He met Monet when he, Auguste Renoir (cats. 32 and 33), and Frédéric Bazille were students in the academic painter Charles Gleyre's studio, which he entered in 1862 after enrolling in the École des Beaux-Arts.[2] By the following year Sisley had taken to painting outdoors in the environs of Paris, eventually carving a niche for himself as a master of plein-air landscapes like *Frosty Morning in Louveciennes*.

Although his parents were English, Sisley was born and raised in Paris. His father was a successful importer of artificial flowers (a key ingredient in the Parisian fashion industry), and he provided the family with a very comfortable upper-middle-class lifestyle. At the age of eighteen, the young Sisley was sent to London to prepare for a career in business. Though he demonstrated little aptitude for business while in England, Sisley did have the opportunity to see the work of the English landscapists John Constable and J. M. W. Turner and, perhaps inspired by their example, developed an interest in art. Indeed, when Sisley returned to France to pursue an artistic career, landscape painting became his primary focus.[3]

Like many French artists who painted landscapes in the 1860s, Sisley was particularly drawn to the Forest of Fontainebleau, an interest that did not diminish for at least twenty years hence, as evidenced by *The Outskirts of the Fontainebleau Forest* (cat. 39). Following in the footsteps of such Barbizon painters as Camille Corot (cats. 21–23), Narcisse Virgile Diaz de la Peña (cats. 29 and 30), and Charles-François Daubigny (cat. 28), Sisley turned his attention to observing and recording nature, weather, and light.[4]

When Paris was rocked by civil war following the Franco-Prussian War (1870–71), Sisley moved his family from Paris to Louveciennes, a village about six miles to the west, where Pissarro and Renoir both had lived.[5] Pissarro was most likely the first of the Impressionists to paint in Louveciennes (see his *Springtime at Louveciennes*, c. 1868–69, National Gallery, London), and Sisley, too, discovered an inexhaustible range of landscape subjects in the village, as well as in the nearby towns of Port Marly, Bougival, and Argenteuil.[6]

Sisley painted *Frosty Morning in Louveciennes* during the early 1870s, a period in his career when he was particularly drawn to winter landscapes (see also *Early Snow in Louveciennes*, c. 1870, Museum of Fine Arts, Boston; *Louveciennes in the Snow*, 1872, Norton Simon Museum, Pasadena; and *Snow at Louveciennes*, 1878, Musée d'Orsay, Paris).[7] Although frost blankets the earth and the buildings, the scene is bathed in warm, golden light. Counterbalancing the frosty blues that describe land, buildings, and sky are the luminous golden tones that bring out the trees and shrubs. Sisley's masterful handling of tonal harmonies creates a landscape that, though chilly, is ultimately inviting.

Sisley captures the instant before the rising sun peeks over the eastern hills, when only the tall trees at left and distant town are illuminated, and the grove of

fruit trees and low buildings at right remain cloaked in shadow. These structures, together with the small figures in the center of the composition, are all that suggest a human presence. Loose, thick brushwork characterizes patches of earth, while flat, matte areas of pigment describe the solidity of architectural structures. Rhythmic, textured strokes depict the blue sky, which, tinged with pink at the horizon line, echoes the cool tones in the foreground.

Painted in 1873, *Frosty Morning in Louveciennes* might be seen as a rural corollary to Monet's *Boulevard des Capucines* of the same year (cat. 34), for both artists employ a similar palette and painting style. While Monet's aim is to capture the frenetic energy of the city, however, Sisley's goal is to meditate on the peacefulness of the countryside.

NOTES

1 Sisley participated in four of the eight Impressionist exhibitions (the first in 1874, the second in 1876, the third in 1877, and the seventh in 1882); see Charles S. Moffett, ed., *The New Painting: Impressionism, 1874–1886*, exh. cat. (San Francisco: Fine Arts Museums of San Francisco, 1986), 509.

2 Lorenz Eitner, *An Outline of Nineteenth-Century European Painting* (New York: HarperCollins, 1992), 389.

3 On Sisley's career, see Richard Shone, *Sisley* (New York: Harry N. Abrams, 1992).

4 Eitner, *Nineteenth-Century European Painting*, 390.

5 Eitner, *Nineteenth-Century European Painting*, 391.

6 Robert L. Herbert, *Impressionism: Art, Leisure, and Parisian Society* (New Haven: Yale University Press, 1988), 205. See also Richard Brettell, "Pissarro in Louveciennes: An Inscription and Three Paintings," *Apollo* 136, no. 369 (1992): 315–19.

7 See Charles S. Moffett, ed., *Impressionists in Winter: Effets de Neige*, exh. cat. (Washington, D.C.: Phillips Collection, 1999).

ALFRED SISLEY

English, 1839–1899

39 *The Outskirts of the Fontainebleau Forest*

Oil on canvas,
1885
$23\,^5/_8 \times 28\,^3/_4$ in.
(60 × 73 cm)
Signed: *Sisley 85*
Inv. no. 3422

ALFRED SISLEY painted *The Outskirts of the Fontainebleau Forest* more than twenty years after his first sojourn to the area as a young art student. Fontainebleau, about forty miles from Paris, was discovered in the 1830s by artists such as Camille Corot (cats. 21–23) and Narcisse Virgile Diaz de la Peña (cats. 29 and 30), and, together with the nearby town of Barbizon, it continued to attract landscape painters throughout the nineteenth century.

As in *Frosty Morning at Louveciennes* (cat. 38), *The Outskirts of the Fontainebleau Forest* reveals Sisley's concern with light, color, and seasonal changes, and it demonstrates his use of landscape as a vehicle for exploring visual and natural phenomena. Yet it also marks a stylistic departure for Sisley: whereas the earlier work emphasizes the clarity and solidity of form, this painting asserts a quite different set of pictorial and thematic interests.

In *The Outskirts of the Fontainebleau Forest*, Sisley records the rich colors of autumn with a liberally loaded brush. Thick layers of orange, russet, and violet evoke the impending change of seasons, while wispy, leaf-barren trees confirm that winter is on the way. Sisley has applied paint to canvas in varying textures, revealing raw canvas in some areas, while allowing paint to project off the surface in others—notably the path and the trees in the distance. Perceivable drops of paint describe orange foliage, the mauve path, and the purple stones or bushes that line it. Thick streaks of yellow, peach, and brown on the path suggest rays of light filtering through the trees. Like Monet, Pissarro, and other Impressionists, Sisley had become less dependent on nature than on sensation and had departed from the typical Impressionist palette to introduce higher hues.

Whereas in *Frosty Morning at Louveciennes* Sisley employs the conventional technique of dividing earth and sky into clear horizontal zones, in *The Outskirts of the Fontainebleau Forest* he takes a more dynamic approach. The curving path draws the eye into the background, which is marked by an arc of swaying trees alive with color. These trees are set off by the blue sky, whose diagonal orientation is reinforced by white brushstrokes that imply light, moving clouds. These effects, intensified by contrasting complementary colors and thickly applied paint, reveal Sisley's apparent fascination with the dramatic movement inherent in the landscape. The human presence, while muted in the 1873 painting, has been all but eradicated here. Indeed, this landscape seems to exist purely as a site of solitary meditation for the painter (and the viewer).

In his time, Sisley's art was heralded neither critically nor commercially. During the 1880s, the finan-

cial struggles of his dealer Durand-Ruel weighed heavily on the artist and forced him to solicit the support of longtime patrons. His old friends Claude Monet and Auguste Renoir were thriving in both the press and the marketplace in the 1880s and 1890s (a good example is Monet's *White Water Lilies,* 1899, cat. 36), but Sisley's critical fortunes held little promise during those years. Exhibitions of his later works were met with slim sales and a silent press. Although Sisley enjoyed little success, the expressive spontaneity of *The Outskirts of the Fontainebleau Forest*—together with its assertion of the tactility of paint *for its own sake*—anticipate the next phase of French landscape painting that would dominate French art in the early twentieth century.

CAMILLE PISSARRO

French, 1830–1903

40 *Autumn Morning at Eragny*

Oil on canvas,
1897
21¼ × 25⅝ in.
(54 × 65 cm)
Signed and dated:
C. Pissarro 97
Inv. no. 3403

CAMILLE PISSARRO was born to French parents on the island of St. Thomas in the West Indies. When he was twelve years old his parents sent him to school in France, but he returned to the Caribbean five years later to work in their general store. Though disinclined toward business, the young Pissarro demonstrated a keen interest in art, filling sketchbooks with his observations of the landscape and culture of St. Thomas. In 1855, Pissarro's family granted him permission to return to Paris to pursue his artistic training, and with his father's encouragement, he enrolled in the École des Beaux-Arts. There, he met Camille Corot (cats. 21–23), who encouraged him to pursue landscape painting, to "Go into the country: the Muse is in the woods!"[1]

Pissarro first exhibited at the Salon of 1859, and, in the 1860s, he forged a career as a landscape painter.[2] He received the support of Charles-François Daubigny (cat. 28), a member of the Salon jury who lobbied for Pissarro's inclusion in the official 1868 exhibition. Pissarro's landscapes also attracted the attention of the novelist Émile Zola, who noted that these works inspired an "indescribable feeling of epic grandeur," and who enthused that "never before have paintings appeared to me to possess such overwhelming dignity."[3]

In the late 1860s and early 1870s, Pissarro resided primarily in the rural villages of Louveciennes and Pontoise, where he painted alongside his colleagues Claude Monet (cats. 34–37), Auguste Renoir (cats. 32 and 33), and Paul Cézanne (cats. 55–58).[4] He was a key figure in the Impressionist movement and the only artist to exhibit in all eight of the independent shows; like his fellow Impressionists, he practiced the plein-air technique. As a keen observer of nature, Pissarro's abiding concern was to register light effects—a facet of his work for nearly forty years.

Autumn Morning at Eragny communicates Pissarro's engagement with the rural region in which he lived. He uses thick, painterly brushstrokes to render the abundant trees, sky, and grass, and he delights in the display of autumnal progress in the trees. The fruit tree in the center, for example, bears the mark of fall, for a fringe of orange leaves has started to emerge in its foliage; near this tree is a much taller tree, in the process of losing its leaves. While the small tree anchors the composition, the taller one leads our eye into the distance, its branches filling the sky in the upper-right-hand corner. Just beyond it, a farmhouse reiterates the distant horizon line, while the foreground is demarcated by a group of low trees. In the open space beyond these trees, a diminutive, sketchily rendered peasant walks a horse.

Though completed in the late 1890s, *Autumn Morning at Eragny* is stylistically close to Pissarro's Impressionist works of the 1870s. This formal choice is significant, for it marks a return to his Impressionist origins. By the early 1880s, Pissarro had departed from Impressionism to radically alter his approach, adopting the Pointillist technique pioneered by the Neo-Impressionists Georges Seurat and Paul Signac.[5] Insisting that painting should be a disciplined system rather than an intuitive, spontaneous process, Seurat and Signac replaced the thick impasto of Impressionist technique with evenly applied dots (or *points*) of complementary colors. These avant-garde painters

were nearly thirty years Pissarro's junior, but his association with them attests to his openness to new ideas.

Significantly, Pissarro's affinity with Seurat and Signac was not limited to painting, for he shared their politics as well. Though a self-proclaimed socialist, Pissarro embraced the younger artists' anarchism and aligned himself with their populist views.[6]

When Seurat died in 1891 at the age of thirty-two, Pissarro abandoned the purely scientific concerns of Pointillism (as it came to be known) and returned to the Impressionist vocabulary of thickly applied paint and approximated forms, now modified by his experience with the younger painters. The result was a highly calculated juxtaposition of pigments and creation of tapestry-like surfaces. This is the spirit in which Pissarro painted *Autumn Morning at Eragny*, as well as the many works from his fruitful late period. Throughout the 1890s Pissarro continued to paint rural landscapes from his home base in Eragny, and, late in the decade, he returned to Paris to embark on an ambitious series of urban scenes.

NOTES

1 Lorenz Eitner, *An Outline of Nineteenth-Century European Painting* (New York: HarperCollins, 1992), 399.

2 See Rachael Ziady Delue, "Pissarro, Landscape, Vision, and Tradition," *Art Bulletin* 80, no. 4 (1998): 718–36.

3 Eitner, *Nineteenth-Century European Painting*, 403.

4 See Barbara Ehrlich White, *Impressionists Side by Side: Their Friendships, Rivalries, and Artistic Exchanges* (New York: Knopf, 1996).

5 See Martha Ward, *Pissarro, Neo-Impressionism, and the Spaces of the Avant-Garde* (Chicago: University of Chicago Press, 1996).

6 Eitner, *Nineteenth-Century European Painting*, 411. On the relationship between Pissarro's painting and his politics, see T. J. Clark, "We Field-Women," in *Farewell to an Idea: Episodes from the History of Modernism* (New Haven: Yale University Press, 1999), 55–137.

CAMILLE PISSARRO

French, 1830–1903

41 *L'Avenue de l'Opéra, Snow, Morning*

Oil on canvas,
1898
25 ⅝ × 32 ¼ in.
(65 × 82 cm)
Signed and dated:
C. Pissarro 98
Inv. no. 3323

PISSARRO left Eragny early in 1898 and took up residence in a Paris hotel. This was a difficult time for the artist: his son Félix had died of tuberculosis the previous year, and his other son Lucien, who lived in London, was terribly ill. The elder Pissarro maintained a close relationship with Lucien that is well documented by their extensive correspondence.[1] Shortly after settling in Paris in January 1898, for example, Pissarro wrote to his son describing the view from his hotel window, looking north over the Place du Palais Royal and up the avenue de l'Opéra: "I forgot to tell you that I have found a room in the Grand Hôtel du Louvre which has a superb view over the Avenue de l'Opéra and that corner of the Place du Palais-Royal. It's going to be beautiful to paint. It is not very aesthetic perhaps, but I am delighted to be able to try to do these Paris streets which are so often called ugly but which are so silvery, so luminous and so lively and which are so different from the boulevards—it is completely modern."[2]

Adopting a serial practice clearly derived from Monet's, Pissarro painted fifteen versions of this view, recording it over the course of many months, in different seasons, and at different times of day.[3] Pissarro also shared the concern with plein-air painting that Monet had expressed so eloquently twenty-five years earlier in *Boulevard des Capucines* (1873, cat. 34), for he too painted *L'Avenue de l'Opéra, Snow, Morning* from his open window. Indeed, just as Monet had gazed out a window for the sake of capturing the brilliant spontaneity of a bustling Parisian street, Pissarro recognized the unlikely yet poetic beauty of a wintry morning in the city.

Situated firmly in the nineteenth-century urban landscape tradition, *L'Avenue de l'Opéra, Snow, Morning* celebrates Paris as dynamic urban theater. Carriages and pedestrians, undeterred by the weather, make their way along the crowded avenue in a display of mundane pageantry that is clearly more fascinating to Pissarro than are the staged performances at the nearby Comédie Française and Opéra.

This view also represents one of the great achievements of Haussmannization, the civic works project initiated by the Emperor Napoleon III and overseen by the Baron Georges-Eugène Haussmann during the Second Empire (1851–70).[4] Under Haussmann's direction, streets were widened, lighting was updated, sewers were built, and transportation was improved; as a result, Paris was transformed from a medieval city into a modern capital. The avenue de l'Opéra was constructed to show off the city's new opera house to full advantage. In this painting, however, Pissarro reduces the grand building to a hazy outline, barely visible against the dense, cloudy sky.

Instead, Pissarro focuses on the busy avenue, the apartment buildings that line it, and the circular traffic islands of the plaza. Although he paints with the thickly loaded brush and apparently hasty manner of an Impressionist, Pissarro relies on one of the most traditional compositional devices: perspective. The wide avenue and buildings that flank it draw the eye back into space. Color and light reinforce this recession, for the center of the avenue is light in tone where carriages have cleared the snow and darker at its parallel, less-traveled edges.

The year Pissarro painted *L'Avenue de l'Opéra, Snow, Morning* was one of political and social unrest in Paris. Four years earlier, the Jewish army officer Alfred Dreyfus had been unjustly accused of treason, and, by 1898, discourses on the Dreyfus Affair had reached a fever pitch.[5] Earlier that year, Émile Zola had published his essay "J'Accuse," a defense of Dreyfus and a scathing attack on his accusers, and Pissarro, who supported Zola's stance, wrote to Lucien about the tense climate in Paris in early 1898. His words, however, are hardly those of revolutionary engagement: "Despite the serious events that are unraveling in Paris, I am forced, in spite of my worries, to work at my window as if nothing were happening."[6] Rather than paint a scene of contemporary strife, Pissarro captures the seemingly timeless rhythms of the city and the rituals of the morning commute.

NOTES

1 See Camille Pissarro, *Camille Pissarro: Letters to His Son Lucien,* John Rewald, ed., with the assistance of Lucien Pissarro, 3rd ed., rev. John Rewald (Mamaroneck, N.Y.: Appel, 1972); and Lucien Pissarro, T*he Letters of Lucien to Camille Pissarro, 1883–1903,* ed. Anne Thorold (Cambridge: Cambridge University Press, 1993).

2 Camille Pissarro, letter to Lucien Pissarro, 1898, reprinted in Richard Brettell and Joachim Pissarro, *The Impressionist and the City: Pissarro's Series Paintings,* exh. cat. (New Haven: Yale University Press, in association with the Philadelphia Museum of Art, 1992), 79.

3 This series is discussed in Brettell and Pissarro, *Impressionists and the City,* 79–101. Paintings that depict the same view as the Pushkin work are in the Dallas Museum of Art, the Minneapolis Institute of Arts, Musée des Beaux-Arts, Reims, and the National Museum of Belgrade. On the practice of serial painting and the market for such works, see John Klein, "The Dispersal of the Modernist Series," *Oxford Art Journal* 21, no. 1 (1998): 123–35.

4 The Opéra was not completed until 1875, but the building, designed by the architect Charles Garnier, was a key monument in the emperor's vision for modern Paris. On Haussmannization see David H. Pinkney, *Napoleon III and the Rebuilding of Paris* (Princeton, N.J.: Princeton University Press, 1972).

5 On the Dreyfus Affair, see Gordon Wright, *France in Modern Times* (Chicago: Rand McNally, 1960), 321–24.

6 Camille Pissarro, letter to Lucien Pissarro, 1898, reprinted in Brettell and Pissarro, *Impressionists and the City,* 81.

EDGAR DEGAS
French, 1834–1917

42 *Dancer Posing for a Photographer*

Oil on canvas,
1875
25 5/8 × 19 5/8 in.
(65 × 50 cm)
Signed: *Degas*
Inv. no. 3274

PERHAPS NO subject is more closely associated with Edgar Degas than that of the ballet dancer. Degas spent countless hours studying dancers performing and rehearsing, on stage and backstage, at work and at rest. Over the course of his long career he represented dancers in nearly every medium: oil paint, pastel, drawing, photography, and wax sculpture.[1]

Degas was trained in the studio of the history painter Louis Lamothe, a disciple of Jean-Auguste-Dominique Ingres (cat. 20). There he mastered the cornerstones of academic practice: drawing from the model and copying the Old Master works in the Louvre. Degas was a great admirer of the previous generation of great French painters, eventually becoming an avid collector of the works of Ingres, Eugène Delacroix, and others.[2] In keeping with his academic training, Degas initially focused on history painting, depicting the heroes of the ancient and medieval past; in the mid-1860s he turned to subjects from contemporary Parisian life.

Although his classical training and taste are not immediately apparent in *Dancer Posing for a Photographer,* they are evident in the painting's focus on the complex mobility of the human form. When the American collector Louisine Havemeyer asked Degas why he always painted ballet dancers, the artist replied: "Because, Madame, it is all that is left of the combined movement of the Greeks."[3]

Dancer Posing for a Photographer captures a staged moment in a photographer's studio, in which a dancer, about to be immortalized on film, demonstrates her hard-earned balletic grace.[4] Her left foot is on point, while she stabilizes herself with her right,

preparing to launch into a new pose, perhaps a pirouette or an arabesque. She gently lifts her arms to frame her face and gazes outward, beyond the upper frame. Though dressed for performance rather than rehearsal, this dancer entertains a very small audience: the photographer, her dance master, her fellow dancers, her chaperone, Degas, and us, the viewers.

Though the studio is spare, Degas makes it visually interesting by creating a highly structured composition. Just discernable at the right edge of the canvas is the wooden frame of a large mirror in which the dancer checks her appearance, position, and posture. The "foot" of this mirror extends back into pictorial space, reiterating the dancer's foot position, almost like a visual pun. The mirror itself is cropped, cut off by the right edge of the canvas; all that is visible is its frame. Its verticality, together with that of the windowpanes and curtains, echoes that of the dancer's body.

By cropping the mirror, Degas implies that the space and narrative of the picture continue beyond its frame, and that Degas has captured a fleeting moment in the photographer's studio. We imagine that just outside our immediate field of vision is a whole corps of dancers waiting to pose for the photographer (and, by extension, Degas). In using cropping as a compositional device Degas borrowed from two sources: Japanese woodblock prints, which were popular with French collectors, including Degas;[5] and photography, a relatively new medium, invented in 1839.[6]

Photography and the images it produced fascinated Degas, as they did his fellow Impressionists,

who held their first exhibition—of which Degas was a primary organizer—in the studio of the photographer Nadar.[7] *Dancer Posing for a Photographer,* the art historian Richard Kendall observes, "[reminds] us of Degas's lifelong familiarity with photographers and the conventions of their craft, [it] shows a ballerina transposed from the rehearsal room to a roof-level photographic studio, where she strikes a pose against a view of Parisian buildings and appears to check her appearance in a large mirror."[8] The buildings provide the "stage set"; the stage on which the dancer performs is Paris itself.

NOTES

1 Degas's wax sculptures were made for study purposes and were cast in bronze after his death. On the bronzes, see Sara Campbell, "Degas' Bronzes: An Introduction" and "A Catalogue of Degas' Bronzes," *Apollo* 142 (August 1995): 6–48. Only one work, *The Little Dancer,* was exhibited during his lifetime, at the sixth Impressionist exhibition of 1881. See Charles S. Moffett, *The New Painting: Impressionism, 1874–1886,* exh. cat. (San Francisco: Fine Arts Museums of San Francisco, 1986), 361–62.

2 Colta Ives et al., eds., *The Private Collection of Edgar Degas: A Summary Catalogue* (New York: Metropolitan Museum of Art, 1997).

3 Quoted in Richard Kendall, *Degas Backstage* (London: Thames and Hudson, 1996), 22. Degas met Havemeyer through the painter Mary Cassatt.

4 Kendall, *Degas Backstage,* 76.

5 Ives et al., *Private Collection of Edgar Degas.*

6 Beaumont Newhall, *A History of Photography from 1839 to the Present,* rev. ed. (New York: Museum of Modern Art, 1982).

7 See Moffett, *New Painting: Impressionism,* 51.

8 Kendall, *Degas Backstage,* 76.

EDGAR DEGAS

French, 1834–1917

43 *Exercising Racehorses*

Pastel,
1880
14⅛ × 33⅞ in.
(36 × 86 cm)
Signed (twice):
Degas
Inv. no. 3275

DEGAS'S COMMITMENT to studying the anatomy and musculature of bodies in motion extended beyond the ballet dancers and bathers for which he is best known. He also made numerous paintings, drawings, and wax sculptures of horses, producing scenes of hunting and racing, portraits of jockeys and spectators, as well as endless studies of horses both moving and at rest.[1] "Degas was . . . fascinated," wrote the art historian Jean Sutherland Boggs, "by the recently established racetrack at Longchamp in the Bois de Boulogne, and by the hunting and riding sorties of his friends in the country. He loved the social spectacle of the racecourse, but was also intrigued by the nervous tension, the energy under perfect control, of a feisty thoroughbred ready for the start."[2]

Like Degas's numerous depictions of ballet dancers at rehearsal, *Exercising Racehorses* offers a look behind the scenes. This small pastel features six horses and jockeys stepping out onto a field of grass, their single-file alignment leading our eye from left to right. The jockeys, dressed almost identically and lacking facial features, seem generic and interchangeable; in contrast, the particular physical disposition of each horse has been depicted with great care: no two heads or pairs of legs assume the same position. Most of the horses walk placidly, heads lowered toward the ground or lifted up, except for the horse in the right foreground, who rears, whinnying loudly, we imagine, in reaction to something beyond our view. The frame crops the horse on the far right, suggesting that there are more horses ahead of it, walking or trotting across the dewy grass.

The horizontal format of the composition is reiterated in the line of horses, the misty light just beyond them, the rolling hills and horizon line in the distance, and the narrow band of pink and blue sky that stretches across the paper. By using this subtle range of modulated colors Degas suggests the early morning light.

Pastel is especially well suited to Degas's visual interests in *Exercising Racehorses*. He exploits the inherent subtlety of the medium to emphasize the soft contours of the landscape, from the thick green grass in the foreground to the hills in the distance, and he uses highlights to define the structure of the horses' bodies and their sinews.

Degas's engagement with horses as subject matter began in his student days, spanned more than thirty years of artistic production, and encompassed a variety of sources. He made sketches of horses from plaster casts of the Parthenon frieze; he copied horse paintings by the early nineteenth-century French painter Théodore Géricault; and he made drawings of the race of the riderless horses while visiting Rome.[3] Degas also included horses in the visual and narrative schemes of his early history paintings: *Alexander and Bucephalus* (1859–61, National Gallery of Art, Washington, D.C.), *Semiramis Building a City* (1860–62, Musée d'Orsay, Paris), and *Scene of War in the Middle Ages* (1863–65, Salon of 1865, Musée d'Orsay, Paris). And, after he abandoned history painting in 1865, he combined ballet and horses in the genre painting *Mlle Fiocre in the Ballet "La Source"* (1867–68, Salon of 1868, Brooklyn Museum of Art).[4]

139

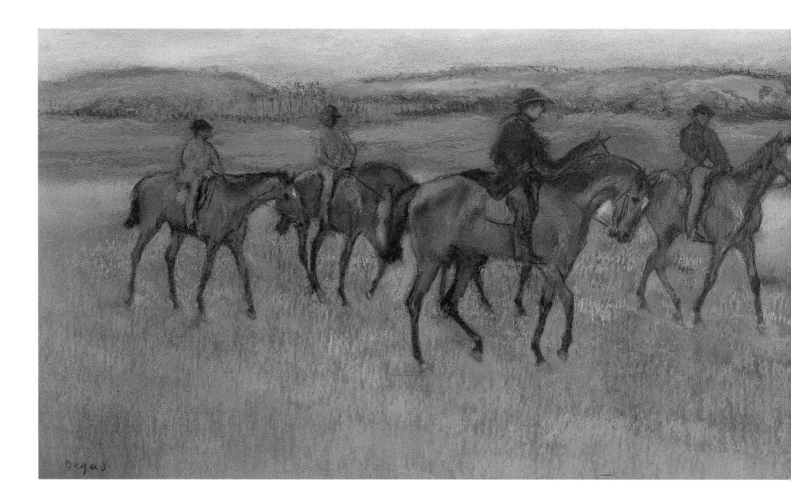

Indeed, so taken was Degas with horses that he wrote a sonnet about them entitled "Pure Bred":

You can hear him coming, his pace checked by the bit,
His breath strong and sound. Ever since dawn
The groom has been putting him through his paces
And the brave colt, galloping, cuts through the dew.
. .
Nonchalant and diffident, with slow-seeming step,
He returns home for oats. He is ready.
Now, all at once, the gambler grabs him.
And for the various games where he's used for gain
He's forced onto the field for his debut as a thief,
All nervously naked in his dress of silk.[5]

While the poem attests to Degas's sincere concern for the noble animal, *Exercising Racehorses* expresses it with an eloquence his words cannot match.

NOTES

1 The wax sculptures Degas made for study purposes were cast in bronze after his death (see previous entry, note 1). On the bronze horses, see Daphne S. Barbour and Shelley G. Sturman, "Horses in Wax and Bronze," in Jean Sutherland Boggs, *Degas at the Races*, exh. cat. (Washington, D.C.: National Gallery of Art, 1998), 180–207.

2 Boggs, *Degas at the Races*, 7.

3 Boggs, *Degas at the Races*, 18–21.

4 See Boggs, *Degas at the Races*, 26–32.

5 Degas, "Pur Sang," in *Impressionism and Post-Impressionism, 1874–1904*, ed. Linda Nochlin (Englewood Cliffs, N.J.: Prentice-Hall, 1966), 68.

PIERRE PUVIS DE CHAVANNES
French, 1824–1898

44 *The Poor Fisherman*

Oil on canvas,
1879
26 × 35 7/8 in.
(66 × 91 cm)
Inv. no. 3324

PIERRE PUVIS DE CHAVANNES is best known as a painter of decorative, allegorical murals in French public buildings such as the Hôtel de Ville in Paris and the Musée des Beaux-Arts in Lyons; he also produced murals for the Boston Public Library.[1] Puvis was an unusual figure in the late-nineteenth-century French art world, heralded by both the official art establishment and avant-garde artists. His hybridizing style combined classical elements with more distinctly modern ones. He emulated early Italian Renaissance frescoes, as well as French forebears, such as Nicolas Poussin (cat. 1) and Jean-Auguste-Dominique Ingres (cat. 20). Likewise, he was admired by such contemporaries as Edgar Degas (cats. 42 and 43), Paul Gauguin (cats. 52–54), Maurice Denis (cat. 59), and Georges Seurat—though he had detractors as well, such as Camille Pissarro (cats. 40 and 41), who deemed Puvis's work "cold and tiresome."[2]

In 1879, Puvis began to work on a large-scale painting called *The Poor Fisherman* (1881, Musée d'Orsay, Paris, 61 × 75¾ in. [155 × 192.5 cm.]), a project that would occupy him for two years. The Pushkin version of *The Poor Fisherman* is one of many preliminary works that Puvis produced as he developed his concept for the large-scale finished version, which was exhibited at the Salon of 1881. This oil sketch maps out essential features of Puvis's treatment of the landscape and the figures, as well as chromatic and tonal relationships.

The fisherman's boat is moored at the shore. A baby sleeps on the bank while a young girl picks flowers. This family, bereft of a wife and mother, occupies distinct zones of the composition, each absorbed in an isolated activity.[3] Though facial features aren't described in the sketch, gestures and poses convey the narrative mood. The thin fisherman stands erect, his arms clasped as if in prayer. The girl picking flowers in the otherwise bleak landscape seems oblivious to her father and infant brother. The flowers provide the only respite from the otherwise melancholy tone of the work. The vast expanse of water stretching back to the horizon suggests an insurmountable challenge for the fisherman, equipped only with his small boat—and resigned faith.

Scholar Aimée Brown Price has argued that *The Poor Fisherman* (1881, Musée d'Orsay, Paris) is a "simple, powerful and elusive painting and one of Puvis de Chavannes's most profoundly original images" and that it "reveals the power of Puvis's invention and secures his place in the development of modernism."[4] Puvis was nervous, however, about submitting the work to the Salon in 1881. He tried to withdraw it, in fact, "for he feared a critical thrashing, 'that I don't merit since I would have been the first to condemn myself. Nothing can give an idea of how this kind of painting jars in the ensemble of the others, which doesn't at all modify the feeling it can contain, some boob's first sentiment will surely be repulsion and there's no need to put it to the test.'"[5]

As it happened, *The Poor Fisherman* was purchased by the State, a move that thoroughly surprised Puvis, who didn't consider the work a "museum painting."[6]

The theme of fishing and fishermen occurs in Puvis's work as early as the 1850s and into the 1890s (for example, *The Fisherman's Family,* 1887, Art Institute of Chicago; *The Poor Fisherman,* 1887–92, National Museum of Western Art, Tokyo). Puvis's representations of poor, humble fishermen suggest his empathy for them. In fact, he commented in 1881 that the "true poor people, damn it, are invisible." Puvis's choice to depict socially and economically marginal figures aligns him with the great Realist painter and champion of the rural and disenfranchised, Jean-François Millet (cat. 26). Puvis's fisherman resembles the praying peasant in Millet's *Angelus* (1859, Musée d'Orsay, Paris).[7] Indeed, the poignant struggle Puvis describes in *The Poor Fisherman* is timeless and universal.[8]

NOTES

1 On the aesthetic, social, and political meanings of Puvis's murals, see Jennifer L. Shaw, "Imagining the Motherland: Puvis de Chavannes, Modernism, and the Fantasy of France," *Art Bulletin* 79, no. 4 (1997): 586–610.

2 Robert Rosenblum, *Paintings in the Musée d'Orsay* (New York: Stewart, Tabori, and Chang, 1989), 72; Camille Pissarro, "Letter to Lucien, 21 November 1895," in *Art in Theory, 1815–1900,* ed. Charles Harrison, Paul Wood, and Jason Gaiger (Oxford: Blackwell, 1998), 974.

3 Puvis identified the girl as the fisherman's daughter and saw her as vital to the meaning of the work. Aimée Brown Price, *Pierre Puvis de Chavannes,* exh. cat. (Amsterdam: Van Gogh Museum; Zwolle: Waanders, 1994), 49.

4 Price, *Puvis de Chavannes,* 45. For an extensive discussion of *The Poor Fisherman* (1881, Musée d'Orsay, Paris) and related works, see "The Poor Fisherman: A Painting in Context" in Price, *Puvis de Chavannes,* 45–53.

5 Price, *Puvis de Chavannes,* 46.

6 Price, *Puvis de Chavannes,* 46. Ironically, because this was the work on view, it was also Puvis's best-known work and the one that inspired the younger generation: Paul Gauguin, Maurice Denis, and the Nabis.

7 Furthermore, the image evokes Christian themes, relating to Christ's role as a fisher of men; Price, *Puvis de Chavannes,* 47–48.

8 See Claudine Mitchell, "Time and the Idea of Patriarchy in the Pastorals of Puvis de Chavannes," *Art History* 10, no. 2 (1987): 188–202.

JULES BASTIEN-LEPAGE
French, 1848–1884

45 *The Village Lovers*

Oil on canvas,
1882
76 3/8 × 70 7/8 in.
(194 × 180 cm)
Signed and dated:
J. Bastien-Lepage
Damvillers 1882
Inv. no. 3482

IN *The Village Lovers,* Jules Bastien-Lepage portrays his human subjects with almost photographic realism. Rather than idealizing these amorous young peasants, he shows them as authentic, humble, rural folk—the man in torn chaps and muddy boots, and the woman in a simple frock.[1] Their intimacy does not depend on fancy dress or elegant diversions but instead thrives on simple gestures and quiet moments. The ruggedly handsome young man has just given his beloved (perhaps his betrothed) a flower. The young woman contemplates the flower as she leans toward her suitor.

The lovers are literally and metaphorically separated by a fence, which presumably will be traversed once they formalize their relationship through marriage. Despite this nod to convention, however, the lovers' mood is anything but formal: their physical proximity suggests trust and ease, even though they do not look directly at one another. Instead, the young man concentrates intently on cleaning a fingernail—an awkward, thoroughly mundane gesture that Bastien-Lepage has recorded with the attentiveness of an anthropologist.

While the figures of the man and his betrothed give focus to and anchor the composition, the setting in which they shyly flirt is equally important. Bastien-Lepage painted *The Village Lovers* in his hometown, Damvillers, in the northeast of France, and this region is recognizable in the carefully described examples of local flowers, vegetables, and foliage that envelop the figures. Flanking the young man is a beanstalk boasting a generous yield; in the middle ground, a person—perhaps the girl's father—works

in the garden. These reminders of the fecundity of nature suggest a happy future for this young pair. That such a future requires marriage is underscored by the church steeple that looms beyond the low horizontal buildings along the skyline, a reminder that this couple, presently enjoying a private moment, will one day join together publicly in a celebration attended by the whole community.

The painting's emphasis on peasant life situates it squarely in the tradition of French Realism, a movement that preceded Impressionism and endured until the end of the nineteenth century. Bastien-Lepage began painting rural scenes in the 1870s, when he decided to dedicate his energies to his "corner of the earth," explaining that "nothing is good but truth. I come from a village in Lorraine. I mean first of all to paint the peasants and landscapes of my home as they really are."[2]

While his subject matter recalls works by Gustave Courbet and Jean-François Millet (cats. 26 and 27), Bastien-Lepage's painting technique owes a debt to the more conservative academic practices that he learned as a student of Alexandre Cabanel at the École des Beaux-Arts beginning in 1868.[3] Thus, while his Realist and Impressionist contemporaries emphasized avant-garde painting techniques such as the thick and rapid application of paint to canvas, Bastien-Lepage favored a highly naturalistic style in which brushwork is nearly invisible.[4]

Indeed, even though Bastien-Lepage diverged from the academic preference for subjects drawn from ancient history, mythology, and religion, his adherence to academic style guaranteed him warm

receptions at the official Salon exhibitions. So successfully did he combine these seemingly divergent artistic trends that his mastery of rural settings and sentimental subjects made him wildly popular with Parisian Salon audiences, as well as with audiences in Britain.[5] Much of his fame resulted from his keen awareness of his audience's taste for sentimentality. Before he began to paint *The Village Lovers* he announced to his British admirers: "I am going to paint a picture which shall satisfy you sentimental English with all your *sensiblerie*. I will paint a village tryst—lovers meeting; even the sky shall be sentimental." In response, the British *Magazine of Art* found the work to be a "canvas which is completely a picture. And it has the most important quality: sentiment."[6]

Bastien-Lepage's paintings were frequently issued as prints; the year following its positive reception at the Salon of 1883, *The Village Lovers* was reproduced in the newspaper *La Presse illustrée* and characterized as the "famous canvas of Bastien-Lepage," rendered with "poetic realism."[7]

NOTES

1 James Thompson, *The Peasant in French Nineteenth-Century Art*, exh. cat. (Dublin: Douglas Hyde Gallery, Trinity College, 1980).

2 William Feldman, *Jules Bastien-Lepage, Damvillers 1848–Paris 1884*, exh. cat. (Verdun, France: Musée de la Princerie, 1984), 112.

3 Gabriel Weisberg, *The Realist Tradition: French Painting and Drawing, 1830–1900*, exh. cat. (Bloomington: Indiana University Press, in association with the Cleveland Museum of Art), 269.

4 Gabriel Weisberg, *Beyond Impressionism: The Naturalist Impulse* (New York: Harry N. Abrams, 1992).

5 Kenneth McConkey, "The Bouguereau of the Naturalists: Bastien-Lepage and British Art," *Art History* 1, no. 3 (1978), 371–82.

6 Weisberg, *Realist Tradition,* 268.

7 Gabriel Weisberg, "Jules Breton, Jules Bastien-Lepage, and Camille Pissarro in the Context of Nineteenth-Century Peasant Painting and the Salon," *Arts Magazine* 56 (February 1982): 115–19.

ÉDOUARD MANET
French, 1832–1883

46 *The Bar*

Oil on canvas,
1882–83
28³/₈ × 36¹/₄ in.
(72 × 92 cm)
Inv. no. 3443

THE BAR was one of many paintings in which Manet depicted contemporary Parisians drinking and socializing. Café, bar, and nightclub culture were integral parts of mid-nineteenth-century Parisian life,[1] and Manet frequented such establishments for lively conversation and debate with his literary, musical, and artistic friends. So enamored was Manet of the bar theme that he kept a marble café table in his studio.

Manet's most famous nightclub scene is *Bar at the Folies-Bergère* (1881–82, Courtauld Institute Galleries, London). In it, he explores complex spatial, temporal, and social relationships as they unfold in a lavish, crowded setting and are reflected in a spectacular mirror.[2] The focal point of the work is the interaction between the barmaid and the approaching top-hatted patron. *The Bar* explores a similar transaction through a different set of pictorial devices.

Instead of the frenzy of the bar depicted in *Folies-Bergère*, the setting in the Pushkin work is one of the simple, pared-down outdoor bars that were ubiquitous in Paris. At its counter are an introspective bartender and an intoxicated patron, neither of whom acknowledges our presence, in contrast to the outward-gazing working girl who tends bar in *Folies-Bergère*. Their duality is magnified by the play of doubles in the composition: two figures, two glasses, two wine bottles, two horizontal surfaces. A tree divides the work asymmetrically and establishes its outdoor setting.

As the bartender—identifiable by the blue shirt typical of his profession—smokes his pipe and gazes absentmindedly into the distance, the patron slumps on the bar. Apparently this man has emptied the glasses in front of him, as well as those on the table in the foreground—and perhaps others that we do not see. So profoundly has he overindulged that he is

reduced to a faceless figure. We see only his back, his rumpled white shirt, and the white cap that covers his head, clothing that provides clues to this man's likely social and class status as a manual laborer. That he is a drunken manual laborer speaks to a broader social problem, for while it was considered safer to drink wine rather than water in nineteenth-century France, excessive alcohol consumption was a significant public health concern.[3] Yet Manet's view of this common scenario is far from judgmental; indeed, he records the man's inebriation with the documentary impartiality of a journalist.

He used a similar strategy in his numerous scenes of Parisian life, whose diverse aspects and socioeconomic echelons fascinated him endlessly. He painted street singers as well as elegant concerts, middle-class couples at leisure as well as working-class women subsisting as barmaids or prostitutes, and contemporary tragedies as well as simple still lifes, genre scenes, and portraits. And he was just as interested in tradition as he was in the contemporary moment.

Manet was trained in the studio of Thomas Couture (cat. 24), but his true masters were the great painters of the past. As a young man he honed his craft directly from the canvases he copied in the Louvre and in other great museums. The artists Manet admired most were Titian, Giorgione, Diego Velázquez, Rembrandt, Peter Paul Rubens, Frans Hals, Francisco de Goya, and Eugène Delacroix.[4] He consistently referenced their works in his art, updating them in novel ways. His controversial *Déjeuner sur l'Herbe* (1862, Musée d'Orsay, Paris), for example, cast the bohemians and their muses of Giorgione's *Fête Champêtre* (1508, Musée du Louvre, Paris) as contemporary urban Parisians. And *Olympia* (1863, Musée d'Orsay, Paris) presented

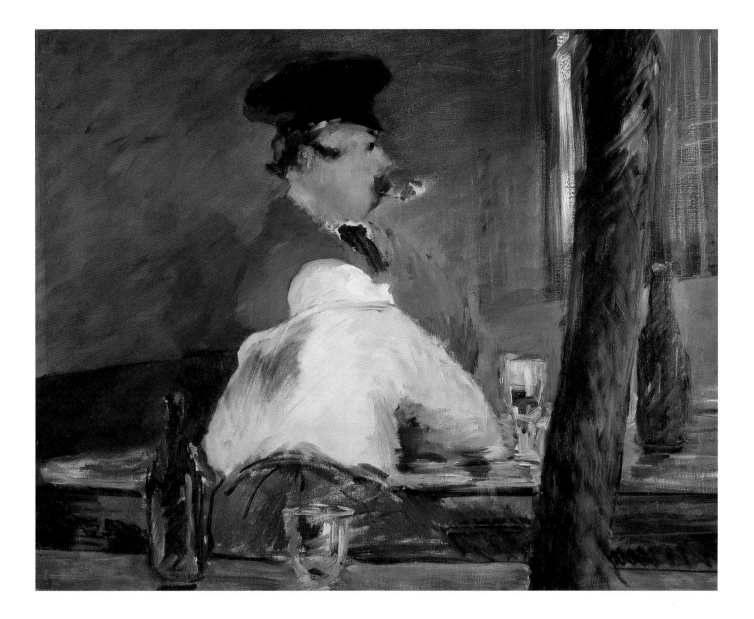

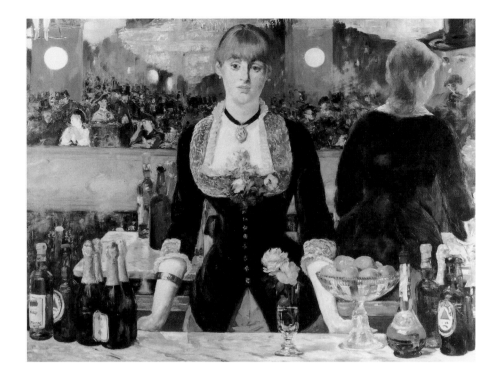

Édouard Manet.
Bar at the Folies-Bergère. 1881–82.
Oil on canvas,
37 1/2 × 51 in.
(80 × 129.5 cm).
Courtauld Institute,
London.
© Foto Marburg/
Art Resource, N.Y.

Titian's chaste *Venus of Urbino* as a modern prostitute. Manet's cleverness, however, was lost on his critics. Rather than praising him for his originality, they lambasted his paintings—both subject matter and technique.[5]

Stylistically, Manet's ties were closest to the Impressionists. Like them, he painted contemporary subjects in a vigorously anti-academic manner characterized by loose painterly brushstrokes, such as those evident in *The Bar.* This departure from the accepted academic mode often excluded Manet and his avant-garde comrades from the official Salons of the 1860s and 1870s. Manet's close friends Edgar Degas (cats. 42 and 43) and Claude Monet (cats. 34–37) responded to these institutional rebukes by launching the first "Impressionist" exhibition in 1874.

In spite of his close social and artistic ties to the group, Manet never exhibited in these Impressionist shows. Instead, he continued to seek acceptance from the official Salon, for he yearned for a place in the canon of French painting. Official recognition, however, eluded Manet during his lifetime, even though he was championed by his fellow artists, as well as by writers like Émile Zola, Charles Baudelaire, and Stéphane Mallarmé, as an avant-garde hero.

NOTES

1 Barbara Stern Shapiro, ed., *Pleasures of Paris: Daumier to Picasso*, exh. cat. (Boston: Museum of Fine Arts, 1991).

2 On this painting, see T. J. Clark, *The Painting of Modern Life: Paris in the Art of Manet and His Followers* (Princeton: Princeton University Press, 1984), 205–58; Bradford R. Collins, ed., *Twelve Views of Manet's Bar* (Princeton: Princeton University Press, 1996); and Ruth E. Iskin, "Selling, Seduction, and Soliciting the Eye: Manet's *Bar at the Folies-Bergère*," *Art Bulletin* 77, no. 1 (1995): 25–44.

3 See essay by Susanna Barrows in Shapiro, *Pleasures of Paris*, 17–26; see also Susanna Barrows and Robin Room, eds., *Drinking: Behavior and Belief in Modern History* (Berkeley: University of California Press, 1991).

4 See Anne Coffin Hanson, *Manet and the Modern Tradition* (New Haven: Yale University Press, 1977).

5 See George Heard Hamilton, *Manet and His Critics* (New Haven: Yale University Press, 1986), 38–80.

HENRI DE TOULOUSE-LAUTREC
French, 1864–1901

47 *Woman by a Window*

Tempera on card-
board, 1889
28 × 18½ in.
(71 × 47 cm)
Signed: *T-Lautrec/
89*
Inv. no. 3288

A FLAMBOYANT participant in Parisian Belle Époque nightlife, Henri de Toulouse-Lautrec drew on themes of entertainment to make his mark on the avant-garde art world. A scion of an aristocratic family from provincial Albi, Toulouse-Lautrec pursued a bohemian life in the capital. He settled in the arts district of Montmartre, frequenting its cafés, dance halls, circuses, and brothels, and making these subjects staples of his artistic production.[1] The critic Gustave Geffroy characterized Toulouse-Lautrec's images of "dance halls, brothel interiors and unnatural liaisons" as "brashly humorous and cruel" and, thirteen years after the artist's death, remarked on Toulouse-Lautrec's legacy as "the quintessential chronicler of Paris, as it is understood by those who come here seeking bright lights and wild pleasures."[2]

Toulouse-Lautrec studied alongside Vincent van Gogh (cats. 50 and 51) and Émile Bernard in the private studios of the painters Léon Bonnat and Fernand Cormon; his influences, however, extended beyond the boundaries of these milieus. He admired the linear style and formal strategies of Edgar Degas (cats. 42 and 43), and, like Degas, gravitated to subjects from the world of performance and entertainment. He also worked as an illustrator and printmaker, an occupation that, for many scholars, establishes Toulouse-Lautrec as an heir to the legacy of the great lithographer Honoré Daumier.[3]

During the 1890s, Toulouse-Lautrec was a key collaborator on such magazines as *La Revue blanche*. He also produced posters advertising Les Ambassadeurs, the Moulin Rouge, and other famous dance halls, as well as star performers like Jane d'Avril and La Goulue.[4] His extensive graphic production included book, magazine, and newspaper illustrations, as well as menus and theater programs.[5] And his style, rooted in the practice of drawing, according to one observer, produced images that were "badly painted [but] acutely drawn."[6]

Toulouse-Lautrec's background as a commercial artist is evident in the expert draughtsmanship of *Woman by a Window*, a small tempera sketch that is most likely a study for a major figure in *Moulin de la Galette* (1889, Art Institute of Chicago).[7] Its subject is a woman in profile, loosely rendered in unblended, unconventional colors. Dark blue pigment describes her upswept hairstyle, whose sheen is suggested by lighter blue highlights; pinks, reds, and mauves accent her collar, which offsets and frames her head. Larger areas of dark blue signify her dress, which becomes increasingly schematized below its cinched waist. The woman's face, shown in profile, is the most finished part of the composition. She may be Jeanne Fontaine, a young woman whom Toulouse-Lautrec frequently employed as a model. Although her identity has not been firmly established, Toulouse-Lautrec has represented this woman as a unique individual, capturing the particularities of her broad right cheek, upturned nose, and close-lipped, slightly smirking smile. When *Moulin de la Galette* was exhibited in 1889, the critic Félix Fénéon characterized the woman in profile as a "pretty . . . young prostitute in a smart collar, [with] mischievous eyes a little clouded by alcohol."[8] The space the woman occupies is ambiguous. She appears to be seated at a table, whose top and edges are suggested only faintly by

Henri de Toulouse-Lautrec. *Moulin de la Galette.* 1889. Oil on canvas, 34⁷/₈ × 39⁷/₈ in. (88.5 × 101.3 cm). The Art Institute of Chicago. The Mr. and Mrs. Lewis Larned Coburn Memorial Collection, 1933.458.

horizontal bands of yellow pigment. This highly abbreviated surface is all that separates the woman from the wall, which itself is a series of flat, dense areas of blue into which is set a window, its panes— as well as the light shining through them—described by broad strokes of yellow, pink, and blue. An empty chair occupies the compressed space between the woman and this wall, implying that she is alone only momentarily and that her companion perhaps approaches from outside the frame, just beyond her gaze.

While many of Toulouse-Lautrec's works— including the finished painting for which this is a study—emphasize the frenetic energy of Paris and its public spaces, *Woman by a Window* offers a moment of stillness. And although Toulouse-Lautrec developed a graphic style to communicate such energy, here he uses this style to capture his subject in a contemplative moment. Dancers, singers, drinkers, and observers fill the space and animate *Moulin de la Galette,* but the woman in profile, seated at the far left, still seems profoundly alone.

NOTES

1 On Toulouse-Lautrec's circus images see Marcus Verhagen, "Whipstrokes," *Representations*, no. 58 (1997): 115–40; on the cultural milieu of fin-de-siècle Paris in which he worked, see David Sweetman, *Explosive Acts: Toulouse-Lautrec, Oscar Wilde, Félix Fénéon and the Art and Anarchy of the Fin de Siècle* (New York: Simon and Schuster, 1999).

2 Gustave Geffroy, "Toulouse-Lautrec, boulevard Montmartre," *La Justice*, 15 February 1893; and "Henri de Toulouse-Lautrec, 1864–1901," *Gazette des Beaux-Arts* 4, no. 12 (1914): 89–104, reprinted in Marianne Ryan, ed., *Toulouse-Lautrec*, exh. cat. (London: Hayward Gallery, in association with South Bank Centre, London, 1991), 13.

3 Background information from H. H. Arnason and Marla Prather, eds., *History of Modern Art*, 4th ed. (New York: Prentice Hall and Harry N. Abrams, 1998), 89.

4 Ebria Feinblatt, *Toulouse Lautrec and His Contemporaries: Posters of the Belle Époque*, exh. cat. (Los Angeles: Los Angeles County Museum of Art, 1985).

5 Edgar Peters Bowron and Mary G. Morton, *Masterworks of European Painting in the Museum of Fine Arts, Houston* (Princeton, N.J.: Princeton University Press, in association with the Museum of Fine Arts, Houston, 2000), 197–98.

6 Critic Jules Christophe, "L'Exposition des artistes indépendants," *Journal des artistes*, 29 September 1889, 304–6, quoted in Ryan, *Toulouse-Lautrec*, 242.

7 On the sketch and the finished work at the Art Institute of Chicago, see Ryan, *Toulouse-Lautrec*, 242–43; and Charles F. Stuckey, *Toulouse-Lautrec: Paintings*, exh. cat. (Chicago: Art Institute of Chicago, 1979). Renoir also painted this popular dancing establishment in *Ball at the Moulin de la Galette* (1876, Musée d'Orsay, Paris). For a discussion of this work, see catalogue entry for Renoir *In the Garden* (1876, cat. 33).

8 Félix Fénéon, "Tableaux: Exposition de M. Claude Monet, Paris, Galerie Georges Petit, 8, rue de Sèze; 5e exposition de la Société des Artistes Indépendants, Paris, 84, rue de Grenelle," *La Vogue* (September 1889), reprinted in *Oeuvres plus que complètes* 1, ed. Joan U. Halperin (Geneva: Droz, 1970), 168, quoted in Ryan, *Toulouse-Lautrec*, 242.

JEAN-FRANÇOIS RAFFAËLLI
French, 1850–1924

48 *Boulevard Saint-Michel*

Oil on canvas,
c. 1890
25 1/8 × 30 1/4 in.
(64 × 77 cm)
Signed: *J. F.
Raffaëlli*
Inv. no. 3431

JEAN-FRANÇOIS RAFFAËLLI's *Boulevard Saint-Michel* belongs to the urban landscape tradition practiced by Claude Monet (see cat. 34), Camille Pissarro (see cat. 41), and Albert Marquet (see cats. 65 and 66). Like Monet and Pissarro, Raffaëlli uses architecture to create a strong sense of perspective. Yet, whereas these artists typically privileged atmosphere over detail, Raffaëlli, informed by nineteenth-century popular literature and illustrations, emphasizes the legibility of the street scene and the people who animate it.[1]

Apartment buildings lead the eye back in space to the Panthéon, the impressive domed structure that sits at the top of the rue Soufflot and dominates the background of the painting. Formerly a Catholic church, the Panthéon was desacralized during the French Revolution and now commemorates *les grands hommes de la patrie* (the great men of France). It faces the Luxembourg Gardens, which stretch along the opposite side of the boulevard, just outside the frame to the right and slightly behind our vantage point.

Despite his faithful description of Parisian geography, Raffaëlli is concerned not with landmarks but with the ordinary people who populate the sidewalks and the street. Fashionably dressed couples stroll and carriages amble along the boulevard Saint-Michel, one of the arteries of the Left Bank, lined by brightly lit cafés. Whereas his Impressionist peers would have merely suggested such figures, Raffaëlli takes pains to describe their facial features, gestures, and dress, especially in his representation of the groups in the foreground. He pays close attention to the distinctive characteristics of the ladies' hats, even registering the

flowers that decorate them. This attention to detail contrasts, however, with passages elsewhere in the painting where Raffaëlli employs the loose brushwork of Impressionism. For instance, the pavement consists of long, thick strokes that capture the light reflecting off the boulevard's surface and suggest the slickness left by a recent rain; a similar technique is used to describe the clouds hovering above.

Indeed, *Boulevard Saint-Michel* demonstrates Raffaëlli's mastery of two very different modes of representation. On one hand, he paints with the descriptive clarity of a popular illustrator. On the other, he embraces the spontaneity and expressive quality of Impressionism. This hybrid style reveals Raffaëlli's various pictorial sources, as well the techniques that informed his painting career.

At the age of fourteen, owing to his father's financial woes, Raffaëlli took his first job. He changed careers numerous times, working as a lace salesman, a dentist's assistant, a jewelry manufacturer, and a bookkeeper. He educated himself about art during lunchtime trips to the Louvre and eventually took up drawing and painting, supporting himself as a singer. Though largely self-trained, Raffaëlli successfully submitted a landscape painting to the Salon of 1870. The following year he enrolled in the École des Beaux-Arts and entered the studio of Jean-Léon Gérôme. Although Raffaëlli worked within this formal structure for only three months, the brief apprenticeship launched his artistic career.

Raffaëlli achieved success and notoriety when he exhibited a realistic portrait of a Breton peasant family at the Salon of 1877.[2] Thanks to the support of

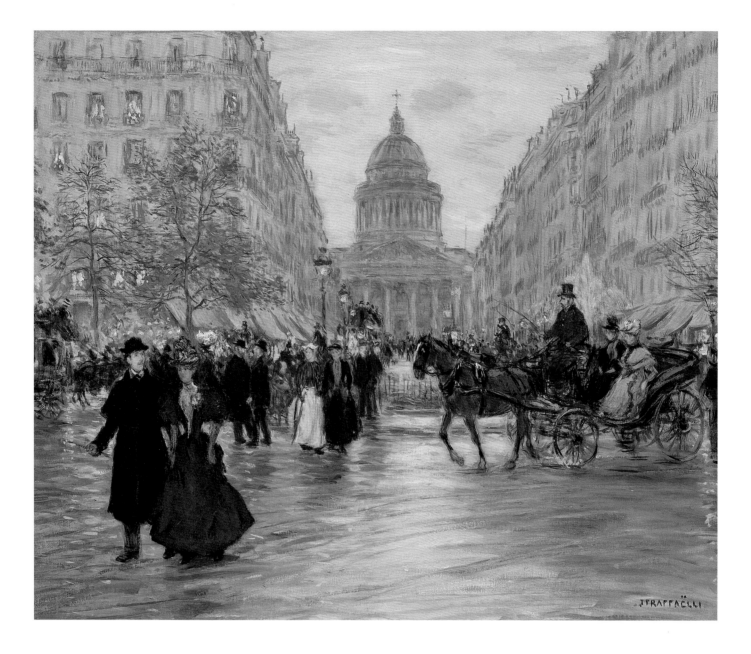

Edgar Degas, he was among a group of Realists invited to participate in the fifth and sixth Impressionist exhibitions of 1880 and 1881.[3] Later that decade he specialized in detailed observations of the disenfranchised workers who inhabited the Paris suburbs. Among these pictures was *The Absinthe Drinkers* (1881, private collection), a work that earned Raffaëlli the following positive critique: "Like Millet he is the poet of the humble. What the great master did for the fields, Raffaëlli begins to do for the modest people of Paris. He shows them as they are, more often than not stupefied by life's hardships."[4]

In the early 1890s, Raffaëlli turned his attention to the fashionable urban types who inhabited the public spaces of Paris, developing a fascination with the city's socioeconomic hierarchy that links his work to nineteenth-century French naturalist novels and popular sociological literature.[5] In an 1884 essay Raffaëlli articulated the link between his social conscience and his art, explaining that his guiding principle was that "art fulfills its descriptive and analytical function through the portrayal of . . . *caractère*."[6] *Boulevard Saint-Michel* attests to Raffaëlli's interest in human character, for the figures he depicts in the cityscape are not generic and anonymous, but identifiable individuals.

NOTES

1 Gabriel Weisberg, *The Realist Tradition: French Painting and Drawing, 1830–1900*, exh. cat. (Bloomington: Indiana University Press, in association with the Cleveland Museum of Art, 1980), 308.

2 All information about Raffaëlli's background and training is from Weisberg, *Realist Tradition*, 308. See also Barbara Schinman Fields, "Jean-François Raffaëlli (1850–1924): The Naturalist Artist" (Ph.D. diss., Columbia University, 1978).

3 The inclusion of Raffaëlli and other realist painters in these Impressionist shows caused considerable dissent. In a letter to Pissarro (who did not share the same view), Gustave Caillebotte argued vehemently against their participation. See Gustave Caillebotte, letter to Camille Pissarro, 24 January 1881, in Fronia E. Wissman, "Realists among the Impressionists," in Charles S. Moffett, ed., *The New Painting: Impressionism, 1874–1886*, exh. cat. (San Francisco: The Fine Arts Museums of San Francisco, 1986), 337. See also Joel Isaacson, *The Crisis of Impressionism, 1878–1882*, exh. cat. (Ann Arbor, Mich.: University of Michigan Museum of Art, 1979).

4 Albert Wolff, *Le Figaro*, 10 April 1881, quoted in Moffett, *New Painting*, 368. The painting is reproduced in Moffett.

5 Raffaëlli's work resonates with the fiction of Balzac, Emile Zola, and Joris Karl Huysmans, as well as with the social taxonomies of Paul de Kock and the genre of the Parisian *physiologies*. See Weisberg, *The Realist Tradition*, 307.

6 Weisberg, *The Realist Tradition*, 307. Raffaëlli's theory of "characterism," derived in part from the work of the academician Hippolyte Taine, was articulated in "Étude des mouvements de l'art moderne et du beau caractériste," in *Catalogue illustré des oeuvres de J. F. Raffaëlli exposées 28 bis, avenue de l'Opéra, 15 mars au 15 avril 1884* (Paris: n.p., 1884).

EUGÈNE CARRIÈRE

French, 1849–1906

49 *Mother's Kiss*

Oil on canvas,
c. 1890
37 × 47¼ in.
(94 × 120 cm)
Signed: *Eugène
Carrière*
Inv. no. 3444

ALTHOUGH Impressionism occupied the forefront of the French artistic avant-garde during the 1870s, the movement waned in the 1880s with the end of the independent Impressionist exhibitions. Its demise marked the beginning of a new artistic era in France, one in which artists, seeking alternative visual vocabularies, experimented with styles ranging from the Pointillism of Georges Seurat and the Neo-Impressionists to the radical experiments in form and color of Vincent van Gogh (cats. 50 and 51) and Paul Gauguin (cats. 52–54). The 1880s also witnessed the emergence of Symbolism, a loosely organized movement that attracted artists, writers, and intellectuals seeking to privilege emotion and sensation over pictorial formulas, narrative, and rational thought. Less a clearly defined style than a common, abiding interest in music, poetry, and philosophy, Symbolism accommodated artists as diverse as the abstract painters Gauguin and the Nabis (Pierre Bonnard [cats. 61 and 62], Maurice Denis [cat. 59], Édouard Vuillard [cat. 60]), and the academically trained artist Eugène Carrière.

Carrière's talents were many and varied. Like Jules Bastien-Lepage (cat. 45), he mastered academic technique in the studio of the painter Alexandre Cabanel. But he also trained as an illustrator and made mass-produced images as an employee of the late-nineteenth-century lithographer Jules Cheret. Carrière, who was a sculptor as well, worked in the Sèvres porcelain factory, where he met Auguste Rodin.[1] Eventually, however, Carrière's interest in painting overshadowed his pursuits in lithography

and sculpture, and he enjoyed great successes at the Salons of 1886 and 1887.[2]

From these vastly different experiences Carrière developed a highly personal style that fuses seemingly disparate visual modes. *Mother's Kiss* reveals an academician's grasp of realism, a lithographer's understanding of how to suggest three-dimensionality using a nearly monochromatic palette, and a sculptor's sensitivity to the volumes of the body. The painting depicts a tender moment between a mother and two daughters—the artist's wife, Sofie, and the eldest two of their five daughters. Carrière frequently depicted his family members in his work, in paintings such as *The Painter's Family* (1893) and *Intimacy* (1899) (both Musée d'Orsay, Paris).

In *Mother's Kiss*, Carrière portrays maternal love as an emotional and physical symbiosis.[3] The three female bodies carve out the space around them as they emerge, embracing, from a grayish-brown haze. The domestic sphere is only hinted at by a blurred rectangle in the distance, a form suggestive of a picture or a niche in the wall. Indeed, Carrière was interested less in anecdotal detail—so prevalent in nineteenth-century French genre painting—than in the physical expression of familial bonds.

The compositional and spatial ambiguity of *Mother's Kiss* is typical of Carrière's highly personal interpretation of Symbolism, in which "mystery," as Robert Rosenblum explained, "could be conjured up by an ambience of haze and darkness, a milieu closer to reverie and sleep, where smoky phantoms appear and vanish."[4] In his pursuit of mystery Carrière

found common ground with his friend and fellow Symbolist Gauguin, with whom he exchanged self-portraits, even though his largely monochromatic palette contrasted with Gauguin's emphasis on flat areas of color. Indeed, their shared interest in conjuring the intangible overshadows the differences in *how* Carrière and Gauguin painted; like all Symbolists, they "shared the goal of evoking nuanced, nameless emotions."[5]

For Carrière, painting was a vehicle not for expressing visual sensations but, rather, invisible, felt ones. His fascination with the intangibility of emotion was both paralleled and fueled by his admiration of the author Paul Verlaine, who, rather than seeking inspiration from classical literature or contemporary novels, relied on "fragile nuances of feeling and sensation."[6] Carrière was an intense reader of Verlaine. He wished to understand, as he put it, the "tragic sacrifice, even crucifixion, made by this man."[7] He gained access to the strength of his own emotions by exploring the bonds of love, both physical and ineffable, in depictions of his family. Thus, in *Mother's Kiss* love exists as a kind of dynamic fusion, uniting the bodies of the young girls and their mother to express visually what was undoubtedly, for the artist, a fundamentally poetic sentiment.

NOTES

1 All information about Carrière's training comes from Gabriel Weisberg, *The Realist Tradition: French Painting and Drawing, 1830–1900*, exh. cat. (Bloomington: Indiana University Press, in association with the Cleveland Museum of Art, 1980), 281. See also Robert James Bantens, *Eugène Carrière, His Work and His Influence* (Ann Arbor, Mich.: UMI Research Press, 1983).

2 Robert James Bantens, with an introduction by *Robert Rosenblum, Eugène Carrière: The Symbol of Creation* (New York: Kent, 1990), 28.

3 G. Schubert, "Women and Symbolism: Imagery and Theory," *Oxford Journal* 3 (1980): 29–34.

4 Robert Rosenblum, *Paintings in the Musée d'Orsay* (New York: Stewart, Tabori, and Chang, 1989), 538.

5 Rosenblum, *Paintings in the Musée d'Orsay*, 538.

6 Rosenblum, *Paintings in the Musée d'Orsay*, 538.

7 Bantens, *Eugène Carrière*, 14.

VINCENT VAN GOGH

Dutch, 1853–1890

50 *Portrait of Dr. Rey*

Oil on canvas,
1889
25 1/4 × 20 7/8 in.
(64 × 53 cm)
Signed and dated:
Vincent / Arles / 89
Inv. no. 3272

VINCENT VAN GOGH was innovative within the rigid conventions of portraiture.[1] As he explained in an 1890 letter to his sister, his goal was not to re-create the likeness but rather to capture the spirit of the sitter:

> What impassions me most—much, much more than all the rest of my métier—is the portrait, the modern portrait. I seek it in color. . . . I *should like* to paint portraits which would appear after a century to the people living then as apparitions. . . . I do not endeavor to achieve this by a photographic resemblance, but by means of our impassioned expressions—that is to say, using our knowledge of and our modern taste for color as a means of arriving at the expression and the intensification of the character.[2]

Van Gogh achieved this "intensification of character" in his dynamic use of decorative patterns and complementary colors in the *Portrait of Dr. Rey*, a tribute to the doctor who took care of him during his first bout with mental illness.

Van Gogh was a vital if unlikely participant in the late-nineteenth-century avant-garde. He enjoyed neither critical nor commercial success during his lifetime, and he came to painting only after he had tried—and failed at—several careers. These included working as a minister, a teacher, and an art dealer (a profession at which his brother, Theo, was far more successful). Although van Gogh abandoned these vocations to become a painter, they offered him experiences that influenced his character, for he remained empathetic toward the poor, inquisitive about the world around him, and deeply engaged with the contemporary artistic milieu.

In 1886 van Gogh left his native Holland for France, a move that would have a profound impact on modern French painting. His expressive use of color and his abbreviated yet powerful depictions of people and objects would inspire Henri Matisse (cats. 73–75) and the Fauves, as well as the German Expressionists. In Paris, van Gogh met artists both established and aspiring, including Edgar Degas (cats. 42 and 43), Paul Gauguin (cats. 52–54), Henri de Toulouse-Lautrec (cat. 47), Georges Seurat, and Paul Signac, and he nourished his passion for painting with visits to Parisian galleries and museums. He absorbed the lessons of Impressionism, recognizing that applying paint loosely with a thickly laden brush offered enormous possibilities for expressive color and technical freedom. And he was fascinated by Eugène Delacroix's dramatic use of color and Jean-François Millet's treatment of landscape and peasant themes (cat. 26). In addition, he shared the nineteenth-century French vogue for collecting Japanese woodblock prints, whose bold compositions and use of color he admired.[3] Van Gogh synthesized these diverse sources into a painting style that was uniquely his.

A sojourn to the south of France in 1888 proved to be the most fruitful period of van Gogh's career. He settled in the small town of Arles and was joined briefly by Gauguin, with whom he shared a tempestuous friendship.[4] In Arles, van Gogh embarked on a period of feverish production that continued through stays in Saint-Rémy and Auvers and lasted until his death in 1890. He capitalized on the advances of his Impressionist forebears and his post-Impressionist peers. He insisted on color as a vehicle for expression rather than description, and he exaggerated the

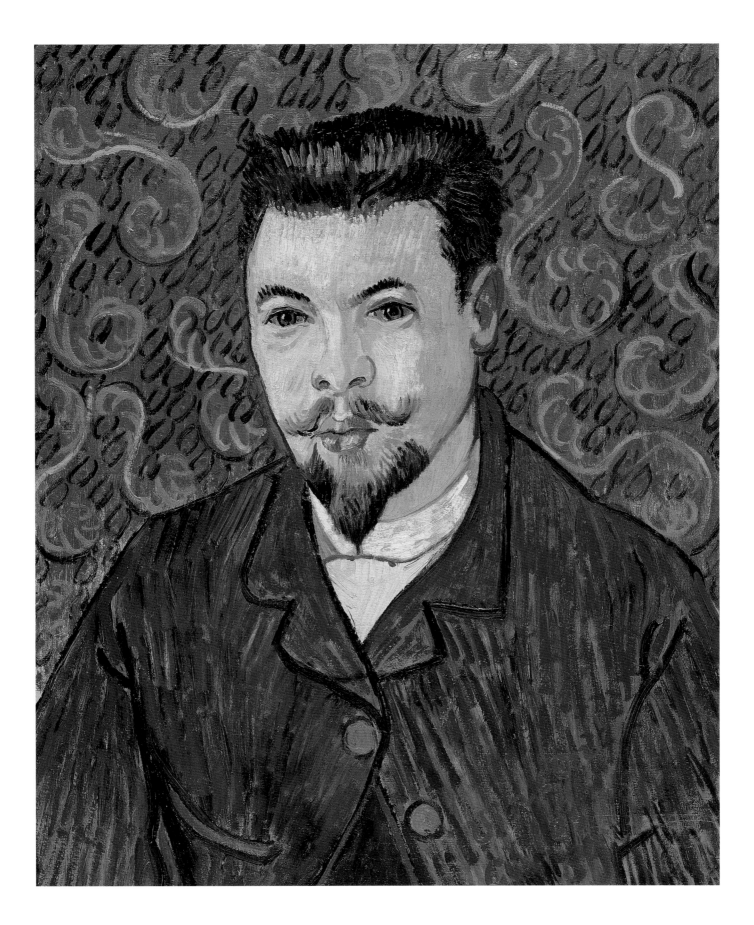

Impressionist brushstroke, transforming its small dabs into thick, almost sculptural applications of paint. Drawing on his experiences in the local community for inspiration and subject matter, van Gogh painted highly original landscapes, genre scenes, still lifes, and portraits.[5]

The *Portrait of Dr. Rey* conveys seriousness and warmth, as well as a sense of intimacy and trust. In it, van Gogh creates an animated composition through simple means. The sitter poses against a whimsical backdrop of abstract, brightly colored wallpaper and wears a blue jacket that, together with the wallpaper, frames his broad, pale face. Van Gogh's aim is not to reproduce the young doctor's appearance but instead to evoke his character, to capture his direct gaze and fastidious grooming, evidenced by his closely cropped hair and carefully trimmed moustache and beard.

Although van Gogh updates portraiture in the *Portrait of Dr. Rey,* he also demonstrates his understanding of this highly traditional genre. Van Gogh was well aware that the portraitist must convey the sitter's physical characteristics and social status; as well as express intangibles such as the sitter's fundamental psychology. Yet, whereas portraitists were typically employed by patrons, van Gogh was motivated by gratitude and painted the *Portrait of Dr. Rey* as a gift to the individual who had cared for him during his illness.[6]

NOTES

1 See George S. Keyes, Joseph J. Rishel, and George T. M. Shackelford, eds., *Van Gogh Face to Face: The Portraits,* exh. cat. (London: Thames and Hudson, in association with the Detroit Institute of Arts, 2000).

2 Vincent van Gogh, letter to Wilhemina (spring 1890), in *The Complete Letters of Vincent Van Gogh,* 3 vols. (Boston: New York Graphic Society, 1981), W22, quoted in Carol Zemel, *Van Gogh's Progress: Utopia, Modernity, and Late-Nineteenth-Century Art* (Berkeley: University of California Press, 1997), 87.

3 Tadashi Goino, *Van Gogh's Japanese Prints,* exh. cat. (Nagano, Japan: Soei, in association with the Birmingham Museum and Art Gallery, Great Britain, 1994). On the vogue for *japonisme,* see also Deborah Johnson, "Confluence and Influence: Photography and the Japanese Print in 1850," in Kermit S. Champa, *The Rise of Landscape Painting in France: Corot to Monet,* exh. cat. (Manchester, N.H.: Currier Gallery of Art, 1991), 78–97.

4 For the collaboration between van Gogh and Gauguin see Douglas Druick and Peter Kort Zegers, *Van Gogh and Gauguin: The "Studio of the South,"* exh. cat. (London: Thames and Hudson, in association with the Art Institute of Chicago, 2001). See also Bradley Collins, Jr., *Van Gogh and Gauguin: Electric Arguments and Utopian Dreams* (Scranton, Pa.: Westview, 2001).

5 For a discussion of van Gogh's work in relation to significant cultural and historical phenomena, see Zemel, *Van Gogh's Progress.* On his portraits see especially chapter 3, "Modern Citizens: Configurations of Gender in van Gogh's Portraiture," 87–133.

6 Van Gogh made his intentions clear in letters to his brother Theo, written in January 1889. See nos. 568, 569, and 571 in *The Complete Letters of Vincent van Gogh* (New York: Bulfinch, 2001). See also Keyes, *Van Gogh Face to Face,* 132.

VINCENT VAN GOGH

Dutch, 1853–1890

51 *The Prison Courtyard*

Oil on canvas,
1890
31 1/2 × 25 1/8 in.
(80 × 64 cm)
Inv. no. 3373

VAN GOGH painted *The Prison Courtyard* during his hospitalization at the Saint-Paul-de-Mausole asylum in Saint-Rémy.[1] Completed five months before his death from a self-inflicted gunshot wound, this work conveys a sense of tragic hopelessness. Thirty-three inmates, temporarily released from their cells, walk grimly in a circle defined by the dark, enclosed space of the prison courtyard, their joyless procession nominally supervised by three guards. Rising up and extending beyond the frame are impenetrable stone walls, which contain the figures in a pervasively blue world devoid of natural or man-made beauty.

Though united in their shared misery, these men are not uniformly anonymous. Some of their facial features are clearly identifiable, most notably those of the central figure, with his brilliantly illuminated shock of blond hair. He gazes directly into our space, his high cheekbones and penetrating stare bearing an uncanny resemblance to Vincent himself; indeed, this figure has been interpreted as a "metaphoric self-portrait."[2]

Van Gogh entered the hospital at Saint-Rémy in May 1889 after suffering a breakdown, the culmination of a long struggle with chronic, debilitating mental and physical illness. This episode coincided with familial and professional stresses, most specifically the quarrel with Gauguin in Arles, which effectively ended van Gogh's dream to create an artist's colony in the south.[3] With the support of his doctors van Gogh continued to paint during his stay at the Saint-Paul asylum. There he produced many works featuring the imprisoned, the exhausted, and the dying—

works that, like *The Prison Courtyard*, seem to comment on his own condition.[4]

There is no doubt that van Gogh suffered terribly from his illness. He experienced seizures and hallucinations, the cause of which have been diagnosed variously as epilepsy or some other neurological disorder; an inner-ear malady; venereal disease; a chemical or metabolic imbalance; depression; alcoholism; sunstroke—or some combination thereof.[5] He wrote to his brother Theo, however, that he painted only when he felt lucid.[6] Thus, it is a disservice to van Gogh's legacy and to the expressive power of his works to reduce his creative genius (or use of color) to his experience of illness. While *The Prison Courtyard* is undeniably grim in terms of content and tone, van Gogh's pictorial imagination was nourished by sources that extended beyond his personal circumstances.

In spite of its dark subject matter, *The Prison Courtyard* attests to van Gogh's engagement with a range of artistic sources. He admired the great seventeenth-century Dutch painters Rembrandt van Rijn (whose works he copied), Frans Hals, and Jacob van Ruisdael.[7] After he moved to France in 1886 he became committed to updating and reinterpreting the traditions of Dutch and French painting, immersing himself in French art and visual culture and broadening his artistic enthusiasms to encompass diverse styles and media.

Van Gogh was also an enthusiastic connoisseur of prints, which he had begun collecting in 1881; by the following year he had amassed a thousand pieces.[8]

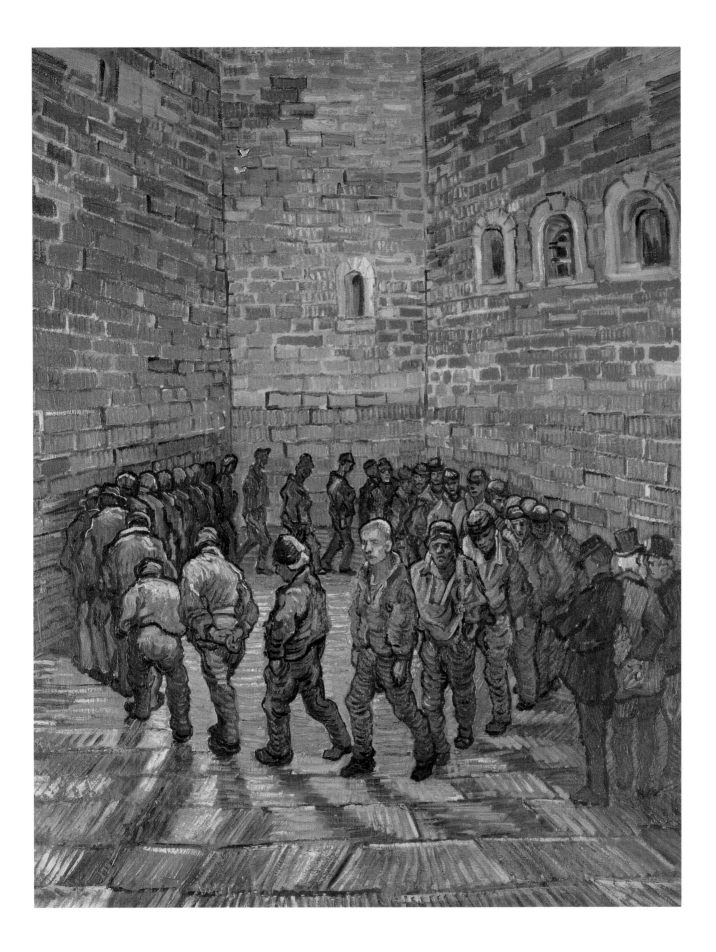

His tastes ranged from popular English and French illustrations to Japanese woodblock prints, and his holdings included works by Honoré Daumier and Paul Gavarni; he also owned, notably, Gustave Doré's *Newgate, Exercise Yard*. This wood engraving, from an unknown Dutch periodical, was an illustration for the 1872 book *London, A Pilgrimage*. It provided van Gogh with a template for *The Prison Courtyard* and, together with examples of prison imagery in his print collection, suggests an early interest in the composition and theme that he developed in the painting.[9]

First and foremost, van Gogh was a painter who painted professionally until the end of his life and engaged a broad range of artistic sources.[10] We must remember that he painted landscapes and portraits during his stay at Saint-Paul that bear no trace of darkness or tragedy—works such as *Irises* (1889, J. Paul Getty Museum, Los Angeles). In spite of his sadness and pain, van Gogh was capable of celebrating life, light, and color.

NOTES

1 Van Gogh left Auvers in May 1889 and was admitted to the hospital, where he remained until his death on July 29, 1890. See George S. Keyes, Joseph J. Rishel, and George T. M. Shackelford, eds., *Van Gogh Face to Face: The Portraits*, exh. cat. (London: Thames and Hudson, in association with the Detroit Institute of Arts, 2000), 174.

2 Carol Zemel, *Van Gogh's Progress: Utopia, Modernity, and Late-Nineteenth-Century Art* (Berkeley: University of California Press, 1997), 165.

3 Zemel, *Van Gogh's Progress*, 165. For the quarrel between van Gogh and Gauguin, see Douglas Druick and Peter Kort Zegers, *Van Gogh and Gauguin: The "Studio of the South,"* exh. cat. (London: Thames and Hudson, in association with the Art Institute of Chicago, 2001).

4 Zemel, *Van Gogh's Progress*, 165.

5 On the range of diseases and disorders, see Wilfred Niels Arnold, *Vincent van Gogh: Chemicals, Crises, and Creativity* (Boston: Birkhäuser, 1992), 76–191.

6 Dr. Peyron confirmed van Gogh's state of mind in a letter to the artist's brother Theo: "Dear Sir, I add few words to your brother's letter to inform you that he has quite recovered from his crisis, that he has completely regained his lucidity of mind, and that he has resumed painting just as he used to do. His thoughts of suicide have disappeared, only disturbing dreams remain, but they tend to disappear too, and their intensity is less great. His appetite has returned, and he has resumed his usual mode of life." See no. 602 in *The Complete Letters of Vincent van Gogh*, vol. 3 (New York: Bulfinch, 2000), 195.

7 See George S. Keyes, "The Dutch Roots of Vincent van Gogh," in Keyes et al., *Van Gogh Face to Face*, 21–49. On van Gogh's copying, see Cornelia Homburg, *The Copy Turns Original: Vincent van Gogh and a New Approach to Traditional Art Practice* (Amsterdam: John Benjamins, 1996).

8 *Van Gogh's Sources of Inspiration: 100 Prints from His Personal Collection*, exh. cat. (Brooklyn: Brooklyn Museum, 1971), 1.

9 *Van Gogh's Sources of Inspiration*, 2. He also owned a print by Félix Régamey, "Returning from Work," no. 1 of *American Sketches: Prison Life on Blackwell's Island*.

10 This is a central argument in Zemel, *Van Gogh's Progress*.

PAUL GAUGUIN

French, 1848–1903

52 *The Flowers of France*

Oil on canvas,
1891
28 ³/₈ × 36 ¼ in.
(72 × 92 cm)
Signed and dated:
P. Gauguin / '91;
Inscribed: *Te tiare
farani*
Inv. no. 3370

IN APRIL 1891, Paul Gauguin departed from Paris and set sail for Tahiti. Artists had long been attracted to distant lands, and Gauguin was no exception. Tahiti offered him an environment and set of experiences that significantly influenced his artistic development. In terms of distance and duration, however, his artistic journey was unprecedented.[1]

Gauguin went to Tahiti in search of an unspoiled paradise, and, although the reality was far from this ideal, he persisted in representing Tahiti as he had imagined it—not only in his paintings, sculptures, and drawings, but also in his letters, journal entries, and artistic treatises.[2] Although many of the works that Gauguin completed in Tahiti have allegorical or mythological overtones, he primarily painted landscapes, genre scenes, nudes, and portraits, and his genius was to insert Tahitian subjects into these traditional Western modes.

The Flowers of France, painted during Gauguin's first months in Tahiti, combines portraiture, genre painting, and still life. On the table is a vase overflowing with flowers, which take up three-quarters of the space and relegate the human figures—a woman standing beside a boy in a hat—to the left edge of the canvas. The boy meets our gaze with a wary expression, and the woman smiles warmly and averts her eyes. The boy's arm is cropped at the edge of the canvas, a compositional technique Gauguin had learned from Edgar Degas (cats. 42 and 43).

The tropical flowers and setting offer Gauguin a vehicle for experimenting with color. The pink, mauve, and orange flowers stand out against the bright-yellow and purple background; balancing these dynamic tones are the human figures and table, which add almost sculptural solidity to the composition. Inscribed on the lowest edge of the table are the words "Te tiare farani," which translate as "the flowers of France." This title refers to still-life paintings by Gauguin's predecessors, colleagues, and friends—the artists he most admired, notably Paul Cézanne (cats. 55–58) and Édouard Manet (cat. 46).[3]

The Flowers of France was one of several works that Gauguin sent back to Paris in 1893 for an exhibition at the influential Galerie Durand-Ruel. The fact of this exhibition—together with clear references in *The Flowers of France* to French avant-garde art and artists—reveals that Gauguin, despite his isolation in Tahiti, remained intimately connected with the Parisian art world.

These ties date back to the 1870s, when Gauguin, an amateur painter, left a successful career as a stockbroker to forge his artistic identity with the Impressionists. He gained entry into the Impressionist milieu as a collector of the works of Camille Pissarro and others. His artistic debut took place at the Salon of 1876; he participated in the Impressionist exhibition of 1879 after securing a last-minute invitation from its organizers, Degas and Pissarro (cats. 40 and 41). Most likely, Gauguin's persistence and negotiating skills secured him a spot in this exhibition, for he was included only after lending three works by Pissarro.[4]

Gauguin strengthened his ties to the Impressionists and their associates by studying their work. In doing so he developed a command of painting techniques. As a self-taught artist, Gauguin was a

167

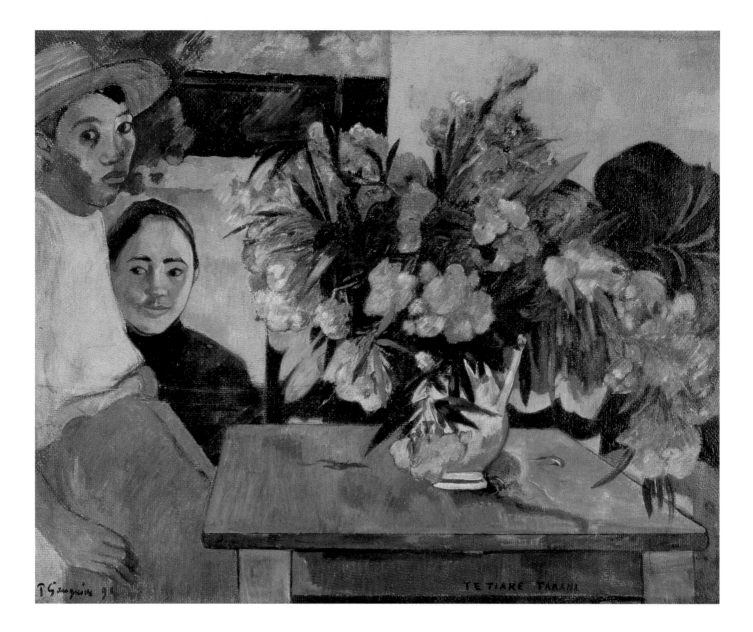

tremendous synthesizer, and he absorbed lessons from sources ranging from trailblazers like Degas, Pissarro, Cézanne, and van Gogh, to earlier avant-garde artists like Manet, to the arts of Egypt and ancient Greece, to Art Nouveau and Japanese prints.

Navigating the terrain of the late-nineteenth-century Parisian art world proved difficult for Gauguin. He struggled to support his wife and five children, and, as a result, the family moved often and separated frequently. In the end Gauguin found family life incompatible with his artistic ambitions, and he left his wife and children.

As he distanced himself from his family, Gauguin cultivated the taste for other cultures that had begun with travels in Europe and South America in his childhood and adolescence. In 1886 he lived and worked in Brittany, settling in the village of Pont Aven, and the following year he visited Panama and Martinique. In 1888 these peripatetic inclinations took Gauguin to Arles, where he formed an association with Vincent van Gogh (cats. 50 and 51). Although the well-documented turmoil between the two artists brought Gauguin back to Paris after only three months, his encounter with van Gogh was formative, for through him Gauguin achieved a new understanding of color—one that he applied brilliantly in *The Flowers of France.*

NOTES

1 Marilyn Kushner, *The Lure of Tahiti: Gauguin, His Predecessors and Followers,* exh. cat. (New Brunswick, N.J.: Jane Voorhees Zimmerli Art Museum, Rutgers University, 1988).

2 Françoise Cachin, *Gauguin: The Quest for Paradise,* trans. I. Mark (New York: Harry N. Abrams, 1992); and "Going Native: Paul Gauguin and the Invention of Primitivist Modernism" in *The Expanding Discourse: Feminism and Art History,* eds. Norma Broude and Mary D. Garrard (New York: HarperCollins, 1992), 312–29. See also Gauguin's Tahitian journal, *Noa Noa,* trans. O. F. Theis (San Francisco: Chronicle, 1994).

3 Richard R. Brettell et al., eds., *The Art of Paul Gauguin,* exh. cat. (Washington, D.C.: National Gallery of Art, 1988), 220–21.

4 Brettell et al., *Art of Paul Gauguin,* 11–12.

PAUL GAUGUIN
French, 1848–1903

53 *Eiaha Ohipa ("Do Not Work")*

Oil on canvas,
1896
25 5/8 × 29 1/2 in.
(65 × 75 cm)
Signed and dated:
P. Gauguin / '96;
Inscribed: *Eiaha
ohipa*
Inv. no. 3267

IN THE autumn of 1893, Gauguin left Tahiti and returned to France, where he stayed for nearly two years, spending time in Brittany and Paris. This was a period of intense activity for the artist. His first exhibition of Tahitian paintings, held at the Galerie Durand-Ruel in November 1893, was a commercial and critical disappointment, for the public was baffled by Gauguin's work, in part, no doubt, because he refused to translate the Tahitian titles. Although he had a few supporters—notably Degas—and although the critic Fabien Veilliard wrote a "particularly splendid article [on Gauguin] in the manner of [the Symbolist poet] Mallarmé," Gauguin realized that he must educate his Parisian audience about his art.[1]

Undeterred by the enormity of the challenge, he launched an ambitious campaign. During his twenty-two-month stay in France he published eight articles in such journals as *Le Moderniste, Essais d'art libre, Journal des artistes, Mercure de France, L'Éclair,* and *Le Soir.* He held regular soirées at his brightly painted, fabulously decorated studio, which he called Studio of the South Seas and festooned with his paintings, sculptures, objets d'art, and "flea-market exotica."[2] In 1894 he held a private exhibition there, showing unsold works from the Durand-Ruel exhibition, as well as new paintings, woodcuts, and watercolor monotypes. While sales were again anemic, Gauguin had made a mark on the Parisian avant-garde.

The burden of simultaneous creation and self-promotion took its toll. Tired of Paris and its concomitant social and economic pressures, Gauguin left France for the South Seas in July 1895, never to

return. His business interests remained in Paris, however, and Gauguin relied on friends and associates to manage his affairs.[3]

Upon his return to Polynesia, Gauguin painted *Eiaha Ohipa* (also known as *Tahitians in a Room*), a work that presents what was, for him, a relaxing alternative to the hectic Parisian pace. In this updated version of a traditional genre scene, Gauguin focuses on the interior while showing tremendous empathy for his Tahitian models.[4] A man and a woman sit on the floor, idly passing the time while a cat sleeps at their knees. They relate to one another with casual intimacy; the man lazily smokes a cigarette. All is tranquil in this simple home, lassitude that is explained by the title, which translates as "do not work."

This domestic scene belongs to a long tradition of French genre painting. Yet unlike the earnest moralizing of works by the eighteenth-century artist Jean-Baptiste-Siméon Chardin or the racy undertones of paintings by Louis-Léopold Boilly (cats. 16 and 17), Gauguin's work is nearly devoid of narrative. Rather than "reading" the painting we experience it as voyeurs. Our presence, however, apparently does not disturb the couple, who, rather than engage in imminent melodrama, simply follow the mundane rhythms of the household.

Gauguin's emphasis on the tranquility of his subjects is mirrored here in his visual preoccupation not with action but with static forms and patterns. He delights in the solidity of the bodies, paying close attention to the sculptural volumes of legs, arms, and torsos, and employing thick outlines. A broad palette ranging from golden reds and browns to mossy

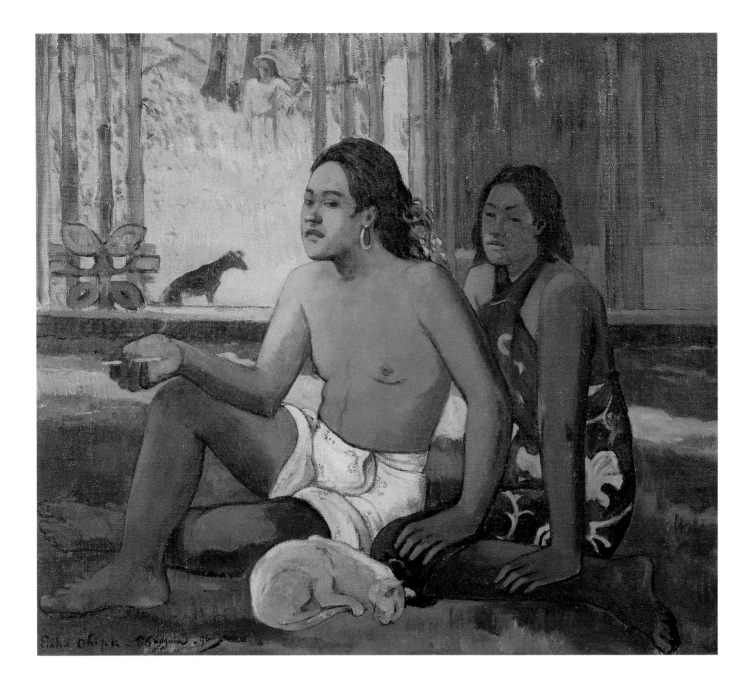

greens describes their skin, and patterning proliferates in the woman's *pareo* (a sarong made from printed cloth) and in the light and shadows cast on the floor. The vertical supports of the open window and the thick beam against the back wall create further patterning, which is in turn reiterated in the trees and the standing figure in the landscape. The torsos of the seated figures reinforce this vertical dynamic, while their extended legs echo the pronounced horizontality of the floor. As a result, the composition is stable and uncluttered, and this, together with the figures' relaxed poses, results in a brilliant evocation of the peaceful, meditative, and sensuous quality of the moment.

NOTES

1 Richard R. Brettell et al., eds., *The Art of Paul Gauguin*, exh. cat. (Washington, D.C.: National Gallery of Art, 1988), 300.

2 Brettell et al., *Art of Paul Gauguin*, 301.

3 Brettell et al., *Art of Paul Gauguin*, 389.

4 See Stephen F. Eisenman, *Gauguin's Skirt* (London: Thames and Hudson, 1997).

PAUL GAUGUIN

French, 1848–1903

54 *The Ford (The Flight)*

Oil on canvas,
1901
30 × 37 3/8 in.
(76 × 95 cm)
Signed and dated:
Paul Gauguin 1901
Inv. no. 3270

IN *The Ford*, Gauguin creates a vivid landscape by arranging four distinct bands of color in a diagonal pattern. In the distance are green, white-capped waves that crash against a pink shore demarcated by thick purple trees. In the foreground is a patch of land consisting of mottled pink, mauve, and white areas. Curving through the middle ground is a violet river.

Several figures inhabit this fantastical, stylized landscape, humans who coexist in harmony with nature. Two men, about to embark on a sea journey, work in a boat while a third pushes it into the water. Meanwhile, on solid ground, two figures on horseback traverse the iridescent landscape and approach the purple stream. A bare-chested, hooded woman in a *pareo* rides a pale horse; following her is a man on a dark brown horse, with a dog running alongside.

The hooded figure traditionally symbolizes the spirit of the dead, a theme that Gauguin also explored in *Manao Tupapao* (*Spirit of the Dead Watches*), one of his earliest Tahitian works.[1] Gauguin's use of this motif in *The Ford* has been linked to European imagery that deals with the theme of death; indeed, scholarship has shown that Gauguin mined a variety of iconographic sources. He owned a print of Albrecht Dürer's *Knight, Death, and the Devil*, a composition that, like *The Ford*, features a horse and a running dog; he also owned a print of Delacroix's *Shipwreck of Don Juan*, which may have served as a model for the hooded female rider. He was certainly also familiar with Edgar Degas's numerous images of horses (see cat. 43), and like Degas, he quotes from the Parthenon frieze. Yet far from being derivative, Gauguin is startlingly original in his appropriation

and synthesis of numerous pictorial sources in *The Ford*. Though inspired by artistic forebears from the sixteenth to the nineteenth centuries, he innovates with his bold use of color, flattening of space, and emphasis on decorative patterns. These artistic choices resonate with the works of Vincent van Gogh (cats. 50 and 51), Édouard Vuillard (cat. 60), and Henri Matisse (cats. 73–75).

Gauguin was an articulate and prolific writer. In a letter of 1899, he captured the ominous and supernatural atmosphere he would later depict in *The Ford*:

> Here near my cabin, in complete silence, amid the intoxicating perfumes of nature, I dream of violent harmonies. A delight enhanced by I know not what sacred horror I divine in the infinite. An aroma of long-vanished joy that I breathe in the present. Animal figures rigid as statues, with something indescribably solemn and religious in the rhythm of their pose, in their strange immobility. In the eyes of that dream, the troubled surface of an unfathomable enigma.[2]

Some scholars have suggested that *The Ford* represents the mythic journey between life and death, and that it points to a broader preoccupation with death in Gauguin's work following the decline in his health during his last years in Polynesia.[3]

Between his return to the South Seas in 1895 and his death in 1903, Gauguin experienced extreme financial hardship and operatic shifts in fortunes. As Richard Brettell writes, Gauguin

> was in the hospital at least four times, often for prolonged periods; claimed to have attempted suicide

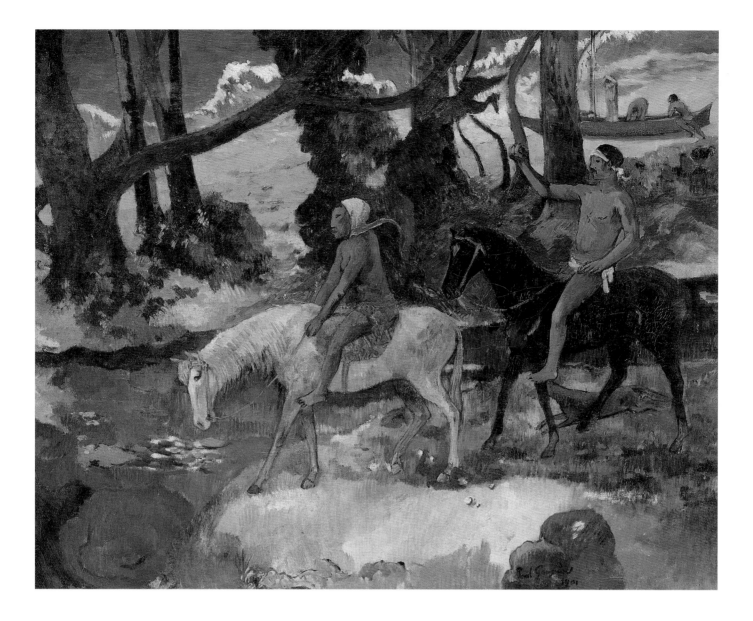

once and perhaps succumbed to his temptations in 1903; built three houses; fathered at least three children; edited one newspaper and wrote, designed and printed another; completed three book-length texts; sent paintings and drawings to many European exhibitions; finished nearly 100 paintings; made over 400 woodcuts; carved scores of pieces of wood; wrote nearly 150 letters and fought both civil and ecclesiastical authorities with all the gusto of a youth. He was only fifty-four years old when he died, but he had lived his life with such fervor and worked so hard when he was healthy that we must remember the achievements even as we read the litany of the failures and miseries.[4]

This litany of failures was redeemed after Gauguin's death in May 1903. A short time afterward, two exhibitions of his works were held in Paris. A few paintings were shown at the *Salon d'Automne*, and fifty (including this one) were on view in Gauguin's honor at the Ambroise Vollard Gallery. Three years later, *The Ford* was shown again at the *Salon d'Automne*, and an extensive retrospective at the Grand Palais celebrated this modern master's contribution to the development of French art. His example inspired a new generation of artists led by André Derain (cat. 68) and Henri Matisse (cats. 73–75).

NOTES

1 Richard R. Brettell et al., eds, *The Art of Paul Gauguin*, exh. cat. (Washington, D.C.: National Gallery of Art, 1988), 459.

2 Paul Gauguin, "Letter to Monsieur Fontainas," March 1899, in *Impressionism and Post-Impressionism, 1874–1904*, ed. Linda Nochlin (Englewood Cliffs, N.J.: Prentice-Hall, 1966), 179.

3 Brettell et al., *Art of Paul Gauguin*, 389.

4 Brettell et al., *Art of Paul Gauguin*, 459–60.

PAUL CÉZANNE
French, 1839–1906

55 *Pierrot and Harlequin*

Oil on canvas,
1888
40 × 31⅞ in.
(101.5 × 81 cm)
Inv. no. 3335

AS A young man Paul Cézanne studied law, but he abandoned the field to attend art school in Paris.[1] While studying in Paris, Cézanne forged close relationships with Claude Monet (cats. 34–37), Auguste Renoir (cats. 32 and 33), Camille Pissarro (cats. 40 and 41), and other young painters who would become known as the Impressionists. When Cézanne met with difficulties in Paris he returned to his native Aix-en-Provence to work at his father's bank. When banking proved unsatisfying he went back to Paris to resume painting. He continued this pattern of traveling between the capital and Aix throughout his career, establishing himself in Paris only to return home to discover new subjects to paint.

Beginning in the 1870s Cézanne participated in the Impressionist exhibitions, eight of which were held between 1874 and 1886, and he maintained close artistic and social ties to the group.[2] He was also deeply familiar with the traditions of European painting, and his admiration for past masters led him to unprecedented innovation.

Cézanne wished to push representation beyond the realistic depiction of the seen world to a personal translation of that world into art. From the 1860s until his death in 1906 he pursued this aim in paintings dealing with a multitude of traditional subjects, including still life, genre scenes, portraits, nudes, and landscapes, as well as the mythological, religious, historical, and literary paintings of his early career.[3]

Pierrot and Harlequin features stock characters from the commedia dell'arte, a theatrical genre that, like the circus, had captivated artists from Antoine Watteau in the early eighteenth century to Pablo

Picasso in the early twentieth (cat. 69). Cézanne recreated the commedia dell'arte in his studio, casting his teenage son Paul as Harlequin, transforming him into the beloved clown by clothing him in a red and black costume and hat, a walking stick tucked haughtily under his arm. Paul strides confidently onto the fictional "stage," which extends from the pictorial realm into our space, albeit at a raking angle created by the precipitously downward-sloping floor. Patterned drapery on the left emulates a theater curtain, from which emerges Pierrot, clad in white and "played" by young Paul's friend Louis Guillaume. Through this "performance" the painter's studio becomes an improvised theater.

Cézanne's visual interests here range from a portraitist's attention to the boys' features, expressions, and gestures to a still-life painter's love of fabrics and textures. He revels in Pierrot's voluminous white costume as a vehicle for the exploration of color: close inspection of this apparently monochromatic suit reveals that Cézanne has created its many folds and indentations through the subtle juxtaposition of varying shades of green, mauve, blue, and brown. This love of color, texture, and complex design is also evident in Cézanne's treatment of the drapery, whose rich browns, greens, and golds are echoed in the floorboards. The result of this complexity of color and patterning is a kind of visual sampler that thrives on juxtapositions.

The drapery reinforces the compositional placement of the figures. The curtain on the right swoops upward and extends into the space on the stage, echoing the forward stride of Harlequin. The billowing

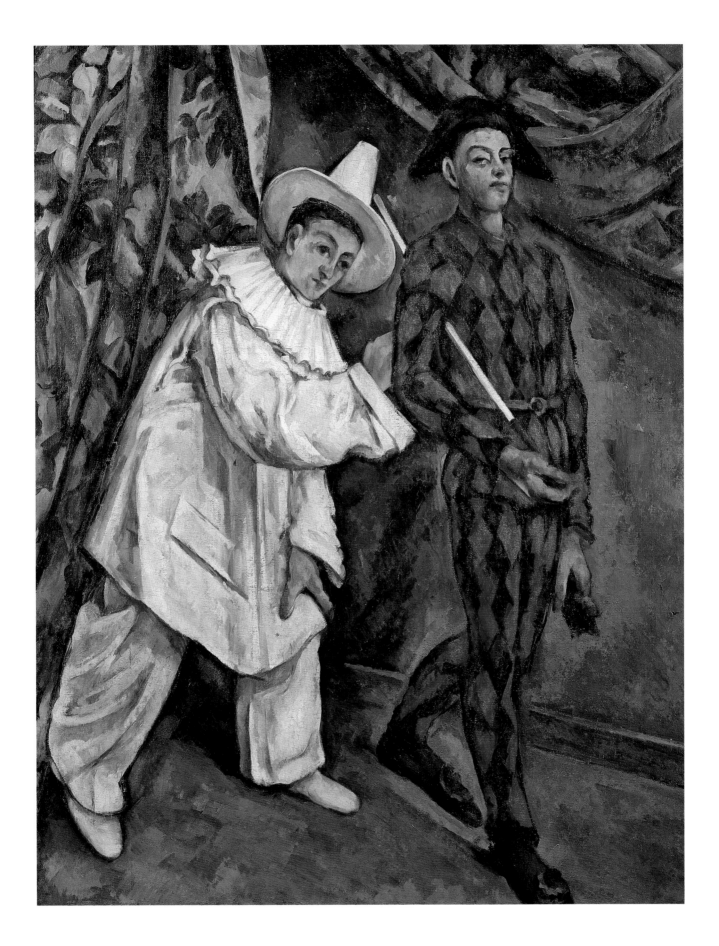

curtain on the left resonates with the more generous form of Pierrot, who remains in the background while gently nudging his companion onto the stage.

This contrived scene shares many features with Cézanne's still lifes and portraits. In it, the artist demonstrates an abiding fascination with spatial and formal relationships, and he explores a multitude of patterns and colors. Though these characters from the theater are the ostensible subject of the work, the performance at which we marvel is that of the painter.

NOTES

1 Lorenz Eitner, *An Outline of Nineteenth-Century European Painting: From David Through Cézanne* (New York: HarperCollins, 1992), 421.

2 Charles S. Moffett, *The New Painting: Impressionism, 1874–1886,* exh. cat. (San Francisco: Fine Arts Museums of San Francisco, 1986), 17–24.

3 Linda Nochlin, "Cézanne: Studies in Contrast," *Art in America* 84 (June 1996): 56–67.

PAUL CÉZANNE
French, 1839–1906

56 *The Pipe Smoker*

Oil on canvas,
1890–92
35 $\frac{1}{2}$ × 28 $\frac{3}{8}$ in.
(91 × 72 cm)
Inv. no. 3336

THE MAN in this painting recalls the figures who populate Cézanne's many representations of groups of three or four men engaged in the quiet, smoky, social activity of playing cards.[1] The setting is Cézanne's studio in Aix-en-Provence, the site of a related work, *Man with a Pipe* (1892–96, National Gallery of Art, Washington, D.C.), which shows a man with similar features in profile. Indeed, Cézanne's models, far from being professionals, were working-class citizens of Cézanne's hometown.

Supporting his head with his right arm, which rests sturdily on the table, the pipe-smoking man strikes an informal pose, re-creating in the studio the incidental gestures of someone for whom formality is reserved for special occasions. Belying this apparent casualness is the pipe in the man's mouth, which produces no smoke and thus imbues the painting with a static, unnatural quality.

Such stiffness is somehow appropriate, however, for the scene unfolds not in a café or a bar but in Cézanne's studio. An unstretched canvas (a partially visible portrait of a woman in blue) hangs on the wall; another picture leans, turned, against the wall beneath it; under the table is a portfolio. Behind the figure hangs a curtain that seems at first glance to be a canvas on which has been painted a thick, wooded landscape. This curtain, crafted from Cézanne's colors and brushes, is akin to the other painted representations in the composition: the portrait, the tablecloth, the man's suit. In many ways *The Pipe Smoker* is a meditation on the act of applying paint to a cloth support to produce an image. It is a painting about the artist's craft of seeing and transcribing the world he observes.

In *The Pipe Smoker* Cézanne plays with thematic and visual repetition. He is fascinated by the representation of cloth, and he depicts each fabric—curtain, suit, tablecloth, canvas—with a distinct yet tonally harmonious chromatic range dominated by browns, greens, and dark blues. The background of the portrait picks up the colors in the tablecloth, and the woman's dress in the painting-within-the-painting resonates with the studio walls. This arrangement of colors and patterning emphasizes the painting's two-dimensionality and thwarts it at the same time, for the curves of the flowers in the tablecloth conform to the table's hard edge, creating spatial ambiguity that anticipates Cubism.

The pose of the woman in blue complements that of the pipe smoker. Her right arm creates a gently curving arc that resolves with her hand in her lap, while the man's left arm hangs and curves, drawing the eye downward to his large hand resting on his thigh. These arm positions were most likely directed by Cézanne himself, and thus the compositional balance they create is a product not of the natural world but of the artifice produced by the painter in his studio.

The woman in blue is probably Cézanne's wife, Hortense Fiquet, with whom he had one son, Paul, in 1872. Over the course of nearly thirty years Cézanne painted forty-four portraits and made numerous drawings of Hortense.[2] This particular example may be the portrait of Madame Cézanne (c. 1885) housed at the Detroit Institute of Arts,[3] though the position of the arm and the blue dress also appear in Cézanne's *Woman with a Coffee Pot* (1890–95, Musée d'Orsay, Paris).[4] The latter is probably a por-

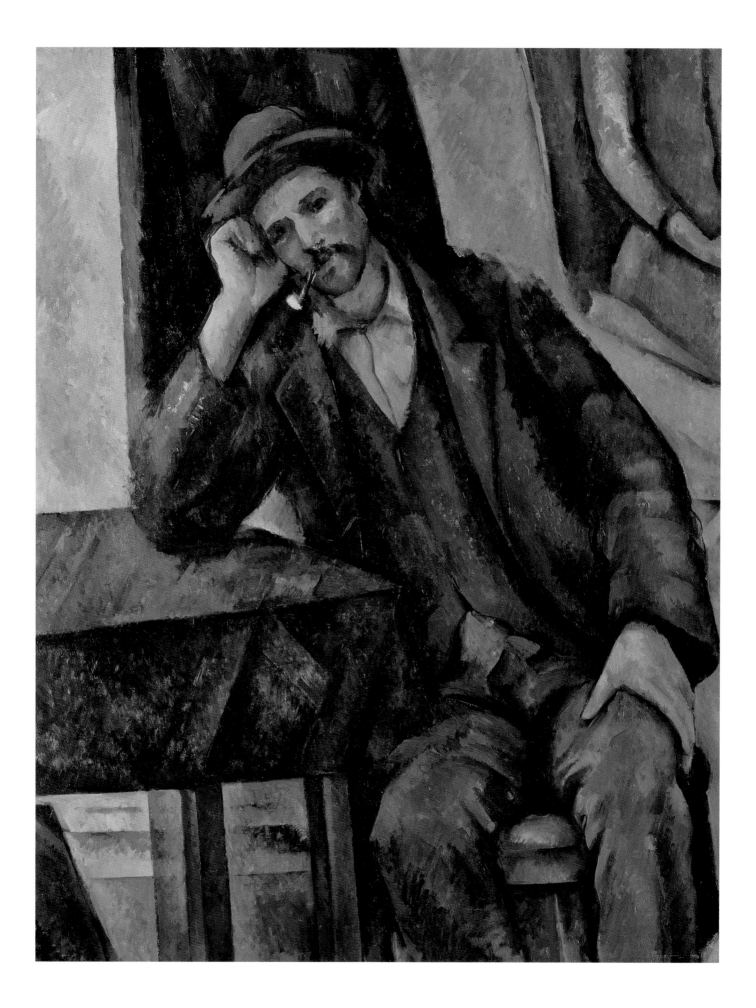

trait of a household servant, suggesting a certain consistency in the poses of Cézanne's models and pointing to the manipulations in which the artist engaged even as he reproduced their likeness.

The man with a pipe poses for Cézanne at a particular moment in time, just as the woman in blue had posed before him. We therefore imagine a progression: the posing model is transformed from a person sitting in Cézanne's studio to a representation on a canvas. The finished product will join the other canvases that hang or lean against the walls, while the pipe-smoking man will leave the studio and return to his family, his friends in the café, his vocation. The moments he spent being observed by the artist have been fixed on a canvas that is both his portrait and Cézanne's highly self-referential genre scene. By situating the pipe smoker in the private space of his studio Cézanne documents not just his subject but his own working practices.

NOTES

1 See, in particular *Card Players* (1890–92, Metropolitan Museum of Art, New York). On Cézanne's images of card players, see Joyce Medina, *Cézanne and Modernism: The Poetics of Painting* (Albany: State University of New York Press, 1995).

2 Edgar Peters Bowron and Mary G. Morton, *Masterworks of European Painting in the Museum of Fine Arts, Houston* (Princeton: Princeton University Press, in association with the Museum of Fine Arts, Houston, 2000), 170.

3 On related works see Theodore Reff, "Painting and Theory in the Final Decade," in *Cézanne: The Late Work*, exh. cat., ed. William Rubin (New York: Museum of Modern Art, 1977), 17–20.

4 Robert Rosenblum, *Paintings in the Musée d'Orsay* (New York: Stewart, Tabori, and Chang, 1989), 363. Madame Cézanne is portrayed in the same dress and a similar pose in *Madame Cézanne in Blue* (1888–90), in the collection of the Museum of Fine Arts, Houston; see Bowron and Morton, *Masterworks of French Painting*, 170.

PAUL CÉZANNE

French, 1839–1906

57　*Bathers*

Oil on canvas,
1890–94
10¼ × 15¾ in.
(26 × 40 cm)
Inv. no. 3414

CÉZANNE belongs to a long tradition of French artists who painted figures in a landscape setting. Throughout his career he explored the theme of bathers in paintings featuring groups of men and women alike.[1] But even though Cézanne was deeply familiar with and admired the traditions of European painting, he was intent on innovation. He advised fellow artists: "Go to the Louvre, but after [having] seen the Masters who hang there . . . hasten to leave and to revive in [yourself], in contact with nature, the instincts, the sensations of art that live within us."[2]

Indeed, Cézanne recognized that learning from the great art of the past was an integral part of an artist's education, and, together with Édouard Manet (cat. 46), Claude Monet (cats. 34–37), Edgar Degas (cats. 42 and 43), and other artists, he spent a great deal of time studying the treasures in the Louvre. He admired the seventeenth-century landscape painters Nicolas Poussin and Claude Lorrain (cats. 1 and 2), as well as the nineteenth-century master Camille Corot (cats. 21–23). In addition, he was indebted to Eugène Delacroix for his treatment of the human figure, particularly the nude. Yet *Bathers* does not suggest any particular precedent, for Cézanne studied the Old Masters in order to achieve a thoroughly original, thoroughly modern synthesis.[3]

In this painting, six nude male figures, differentiated only by their respective positions and gestures, bathe in a wooded glade.[4] Only two of the figures' faces are visible, yet they are represented in a blurry, almost featureless manner. Cézanne is interested in the relationship between the body and nature; just as the trees assume many forms, so too do the bodies.

These heavily delineated bodies recall Manet's nudes from the 1860s. Mottled colors, loose brushstrokes, and washes of color suggest mass and volume, while tighter and more systematic brushwork describes the landscape setting. A mosaic of short vertical strokes forms a lush carpet of greenery, the sturdy tree at left, and a veil of foliage in the distance. The viewer does not have a clear sense of spatial distance, only the gorgeous play of light in this pastoral spot.

The figures are arranged in a contrapuntal rhythm, alternating between crouched and standing positions, like opposing musical notes. The figure on the left sits, facing the viewer and bending his right knee. His left leg, in contrast, seems to disappear— but into what? Water? Marshy grasses, perhaps? This visual puzzle remains unsolved. To the left of the seated man another man stands with his back to the spectator, a towel draped over his right forearm. Echoing him is a second standing figure, who, his back also turned, stretches his arms. Between them are two more figures: one seated on the shore as his legs dangle in the water; the other approaching the shoreline, submerged in the water up to his shoulders. A short distance across the narrow body of water, a sixth man stands with his legs spread wide.

In choosing to focus on the male nude Cézanne situates himself in the tradition of French academic history painting, particularly that of the great master Jacques-Louis David (cat. 14). For David and his followers, the male nude—studied and rendered in a variety of poses—was the building block of history painting. The apex in the hierarchy of genres, history

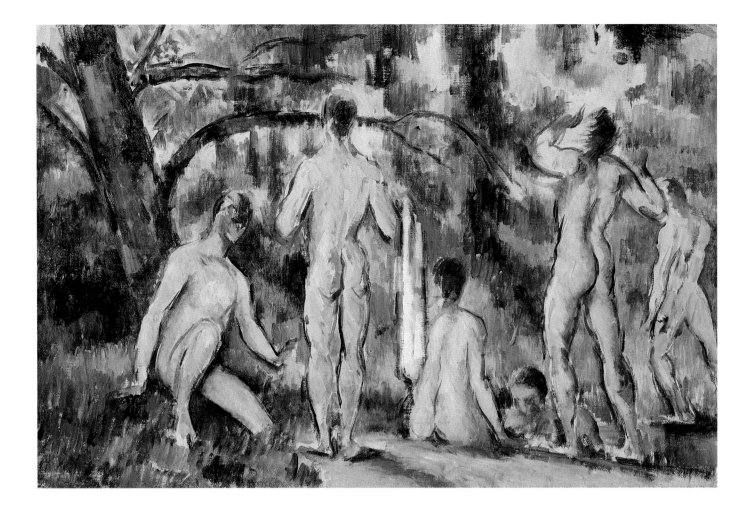

painting was based on heroic moral tales from the history and literature of ancient Greece and Rome, where brave men exhibited unwavering dedication to their principles.

In *Bathers*, Cézanne embraces this time-honored practice of using male models, yet the resulting figures express neither drama nor pathos, nor do they enact important narratives from the past. Rather, they convey the momentary pleasures of bathing in the dappled afternoon light of a timeless, bucolic place.

NOTES

1 Linda Nochlin, *Bathtime: Renoir, Cézanne, Daumier, and the Practices of Bathing in Nineteenth-Century France* (Groningen: Gerson Lectures Foundation, 1991).

2 Paul Cézanne, letter to Charles Camoin, 1903, quoted in Richard Shiff, *Cézanne and the End of Impressionism: A Study of the Theory, Technique, and Critical Evaluation of Modern Art* (Chicago: University of Chicago Press, 1984), 181.

3 Tamar Garb, "Visuality and Sexuality in Cézanne's Late Bathers," *Oxford Art Journal* 19, no. 2 (1996): 46–60.

4 For an interesting discussion of this painting, see T. J. Clark, "Freud's Cézanne," in *In Visible Touch: Modernism and Masculinity* (Chicago: University of Chicago Press, 1997), 28–51.

PAUL CÉZANNE
French, 1839–1906

58 *The Aqueduct*

Oil on canvas,
1898–1900
35 7/8 × 28 3/8 in.
(91 × 72 cm)
Inv. no. 3337

THE LANDSCAPE around Aix-en-Provence provided an endless number of subjects for Cézanne.[1] Among them was Mont Sainte-Victoire, a motif that the artist represented repeatedly.[2] This mountain looms in the distant background of *The Aqueduct,* dwarfed by the central clump of tall trees. In this painting— as well as in a related work, *Mont Sainte-Victoire* (c. 1885, Metropolitan Museum of Art, New York), Cézanne relies on the traditional landscape convention of dividing the canvas into distinct zones: foreground, middle ground, and background. He learned this technique from the masters he admired, including Claude Lorrain (cat. 2), Nicholas Poussin (cat. 1), and Camille Corot (cats. 21–23). In this work he also built on the innovations of these artists, infusing the painting with decidedly unconventional features. For example, whereas trees were traditionally used as anchoring devices, Cézanne makes them the main pictorial event. They block our view of the distance, operating between foreground and middle ground as a mediating screen. Cézanne's interest resides in the structural and geometric relationships between the sturdy verticality of the trees, the pronounced horizontality of the aqueduct in the background, and the rounded solidity of the mountain in the far distance.

Chromatic relationships reinforce these spatial ones, as Cézanne's use of color captures the specificity of the Provençal landscape.[3] Red-orange soil imbues the painting with an unmistakable sense of place: juxtaposed against the verdant trees and grass, it vividly carves out the foreground. In the background the colors are modulated, creating a kind of "atmospheric perspective." The mountain, painted

in shades of mauve, is stippled with beige tones that echo the aqueduct, which is tiny in relation to the massiveness of Mont Sainte-Victoire. The mountain itself seems to elide into the sky, which, painted in light tones where it meets the mountain, is intensely blue above the treetops.

The aqueduct stands as a monumental reminder of ancient Rome, its pervasive empire and its superior engineering. As such, this structure represents a triumph over nature, for its purpose was to bring water to places not served by natural sources. Its repeated arches recall other Roman structures, most notably triumphal arches, the Colosseum, and the Pantheon. In the painting, however, the aqueduct fits snugly into the countryside of Provence, a small part of a much larger whole. Viewed up close it would seem imposing and monumental, but from Cézanne's chosen perspective nature reigns supreme, and the aqueduct appears quaint compared to Mont Sainte-Victoire and the towering trees.

In contrast to the Impressionist practice of celebrating spontaneous brushwork and painting out-of-doors, *The Aqueduct,* along with Cézanne's other late works, reveals a different approach: the use of short, thick brushstrokes to create an intricate mosaic.[4] For Cézanne nature was a point of departure for exploring the sensations and perceptions of visual experience. In a letter to a friend he described art as a "harmony which runs parallel with nature—what is one to think of those imbeciles who say that the artist is always inferior to nature?"[5] Furthermore, Cézanne spoke of "realizing" rather than representing nature, figures, and objects, and he encouraged his fellow

185

painters to embrace geometry and adhere to traditional notions of balance. "Treat nature by the cylinder, the sphere, the cone," he wrote, "everything in proper perspective so that each side of an object or a plane is directed toward a central point."[6]

Cézanne's compositions, however, often suggest multiple viewpoints and simultaneous moments in time, a disciplined yet restrained approach that inspired the Cubists Pablo Picasso (cats. 69–71) and Georges Braque (cat. 72). Though Cézanne could not have predicted the pictorial revolutions that Cubism would initiate, he acknowledged in an 1896 letter that "perhaps I was born too early."[7] Indeed, the development of Cubism early in the twentieth century only confirms Cézanne's status as a visionary father of Modernism.

NOTES

1 Denis Coutagne, *Cézanne in Provence* (New York: Universe, 1996).

2 Robert Morris, "Cézanne's Mountains," *Critical Inquiry* 23 (Spring 1998): 814–29.

3 Pavel Machotka, *Cézanne, Landscape into Art* (New Haven: Yale University Press, 1996). On the relationship between chromatic and musical tonality, see Norman Turner, "Cézanne, Wagner, Modulation," *Journal of Aesthetics and Art Criticism* 56 (Fall 1998): 353–64.

4 Richard Shiff, "Cézanne's Blur: Approximating Cézanne," in *Framing France: The Representation of Landscape in France, 1870–1914* (New York: St. Martin's, 1998), 59–80.

5 Paul Cézanne, letter to Joachim Gasquet, 26 September 1897, in *Art in Theory: 1815–1900*, ed. Charles Harrison, Paul Wood and Jason Gaiger (Oxford: Blackwell, 1998), 992.

6 Paul Cézanne, letter to Émile Bernard, 15 April 1904, in *Impressionism and Post-Impressionism*, ed. Linda Nochlin (Englewood Cliffs, N.J.: Prentice-Hall, 1966), 91.

7 Paul Cézanne, letter to Joachim Gasquet and a young friend [not specified], 1896, in Nochlin, *Impressionism and Post-Impressionism*, 88.

MAURICE DENIS

French, 1870–1943

59 *Portrait of Marthe Denis, the Artist's Wife*

Oil on canvas,
1893
17³/₄ × 21¹/₄ in.
(45 × 54 cm)
Signed and dated:
M. O. D / '93
Inv. no. 3277

MAURICE DENIS was a central figure in the late-nineteenth-century French avant-garde. Like Pierre Bonnard (cats. 61 and 62) and Édouard Vuillard (cat. 60), he was a member of the Nabis. This group of artists derived its name from the Hebrew word for prophet and, seeking to synthesize all of the arts, made architectural panels, designs for glass and decorative screens, book and magazine illustrations, posters, stage sets, and, of course, easel paintings.[1] These artistic correspondences were also central to Symbolism, whose salient principles Denis theorized when he released art from its descriptive role. "We should remember," he wrote, "that a picture—before being a war horse, a female nude, or telling some other story, is essentially a flat surface covered with colors arranged in a particular pattern."[2]

Denis executes such patterning in *Portrait of Marthe Denis, the Artist's Wife,* whose asymmetrically and ornamentally schematized composition owes a debt to Japanese woodcuts. Denis was also inspired by the flat, decorative style of Paul Gauguin (cats. 52–54), but whereas Gauguin described his subjects using vivid colors, Denis portrayed Marthe in calmer, softly muted tones.

Denis depicts his bride, whom he married in June 1893, against the backdrop of their private garden and the town just beyond the garden wall. Though Marthe is Denis's primary subject, her portrait blends elements of genre and landscape. It therefore does not adhere to the traditional conventions of portraiture: unlike the sitters in works by Jean-Baptiste Nattier or even Pablo Picasso (cats. 11 and 70), Marthe does not gaze directly at the viewer; in fact,

she does not acknowledge her status as a sitter at all. Far from looking staged or self-conscious, Marthe exists in an incidental and spontaneous present, her demure gaze not so much averted from ours as focused on the intimate gesture of adjusting the right strap of her garment.

Marthe's dress—or perhaps it is a nightgown, or a slip—just barely covers her breasts, giving the impression that Marthe is in the process of getting dressed—or undressed. Like Bonnard in *Mirror Above a Washstand* (cat. 61), Denis immortalizes his wife in an intimate, quotidian ritual and in this way isolates a private moment from his domestic life.

Marthe's face forms a perfect oval, which is reiterated in the curve of her breasts and the graceful arcs of her right arm. The soft contours of her body contrast with the angularity of the space behind her. She is separated from the garden by a ledge, which demarcates the interior from the exterior space. In the garden behind Marthe is a black-clad figure hanging a sheet on a clothesline. Another figure reaches in to help, but only her arm is visible, for Denis has, like Edgar Degas (cats. 42 and 43), cropped the rest of her body by the frame. Towering over these figures are three trees, which lead our eye back to a vine-filled trellis and a mustard-colored wall. This wall encloses the garden and the home; rising up beyond it is a mass of brown trees. In the far distance are the yellow buildings of the town, and stylized pink clouds— echoing the color of Marthe's cheeks and forehead— float and waft in an azure sky. Directly behind Marthe a large pine tree divides the composition; in spite of this bifurcation, her body bridges both sides.

According to Denis's pictorial logic, Marthe unifies all the elements in the painting: home and garden, the natural and the built environment.[3] Indeed, *Portrait of Marthe Denis* imbues the rhythms of the artist's newly established household with the quality of a dream. In it, Marthe is the central allegory—not only of the domestic sphere, but of the erotic rituals of newlyweds as well.

NOTES

1 H. H. Arnason and Marla F. Prather, *History of Modern Art*, 4th ed. (New York: Prentice Hall and Harry N. Abrams, 1998), 85–88.

2 Maurice Denis, *Théories, 1890–1910: Du symbolisme et de Gauguin vers un nouvel ordre classique*, 3rd ed. (Paris, 1913), 1–12, in *Art in Theory, 1815–1900*, ed. Charles Harrison, Paul Wood and Jason Gaiger (Oxford: Blackwell, 1998), 863.

3 For Marthe's role in Denis's art, see Jean-Paul Bouillon, *Maurice Denis* (Geneva: Skira, 1993).

ÉDOUARD VUILLARD
French, 1868–1940

60 *Interior*

Oil on pasteboard,
1904
19 5/8 × 30 1/4 in.
(50 × 77 cm)
Inv. no. 3366

THE HISTORY of private life is not one of epic battles, political conflicts, or nature's fury. Rather, it is one that opens a window onto the rhythms and rituals that define cultural identity. In the nineteenth and early twentieth centuries, visual and literary representations of the home complemented images of the street and the café, for artists and writers were well aware that cultural life unfolded not only in public, civic spaces, but also in the domestic realm.[1]

This domain offered the painter Édouard Vuillard an inexhaustible range of thematic and visual possibilities.[2] He began focusing on the home in his art during the 1890s, depicting interiors and populating them with his friends and family.[3] He was also commissioned to paint wall panels and screens intended for private spaces.[4] And, like Pierre Bonnard (cats. 61 and 62) and Maurice Denis (cat. 59), he was a member of the Nabis, a group of artists who sought an aesthetic unity of color and decoration.

In *Interior*, five figures sit quietly in a room copiously appointed with intricate floral designs. Vuillard takes pleasure in the patterns of the upholstery, rug, tablecloth, wallpaper, and curtains, as well as in how this profuse ornamentation plays off the crystal chandelier, the flowers on the table, and the large landscape painting in its ornate, gilded frame. Vuillard's pictorial fascination with surface pattern was shared by Henri Matisse (cats. 73–75).

Two women sit at a table, seemingly occupied by such traditional activities as embroidery or knitting, each absorbed fully in her task. Just to their left are two large chairs, conspicuously empty, as if beckoning us to join this atmosphere of quiet productivity.

In the background a third woman leans over the shoulder of a bearded man seated at his desk. On the other side of the desk is a boy, propped on his elbows. Conversation appears minimal in this room: not one of the figures interacts directly—visually or verbally—with the others. Despite the plush comfort that surrounds them, these people seem to enjoy neither interpersonal warmth nor intimacy; each individual seems isolated in his or her private space within the cocoon of the home.

Although the man, woman, and boy at the desk would appear to be a family, and although the two women at the table might be sisters or aunts, the identity of the figures—as well as their relationships to one another—is not clear.[5] Vuillard provides just enough information to determine gender (and, to a lesser extent, age), and he intentionally blurs facial features, obscuring individualizing characteristics. As a result, this well-appointed interior appears to absorb its human inhabitants, making them inseparable from its busy decorative scheme.

Vuillard's richly colored and intricately patterned canvas imagines the home as a constructed space, a field for the representation of the dense web of complex pictorial and interpersonal relationships that unfold within.[6] His vision of private space, as Vuillard scholar Susan Sidlauskas explains,

> made a positive virtue of the discontinuities, ruptures, and ill-fitting joins that occur, inevitably, when a conceptual or psychological fusion becomes a pictorial one—when body and space become figure and ground. In our post-Freudian age, repression is said to be the hallmark of the domestic

interior. But Vuillard refused to bury anything beneath the surface. Surface is where representation is at its truest, he believed, where layers of self shift unpredictably but revealingly for their various circumstances and audiences. . . . He also suggests that the world outside is never entirely excluded from the world within, but seeps through and unsettles the very walls, inflecting the shape, the comportment, and the economic politics of the interior.[7]

Vuillard's paintings penetrate the private sphere of the home and invite us to explore what lurks beneath its flowery surfaces, for within this apparently comfortable parlor unfold human interactions in all their potential difficulty and tension.

NOTES

1 See Michelle Perrot, ed., *A History of Private Life: From the Fires of Revolution to the Great War,* trans. Arthur Goldhammer (Cambridge, Mass.: Belknap Press of Harvard University Press, 1990); as well as Inga Bryden and Janet Floyd, eds., *Domestic Space: Reading the Nineteenth-Century Interior* (Manchester: Manchester University Press, 1999); and Sharon Marcus, *Apartment Stories: City and Home in Nineteenth-Century Paris and London* (Berkeley: University of California Press, 1999).

2 See Elizabeth Wynne Easton, *The Intimate Interiors of Édouard Vuillard,* exh. cat. (Washington, D.C.: Smithsonian Institution Press, in association with the Museum of Fine Arts, Houston, 1989).

3 Susan Sidlauskas, "Contesting Femininity: Vuillard's Family Pictures," *Art Bulletin* 79, no. 1 (1997): 85–111.

4 See Gloria Groom, *Édouard Vuillard, Painter-Decorator: Patrons and Projects, 1892–1912* (New Haven: Yale University Press, 1993).

5 The man may be Vuillard's friend Tristan Bernard, a popular playwright whose son, perhaps pictured here, became a film director; a similar chandelier appears in Vuillard's *Salon of Tristan Vuillard* (c. 1904, National Gallery, Ottawa). Tristan was the lover and eventual second husband of Mme. Aron, the cousin of Vuillard's own intimate, Lucy Hessel.

6 Susan Sidlauskas, "Psyche and Sympathy: Staging Interiority in the Early Modern Home," in *Not at Home: The Suppression of Domesticity in Modern Art and Architecture,* ed. Christopher Reed (London: Thames and Hudson, 1996), 65–80.

7 Susan Sidlauskas, *Body, Place, and Self in Nineteenth-Century Painting* (Cambridge: Cambridge University Press, 2000), 122–23.

PIERRE BONNARD
French, 1867–1947

61 *Mirror Above a Washstand*

Oil on canvas,
1908
47 ¼ × 38 ⅛ in.
(120 × 97 cm)
Signed upper right
in white paint:
Bonnard; written
on the back: *Glace
cabinet de toilette.
Ne pas vernir.
P. Bonnard*
Inv. no. 3355

"AS FOR the mirror, it is the instrument of a universal magic that changes things into spectacles, spectacles into things, me into others, and others into me."[1] The French philosopher Merleau-Ponty's musings capture the mysterious qualities of the mirror in Bonnard's painting, *Mirror Above a Washstand.*[2] For Bonnard, the mirror is simultaneously a still-life object—no different from a basin, pitcher, or dressing table—and an animated presence. It acts as a picture within the picture—complete with a frame and an image on the surface. But unlike painted images, which essentially remain static, mirror images are ephemeral.

Writing about Bonnard in 1893, the critic Roger Marx observed that the artist "captures fleeting poses, steals unconscious gestures, crystallizes the most transient expressions."[3] The gestures of everyday life that constitute Bonnard's primary subject matter in this work are inherently transient: the nude woman walks toward a dresser to begin her daily toilette, and soon clothes, layer by layer, will supplant nudity. A seated companion sips from a cup. Eventually, she, too, will stand and walk away.

Although figures animate the scene, simple, sturdy objects anchor it and provide context: home. The washstand is the locus of the day's beginning and end, where we "construct" our civilized, public selves in the rituals of bathing and grooming. Between 1907 and 1909, Bonnard painted many versions of the washstand theme, all of which feature the mirror, washstand, dressing table, and accompanying objects, and variously feature a nude figure and perhaps a secondary clothed figure.[4]

In these compositions Bonnard merges the categories of genre, still life, and the nude. In so doing he invokes numerous traditions of Western painting. The mirror has long been employed in art as a device that affords multiple levels of visual description, illusionism, and reality. By using the mirror as a thematic and visual element in his works, Bonnard self-consciously and self-confidently joins the ranks of Jan Van Eyck, Diego Velázquez, Jean-Auguste-Dominique Ingres (cat. 20), Édouard Manet (cat. 46), and his contemporary, Henri Matisse (cats. 73–75).[5] Bonnard's emphasis on depicting humble still-life objects, moreover, places him on a trajectory of French painting that includes Paul Cézanne (cats. 55–58) and Jean-Baptiste-Siméon Chardin, while his innovative treatment of the nude—viewed from the back—references works by Ingres, Gustave Courbet (cat. 27), and Georges Seurat.[6] His habit of hybridizing genres and quoting broadly from the history of art reflects the subtlety and complexity of his practice.

Bonnard's primary concern in this work is twofold: on one hand, his subject, the washstand, serves as a vehicle for exploring the endless possibilities of color and light.[7] On the other, his compositional choices reflect a guiding fascination with perception.[8] Bonnard creates a visual and narrative puzzle and then invites the viewer to sort out the questions he raises by welcoming us into the most private space of his home.

The nude woman depicted in the mirror is most likely Marthe, Bonnard's muse and companion since 1896 (they married, finally, in 1925).[9] Who, we won-

der, is the seated figure? One scholar asserts that this figure is also Marthe, given the similarity between her appearance here and in other portrayals.[10] If Bonnard depicts the same woman, clothed and nude, seated and standing, gazing in the mirror and walking away from it, he confounds our sense of what constitutes "real" time and space. The seated woman occupies a position similar to that of the viewer (and the unseen painter), yet her position is privileged. She sees the front of the woman's body and simultaneously views her from the back in the mirror. If one model posed for both figures, Bonnard presents a moment that is visually impossible but utterly feasible in the minds of the woman, the painter, and the viewer. Within this concrete world of bathing accoutrements and household furnishings Bonnard creates a moment made possible only by imagination or memory.

Bonnard once remarked that painting is the "transcription of the adventures of the optic nerve."[11] But *Mirror Above a Washstand* also attests to his clever manipulations of such visual information in order to launch viewers on intellectual adventures. Bonnard does not depict himself here, but he signals his presence in several ways: with a witness' signature, woven into the decorative wallpaper just above the upper-right corner of the mirror's frame; the small flower still life—really a painting within the painting—that floats above the center of mirror; and, finally, Bonnard's own gaze, taking in and transcribing, from multiple angles, Marthe's bodily presence.

NOTES

1 Merleau-Ponty, quoted in Jean-Louis Prat, *Bonnard,* exh. cat. (Martigny, Switzerland: Fondation Pierre Gianadda, 1999), 70. Translated by Charlotte Eyerman.

2 The work was most likely completed before September 1908, when it was exhibited in Paris at the Galerie Bernheim-Jeune and purchased for that year's Salon d'Automne.

3 Cited in Sarah Whitfield and John Elderfield, *Bonnard,* exh. cat. (New York: Harry N. Abrams, in association with the Tate Museum, London, and the Museum of Modern Art, New York, 1998), 33.

4 Jean and Henry Dauberville, *Bonnard: Catalogue raisonné de l'oeuvre peint,* vol. 2 (Paris: J. et H. Bernheim-Jeune, 1965–74). The works in the series are nos. 473, 481, 484, 486, 488, 529, and 531. Bonnard also treated this theme in 1913–14; see nos. 772 and 811. The Pushkin painting is no. 488; no. 529, *La Glace de la chambre verte* (or *Nu à la glace*) (1909, John Herron Collection, Indianapolis), seems to present the same figures in a precisely inverse arrangement of the Pushkin work: the nude woman faces the mirror and is reflected on the left side, while the seated, sipping woman is seen in the opposite profile. As in the Pushkin work, the dressing table dominates the foreground of *Dressing Table and Mirror* (1913, the Museum of Fine Arts, Houston), but we view the mirror from a lower vantage point and perceive only a fragmented reflection of objects slightly below it: flowers on the washstand, a cropped, seated female nude, and a dog. The Houston work is no. 772.

5 Jan van Eyck, *Arnolfini Wedding Portrait* (1434, National Gallery, London), Diego Velázquez, *Las Meninas* (1656, Prado, Madrid), J. A. D. Ingres, *La Comtesse d'Haussonville* (1845, Frick Collection, New York) and *Madame Moitessier* (1856, National Gallery, London), Édouard Manet, *A Bar at the Folies-Bergère* (1882, Courtauld Institute Galleries, London), and Henri Matisse, *Carmelina [La pose du nu]* (1904, Museum of Fine Arts, Boston).

6 J. A. D. Ingres, *Valpinçon Bather* (1808, Musée du Louvre, Paris), Gustave Courbet, *The Bather,* 1853 (Musée Fabre, Montpelier, France), Georges Seurat, *Les Modèles* (1888, Barnes Foundation, Merion Station, Pa.), and Edgar Degas, any number of his bathers (paintings, pastels, monotypes, drawings)—an exemplary one is *Woman Drying Herself* (c. 1905, the Museum of Fine Arts, Houston).

7 Nicholas Watkins, *Bonnard: Colour and Light* (London: Tate Gallery Publishing, 1998); and Bernice Rose, *Bonnard, Rothko: Color and Light* (New York: Pace-Wildenstein, 1997).

8 Whitfield and Elderfield, *Bonnard,* 33; and Max Kozloff, "A Vertigo of the Senses," *Art in America* 86 (July 1998): 54–61.

9 Whitfield and Elderfield, *Bonnard,* 16.

10 Albert Kostenevich, *Bonnard and the Nabis: From the Collection of Russian Museums,* trans. Irina Walshe, Paul Williams, Yelena Petrova, and Alla Perova (Bournemouth, England: Parkstone/Aurora, 1996), 62–63.

11 Whitfield and Elderfield, *Bonnard,* 33.

PIERRE BONNARD

French, 1867–1947

62 *Summer in Normandy*

Oil on canvas,
1912
44 7/8 × 50 3/8 in.
(114 × 128 cm)
Signed: *Bonnard*
Inv. no. 3356

BONNARD's *Summer in Normandy* invites us to share an intimate moment on the terrace of the artist's country house, Ma Roulette, on the Seine River near Giverny. Typically, Bonnard mixes genres to create a hybrid: portrait, genre scene, landscape. His wife, Marthe, relaxes on a chaise and chats with a friend; the lush terrain forms a panoramic backdrop.

As in *Mirror Above a Washstand*, Bonnard focuses on his immediate environment. Though we have moved from the intimate space of ablutions to the more social realm of the terrace, Bonnard remains focused on those closest to him: his favorite model, Marthe, and Ubu, his beloved dachshund, who sits contentedly on Marthe's lap.[1] Bonnard playfully includes a second dog in the composition, a perky creature who gazes pointedly at Marthe, eyeing a morsel of fruit in her hand. In this seemingly uneventful scene, Bonnard demonstrates his remarkable ability to discover rich pictorial resources in a single, seemingly incidental moment.

The subject of *Summer in Normandy* is ostensibly women chatting on a lazy summer day. Yet Bonnard's true focus here is on the play of color and light. He uses rich, saturated zones of color to create a pictorial space that is at once very flat and very deep, enabling us to discern clearly the foreground, middle ground, and background. And true to the classical landscape tradition (see, for example, cat. 2), Bonnard's symmetrical composition is anchored in the foreground by a tree, which is, in turn, offset by a clump of trees in the distance.

Even as Bonnard suggests the illusion of deep perspective he masterfully achieves the effect of flattened space. For instance, our eye is automatically drawn back to the mauve and green mottled hills in the far distance; yet the canopy over the terrace aligns these compositional elements with the two-dimensionality of the picture plane. Logically, we know that this device should occupy a depth of only a few feet; but visually it acts as a screen that connects the trees in the fore- and middle ground with the orange and purple sky beyond, which is in turn anchored by those distant hills. The river appears in small patches of luminous gray that peek out from the clumps of foliage in the middle ground. Ultimately, Bonnard uses overlapping to suggest spatial layers, but his bright palette and uniformly thick application of paint results in a rich, decorative mosaic of color.[2]

Enhancing this decorative flatness is the privileged, slightly awkward view of the terrace that Bonnard affords the viewer: we seem to hover over Marthe, a view that Bonnard perhaps enjoyed from his adjacent studio. This practice of placing the viewer at dramatically elevated or lowered vantage points is a compositional device that recalls Japanese woodblock prints, as well as a strategy often employed by Edgar Degas (cats. 42 and 43).

As John Rewald aptly observed, Bonnard's paintings are "covered with colors applied with a delicate voluptuousness that confers to the pigment a life of its own and treats every single stroke like a clear note of a symphony."[3] Bonnard's chromatic and pictorial

interests recall those of Édouard Vuillard (cat. 60), who, together with Maurice Denis (cat. 59), joined Bonnard in the Nabis group.

Summer in Normandy, with its brilliant color, flattened space, and clear debt to Japanese prints (which Bonnard and his fellow Nabis collected) brilliantly illustrates the goals of the Nabis group, for it is just as suitable for enhancing an interior as a decorative panel or an ornate screen. Large and mural-like in its horizontality, this is one of several canvases depicting Ma Roulette, and it is closely related to four large decorative canvases commissioned by Ivan Morozov. But this work also indicates that Bonnard had taken his art in a different direction, modifying his decorative emphasis with a return to Impressionist tenets.[4] It also resonates with the major modernist movements and enthusiasms of the late nineteenth century and is a response to the work of such avant-garde artists as Paul Gauguin (cats. 52–54) and Henri Matisse (cats. 73–75).

NOTES

1 Albert Kostenevich, *Bonnard and the Nabis: From the Collection of Russian Museums,* trans. Irina Walshe, Paul Williams, Yelena Petrova, and Alla Perova (Bournemouth, England: Parkstone/Aurora, 1996), 104–6. The name Ubu refers to an avant-garde play, *Ubu Roi,* by Alfred Jarry, which Bonnard admired.

2 See Gloria Groom, *Beyond the Easel: Decorative Painting by Bonnard, Vuillard, Denis, and Roussel, 1890–1930,* exh. cat. (New Haven: Yale University Press, in association with the Art Institute of Chicago, 2001).

3 John Rewald, *Bonnard,* exh. cat. (New York: Museum of Modern Art, 1948), 40; reprinted in Edgar Peters Bowron and Mary G. Morton, *Masterworks of European Painting in the Museum of Fine Arts, Houston* (Princeton: Princeton University Press, in association with the Museum of Fine Arts, Houston, 2000), 220.

4 For Bonnard's return to Impressionism, as well as the Morozov commission, see Groom, *Beyond the Easel.*

HENRI-EDMOND CROSS
French, 1856–1910

63 *Near a House*

Oil on canvas,
1906
24 × 27½ in.
(61 × 70 cm)
Signed: *Henri-Edmond Cross*
Inv. no. 3384

NEAR A HOUSE reveals the multifaceted pictorial interests of the painter Henri-Edmond Cross. He honors his roots in Impressionism by employing a light palette and thick, stippled brushstrokes to render landscape. He also demonstrates his facility with Pointillism—what its pioneer, Georges Seurat, called "chromo-luminism"—by juxtaposing for optimum brilliance tiny dots of complementary colors. Furthermore, certain passages in *Near a House* contain the vivid hues associated with Fauvism, a style developed by Henri Matisse (cats. 73–75) and André Derain (cat. 68) around the time this work was painted.

Born Henri-Edmond Delacroix, Cross's artistic career began in Lille, France. In 1881 he moved to Paris and immediately began to exhibit his work there; by 1883 he had anglicized his name to Cross.[1] His closest ties were to the Pointillists and leaders of Neo-Impressionism, Seurat and Paul Signac. He participated in the 1884 and 1886 Salons des Indépendants, both of which were organized by Seurat, and he was a member of Les Vingt (The Twenty), a group of avant-garde artists who exhibited primarily in Brussels.

Stylistically, *Near a House* reflects Cross's immersion in the late-nineteenth-century French avant-garde, but compositionally the painting is fairly traditional. Anchoring the picture is a tree, which fills the majority of the space in the center, obscuring the white house behind it, as well as an outbuilding in the middle ground to the right. Carving out the space in the foreground is a large hill, its vivid pinks contrasting with the cool colors in the blue sky above and its

purple accents complementing the yellow-orange orbs that appear to be citrus fruits in the leafy green tree. A clear pathway demarcates the space between the tree and the foreground, in which the manicured rows of a garden converge into a V at the edge of the canvas. Just beyond the garden is a tiny figure wearing a white shirt and blue pants. He appears to lean forward, hands on knees, perhaps to examine a plant in the section of the garden surrounding the house.

According to the Belgian poet Émile Verhaeren, Cross's art was "dedicated to the glorification of nature."[2] Verhaeren sang Cross's praises: "These landscapes, my dear Cross, are not only beautiful . . . but even more, they are motifs of lyrical emotion. They satisfy painters thanks to their rich harmonies, poets exalt in the luxurious and sumptuous vision they offer. However, this abundance is not excessive. It remains light and charming."[3] Indeed, explained Verhaeren in 1910, the year Cross died, more than merely evoking the appearance of nature in his work, the artist "painted . . . the glorification of his interior visions. His importance as an initiator can only grow decade by decade."[4]

While Cross was indebted to the example of the better-known Seurat and Signac, *Near a House* reveals the individuality of his approach to the Pointillist technique. By applying paint in thick dabs he creates a mosaic of color that covers the surface of the canvas with a uniform sense of materiality. He understands color theory—the relationship between complementary colors, warm and cool tones—but this work registers his concern for a decorative unity.

NOTES

1 Françoise Baligand et al., eds., *Henri-Edmond Cross,
 1856–1910*, exh. cat. (Paris: Somogy Éditions d'Art, 1998), 13.

2 Marc Quahebeur, *Émile Verhaeren, un musée imaginaire*,
 exh. cat. (Paris: Musée d'Orsay, 1997), 172. Translated by
 Charlotte Eyerman.

3 Émile Verhaeren, "Preface," in *H. E. Cross*, exh. cat. (Paris:
 Galerie Druet, 1905), cited in Baligand et al., *Henri-
 Edmond Cross*, 106. Translated by Charlotte Eyerman.

4 Émile Verhaeren, "Henri Edmond Cross," *Nouvelle revue
 française* (July 1910): 44, reprinted in *Sensations* (Paris: Cres,
 1927), 104, and cited in Baligand et al., *Henri-Edmond
 Cross*, 106.

HENRI-CHARLES MANGUIN

French, 1874–1949

64 *Bathing Woman*

Oil on canvas,
1906
24 × 19¼ in.
(61 × 49 cm)
Signed: *Manguin*
Inv. no. 3389

HENRI-CHARLES MANGUIN exhibited *Bathing Woman* at the 1906 Salon d'Automne, alongside works by André Derain (cat. 68), Henri Matisse (cats. 73–75), and Maurice Vlaminck. These artists came of age in the first decade of the twentieth century and were therefore familiar with the major movements of late-nineteenth-century French modernism. They were particularly inspired by the expressive use of vivid color pioneered in the 1880s and 1890s by Vincent van Gogh (cats. 50 and 51) and Paul Gauguin (cats. 52–54). So bold was their own use of color that the critic Louis Vauxcelles dubbed them *"les fauves"* (the wild beasts).[1]

Bathing Woman explores color through the conventional genre of the nude in a landscape. Unlike François Boucher's *Jupiter and Callisto* (cat. 5), this picture neither generates a complex narrative nor contains an identifiable literary source. Instead of telling a story, Manguin records the moment: a woman emerges from the sea and towels off, her gaze averted from the spectator, for she is absorbed in the simple pleasures of the warm summer day.

Manguin's primary interest lies in the formal relationship between the nude woman's body and the landscape that surrounds her. He renders his voluptuous model with sculptural solidity, defining her form with heavy outline and employing a varied palette to suggest the contours of her musculature. This vibrant color takes the place of the shading typical of conventional modeling; for instance, a thick blue-green stripe runs along the woman's thigh and defines her quadriceps, while warm pink, mauve, and orange suggest the indentation of her buttock. The shadows cast by her raised arms and her towel consist

primarily of mauve, tinged with green, yellow, and orange. Her face is nearly featureless, a mottled array of warm red and orange tones. Conventional flesh tones are most pronounced on the front of the model's legs, her left hip, and her arms, but this paint is thickly applied and interspersed with additional colors.

By using unmixed, nongradated hues, along with heavy impasto, the artist could not have deviated more from the academic paradigm that insisted on highly blended and smooth surfaces. Manguin was familiar with this tradition, for he had studied in the studio of Gustave Moreau, a late-nineteenth-century academic painter who had also trained Matisse and Marquet.[2] Working directly from the nude model was integral to academic training, an aspect of Manguin's education that is suggested in the muscularity of the figure in *Bathing Woman*.

But Manguin's treatment of the nude is also thoroughly avant-garde, for in this work the body becomes a vehicle for chromatic experimentation. Manguin freely plays with color juxtapositions in his treatment of the model's flesh, as well as in his framing of the lower and upper halves of her body with the flat sea and distant landscape. He distinguishes each of these zones by varying both his palette and his technique. Whereas the body consists of thickly applied brush strokes that reiterate the woman's vertical orientation, the sea has been constructed as a mosaic of short horizontal strokes. There, color is used to map out distance: pink, yellow, and blue represent the shallow water in the foreground, while dark green depicts the deeper water in the background.

A large orange mountain looms in the distance directly behind the figure, its precipitous slope coinciding exactly with the woman's right arm, the warm colors of its rocky form echoed in her face. At the left edge of the canvas is a hill, rendered in a palette consisting of variegated warm tones that complement the cool colors of the sea. A lone tree fills the space at the upper left, while the right side of the canvas opens to an expansive cloud-filled sky and low blue hills in the far distance. Manguin constructs a world in which woman and nature coexist in harmony, a theme Matisse explored in his groundbreaking *Luxe, calme et volupté* (1904–5, Musée d'Orsay, Paris).

NOTES

1 For Fauvism see John Elderfield, *The "Wild Beasts": Fauvism and Its Affinities*, exh. cat. (New York: Museum of Modern Art, 1976); and Clement T. Russell, *Les Fauves: A Sourcebook* (Westport, Conn.: Greenwood Press, 1994). A van Gogh exhibition was held in Paris at the Galerie Bernheim-Jeune in 1901, and a retrospective of Gauguin's work took place after the artist's death in 1903.

2 See Pierre-Louis Matheiu, *Gustave Moreau*, trans. James Emmons (Oxford: Phaidon, 1977).

ALBERT MARQUET
French, 1875–1947

65 *Le Pont Saint-Michel in Paris*

Oil on canvas,
1908
25 5/8 × 31 7/8 in.
(65 × 81 cm)
Signed: *Marquet*
Inv. no. 3289

THIS PAINTING captures the view looking westward from Marquet's sixth-floor studio window onto the quai Saint-Michel. Marquet painted this scene many times, as did his friend Henri Matisse (cats. 73–75), who kept a studio in the same building.[1] In his 1908 essay "Notes of a Painter" Matisse expresses ideas that could easily apply to Marquet's painting: "What I dream of is an art of balance, of purity and serenity, devoid of troubling or depressing subject matter, an art which could be for every menial worker, for the businessman as well as the man of letters, for example, a soothing, calming influence on the mind, something like a good armchair which provides relaxation from physical fatigue."[2] Marquet weaves such calm and balance into *Le Pont Saint-Michel in Paris,* eschewing the city's frenetic energy to paint a Paris that is orderly and accessible.

The pont Saint-Michel and the pont Neuf—the two bridges in the heart of Paris that span the Seine between the Île de la Cité and the quai Saint-Michel on the Left Bank—demarcate the foreground and background of the painting. Bright morning sunshine illuminates the Seine and the buildings that line its banks. Rather than the snowy haze that pervades *Notre-Dame in Winter* (cat. 66), the clear light of summer dominates *Le Pont Saint-Michel in Paris.* This change in atmosphere announces the entirely different set of visual interests that engage Marquet in this work. Whereas the reduced palette and lack of detail in *Notre-Dame in Winter* draw our attention to the cathedral, the urban landscape in *Le Pont Saint-Michel in Paris* is far less abbreviated. For instance,

Marquet does not treat the river as a mere vehicle for color or as a compositional device. Instead, the water acts as a reflective surface, mirroring the bridge and the embankment in the right foreground. Marquet maintains this illusion even as a boat glides through the reflection.

The bridge's wide horizontal surface and the arches that support it are pictorially compelling, and Marquet builds his entire composition around the pale color of this structure and the geometry of its straight and curving lines. As a result, the pont Saint-Michel stabilizes the composition and provides the template for its pictorial and chromatic harmonies. Pedestrians, horse-drawn carriages, and omnibuses traverse the bridge, animating the foreground of the painting. Here Marquet displays his Fauvist interest in color: by using it sparingly but effectively, he animates the foreground with red, yellow, and green accents. Marking the transition to the middle ground is a long row of full, verdant trees.

As space recedes, Marquet's palette changes further, and the dark, murky green of the Seine in the immediate foreground gives way to pale, silvery blue with green patches, the reflections of the trees just past the bridge, as well as those further back on the left. Quays in the middle ground and background create a gentle curve that resonates with the arches of the pont Saint-Michel, as well as those of the pont Neuf in the distance. Just beyond the pont Neuf, the rooftops of the Louvre are discernable, blurry testaments to the rich traditions of French painting that Marquet studied as he honed his craft.[3]

207

NOTES

1 Cited in John Elderfield, *Henri Matisse: A Retrospective,* exh. cat. (New York: Museum of Modern Art, 1992), 121–22.

2 Henri Matisse, "Notes of a Painter" (originally published as "Notes d'un peintre," in *La Grande revue,* Paris, 25 December 1908), in *Art in Theory, 1900–1990,* ed. Charles Harrison and Paul Wood (Oxford: Blackwell, 1992), 76.

3 On Marquet's work, see *Mikhail Guerman, Albert Marquet: The Paradox of Time* (St. Petersburg, Russia: Aurora Art Publishers, 1995); and *Albert Marquet, 1875–1947* (London: Wildenstein, 1995).

ALBERT MARQUET

French, 1875–1947

66 *Notre-Dame in Winter (Snow, Winter)*

Oil on canvas,
1908
25 5/8 × 31 7/8 in.
(65 × 81 cm)
Signed: *Marquet*
Inv. no. 3289

THE CITY of Paris was a favorite subject of nine-teenth-century French painters, especially the Impressionists. Indeed, artists like Claude Monet (cat. 34) and Camille Pissarro (cat. 41) immortalized the wide streets and boulevards of the capital, and their legacy endured into the early twentieth century as a new generation of artists came of age. Monet, Pissarro, and their contemporaries, for example, provided models for Albert Marquet's *Notre-Dame in Winter (Snow, Winter)*, a painting of the view from his upper-story studio overlooking the quai Saint-Michel on the Left Bank and the cathedral of Notre Dame beyond. But whereas the Impressionists had celebrated the color and movement of the urban landscape, Marquet takes a more static approach to the city and one of its most iconic monuments.

Marquet was a member of the Fauves, a group known for its use of vivid color. Here, however, his palette consists of gradations of gray and white with black accents. As if to underscore the radical differences between the southern coast with its sun-drenched skies and the gray-blue skies of the north, Marquet reduced his range of colors to focus on the solidity of the simple geometry of architectural forms and the chilly atmosphere and diffuse light of the wintry Paris day. The urban landscape is largely deserted—only a few diminutive figures, represented by abbreviated black brushstrokes, make their way through the snowy streets.

The highly structured composition of *Notre-Dame in Winter* gives the painting its dynamism. A pattern of strong diagonals leads the eye back into space from left to right. The Seine occupies the center of the composition, its dark gray water offset by the white quays on each side. A long, thin barge, depicted by a configuration of horizontal bands of white and black, is moored on the far bank; just above it is a stairway, indicated by a short diagonal ramp. In the right foreground, small figures walk along the street-level sidewalk. On the right side of their path are rectangular structures, stalls from which vendors sell books, prints, and other collectible items.

A large gray building on the far bank echoes the color of the river. Beyond it is an open space that is connected to the opposite bank by a small bridge, across which an extremely schematized horse-drawn carriage makes its way. On the other side of the bridge the river changes color, becoming lighter and less defined, as do the hard-edged streets that border it. Notre Dame looms majestically in the distance, its imposing form seeming to emerge organically from the plaza, even as its towers carve out a clear silhouette against the cloud-thick sky. These towers are all that identify the cathedral in this painting, as Marquet blurs the details of its medieval facade and stunning stained-glass windows by dim light and hazy distance.

Henri Matisse (cats. 73–75) also painted Notre Dame, and, like Marquet, preferred the sculptural solidity and formal grandeur of the centuries-old building to the Eiffel Tower, erected in 1889. Matisse kept a studio in the same building on the quai Saint-Michel as Marquet's, and he, too, captured the view of Notre Dame in such paintings as *Notre-Dame in the Late Afternoon* (1902, Albright-Knox Art Gallery, Buffalo, New York).[1] Both artists treat the cathedral as a majestic still life, reigning over the Parisian landscape from the heart of the city. Their views of Notre Dame assert the building's significance as a subject of modern painting, and they focus on its status as a beautiful, poetic form.

NOTE

[1] A photograph taken from the window of Matisse's studio—the same view as from Marquet's studio—is reproduced in John Elderfield, *Henri Matisse: A Retrospective*, exh. cat. (New York: Museum of Modern Art, 1992), 86.

HENRI ROUSSEAU
French, 1844–1910

67 *Jaguar Attacking a Horse*

Oil on canvas,
1910
35 3/8 × 45 5/8 in.
(90 × 116 cm)
Signed: *Henri
Rousseau*
Inv. no. 3351

HENRI ROUSSEAU'S *Jaguar Attacking a Horse* transformed the landscape genre. Whereas French landscape painters from Claude Lorrain (cat. 2) to Claude Monet (cats. 34–37) recorded the natural world they observed, Rousseau chose to paint the lush jungles he imagined. Like Paul Gauguin (cats. 52–54), moreover, he dispensed with recording the optical effects of light in order to emphasize nature's forms and patterns, and he developed an interest in color and flattened pictorial space that links him to such modern masters as Henri Matisse (cats. 73–75).

We experience the drama of *Jaguar Attacking a Horse* as if hunched in the thick fringe of low grasses that presses against the picture plane. Bright-orange, red, white, and violet flowers punctuate this dense array of overlapping greens, creating an area of decorative patterning that almost distracts us from the violence unfolding just beyond our reach. Enveloped by these copious plants, two animals are caught in a deadly embrace. A white horse, perhaps symbolizing man's incursion into nature, gazes directly at us while a jaguar lunges at its neck. Lush beauty and primal brutality coexist in Rousseau's jungle.

Rousseau painted his first jungle scene, *Surprise!*, in 1891 (National Gallery, London).[1] During the next several years he focused on conventional landscapes and cityscapes, such as *The Eiffel Tower* (c. 1898, the Museum of Fine Arts, Houston). Only in 1904 did Rousseau return to painting jungle pictures, a thematic engagement that would occupy him for the duration of his career.

Like Gauguin, Rousseau was a self-trained artist who got his start as a "Sunday painter." Whereas Gauguin had been a successful stockbroker who ulti-

mately fled Paris for Tahiti in search of the "exotic," Rousseau was a low-level civil servant in the municipal toll service and never traveled anywhere more exotic than Paris.[2] Though some biographies erroneously suggest that Rousseau went to Mexico during his military service, his only exposure to the plants and animals of faraway lands happened at the Paris zoo and botanical garden, the Jardin des Plantes.[3]

Rousseau gained entry into the Parisian art world with the help of his neighbor, the academic painter Félix Clément. Through Clément, he met the academicians William-Adolphe Bouguereau and Jean-Léon Gérôme. These established artists encouraged their protégé to "keep his naiveté," yet they also undoubtedly helped Rousseau obtain vital letters of recommendation to make copies in the Louvre, in 1884.

Rousseau admired the work of the orientalist Gérôme, and he copied Eugène Delacroix's *Encounter of a Lion and a Tiger* (c. 1828–29, National Gallery, Prague).[4] He also frequented the Musée du Cluny, where he admired the fifteenth-century *Lady with the Unicorn*, a tapestry that features decorative animal and landscape motifs.[5]

Rousseau gained increasing exposure to the traditions and procedures of French art. However, as an autodidact, he lacked the artistic pedigree to surmount the obstacles posed by the Salon jury. Although Rousseau aspired to such official acceptance, his career was launched when his work appeared at the avant-garde Société des Artistes Indépendants, founded by Paul Signac in 1885 as an alternative to the Salon.[6]

213

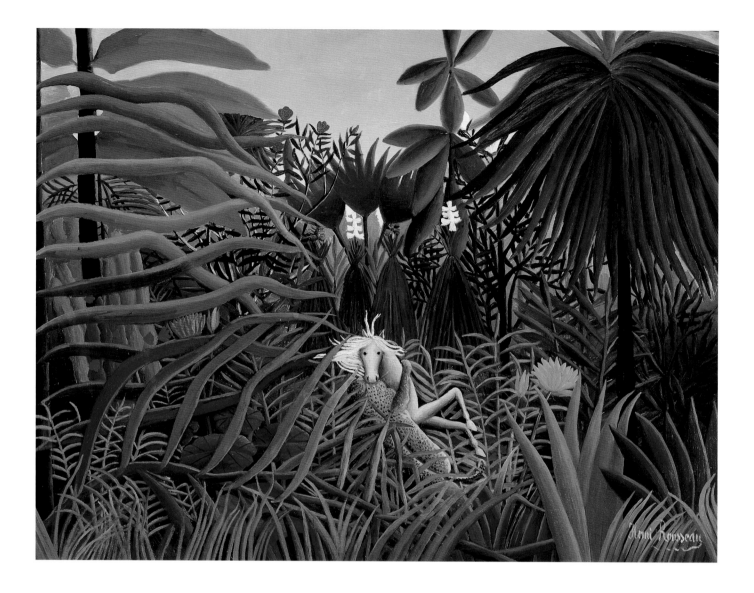

Working in obscurity and crushing poverty for the next several years, Rousseau finally gained critical recognition in 1894 with his portrait of the playwright Alfred Jarry (now lost). Through Jarry, Rousseau met Gauguin, whose studio he frequented, often as an uninvited guest. There he mingled with such illustrious individuals as Edgar Degas (cats. 42 and 43), the playwright August Strindberg, and the poet Stéphane Mallarmé.[7] In spite of his financial struggles, Rousseau had managed to penetrate the inner sanctum of the Parisian avant-garde.

In 1905, Rousseau triumphed at the Salon d'Automne with *The Hungry Lion* (1905, Ernst Beyeler Collection, Basel). This painting of a lion devouring an antelope is a precedent to *Jaguar Attacking a Horse*. In fact, the 1905 work served as a compositional and thematic template for the series of jungle pictures that Rousseau produced over the next five years. These works invite the viewer into a seemingly bucolic landscape, only to reveal that life-and-death conflicts in the animal world take center stage in Rousseau's pictorial imagination.

NOTES

1 Werner Schmalenbach, *Henri Rousseau: Dreams of the Jungle,* trans. Jenny Marsh (Munich: Prestel, 1998), 19.

2 Biographical information is from *Henri Rousseau*, exh. cat. (New York: Museum of Modern Art, 1985), 11–12.

3 He also relied on illustrated albums about the Jardin des Plantes and about wild animals. See Schmalenbach, *Henri Rousseau*, 31, 35.

4 Schmalenbach, *Henri Rousseau*, 22. Rousseau's copy, *Tiger Attacking a Lion*, 1885, is also in the National Gallery, Prague.

5 Schmalenbach, *Henri Rousseau*, 20.

6 Information about Rousseau's academic contacts, aspirations, and his entry into Signac's group is from *Henri Rousseau* (Museum of Modern Art), 12–13. Among the artists who participated in these independent exhibitions were Seurat, Cézanne, Toulouse-Lautrec, Renoir, Gauguin, and van Gogh.

7 *Henri Rousseau* (Museum of Modern Art), 14–15. On the artistic and intellectual milieu at this moment in Paris, with particular emphasis on Alfred Jarry, Rousseau, Eric Satie, and Guillaume Apollinaire, see Roger Shattuck, *The Banquet Years: The Arts in France, 1885–1918* (London: Faber and Faber, 1958).

ANDRÉ DERAIN

French, 1880–1954

68 *The Castle*

Oil on canvas,
1910
26 × 32 ¼ in.
(66 × 82 cm)
Signed on back:
A. Derain
Inv. no. 3279

ALTHOUGH André Derain is best known as a member of the Fauves, by 1910, influenced by Cubism, he had begun to supplement his interest in color with an exploration of form. Like Georges Braque (cat. 72) and Picasso (cats. 69–71) (with whom he had painted on a 1910 trip to Spain), Derain responded to Cézanne's pictorial and spatial experiments. In the same way that Cézanne's repeated representations of Mont Sainte-Victoire (cat. 58) were echoed in Braque's serialization of La Roche-Guyon (cat. 72), Derain made numerous paintings of Cagnes-sur-Mer and its architecture. Yet whereas Braque confounds our notions of spatial distance in the Cubist *Château la Roche-Guyon,* Derain focuses on the solidity of architectural forms.[1]

In this painting Derain depicts the solid structures of the old hillside town. The warm orange and yellow tones of these ancient buildings are complemented by the blue sky and lush green foliage, interspersed with areas of ochre and brown in the foreground and at the right edge. Derain uses overlapping—a fairly traditional technique—to establish clear spatial relationships. In the extreme foreground, two leafless trees mediate between the pictorial realm and the viewer's space, creating a permeable screen through which the first two rectangular buildings are visible. Just up the hill is a second level of buildings, stacked one after the other; leading our eye up to them is a diagonal structure that resembles a covered bridge. Derain clearly delineates each of these architectural junctures, and in doing so he asserts the formal integrity of each structure.

The result of Derain's approach is a highly legible composition, one that, in contrast to many Cubist works, neither disorients nor puzzles the viewer. Instead, *The Castle* represents a confluence of Derain's love of color and exploration of form into the depiction of a world that is immediately recognizable. Derain articulated his ideas about painting in a letter to the painter Maurice de Vlaminck in 1905:

> All in all, I can see no future except in composition, because in working from nature I am a slave to such stupid things that my emotions feel the repercussions of it. I don't see the future as corresponding to our trends; on the one hand, we are trying to disengage ourselves from objective things, and on the other hand, we retain them as both origin and final aim.... To compose visually, to amuse oneself in composing pictures like Denis, which are things one can see, is ultimately nothing but the transposition of a theatrical set. I think that the problem is rather to group forms in the light and to harmonize them simultaneously with the materials available.[2]

Not only did Derain believe that personal expression should take a back seat to an artist's formal choices, he also felt that subject matter was of secondary importance. In 1909, he again wrote to Vlaminck:

> I'm going to do some landscapes, but against my will, almost. I don't feel the need for landscapes, nor for portraits, nor for still lifes. I've had wonderful feelings, whose grandeur can only be matched by a

total possession of forms, which I use equally to create the grandeur. It's very difficult to possess a landscape. But it's easier to create a harmonious shape, which in its very essence carries its own title, creating through those affections one has felt in the physical world.[3]

Indeed, *The Castle* reflects a real place observed by the painter, as well as a pictorial world of his own invention.

NOTES

1 See Jane Lee, *Derain*, exh. cat. (Oxford: Museum of Modern Art, Oxford, 1990), 12, 33.

2 André Derain, "A letter to Vlaminck," 1905, reprinted in *Art in Theory, 1900–1990*, ed. Charles Harrison and Paul Wood (Oxford: Blackwell, 1992), 65.

3 Derain, "A letter to Vlaminck," 1909, reprinted in Harrison and Wood, *Art in Theory, 1900–1990*, 66.

69 *Harlequin and His Companion (The Saltimbanques)*

Oil on canvas,
1901
28 3/4 × 23 5/8 in.
(73 × 60 cm)
Signed: *Picasso*
Inv. no. 3400

A NATIVE of Spain, Pablo Picasso spent the majority of his artistic career in France. Though he is most often associated with his groundbreaking Cubist works, as a young man he attended art academies in Madrid and Barcelona, conventional arenas for artistic training. At the academies Picasso learned to produce convincing and illusionistic depictions of the nude, as well as portraits, genre scenes, and still lifes. In the 1900s and 1910s, however, he supplemented his classical training with the increasingly abstract modes for which he is better known.

At the age of nineteen Picasso made his first trip to Paris, where he would forge his identity as an avant-garde pioneer. In Paris, Picasso studied and absorbed the examples of his nineteenth-century French predecessors, particularly Paul Cézanne (cats. 55–58), Edgar Degas (cats. 42 and 43), Édouard Manet (cat. 46), Auguste Renoir (cats. 32 and 33), Paul Gauguin (cats. 52–54), and Henri de Toulouse-Lautrec (cat. 47). He painted many genre scenes in the Impressionist and Post-Impressionist manners and was especially drawn to themes of performance, entertainment, and socializing.

In Harlequin and His Companion (The Saltimbanques), Picasso interprets and updates one of the most popular Impressionist subjects, the café. He spent a great deal of time in Parisian cafés, associating with bohemians, intellectuals, and entertainers. Here he depicts such an establishment, but he belies its characteristic conviviality by populating it with a desolate-looking man and his equally down-and-out companion. The man's dress identifies him as Harlequin, a stock character in the commedia dell'arte. Artists such as Paul Cézanne had previously immor-

talized Harlequin (cat. 55), and Picasso, in choosing to paint this clown, aligns himself with his predecessors. But Harlequin was also a fixture in Picasso's bohemian existence, for he was a character typically personified by the itinerant performers known in the nineteenth and early twentieth centuries as *saltimbanques*.[1] The recurrence of figures like Harlequin in Picasso's work from this period suggests that the artist worked with "stock" characters from his experiences on the streets and in the cafés of Paris.

In this example, a man in white face, dressed in Harlequin's checked costume, is seated at a café table next to a woman in orange—two apparently joyless

Edgar Degas.
Absinthe. 1876.
Oil on canvas,
36 1/4 × 26 3/4 in.
(92 × 68 cm).
Musée d'Orsay,
Paris.
© Réunion des
Musées
Nationaux/Art
Resource, N.Y.

individuals lost in thought. The woman has nearly drained her glass, while the man's glass still contains a greenish liquid, most likely the narcotic drink absinthe. Though the two sit close together, each seems utterly self-absorbed, their poses communicating a closed, perhaps defensive stance.[2] The woman is aware of our presence, for she gazes impassively at us. Her wide, heavily made-up eyes observe, evaluate, and betray no emotion.[3] The man turns away, gazing out beyond the frame, psychologically disengaged from the woman and from us.

Harlequin and His Companion synthesizes many late-nineteenth-century pictorial sources and painting styles. Both Manet (*The Plum,* c. 1877, National Gallery of Art, Washington, D.C.) and Degas (*Absinthe*, 1876, Musée d'Orsay, Paris) had depicted people staring disconsolately across half-empty glasses on café tables, and both characteristically used heavy outlines to define their figures. Picasso's use of bright color and matte surfaces, moreover, indicates his familiarity with Gauguin's work.

Picasso revisited the theme of Harlequin numerous times over the course of his career, often using the clown as a guise for self-portraiture.[4] The Harlequin figure in Picasso's *Family of Saltimbanques* (1905, National Gallery of Art, Washington, D.C.), for example, bears a striking resemblance to the artist. Carl Jung interpreted this habit as the expression of Picasso's subconscious wish to play the role of Harlequin, "to juggle with everything,"[5] and the critic Roland Penrose interpreted the disguise as an enactment of Picasso's wish to remain "aloof and irresponsible."[6] For Picasso, the circus figure—often depicted as isolated and alone—served as a metaphor for the challenges and anxieties the artist faced.[7]

Indeed, Harlequin draws comfort neither from his companion nor his environment. Though his role requires him to play the fool and amuse others, Picasso realizes the rigors of such a performance and grants Harlequin a moment of reprieve. The café is like a refuge, but the shelter is only temporary: Harlequin's companion is distracted, his glass is nearly drained, and soon, he will be summoned back to the stage. Only then will he animate that mask-like, impenetrable expression and turn his attention to the audience.

NOTES

1 On this theme in Picasso's early work, as well as on Harlequin, see E. A. Carmean, *Picasso: The Saltimbanques,* exh. cat. (Washington, D.C.: National Gallery of Art, 1980).

2 Picasso employed a similar composition in *The Frugal Meal,* etching (1904, Metropolitan Museum of Art, New York).

3 For instance, a similar female figure appears in Picasso's *Woman with Chignon* (1901, Fogg Art Museum, Cambridge, Mass.) and in his *Absinthe Lover* (1901, State Hermitage Museum, St. Petersburg).

4 See Carla Gottlieb, "Picasso as a Self-Portraitist," *Colóquio: Artes* 50 (September 1981): 14–23.

5 Carl Jung, cited in John Walker, *National Gallery of Art, Washington* (New York: Harry N. Abrams, 1984), 600.

6 Roland Penrose, quoted in Walker, *National Gallery of Art,* 600.

7 Richard A. Cardwell, "Picasso's Harlequin: Icon of the Art of Lying," in *Leeds Papers on Symbol and Image in Iberian Arts* (1994): 249–81.

PABLO PICASSO

Spanish, 1881–1973

70 *Spanish Woman from Mallorca*

Gouache and
watercolor
on pasteboard,
1905
26 1/4 × 20 in.
(67 × 51 cm)
Signed: *Picasso*
Inv. no. 3316

SPANISH WOMAN FROM MALLORCA is a three-quarter-length portrait of an unknown woman. Picasso painted this image in his Paris studio, drawing inspiration from memories of holidays in his native Spain, as well as from, perhaps, letters and postcards from an artist friend who visited Mallorca in 1905.[1] Although the title suggests that the sitter is a native of this Spanish island, the sitter herself closely resembles Picasso's French lover Fernande Olivier.[2] Although the identity of the "Spanish woman" is ultimately a mystery, her portrait reveals much about Picasso's early artistic sources and interests. Her frozen, regal pose conveys confidence and strength, and it displays a sculptural sensibility that is characteristic of Picasso's "first classical period."[3] This phase lasted from 1905 to 1906, when the artist, newly settled in Paris, frequented the Louvre and marveled at the recent discovery of archaic Greek terracotta statuettes from the Iberian Peninsula.[4]

That Picasso's concerns were sculptural in *Spanish Woman from Mallorca* is revealed further in the painting's nearly monochrome, beige-and-blue palette. He applied these pigments to an unprimed pasteboard support that shows through in patches to form the woman's left arm, anticipating the merging of figure and ground that would characterize Cubism. Dark, quickly rendered outlines and shaded areas define the woman's body and garments, and they create contrasts that impart seriousness to her pale, mask-like face. Space is suggested only by the ambiguous patchy blue background, which offers no clue to the woman's location. Her only iconographic attributes are her clothing: pointed hat and traditional muslin headscarf known as a *rebocillio*.

The woman raises her elongated left arm to touch her shoulder—a distinctive pose that is consistent with another painting: the large-scale (83 3/4 × 90 3/8 in. [212.8 × 229.6 cm]) *Family of Saltimbanques* (1905, National Gallery of Art, Washington, D.C.). Indeed, in addition to being a portrait, *Spanish Woman from Mallorca* is a sketch for the Washington work, one of Picasso's many depictions of itinerant street actors, as well as performers at the Cirque Médrano in Montmartre.[5] The "Spanish woman" anchors the lower right-hand corner of *Family of Saltimbanques*, where she sits isolated from a group of five figures: a harlequin, a jester, two young acrobats, and a little dancing girl. A nearby water jug suggests domestic chores, yet the woman's relationship to the group of performers is unclear: is she a mother or a wife, or perhaps a hostess to the saltimbanques? Her large size only makes her presence more problematic: if she were to stand she would tower over the rest of the saltimbanques.

Thus, *Spanish Woman from Mallorca* is not a portrait in the traditional sense, for its sitter remains anonymous and its commission nonexistent. Instead, the image was an integral part of Picasso's artistic process in developing the composition for *Family of Saltimbanques*. Although it is a sketch with a clear link to a much larger, finished painting, *Spanish Woman from Mallorca* stands on its own as a powerful expression of Picasso's spirit of pictorial experimentation.[6]

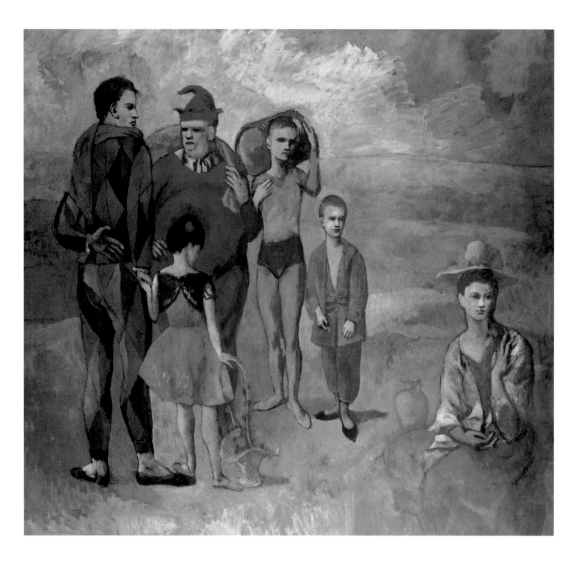

Pablo Picasso.
*Family of
Saltimbanques.* 1905.
Oil on canvas, 6 ft.
11³/₄ in. × 7 ft. 6³/₈ in.
(2.1 × 2.3 m).
The Chester Dale
Collection. National
Gallery of Art,
Washington, D.C.
© 2002 Board of
Trustees, National
Gallery of Art,
Washington.

NOTES

1 Josep Palau I Fabre, *Picasso, the Early Years, 1881–1907*
 (New York: Rizzoli, 1981), 422.

2 Pierre Daix suggests that the sitter is Fernande, based on
 reviews of works for which Fernande was the known model.
 See Daix, *Picasso: Life and Art* (New York: HarperCollins,
 1993), 46.

3 Anne Baldessari, *Picasso and Photography* (Paris:
 Flammarion, in association with the Museum of Fine Arts,
 Houston), 36.

4 John Walker, *National Gallery of Art, Washington* (New
 York: Harry N. Abrams, 1984), 600.

5 Walker, *National Gallery*, 600; see also H. H. Arnason and
 Marla F. Prather, *History of Modern Art*, 4th ed. (New York:
 Prentice-Hall and Harry N. Abrams, 1998), 184.

6 On Picasso's early work, see Marilyn McCully, ed.,
 Picasso—The Early Years, 1892–1906, exh. cat. (Washington,
 D.C.: National Gallery of Art, 1997).

PABLO PICASSO

Spanish, 1881–1973

71 *The Violin*

Oil on canvas,
1912
21 5/8 × 18 1/8 in.
(55 × 46 cm)
Inv. no. 3321

BY 1912, Picasso had fully embraced Cubism, a radical new style that he had developed with Georges Braque (cat. 72). The two artists met in 1907, and they collaborated and experimented together until pursuing separate paths in 1914. According to their dealer, Daniel-Henry Kahnweiler, Picasso and Braque were preoccupied not only with the problem of representing objects, but also with the ways that objects interacted with one another and with the space around them. In *The Rise of Cubism* (1915), Kahnweiler wrote: "In the winter of 1908, the two friends began to work along common and parallel paths. The subjects of their still-life painting became more complex. . . . The relation of objects to one another underwent further differentiation, and . . . took on more intricacy and variety. Color, as the expression of light, or chiaroscuro, continued to be used as a means of shaping form. Distortion of form, the usual consequence of the conflict between representation and structure, was strongly evident."[1]

In confronting this conflict, Picasso dispensed with a tenet of his academic training: that looking at a picture should be like looking through a window.[2] Working with Braque, he replaced this principle with Cubism, an artistic mode that subverted expectations of how to depict objects in space.[3]

Musical instruments fascinated Picasso, particularly during his Cubist period, and his paintings, collages, and constructions often incorporated musical themes.[4] In the tradition of still-life painting, instruments symbolize the sense of sound, alluding as well to the abstract language of music to which painting was often compared. Picasso's use of them taps into this long-standing visual tradition, but it also engages themes of the processes and products of creativity. Furthermore, he was enamored of the formal and geometric qualities of violins and other stringed instruments.

In *The Violin*, Picasso transforms the recognizable, three-dimensional musical instrument into a series of flattened, overlapping, abstract forms. The violin itself is at the center of the composition, its curves echoed in the oval-shaped canvas, its surface suggested by simulated wood grain, its disproportionate f-holes floating prominently on the surface, its strings and tailpiece jutting off to the left. These features, however, are all that signify the subject's "violin-ness," for Picasso has reduced the actual violin to an arrangement of angular shards that gives way to a complex mosaic of gray and brown squares. By shattering the instrument he invites us to see and understand it in an entirely new way.

In *The Violin* Picasso collapses the time-space continuum and allows us to see the object from multiple points of view simultaneously. He literally pulls the instrument apart, exposing its constituent elements as separate entities rather than as an integrated whole. And although the instrument appears fragmented, Picasso's treatment of its shape and materials results in a highly legible equation: the sum of the parts is, indisputably, a violin. Moreover, although *The Violin* is technically a still-life painting whose subject is an inanimate object, Picasso infuses it with a dynamism that hints at the way the instrument moves when played.[5]

Although Picasso rejects pictorial illusionism, he nonetheless makes reference to its traditional tools—line and color, light and shade—which he employs to

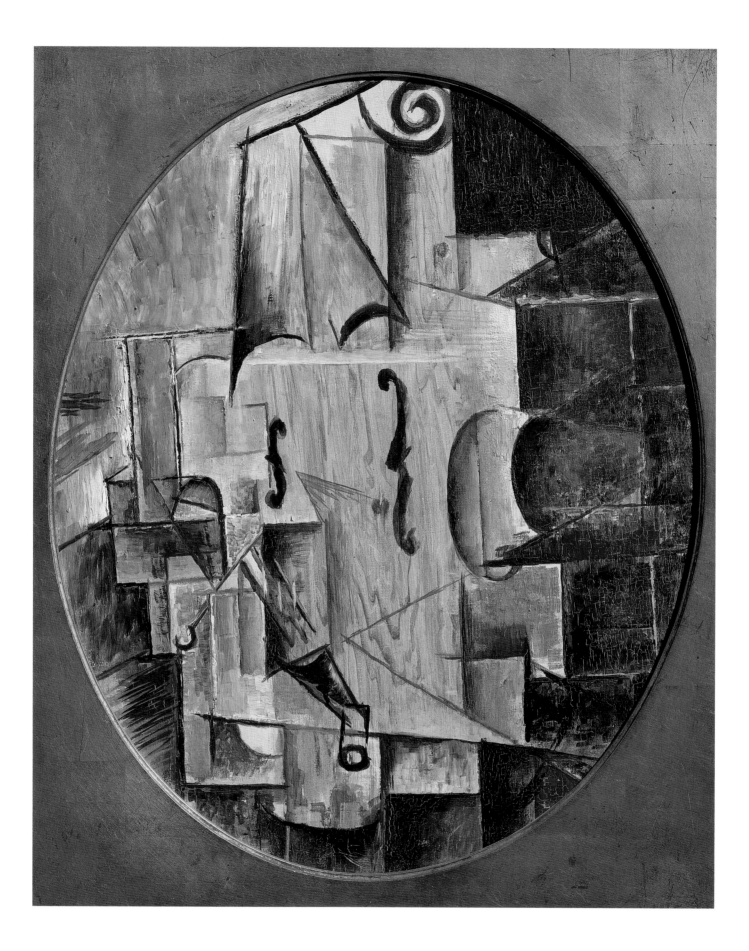

untraditional ends. Tonal contrasts in the space surrounding the violin, for example, suggest that the instrument is balanced precariously on the edge of a surface. This surface (perhaps a piano) is constructed of dark brown and black squares that mimic the solidity of wood and contrast with the mottled background of light and dark gray at left, an ambiguous region that is perhaps a wall or the floor. Indeed, though not a "realistic" representation, *The Violin* asserts a pictorial harmony rooted in Picasso's use of color and repeating shapes.

Like so many of Picasso's Cubist paintings and collages, *The Violin* constructs an image that must be decoded. Indeed, Picasso likened painting to a language, understandable only with familiarity to its rules: "We all know that Art is not truth. Art is a lie that makes us realize truth ... Cubism is no different from any other school of painting. The same principles and the same elements are common to all. The fact that for a long time Cubism has not been understood and that even today there are people who cannot see anything in it, means nothing. I do not read English, and an English book is a blank book to me. This does not mean that the English language does not exist, and why should I blame anybody else but myself if I cannot understand what I know nothing about?"[6]

While the visual puzzle of *The Violin* challenges traditional ways of representing familiar objects, Picasso clearly references these objects even as he transforms them.

NOTES

1 Daniel-Henry Kahnweiler, "The Rise of Cubism," 1915 (originally published as *Der Weg zum Cubismus* [Munich: Delphin, 1920]), in Herschel B. Chipp, *Theories of Modern Art* (Berkeley: University of California Press, 1968), 253–54. On the relationship between Picasso and Braque, see also Douglas Cooper and Gary Tinterow, *The Essential Cubism, 1907–1920: Braque, Picasso and Their Friends*, exh. cat. (London: George Braziller, in association with Tate Gallery, 1983); and William Rubin, ed., *Picasso and Braque: Pioneering Cubism*, exh. cat. (Boston: Bulfinch, in association with the Museum of Modern Art, New York, 1989).

2 Articulated and codified in 1435 by Leon Battista Alberti in *On Painting*, rev. ed., trans. John R. Spencer (New Haven: Yale University Press, 1966), 47, 75, and 89.

3 On Picasso's Cubist style and practices, see John Golding, *Cubism: A History and an Analysis, 1907–1914*, 3rd ed. (Cambridge, Mass.: Harvard University Press, 1988); T. J. Clark, "Cubism and Collectivity," in *Farewell to an Idea: Episodes from the History of Modernism* (New Haven: Yale University Press, 1999), 169–223; Christine Poggi, *In Defiance of Painting: Cubism, Futurism, and the Invention of Collage* (New Haven: Yale University Press, 1992); and Edward F. Fry, "Picasso, Cubism, and Reflexivity," *Art Journal* 47, no. 4 (1998): 296–310.

4 See Jeffrey S. Weiss, "Picasso, Collage, and the Music Hall," in *Modern Art and Popular Culture: Readings in High and Low*, ed. Kirk Varnedoe and Adam Gopnik (New York: Harry N. Abrams, in association with the Museum of Modern Art, New York, 1990), 82–115; as well as Lew Kachur, "Picasso, Popular Music, and Collage Cubism," *Burlington Magazine* 135, no. 1081 (1993): 252–60; and Ronald Johnson, "Picasso's Musical and Mallarmean Constructions," *Arts Magazine* 51, no. 7 (1977): 122–27.

5 Jean Sutherland Boggs, *Picasso and Things: The Still Lifes of Picasso*, exh. cat. (Cleveland: Cleveland Museum of Art, 1992).

6 Pablo Picasso, in an interview with Marius de Zayas published as "Picasso Speaks," *Arts* (May 1923): 315–26, in Herschel B. Chipp, *Theories of Modern Art* (Berkeley: University of California Press, 1968), 264.

GEORGES BRAQUE

French, 1882–1963

72 *Château la Roche-Guyon*

Oil on canvas,
1909
36 $\frac{1}{4}$ × 28 $\frac{3}{4}$ in.
(92 × 73 cm)
Signed on back:
Braque
Inv. no. 3258

IN 1907, Georges Braque met Pablo Picasso, and the two forged a collaboration that was both fortuitous and fruitful.[1] As young artists, both men had worked in a variety of styles; the year before they met, however, they had begun, independently, to develop the visual experiments that resulted in Cubism (see also cat. 71).[2] Braque and Picasso were raising questions about the nature of representation, and they were particularly concerned with finding ways to depict the multiple dimensions of "reality" in the limited, two-dimensional format of painting. For them, the most viable solution was initially to deconstruct objects by reducing them to geometric components and by situating them in seemingly conflicting positions in time and space. When Braque unveiled his experiments in this vein at the 1908 Salon d'Automne, Henri Matisse (cats. 73–75) characterized them as paintings "with little cubes." Matisse's remark led the critic Louis Vauxcelles to coin the term Cubism.[3]

Braque spent the summer of 1909 working in La Roche-Guyon, a village on the Seine River near Mantes. Like many of his peers and predecessors, Braque practiced close and intense study of a particular motif in nature. He painted at least eight works that depict the castle at La Roche-Guyon, continually adjusting his point of view.

Château la Roche-Guyon reveals Braque's fascination with geometry and abstraction. The arrangement of forms reads clearly as buildings in a landscape, yet the artist has reduced these structures to their most essential elements: rectangles, cylinders, and triangles. As a result, the buildings are solid and blocky, and

depicted with little detail. The architecture, moreover, is uniform in color and texture, an effect that levels the differences between the modest homes of the village and the presumably grand château.

As was typical of early Cubism, this work reveals an innovative approach to the landscape genre. In contrast to the two other "castle paintings" in the exhibition, Corot's *Castle of Pierrefonds* (cat. 22) and Derain's *The Castle* (cat. 68), Braque resists using overlapping to define spatial relations. Instead, *Château la Roche-Guyon* confounds the viewer's expectations. A large tree on the right frames the castle but provides no clear sense of distance or space. Likewise, a clump of leaves occupies the upper-left corner of the work, but where does it come from and why does it loom over the castle?

Braque made it clear that his aim was not to produce pictures that look "real," but instead to "create a new sort of beauty, the beauty that appears to me in terms of volume of line, of mass, of weight, and through that beauty interpret my subjective impression. Nature is a mere pretext for a decorative composition, plus sentiment. It suggests emotion, and I translate that emotion into art. I want to expose the Absolute, and not merely the factitious."[4]

Braque's formal experiments owe a clear debt to Paul Cézanne (cats. 55–58), whose work was shown at a huge retrospective exhibition in Paris shortly after his death in 1906.[5] Cézanne rejected the stippled brushwork and atmospheric immediacy typical of Impressionists like Monet (cats. 34–37) in favor of a more deliberate technique called *passage*: the use

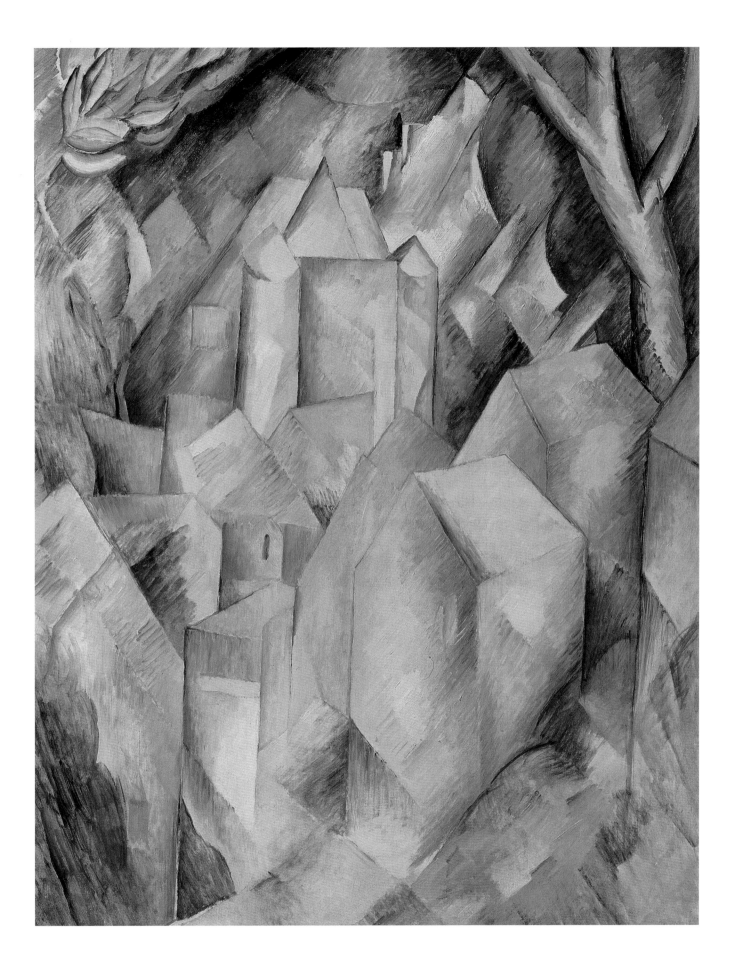

of a single plane to describe two dimensions. Braque responded to Cézanne's example in *Château la Roche-Guyon,* employing passage in the large houses on the lower right, whose front and sides are flattened to become uniformly parallel with the picture plane.

Although Braque returned many times to La Roche-Guyon to study the castle, its surrounding structures, and the landscape over which it loomed, he later maintained that "to work from nature is to improvise."[6] Indeed, his serial practice allowed him to continually explore the forms of the built and the natural environment. Furthermore, he insisted that "one must be aware of a formula [that is] *good for everything,* that will serve to interpret the other arts as well as reality, and that instead of creating will only produce a style, or rather a stylization."[7] For Braque, Cubism yielded not mere formulas, but innovative solutions that suggested endless pictorial possibilities.

NOTES

1 Russell T. Clement, *Georges Braque: A Bio-Bibliography* (Westport, Conn.: Greenwood, 1994).

2 Douglas Cooper and Gary Tinterow, *The Essential Cubism: Braque, Picasso, and Their Friends, 1907–1920,* exh. cat. (New York: George Braziller, in association with Tate Gallery, London, 1984).

3 Daniel Henry Kahnweiler, "The Rise of Cubism," 1915 (originally published as *Der Weg zum Kubismus* [Munich: Delphin, 1920]), in Herschel B. Chipp, *Theories of Modern Art* (Berkeley: University of California Press, 1968), 248.

4 Georges Braque, "Statement," 1908 or 1909, in Chipp, *Theories of Modern Art,* 259–60.

5 William Rubin, "Cézannisme and the Beginnings of Cubism," in *Cézanne: The Late Work,* exh. cat., ed. William Rubin (New York: Museum of Modern Art, 1977).

6 Georges Braque, "Thoughts and Reflections on Art," 1917, in Chipp, *Theories of Modern Art,* 259–60.

7 Braque, "Thoughts and Reflections on Art," 260. The emphasis is Braque's.

HENRI MATISSE
French, 1869–1954

73 *Goldfish*

Oil on canvas,
1912
55 ⅛ × 38 ⅝ in.
(140 × 98 cm)
Inv. no. 3299

HENRI MATISSE began his working life as a lawyer, but he abandoned this vocation in favor of painting. As a novice artist he followed the traditional academic track, working with the painter William-Adolphe Bouguereau to prepare for the entrance exam to the École des Beaux-Arts. After failing the exam in 1892, Matisse informally entered the studio of Gustave Moreau, where he studied alongside Henri-Charles Manguin (cat. 64) and Albert Marquet (cats. 65 and 66).[1] In 1895 he finally gained entry to the official art school and enrolled in Moreau's studio. There he studied the live model as well as the masterworks in the Louvre. He made copies of paintings by Dutch, Spanish, and Italian old masters, but he focused on seventeenth- and eighteenth-century French artists—especially Nicolas Poussin (cat. 1), Antoine Watteau, Honoré Fragonard, and Jean-Baptiste-Siméon Chardin. Matisse's life as an artist reflected this education, for he made his mark as a painter of landscapes, the nude, genre scenes, and still lifes like *Goldfish*.

Goldfish abounds in vivid color. Orange-red fish swim in a small, cylindrical glass tank, their bodies reflected on the surface of the water. These living things form a warm core at the center of the composition, which contrasts with the coolness of the purple table, turquoise chair, and green plants that surround it. Matisse's obvious delight in juxtaposing live fish and plants with inanimate objects is carried over into the counterbalance between the pink flowers in full bloom at the painting's lower- and upper-right edges and the chair and pink and green wallpaper on the left. These objects form a circle around the central table, which is tilted rather than foreshortened (a

technique employed by Paul Cézanne, cats. 55–58), its flat, round surface reiterating the shape of the fish tank like a nimbus. This compositional choice suggests that Matisse's primary interests are decorative patterning and chromatic relationships rather than naturalism.

Combining a variety of objects with distinctive shapes, textures, and "life spans" was a time-honored practice of still-life painters; it was perfected in the eighteenth century by Chardin in his masterpiece *The Ray* (1728, Musée du Louvre, Paris). Matisse was a great admirer of Chardin, and he had faithfully transcribed the composition of *The Ray* in his own *The Ray, after Jean-Baptiste-Siméon Chardin* (no date, Musée Matisse, Le Cateau-Cambrésis, France). In the center, a large, eviscerated ray fish hangs from a hook. At left, a cat prepares to pounce; at right are typical kitchen tools. A knife and a crumpled white cloth project off the table's edge, extending into the viewer's space. Matisse's copy does not aim to reproduce Chardin's glossy illusionism but concentrates instead on combinations of animate and inanimate objects. *Goldfish* similarly plays with such contrasts, suggesting that *The Ray* is a significant precedent. Indeed, both paintings are meditations on how different objects and elements endure through time.

Matisse painted *Goldfish* shortly after he returned to France from a trip to Morocco.[2] Travel to North Africa inspired Matisse, just as it had inspired Eugène Delacroix and Eugène Fromentin (cat. 31) before him;[3] he had traveled to Algeria in 1906 and made two trips to Morocco in 1912. There Matisse discovered the intricate patterning of Islamic textiles and miniatures, which inspired him to pursue the

231

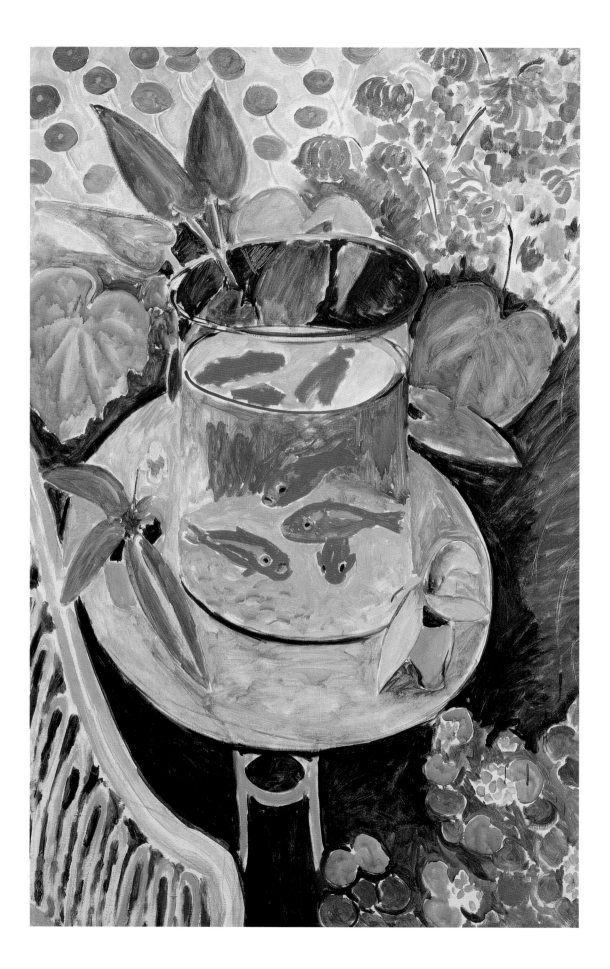

Jean-Baptiste-
Siméon Chardin.
The Ray. 1728.
Oil on canvas,
44 $^7/8$ × 57 $^1/2$ in.
(114 × 146 cm).
Musée du Louvre,
Paris.
© Réunion des
Musées Nationaux/
Art Resource, N.Y.
Photograph: J. G.
Berizzi.

decorative in his own work. Morocco was the setting for *Moroccan Café* (1912–13, State Hermitage Museum, St. Petersburg)—Matisse's first depiction of goldfish in a bowl—and he returned to the motif in works like *Goldfish and Sculpture* (1912, Museum of Modern Art, New York), *Goldfish* (1912, State Art Museum, Copenhagen), and *Interior with Goldfish* (1912, Barnes Foundation, Merion Station, Pennsylvania).

Though thematically *Goldfish* is related to the work of Chardin, its brilliant color, decorative patterning, and references to North Africa and Islamic art situates it—and its artist—firmly within the early-twentieth-century Parisian avant-garde. Matisse had announced his allegiance to the artistic vanguard in 1905, when he submitted ten canvases to the Salon d'Automne. These he exhibited alongside works by André Derain (cat. 68), Manguin, Marquet, and Maurice Vlaminck, who, with Matisse, were known as the Fauves. As a movement, Fauvism had effectively wound down by 1908, but Matisse retained his interest in color, which he combined with his growing love for decorative flatness.[4] In this he was inspired by

his predecessors Paul Cézanne (cats. 55–58) and Paul Gauguin (cats. 52–54), as well as by his contemporaries Pablo Picasso (cats. 69–71) and Georges Braque (cat. 72). Indeed, Matisse learned as much from his colleagues as from the history of art, and he synthesized these myriad pictorial sources to produce works that, like *Goldfish*, are startlingly original.

NOTES

1 He also enrolled at the École des Arts Décoratifs to maintain academic standing, taking courses in geometry, perspective, and composition. Biographical information from John Elderfield, *Henri Matisse: A Retrospective*, exh. cat. (New York: Museum of Modern Art, 1992), 82–83.

2 Painted at Matisse's studio in Issy-les-Moulineaux.

3 See Nicholas Watkins, "Matisse and Orientalism," *Burlington Magazine* 140, no. 1138 (1998): 59–60.

4 H. H. Arnason and Marla F. Prather, *History of Modern Art*, 4th ed. (New York: Prentice-Hall and Harry N. Abrams, 1998), 139.

HENRI MATISSE

French, 1869–1954

74 *Nasturtiums and The Dance*

Oil on canvas,
1912
75 × 45 in.
(190.5 × 114.5 cm)
Signed: *Henri
Matisse*
Inv. no. 3301

NASTURTIUMS AND THE DANCE was exhibited at the 1912 Salon d'Automne and purchased by the Russian collector Sergei Shchukin. In this large-scale work, Matisse combines his loves for still life and the nude and, as in *Goldfish*, explores objects both living and inert, both in motion and at rest. The painting represents typical items in his studio: chair, pedestal, vase, flowers, and *The Dance*, a painted canvas. By including this painting within the painting, Matisse, like Louis-Léopold Boilly (cat. 17), makes conscious reference to his profession and to his oeuvre. Unlike Boilly, however, he does not signify his craft by including the painter's tools; instead, he depicts the product of painting rather than the process.

The Dance rests against the far wall of Matisse's studio, a representation of pale-pink and beige figures against a deep blue background. Full of movement and yet static, these figures are indeed painted surfaces, as inanimate as the chair in the foreground or the stool in the center of the composition. As if to remind us of this, Matisse depicts the human form in a highly simplified manner, emphasizing bodily curves with dark outlines and delighting in the arcs of arms, torsos, and legs. Facial features are either elided or not visible at all, while hands and feet are merely suggested.

Matisse extends this emphasis on the painterly status of *The Dance* to the entire composition. Bordering the blue ground at the lowest edge of the painting-within-the-painting is a dark, horizontal baseboard that mediates between the canvas and the floor. This floor is painted in a similar color, a deep violet blue, resulting in a flattened pictorial space to which both *The Dance* in the background and the objects in the foreground are subordinated.

Uniting foreground and background even further are the serpentine tendrils of the nasturtiums, which echo the positions of the dancers. Their green leaves contrast with the bright-pink vase that holds them, as do their orange flowers against the blue background. Likewise, the red chair stands out vividly against the blue floor. Indeed, Matisse manipulates color and space to construct his composition as if making a pictorial puzzle, mapping out the spatial construction of the foreground through the strategic placement of the chair and the plant stand.

This chair is cropped by the lower left edges of the canvas, extending into our space as if inviting us to sit down and chat. The upper part of the chair overlaps with the baseboard, indicating that a few feet separate them. Between them is the plant stand, which demarcates the "real" space of the foreground from the "fictional" space of *The Dance*, and at the same time reminds us that all of the pictorial space in Matisse's large canvas is ultimately the space of representation. Thus, Matisse plays with our perceptions of what is real and what is art in a work whose fundamental theme is joy: the joy of dancing, of playing, and, indeed, of looking.

Matisse had explored this theme throughout his career. In *Bonheur de Vivre* (*Joy of Life*, 1905–6, Barnes Foundation, Merion Station, Pennsylvania), a painting that depicts an idealized pastoral landscape in which people embrace, play music, and dance. Six people dance in a circle in the far background, a metaphor for social and natural harmony. This motif so fascinated Matisse that it became the focus of *Dance (I)* (1909, Museum of Modern Art, New York). This large painting features five women, who

234

join hands and dance in a circle, their feet planted on a curving swath of green land, while an elemental blue field looms behind them, representing sky or water. Matisse revisited this composition—and variations on it—in later works, such as *Still Life with "The Dance"* (1909, State Hermitage Museum, St. Petersburg), *Nasturtiums with "The Dance" (I)* (1912, Metropolitan Museum of Art, New York), and this painting from the Pushkin Museum, for which the New York version was most likely a study.

In a discussion of *Nasturtiums and The Dance*, Matisse explained his practice of developing his compositions in several variations on a theme: "For a sketch I always use a prepared canvas of the same size as the finished painting, and I always begin with color. With large canvases it is more exhausting but more logical. I may have the same feeling that I depicted in the first piece, but it would not have as much strength and decorative meaning."[1]

NOTE

1 Henri Matisse as quoted in the memoirs of the American journalist Clara MacChesney, who interviewed Matisse in 1912 at his studio in Issy-les-Moulineaux; see Albert Kostenevich and Natalia Semyonova, *Matisse et la Russie* (Paris: Flammarion, 1993), 134. For more general information about Matisse's approach to his art, see Pierre Schneider, *Matisse,* trans. Michael Taylor (New York: Rizzoli, and Paris: Flammarion, 1984).

HENRI MATISSE

French, 1869–1954

75 *Calla Lilies, Irises, and Mimosas*

Oil on canvas,
1913
57 ½ × 38 ⅛ in.
(145 × 97 cm)
Signed and dated:
Henri. Matisse.
Tangier 1913
Inv. no. 3308

IN THE fall of 1912, Henri Matisse made a second trip to Morocco. Shortly before his return to France, in February 1913, he stayed in Tangier, where he painted *Calla Lilies, Irises, and Mimosas*.[1] In this still life Matisse demonstrates his characteristic love of rich color and decorative patterns, and he juxtaposes natural and manufactured elements, a strategy that recalls *Goldfish* and *Nasturtiums and The Dance* (cats. 73 and 74).

Calla Lilies, Irises, and Mimosas celebrates variety. Three different types of flowers are arranged in a pale blue vase, surrounded by elaborately patterned cloth, wallpaper, and curtains. The abundant bouquet bursts with white, purple, and yellow flowers, all of distinct sizes and shapes. One of the large, heart-shaped leaves of the calla lily hangs over the edge of the vase, its curves reiterated in the sinuous, vine-like

motifs of the tablecloth beneath it. Likewise, the smaller petals of the mimosas are echoed in the floral-patterned wallpaper in the background.

Flower painting, a specialized sub-genre of still life, has a long and venerable history.[2] It reached its apex in seventeenth-century Holland, where the market for such paintings was feverish. Representations of flowers reflected the Dutch interest in horticulture, economic strength, and power in the international arena, a convergence of practices and policies that brought the tulip to the Netherlands from Turkey, a country considered an exotic, faraway land.[3] Typically, such flower paintings were understood as *vanitas* images: pictures that encouraged viewers to meditate on the folly of human vanity, the passage of time, and mortality. Matisse was deeply familiar with the Dutch still-life tradition, and he had copied works by the seventeenth-century Dutch master Jan Davidsz. de Heem, whose paintings hang in the Louvre.

Characteristically, however, Matisse engages with a highly traditional genre and transforms it, and the result is a painting that is quite different from its seventeenth-century Dutch precedents. Whereas de Heem dazzles the viewer with seemingly photographic realism, Matisse celebrates patterns and colors, flattening space for maximum decorative effect. De Heem achieved such stunning illusionism through the meticulous application of oil paint with tiny brushes. Matisse, by contrast, applies paint with expressive freedom, liberally brushing on broad, flat areas of color to describe interior space.

Matisse's still life is, moreover, not primarily a *vanitas* but an exploration of chromatic and spatial relationships. His emphasis is not on the flowers' symbolic value; rather, his focus is on their physical

and visual qualities, and he carefully strives to "arrange" them in equilibrium with their surroundings. Matisse explains:

> Expression, for me, does not reside in passions glowing in a human face or manifested by violent movement. The entire arrangement of my picture is expressive.... Composition is the art of arranging in a decorative manner the diverse elements at the painter's command to express his feelings. In a picture every part will be visible and will play its appointed role.... A work of art must be harmonious in its entirety; any superfluous detail would replace some other essential detail in the mind of the spectator.[4]

Like *Goldfish* and *Nasturtiums and The Dance, Calla Lilies, Irises, and Mimosas* invites the viewer into a hermetic world of dynamic forms and colors.

Matisse's interiors bear no trace of personal, social, or political turmoil, in contrast to his contemporary and chief rival Pablo Picasso, whose still lifes allude directly to political strife. Picasso's collage *Glass and Bottle of Suze* (November 1912, Washington University Gallery of Art, St. Louis), for example, incorporates newspaper clippings pertaining to the Balkan Wars, catalytic events for World War I that were debated avidly—and anxiously— by Picasso and his circle.[5] Indeed, whereas Picasso employed the still-life genre to make reference to political turmoil, Matisse constructed idyllic alternatives to an imperfect world. After the war began Matisse retreated to his studios in Paris, Issy-les-Moulineaux, and Nice, rarely registering social and political events in his brightly colored, decorative canvases. At the same time, Matisse held to the principles he outlined in "Notes of a Painter,"—beauty, balance, and harmony—by representing simple, lush interior spaces.

NOTES

1 For Matisse's orientalism, see Roger Benjamin, *Orientalist Aesthetics: Art, Colonialism, and French North Africa, 1880–1930* (Berkeley: University of California Press, forthcoming).

2 Hans-Michael Herzog, ed., *The Art of the Flower: The Floral Still Life from the Seventeenth to the Twentieth Century*, exh. cat. (Zurich: Edition Stemmle, in association with Kunsthalle, Bielefeld, Switzerland, 1996). For the importance of still-life and flower painting to Impressionists and Post-Impressionists see Eliza E. Rathbone and George T. M. Shackelford, *The Impressionist Still Life* (Washington, D.C.: Phillips Collection, in association with Harry N. Abrams, 2001).

3 On this historical phenomenon, see Mike Dash, *Tulipomania: The Story of the World's Most Coveted Flower and the Extraordinary Passions It Aroused* (New York: Crown, 2000).

4 Henri Matisse, "Notes of a Painter," 1908 (originally published as "Notes d'un peintre" in *La Grande Revue*, Paris, 25 December 1908), in *Art in Theory, 1900–1990*, ed. Charles Harrison and Paul Wood (Oxford: Blackwell, 1992), 73.

5 The connection between Picasso's collages and the Balkan Wars was first discovered by Patricia Leighten; see her "Picasso's Collages and the Threat of War 1912–1913," *Art Bulletin* 67, no. 4 (1985): 653–72, and *Re-Ordering the Universe: Picasso and Anarchism, 1897–1914* (Princeton, N.J.: Princeton University Press, 1989). See also Francis Frascina, "Realism and Ideology: An Introduction to Semiotics and Cubism," in *Primitivism, Cubism, Abstraction: The Early Twentieth Century*, ed. Charles Harrison, Francis Frascina, and Gill Perry (New Haven: Yale University Press, in association with the Open University), 92.

ARTISTS IN THE EXHIBITION

Numbers refer to catalogue entries.

Bastien-Lepage, Jules 45
Boilly, Louis-Léopold 16, 17
Bonnard, Pierre 61, 62
Boucher, François 5, 6, 7
Braque, Georges 72

Carrière, Eugène 49
Cézanne, Paul 55, 56, 57, 58
Claude Lorrain 2
Corot, Camille 21, 22, 23
Courbet, Gustave 27
Couture, Thomas 24
Cross, Henri-Edmond 63

Daubigny, Charles-François 28
David, Jacques-Louis 14
Degas, Edgar 42, 43
Denis, Maurice 59
Derain, André 68
Diaz de la Peña, Narcisse Virgile
 29, 30
Drouais, François-Hubert 12

Fromentin, Eugène 31

Gauguin, Paul 52, 53, 54
Gogh, Vincent van 50, 51
Granet, François-Marius 19

Ingres, Jean-Auguste-Dominique 20

Manet, Édouard 46
Manguin, Henri-Charles 64
Marquet, Albert 65, 66
Matisse, Henri 73, 74, 75
Millet, Jean-François 26
Monet, Claude 34, 35, 36, 37

Natoire, Charles-Joseph 4
Nattier, Jean-Marc 11

Picasso, Pablo 69, 70, 71
Pissarro, Camille 40, 41
Poussin, Nicolas 1
Puvis de Chavannes, Pierre 44

Raffaëlli, Jean-François 48
Regnault, Jean-Baptiste 15
Renoir, Auguste 32, 33
Robert, Hubert 13a, 13b
Rousseau, Henri 67

Sisley, Alfred 38, 39
Subleyras, Pierre 8

Toulouse-Lautrec, Henri de 47
Troy, Jean-François de 3
Troyon, Constant 25

Van Loo, Carle 10
Vernet, Claude-Joseph 9
Vigée-Lebrun, Louise-Élisabeth 18
Vuillard, Édouard 60

Index